On the way to The Gates

On the Way to

The Gates

Central Park, New York City

Christo and Jeanne-Claude

Jonathan Fineberg with photographs by **Wolfgang Volz**

Yale University Press New Haven and London *in association with* **The Metropolitan Museum of Art** New York

Published to coincide with the exhibition "Christo and Jeanne-Claude: The Gates, Central Park, New York City," at The Metropolitan Museum of Art (April 6 to July 25, 2004).

Library of Congress Cataloging-in-Publication Data

Fineberg, Jonathan David.
 Christo and Jeanne-Claude : on the way to The Gates, Central Park, New York City / Jonathan Fineberg ; photographs by Wolfgang Volz.
 p. cm.
 ISBN 0-300-10138-4 (cloth; alk. paper)
 ISBN 0-300-10405-7 (pbk; alk. paper)
 1. Christo, 1935— Gates. 2. Artists' preparatory studies. 3. Artistic collaboration. 4. Site-specific art—New York (State)—New York. 5. Central Park (New York, N.Y.) 6. Christo, 1935– —Interviews. 7. Jeanne-Claude, 1935– —Interviews. 8. Artist couples—United States—Interviews. I. Title.

N7193.C5 A64 2004
709'.2'2—dc22 2003025145

A catalog record for this book is available from the British Library.

The paper in this book meets the guidelines for permanence and durability of the Committee on Production Guidelines for Book Longevity of the Council on Library Resources.

10 9 8 7 6 5 4 3 2

Contents

Foreword

Through five decades of collaboration, the husband-and-wife artists Christo and Jeanne-Claude have created highly celebrated works of art across the globe. From their first collaboration, *Dockside Packages, Cologne Harbor,* in 1961, to projects in Australia, Europe, Japan, and the United States, these artists have staged their outdoor works both in great urban centers and in more remote settings, from *Wrapped Reichstag, Berlin,* in the historic capital of Germany, to the *Running Fence* traversing the rolling countryside of northern California. They have embraced both land and sea, from *Wrapped Trees* in Basel, Switzerland, to *Surrounded Islands, Biscayne Bay,* in Florida, as well as the human response to the meeting of earth and water in *The Pont Neuf Wrapped, Paris.* One of their works, *The Umbrellas, Japan-USA,* has even spanned an ocean. The art of Christo and Jeanne-Claude includes both the projects themselves, which are temporary, and the graphic depictions of these works, most notably the masterly preparatory drawings and collages by Christo, which endure. About the artists' vision Albert Elsen wrote, "Christo and Jeanne-Claude have given us works that sit lightly on the land, touch the heart and forever weigh in the mind."

In 1971, as director of The Museum of Fine Arts, Houston, I was delighted to present the exhibition *Christo: Valley Curtain, Rifle, Colorado, Documentation,* which documented the *Valley Curtain* project, before its completion, with some fifty drawings, collages, photographs, and a model, as well as additional technical data. Thirty-three years later, as director and chief executive officer of the Metropolitan Museum, I am delighted to oversee the presentation of the exhibition *Christo and Jeanne-Claude: The Gates, Central Park, New York City.* With over one hundred items, it celebrates and previews Christo and Jeanne-Claude's project for Central Park planned for February 2005, *The Gates, Project for Central Park, New York City.* This will be their first outdoor work of art in New York City, their home for more than forty years. It is indeed appropriate that the Museum host this exhibition, as *The Gates* project in Central Park will literally surround the Museum when it is constructed—193 of the approximately 7,500 sixteen-foot-tall gates will be installed on the walkways adjacent to the Museum. How appropriate, too, that the Museum collaborate with the City of New York and its Parks Department. For more than 130 years, New York City and the Metropolitan have been partners in the name of art—with the City providing critical funding to the Museum, which, in turn, has enhanced the Museum's centrality to the life of our city.

The Museum's exhibition *Christo and Jeanne-Claude: The Gates, Central Park, New York City* documents the full evolution of the artists' soon-to-be realized Central Park project, from the late 1970s to the present, with fifty preparatory drawings and collages by Christo, most of which are exhibited for the first time, forty photographs, ten maps and technical diagrams, as well as components of an actual gate. All works in the exhibition are lent from the collection of Christo and Jeanne-Claude.

For sixteen days in February 2005, the approximately 7,500 saffron-colored gates (each sixteen feet high, from six to eighteen feet wide, and hung with saffron fabric panels) will be placed at twelve-foot intervals over twenty-three miles of pedestrian walkways that lace Central Park. *The Gates* project, first proposed in 1979 and rejected in 1981, was approved in January 2003 by Mayor Michael R. Bloomberg. This highly anticipated work of art will celebrate both the organic beauty and varied topography of Central Park and the grid structure of the surrounding city blocks. Like *The Pont Neuf Wrapped* and *Wrapped Reichstag* projects, *The Gates* project renders homage to an iconic venue at the center of a great city.

I wish to acknowledge and thank Christo and Jeanne-Claude for their invaluable cooperation in presenting the exhibition and for their generosity as the sole lenders. I extend my thanks as well to Museum colleagues William S. Lieberman, the Jacques and Natasha Gelman Chair-

man of the Department of Modern Art, and especially Anne L. Strauss, assistant curator in the Department of Modern Art, who curated the exhibition and coordinated all related matters, and to Jonathan Fineberg, author of this wonderful book, for his insightful texts on the lives and oeuvre of these pioneering artists. On behalf of the Metropolitan, I express the Museum's profound gratitude to an anonymous sponsor, who has generously made possible this exhibition that we enthusiastically present and that offers the public an in-depth preview of an extraordinary work of art and cultural phenomenon that has been twenty-six years in the making.

Philippe de Montebello, Director
The Metropolitan Museum of Art

On the Way to The Gates

On the Way to *The Gates*

The composer John Cage once described the ambition of his work as "an affirmation of life—not an attempt to bring order out of chaos nor to suggest improvements in creation, but simply a way of waking up to the very life we're living, which is so excellent once one gets one's mind and one's desires out of its way and lets it act of its own accord." The artists Christo and Jeanne-Claude take a similar point of view: "There's not one vantage point that should be seen or a unique point of perception," Christo explained. Every individual has her or his own account of experience in relation to a project by these artists. "They're all slices of different types of interpretations. I think this is how the work is."[1]

On the morning of Saturday, February 12, 2005, more than a quarter century after Christo drew the first sketch for his idea to highlight the walkways of Central Park in New York with a procession of thousands of brilliantly colored, freestanding gates, each with a fabric panel in autumnal gold, hanging from the top and moving with the wind, *The Gates, Project for Central Park, New York City* is at long last scheduled to be completed. *The Gates* is a remarkable story of artistic vision, persistence in the face of long odds, years of hard work, and a creative collaboration that seems to grow more interdependent with time. This temporary work of art will consist of about 7,500 custom-made rectangular frames, sixteen feet tall, placed at approximately twelve-foot intervals and spanning twenty-three miles of walkways in Central Park. In February, the coldest part of the New York winter, when the light tends to be sharp and clear and all the leaves have fallen from the trees, the thousands of shimmering panels will be the most colorful sight in the landscape, and every viewer will see them in a different way.

Christo and Jeanne-Claude have been working on *The Gates* since 1979, when Christo made the first concept drawing, titled *The Thousand Gates* (p. 59). Their desire to create a major work of art in New York, however, spans their entire career in the city, to which they emigrated from Europe with their four-year-old son Cyril in 1964. "I lived eighteen years in New York City," Christo told an audience there in 1982, "and always tried to do a project in New York City. Of course the first thing that impressed us in 1964 was the skyline."[2] They made their first attempt to create a large public work of art in New York that same year, in 1964, with a plan that involved wrapping two buildings in lower Manhattan. The building owners refused permission for the project in 1966, and all that remains of it are some drawings, photomontages, and scale models. Two years later the artists proposed three new projects for New York, although none of them were ever realized: they almost succeeded with the *Wrapped Museum of Modern Art*, but civil unrest in the country over the Vietnam War made the insurance companies and the police too nervous to permit the project; they also proposed to wrap the Whitney Museum of American Art, but the idea was not accepted by the museum's board; and they tried in vain to wrap the Allied Chemical building in the center of Times Square.

In the early 1970s, Christo and Jeanne-Claude focused their energies on three major projects in the western and midwestern United States: *Valley Curtain, Grand Hogback, Rifle, Colorado, 1970–72; Running Fence, Sonoma and Marin Counties, California, 1972–76;* and *Wrapped Walk Ways, Loose Park, Kansas City,*

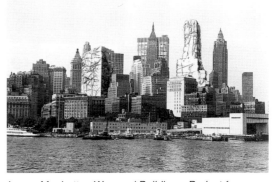

Lower Manhattan Wrapped Buildings, Project for #2 Broadway and #20 Exchange Place, New York
Detail from a photomontage (photos by Raymond de Seynes), 1964–66
20½ x 29½ in. (52 x 75 cm)
Collection: Horace Solomon, New York

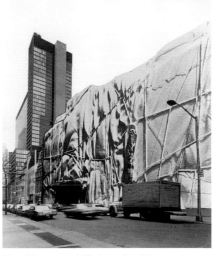

The Museum of Modern Art, Wrapped, Project for New York City
Detail from a photomontage, 1968
28 x 22 in. (71.7 x 55.9 cm)
Photo: Ferdinand Boesch

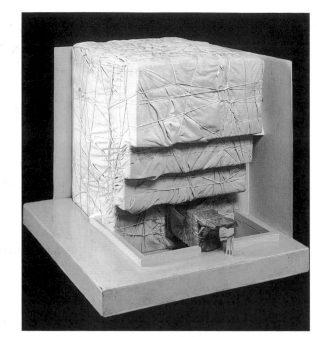

Wrapped Whitney Museum of American Art,
Project for New York City
Scale model, 1967
Fabric, twine, rope, polyethylene, wood, and paint
20 x 19½ x 22 in. (51 x 49.5 x 56 cm)
Collection: Museum Würth, Germany
Photo: Eeva-Inkeri

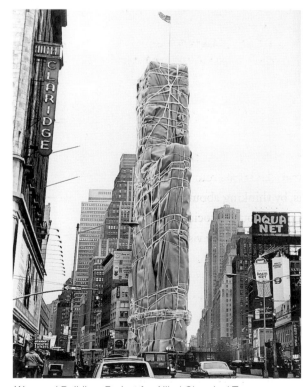

Wrapped Building, Project for Allied Chemical Tower,
Number 1 Times Square, New York City
Detail from a photomontage (photos by Harry Shunk), 1968
18 x 10 in. (45.7 x 25.4 cm)

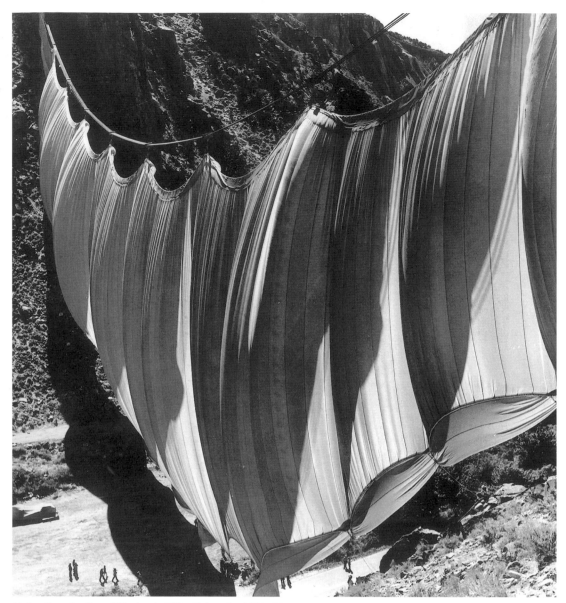

Valley Curtain, Grand Hogback, Rifle, Colorado, 1970–72
142,000 sq. ft. (13,190 sq. m) of nylon fabric and 110,000 lbs. (49,500 kg) of steel cables
Photo: Harry Shunk

Missouri, 1977–78. "At the time of *Valley Curtain,* then *Running Fence,* then *Wrapped Walk Ways,*" Jeanne-Claude explained in 2003, "our enthusiasm toward wrapping a building faded."[3] But New York was still very much on their minds; it is, after all, their home, and all of their large-scale projects have been conceived and coordinated there. Over the course of the 1970s, Christo said, their interest in "buildings and the city skyline started to refocus onto the fantastic amount of people walking in the streets. We were fascinated by how many thousands or sometimes hundreds of thousands of people were walking in the street. We were thinking if we did some project

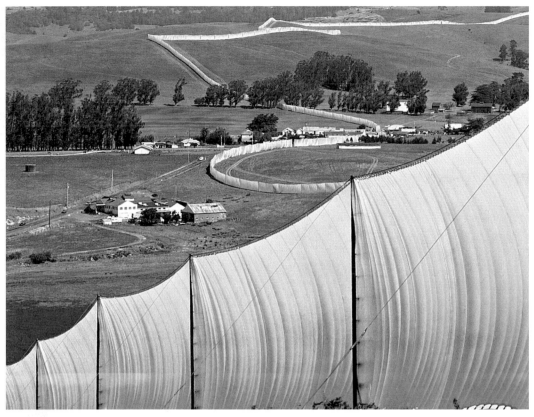

Running Fence, Sonoma and Marin Counties, California, 1972–76
2.3 million sq. ft. (216,000 sq. m) of nylon fabric, steel poles, and steel cables
Height, 18 ft. (5.5 m); length, 24½ miles (39.4 km)

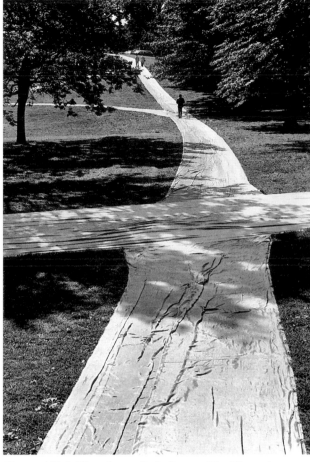

Wrapped Walk Ways, Loose Park, Kansas City, Missouri, 1977–78
135,000 sq. ft. (12,500 sq. m) of saffron-colored nylon fabric covering 2.8 miles (4.5 km) of walkways

in New York it would be related directly to the human scale. Initially we were thinking of using the sidewalk, but the sidewalk was too busy and too used for rational purposes and probably we would never get the permission. The only place really where the people walk casually after working hours is in the parks. From this came the idea, a proposition . . . called *The Gates*."[4]

Working Protocols in the Christos' Projects

For the generation of artists that preceded Christo and Jeanne-Claude—artists of the 1940s and '50s like Jackson Pollock, Willem de Kooning, Jean Dubuffet, and Alberto Giacometti—the content of their work arose from existential issues seen through introspective experience. Christo and Jeanne-Claude, however, emerged at the beginning of the sixties, when European and American artists refocused attention on epistemological questions, by thinking about *how* we know what we know. These ideas played out in social and political events and were disseminated through television and mass marketing on an unprecedented scale. In the ten years after 1947 the number of televisions in the United States jumped from ten thousand to forty million, and over the course of the 1960s it became clear that those with wealth and power could control a democracy by shaping what people saw on television and read in the newspaper, that the "military-industrial complex" had indeed gained the "unwarranted influence" against which President Dwight D. Eisenhower had warned the American people in his farewell address to the nation in 1961.[5]

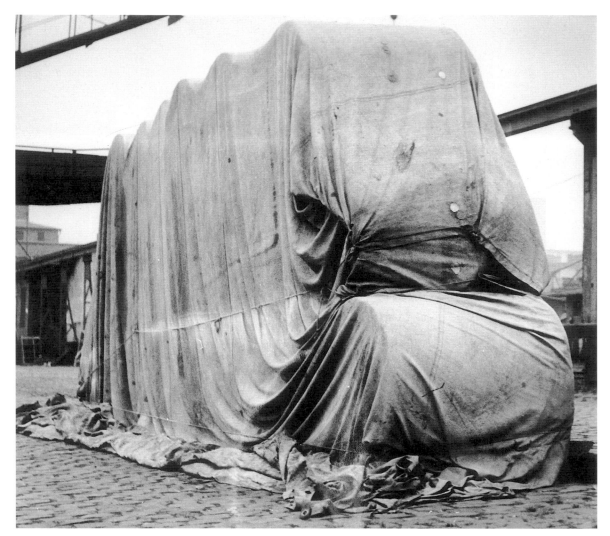

*Dockside Packages,
Cologne Harbor, 1961*
(detail)
Rolls of paper, tarpaulin,
and rope
16 x 6 x 32 ft. (4.9 x 1.8 x
9.7 m)
Photo: S. Wewerka

Building on the non-selective openness to experience in the work of the composer John Cage and the painters Jasper Johns and Robert Rauschenberg, a new group of artists who made what came to be called Pop art—with Edouardo Paolozzi, Andy Warhol, James Rosenquist, Robert Arneson, and Ed Ruscha prominent among them—began to shape a new iconography for art out of the shower of visual images that had begun to replace direct experience in our perception of the world around us. The minimalists—Frank Stella, Carl Andre, Donald Judd, Dan Flavin—began to pare visual language down to focus on the non-illusionistic presence of materials to reclaim what could still be reclaimed of the "direct" experience that was slipping through our fingers. But from the beginning of Christo and Jeanne-Claude's collective work, with the *Dockside Packages* done on the harborside in Cologne in 1961, they began refining a unique social practice of making art. Their process directly engages an increasingly broad cross-

section of the public in a discourse centered on the project, of course, but spreading out in unpredictable ways to shed light on a wide spectrum of issues. This is especially true as everyone watches—with heightened attention—all the public processes that come into play in relation to each of their projects in its particular time and place.

Christo and Jeanne-Claude's direct engagement with public process and collective action (even in the collectivity of their joint practice as artists) sets them apart from the personality-centered art of the hundred years that precedes them, when artists and intellectuals believed that the solitary, introspective explorations of gifted individuals would lead the way to the future. In contrast to an artist like de Kooning or Robert Motherwell, Christo and Jeanne-Claude almost never discuss any personal meaning in their projects; that kind of content may never even occur to them. Instead, they tend to describe the technical features of their productions or talk about the

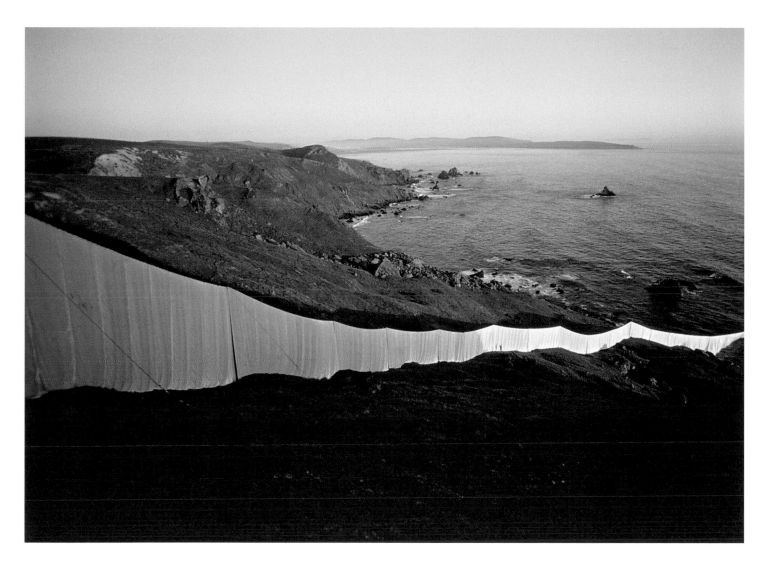

*Running Fence, Sonoma
and Marin Counties,
California, 1972–76*
2.3 million sq. ft. (216,000
sq. m) of nylon fabric, steel
poles, and steel cables
Height, 18 ft. (5.5 m);
length, 24½ miles (39.4 km)

political and social machinations they set in motion. Their public statements and press releases are strictly factual by design. The summer 2003 press release for *The Gates*, as an example, is a two-page outline packed with logistics—"all materials are being shipped to the rented 25,000 square foot (2,250 square meter) assembly plant in Maspeth, Queens," and "all materials will be recycled"—as well as dimensions, quantities, projected dates, and so on (p. 96). For some of the Christos' projects, the press releases also contain cost estimates and progress updates.

For *The Gates*, these ongoing revisions are particularly important, because park maintenance involving sections of the walkways necessitates the elimination of gates in certain locations, whereas tree pruning above sixteen feet may allow for adding gates elsewhere; the tree pruners and maintenance engineers for the park call the project director for *The Gates* on a regular basis to update the constantly changing numbers and

locations of gates. In July 2003, as they entered the final seventeen months before the opening of the project, they were not only working day and night earning the funds necessary to construct the work, but also managing the ongoing politics of retaining the permits (which continue to be at risk until the project is completed), planning the complexities of the installation, and overseeing the manufacturing of all the parts in five different factory locations. As Christo said: "So many things we need to put together in only seventeen months. How many thousands of pieces, the logistic is absolutely unbelievable."[6]

Most writers on Christo and Jeanne-Claude's work have taken their lead in focusing on the material facts. *Running Fence*, for example, garnered an avalanche of publicity, even though it was standing for only two weeks, in September 1976; it appeared on national television, in all the major papers and newsweeklies, and in a variety of specialized journals ranging from a fencing-industry trade periodical to a maga-

zine for marathon runners, and, of course, in the art press. While one article concentrated on the politics of getting permits for the fence and another on the special qualities of running alongside it, each of these discussions, whatever its particular point of view, reported the issues in a markedly factual manner, raising relatively little speculation about any kind of "expression" by the artists. The many books on the artists' works also maintain this reportorial angle, with numerous pictures of the people involved in the process, engineering plans and other documents, the construction and deployment documentation, and tallies of materials literally down to the number of nuts and bolts.

In talking about *Running Fence,* Christo took particular pleasure in describing to students at the University of Illinois in 1977 the technical innovations that were manufactured expressly for the project:

> An engineering company in Wyoming designed special trucks; they developed a machine to build the *Running Fence.* This type of truck was not existing. . . . We built four trucks, which drove fourteen thousand of the special anchors equipped with special sleeves. They were driven hydraulically into the soil and after the anchor had been driven, which was the longest working process, the anchor was locked into position by twisting it. How deep it was driven into the soil had been pre-calculated.[7]

He also enjoyed telling about how the projects transgress the hierarchies that usually segregate art projects from public construction, and in that same talk he explained:

> The United States government decided, in the late sixties, that each human activity which has a great impact on human behavior should have an environmental-impact statement. The Alaskan pipeline has an environmental-impact statement, the Dallas Airport too. *Running Fence* is the first and only work of art with an environmental-impact statement. [A second one was done in 1980 for *The Gates.*] The

report was written by fifteen scientists, it took eight months, and cost us $39,000 and was finally produced into a book of 450 pages. Everything was discussed from marine biology to economics and traffic.[8]

Similarly, there is no evidence of the artist's hand in these works of art, as there would be in a work by Rembrandt or Picasso; that exists only in Christo's wrapped objects and works on paper. Instead, these large public works have a style of collective practice, built by Christo and Jeanne-Claude around a core visual idea that Christo examines in drawings, painted photographs, collages, and scale models. These works clearly extend concepts explored by Christo in his small objects and packages, but, in the projects, Jeanne-Claude is also a partner in shaping the aesthetic. "My drawings form the basis for a project," Christo explained. "I put our ideas on paper and after this, we do everything together."[9] The extent of the collaboration is made clear in the following exchange with the artists:

> **Jeanne-Claude:** You know that people never really look at the work and they never noticed that the *Surrounded Islands* is definitely the most feminine of all our projects. I don't know if it's obvious to you.
> **Fineberg:** It's painterly . . .
> **Jeanne-Claude:** Painterly, flat, pink, and corny . . .
> **Fineberg:** It was Jeanne-Claude's idea?
> **Christo:** Yes, absolutely. . . . We were in Miami with the architectural writer of the *Miami Herald,* Beth Dunlap, and she had the duty to show us all of Miami and the Dade County area. . . .
> **Jeanne-Claude:** In her old Mercedes, she was in charge of driving us everywhere, and showing us every possible building there, et cetera. I kept asking, can we please go back again on that causeway? And when we would arrive, I would say, can we take the other causeway over there, please? And she thought we wanted to wrap a bridge. . . . Then, on a causeway I asked her to please stop and Christo and I came out of the car and . . . I was looking at all the small

islands, and that's when I said, wouldn't it be beautiful to surround *some* islands, and I was thinking three or four.[10]

Another of the operating protocols in Christo and Jeanne-Claude's work is how their projects blend into the surroundings. The colors of the *Surrounded Islands* project, in Miami's Biscayne Bay—the pink fabric, green islands, and the many hues of blue in the water—picked up the colors of the city's art deco hotels, the omnipresent pink flowers with blue stamens and green leaves, even people's clothing in Miami, which has the tropical palette of pinks and light blues and greens. Floating there in Biscayne Bay, the *Surrounded Islands* seemed more like an intensification of nature, some magnificent species of gigantic blossom, than something imposed upon the site; and it did literally incorporate the color of the water and the island vegetation into itself aesthetically. Even the early *Dockside Packages* of 1961 had an uncanny interaction with its surroundings; at first sight it seemed scarcely distinguishable from the piles of goods going on and off the ships—and then the viewer did a double take. The draped floors in the *Wrapped Museum of Contemporary Art* in Chicago, in 1969, looked like workmen's drop cloths; one wasn't sure at first if they were preparation for something or the work of art itself. Similarly, the *Running Fence* and *Wrapped Walk Ways* blended so well into—even commingled with—the real surroundings that for a moment they too seemed an exorbitant part of nature rather than a work of art. This close relationship with ordinary reality forces the viewer to look twice, to grasp nature and the reality surrounding the project in a fresh way.

That momentary and disarming uncertainty is, of course, the point. Christo and Jeanne-Claude deliberately foster the interpenetration of art with "real life," and what they do literally becomes a part of the permanent reality of the place. "You cannot separate that object formally like it exists in a pristine situation," Christo remarked. "It's on the real site, what does it mean the real things? A sunny day, a gray day, the late afternoon, early morning. There are many things in that project working visually. It's not like a Brancusi sculpture that can be

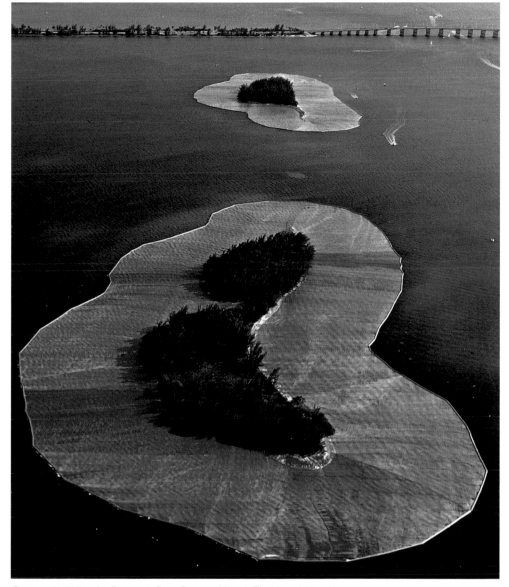

Surrounded Islands, Biscayne Bay, Greater Miami, Florida, 1980–83
6.5 million sq. ft. (600,000 sq. m) of fabric floating around eleven islands

put in an absolute vacuum. By being involved with so many natural elements like a garden, the project is so varied, so complex."[11] Shortly after the completion of *Running Fence* he went even further:

The *Running Fence* and *Valley Curtain* and previous projects have this very broad relation. The ranchers in California or the cowboys in Colorado understood that the work of art was not only the fabric and the steel cable, but there was the hills, rocks, the wind, the fear, they really cannot separate all these emotions. The work of art was that life

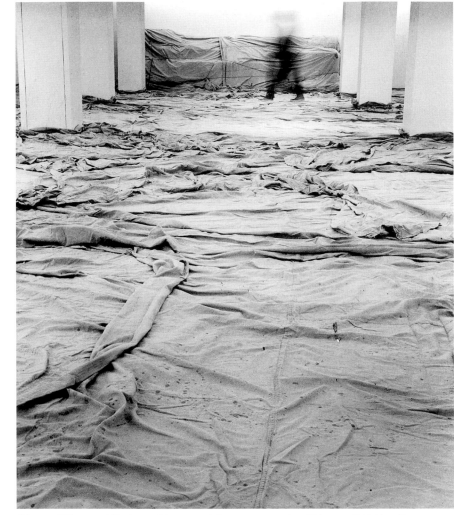

Wrapped Floor and Package, Museum of Contemporary Art, Chicago, 1969 (detail)
Drop cloth and rope
2,800 sq. ft. (252 sq. m)
Photo: Harry Shunk

expedition of a few months or years. It is rewarding to see that the ranchers' appreciation of art was in a complex way. That is, not only a formal way and not only a human way but all these pieces put together, that they can find that a part of *Running Fence* is their cows, and the sky, and the hills, and the barns, and the people.[12]

For Christo and Jeanne-Claude, the reality of these projects is all about memory, ideas, interactions; it is all extremely dynamic, and even after the physical project is removed, the project continues to exist in the minds of everyone who experienced it in the site, and it forever changes the relationship those individuals have to the site. "That is philosophy if really

the removal of the object is the removal of that project," Christo speculated. "Because most of the project will stay there, the hills, the water. The fabric of *Surrounded Islands* is a small part of the project. You cannot say that the fabric *is* the project, that wouldn't be fair to the project. The same with the *Running Fence*. The fabric is removed but overall all the other elements of the project are still there."[13] Indeed, even those who come to the site only after the disappearance of the work inherit a history that has been altered by it.

The projects Christo and Jeanne-Claude create do more than just engage the site where they are constructed; it is part of the complexity of meaning in them that they also set in bold relief all the mechanisms of the human context. All the concerns within a society surface, as each constituency attempts to appropriate the reality of these monumental, temporary works of art into its normal manner of functioning. The people involved in issuing the permits, the lawyers handling the contracts and lawsuits (both pro and con), the policemen patrolling the park in Kansas City or New York or directing the boat traffic in Florida or the cars in California, the factory workers sewing the fabric panels, the mayor, even those in opposition—they all attempt to live and work normally in relation to the project. But the fundamental irrationality of these works, their startling scale and presence, and their disarming formal beauty prompt nearly everyone to look more closely at themselves and at the world around them. "The project is teasing society," Christo explained, "and society responds, in a way, as it responds in a very normal situation like building bridges, or roads, or highways. What we know is different is that all this energy is put to a fantastic irrational purpose, and that is the essence of the work."[14]

Christo and Jeanne-Claude seed the idea for each project with drawings and collages in which Christo includes fragments of engineering plans, photographs or maps of the sites, fabric samples, and other collage elements that extend the reality of the concept and reaffirm the sense that the artists are at work on actually building it. Christo makes the concept so convincingly real, in his drawings, that people begin talking

about the idea. He entices the viewer to imagine with him how the project will look, and this, in turn, builds the reality of the idea in people's minds. Christo and Jeanne-Claude also present the work in lectures and public forums, and all this initiates the momentum that may ultimately drive the project to completion. "The project starts to live its own life," Christo said, "a little bit like a child out of our reach. We hire all types of specialists, but the project builds its own reality, which is beyond anything I can imagine."[15]

The political and social forces, so delicately interwoven into Christo and Jeanne-Claude's process, require an involved dialogue with people at every point. In the end, the realization of each project depends directly on the outcome of that interaction. Without winning the cooperation of the public, they could obtain neither the construction permits nor the commitment of the collectors, whose purchases of drawings, collages, editions, and early works ultimately finance the work. So they press people to engage with them and, in doing so, the people's involvement deepens. "I don't think any of the museum exhibitions have touched so profoundly three hundred people (as our ranchers)," Christo pointed out after his *Running Fence* project, "or three hundred thousand cars who visited *Running Fence,* in a way that half a million people in Sonoma and Marin Counties were engaged in the making of the work of art for three and a half years."[16]

The process is unquestionably a part of the work. It creates an identity and a momentum, in the court battles over permits, in the public hearings to garner local support and placate political concerns; the process exposes the work to criticism and engenders debate over issues that sometimes don't even concern the work, just by virtue of the very public nature of the projects and the atmosphere of critical debate. For the artists, this is all part of the process, and they embrace the consequences, which can only enhance the depth of the project. Someone in the audience at Christo's talk to the College Art Association in 1982 remarked: "I would find a 230-page document [the detailed written rejection of *The Gates* project in 1980 by New York's commissioner of parks and recreation] a very intimidating

refutation and you seem inspired by it." Christo replied: "I find it very inspiring in a way that is like abstract poetry. You have a man who is very serious, he's a lawyer from Harvard and he's in that job and probably he'd like to become secretary of state later and he's involved in discussing that project very seriously. You have a lot of humor and it's refreshing, I feel honored to have that printed and distributed to many places like City Hall and to have it evaluated. He adds a dimension to the work, no matter what he thinks. It's a new dimension because I never think the way he thinks. That enriches the project, it gives it all kinds of angles of perception. It's very revealing."[17]

The discourse prompted by these public projects is at the heart of their conception, along with an aesthetic juxtaposition of an abstract form with a real place, which the artists somehow sense will be provocative on many levels. "The work is a public image," Christo explains. "An open space can be used by anybody for anything. Now, if that is harmful to the project, it's part of the sociology of our time."[18] Even between Jeanne-Claude and Christo themselves there is a constant level of arguing that sometimes surprises outsiders; but that is their process. Indeed, the arguments between them are a microcosm of every other level of the projects, which evolve out of a larger dialectic in the heated, emotionally argued, real politics of each of their unique settings.

The public projects of Christo and Jeanne-Claude always bring emotions to a boil and highlight whatever concerns are emergent in a particular time and place; this makes them always relevant to current events and deeply felt, even by those who resist them. Christo said, "I don't believe any work of art exists outside of its prime time, when the artist likes to do it, when the social, political, economic times fit together." This is not only what makes the work happen, but it also engages the work in a discourse on values. Christo believes that this was as true for the great Renaissance master Fra Angelico, for example, as it is for artists today. "To do valid work then," Christo went on, referring to Fra Angelico, "it was necessary to be profoundly religious. . . . We live in an essentially economic, social, and political world. Our society is directed to social concerns of

our fellow human beings. . . . That, of course, is the issue of our time, and this is why I think any art today that is less political, less economic, less social, is simply less contemporary art."[19]

The financing is one of the perennial flash points on the Christo and Jeanne-Claude projects. Jeanne-Claude is an officer in the corporation constituted to build the projects and limit the couple's personal liability. Christo takes a modest salary. Almost everything the artists do, however, is related to their work; the very utilitarian circumstances of their living space make that clear. They do pay taxes, probably more than they actually owe, just to avoid having to invest time in demonstrating to a government auditor that everything they do is business. The artists never accept grants, state funds, or corporate sponsorship; nor do they make money from souvenirs, films, books, or photographs of their work. They finance everything themselves from the sale of Christo's original drawings, collages, painted photographs, scale models, and wrapped objects. Moreover, Christo stops making collages and drawings for a project once they have built it, so they don't even profit from the success of a completed project, except indirectly. Of course, they will prevail on collectors and museums to buy work on the basis that this helps them realize their current project.

Everything Christo and Jeanne-Claude earn on sales, and then some, they spend on materials, salaries, fabricators, and permissions for their projects. "I cannot charge tickets to Central Park," Christo explained. "We cannot make money like an exhibition, there are no ways to have money back." This, of course, goes against all expectations in our society. Instead of making money on their work, they spend it—all of it. "That drives them berserk," Christo said. "First because they think it's not true. They think we have some hidden resources, that we're lying. Secondly, if it *is* true that is almost imbecile, stupid, impossible. And really probably this is the most powerful trigger part of the project. This is why affluent people living around Central Park were so upset with the project. . . . They think that generosity is only the privilege of the wealthy."[20]

"At the basic level, I think the projects have a subversive di-

mension, and this is why I have so many problems," Christo told me in 1983, a month before the opening of *Surrounded Islands, Biscayne Bay, Greater Miami, Florida, 1980–83*. "All the opposition, all the criticisms of the project are basically that it puts in doubt all the acceptable operations of the system that we should follow normally. If the project was a movie set for Hollywood and we spent a million dollars for the movie, there would be no opposition, they could even burn the islands to be filmed and there would be no problems. The great power of the project is that it's absolutely irrational. And that disturbs, angers the sound human perception of a capitalist society. That is also a part of the project, this is the idea of the project, to put in doubt all the values."[21]

Having been educated in Marxist Bulgaria, Christo believes in the dialectical forces of history and brings a sense of social commitment to everything he does. The projects he creates with Jeanne-Claude aim to enhance people's consciousness of the workings of their society and of their own lives; the artists believe that social progress comes through the insight produced by this kind of public examination. When Christo calls his work "subversive," he means that the engagement, pro and con, of a wide spectrum of people (construction tradesmen, public service personnel, the engineers and lawyers, politicians, art students, news media, and hangers-on) are all prompted to reexamine their relation to one another, their habitual ways of living, and their roles in society from a new perspective. One California rancher, who began as a total skeptic about the artists and their *Running Fence*, which ran across his land, finally came to regard this process as so enlightening that he made his children go to all the public hearings instead of going to school; he had come to the conclusion that they would learn more in those hearings about the forces that shaped their lives than they ever could in a class.

Christo and Jeanne-Claude's work proceeds on the assumption that the most important contribution of art is its impact on the ongoing development of our consciousness as a culture, and that the object itself has little worth once its historical effect on its contemporaries has been achieved. For this

reason, the artists remove all their projects after a display period of a week or two. Indeed, the dismantling of the works adds mystery and a legendary character to the projects that causes still more conversation and thought. But once the work has occurred it also leaves a lasting legacy of ideas, even if it is removed without a physical trace. In 1977, Christo said this:

> I think our mind is the most valuable thing in the world. . . . I was in Israel recently and I went to Jericho. I was driven from Bethlehem to Jericho on small dirt roads to the Jordanian border and everything looked like any other desert, with only one difference: that I can never forget that this was one of the oldest things in the world, that seven thousand years ago people were building all our memories on three hundred kilometers. There is only earth and rocks, there is no evidence, but you know it. It is absolutely antidialectic to say that it is not different from any Arizona desert area. You cannot separate things because our whole perception of the world comes from our mind. You cannot disassociate some kind of formal existence from the mind existence, they are working and fit together.[22]

The Early Years

Christo Javacheff was born in Bulgaria on June 13, 1935, to educated and affluent parents who encouraged his early interest in art. (He later dropped the surname.) "From the age of six, I wanted to do that. I never wanted to do anything except art school."[23] By eighteen he had developed into a skilled draftsman and went to study at the Fine Arts Academy in Sofia. The Russian avant-garde of the 1910s and '20s, about which he learned from his mother and family friends, made an important early impression that stayed with Christo; the Constructivist motto of Vladimir Tatlin—"real materials in real space"—has a prophetic resonance with the projects of Christo and Jeanne-Claude.[24] In addition, Christo built on the Utopic collage and photomontage practices of El Lissitzky and the

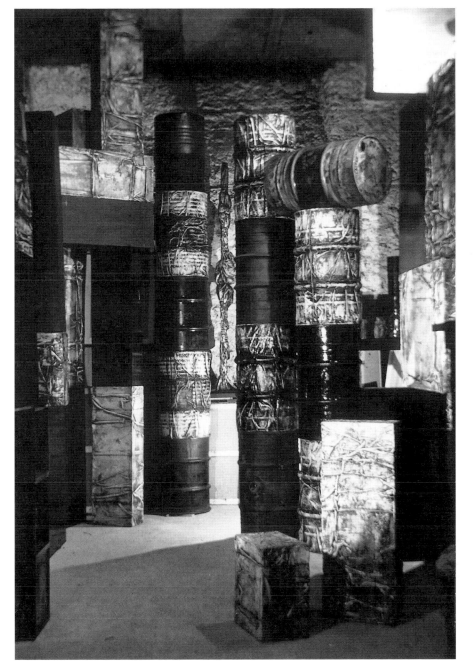

Inventory, 1958–60
Studio view in Paris
Wrapped barrels and crates, a long "package" in the background,
and (on the right) wrapped cans on shelves
Photo: René Bertholo

rigorous drawing skills of socialist realism to create the language with which he persuades viewers and makes real his unlikely propositions.

While at the academy in Sofia, Christo was inculcated with a sense of the social relevance of art. He also learned a collective practice from the requirement that students go on

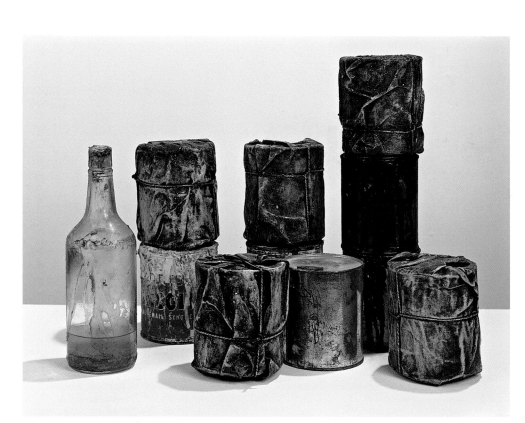

Wrapped Cans and a Bottle, 1958–59
Fabric, rope, lacquer, paint, cans, and glass bottle
5 wrapped cans, each 5⅛ x 6 in. (13 x 10.5 cm)
5 cans, each 4¾ x 4⅛ in. (12 x 10 cm)
1 glass bottle, 10⅝ x 3 in. (27 x 7.5 cm)
Photo: Eeva-Inkeri

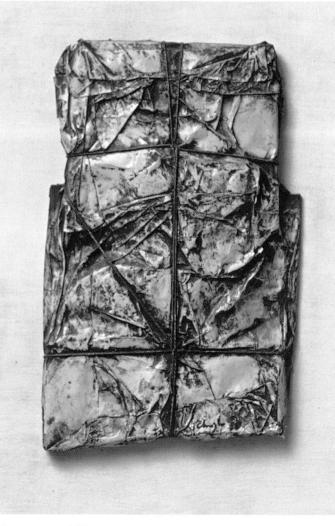

Empaquetage, 1958
Paper, rope, paint, and lacquer, mounted on fabric, board, and wood
29⅛ x 20 in. (74 x 51 cm)
Photo: Christian Bauer

weekends to farms that bordered the rail lines to advise farmers on how to arrange their equipment and produce. In the fifties, Westerners saw Bulgaria only from the windows of the international trains that passed through, and the government wanted the farms to look prosperous. But in general Christo found the academy in Sofia unsatisfying, and having lived through the brutal postwar Stalinization of Bulgaria, he decided to defect to the West, stowing away in a freight car from Prague to Vienna in January 1957. In Vienna, he studied for one semester at the Fine Arts Academy, and then relocated to Geneva in October 1957, working at menial jobs to make ends meet. There he began painting portraits on commission, and

after five months made his way to Paris, where he continued to paint portraits for a living for another few years. He always signed the portraits "Javacheff," however, to distinguish them from his serious efforts as an artist—to these, he gave his artistic signature, "Christo."

Through a remarkable coincidence, Jeanne-Claude Denat de Guillebon was born on exactly the same day as Christo, in Casablanca, Morocco, to a French military family. She, too, had a wartime childhood that contrasted sharply with her later years as a privileged adolescent in France, Switzerland, and Tunisia after the war. Jeanne-Claude received her baccalaureate in Latin and philosophy at the University of Tunis in 1952.

Wrapped Bottle, 1958
Fabric, rope, lacquer paint, and sand
8 x 3 in. (20.3 x 7.6 cm)
Collection: Kimiko and John Powers, Carbondale, Colorado
Photo: Hugo Doetsch

Portrait of Precilda de Guillebon, 1959
(Jeanne-Claude's mother)
Oil on canvas, mounted on painted wooden frame
made by the artist
24 x 15 in. (61 x 38 cm)
Photo: Christian Bauer

In July of 1957, she moved with her parents to Paris, where her father, a distinguished military commander, became head of the famous École Polytechnique.

By the time Christo arrived in Paris, in March 1958, he had already begun work on *Inventory*. *Inventory* consisted of randomly stacked groupings of bottles, cans, oil barrels, and wooden crates; some of these he wrapped in canvas, tied with twine, and painted with brown, gray, and black lacquer automobile paint, while leaving others unwrapped. Some of the unwrapped bottles were corked and partially filled with a layer of powdered pigment. In this, his first major work, there were already themes that would persist in his later objects and proj-

ects: the contrast of wrapped and revealed, the principle of open-ended repetition that implies potential extension into the real environment, the embrace of the ordinary in both the materials (unpretentious surfaces in the manner of Dubuffet) and the imagery (common containers).

In Paris, for the first time, Christo experienced the ambitions of a major art center, seeing a variety of exhibitions, including Yves Klein's scandalous *The Void* (Le Vide) of 1958, which consisted of an empty gallery, mystically "impregnated" with Klein's spiritual presence. This was Christo's first exposure to French Nouveau Réalisme, a movement created by the well-known critic Pierre Restany, who enlisted the artists Ar-

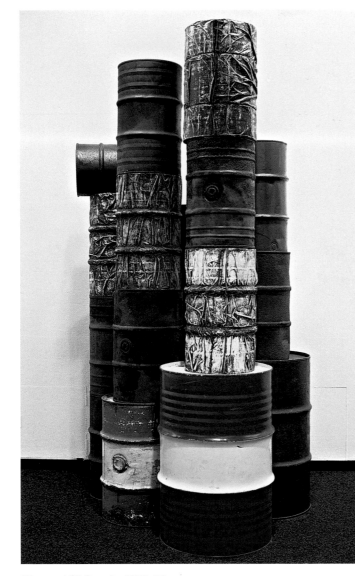

Wrapped Oil Barrels, 1958–59
Fabric, enamel paint, steel wire, and barrels
4 wrapped barrels: 24½ x 14⅜ in. (62 x 36.5 cm), 24½ x 14⅜ in. (62 x 36.5 cm), 25¼ x 14⅜ in. (64 x 36.5 cm), 23⅝ x 15 in. (60 x 38 cm)
14 barrels not wrapped

Wrapped Night Table, 1960
Fabric, rope, twine, and wooden table
37 x 15¾ x 13 in. (94 x 40 x 33 cm)
Photo: Eeva-Inkeri

man (Armand Fernandez), François Dufrêne, Raymond Hains, Yves Klein, Martial Raysse, Daniel Spoerri, Jean Tinguely, and Jacques de la Villeglé. The movement was formally founded later, in a manifesto of October 27, 1960, but Restany did not invite Christo, whose work he knew by this time, to join the Nouveaux Réalistes. Only later did Restany grasp the depth of Christo's work. During this first year in Paris, Christo also traveled to show his work in Germany, where he met the artist Joseph Beuys. In October 1958, Christo began painting portraits for the Guillebon

family, which is how he came to meet Jeanne-Claude.

In January 1959, Christo saw two influential exhibitions, *The New American Painting* (an important show of American Abstract Expressionism) and *Jackson Pollock,* at the Musée National d'Art Moderne. Christo's own focus, at this time, shifted from working exclusively with the small bottles, cans, and other domestic items in *Inventory* to larger, more architectural elements. By the end of the year, wrapping became the predominant métier for Christo. The idea of tying things in plastic or fabric with rope, rather than *representing* things, as in

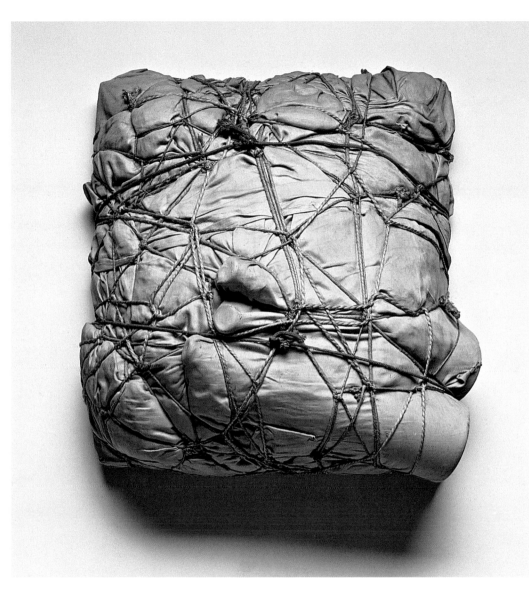

Package, 1961
Fabric, rope, twine, and cord
18 x 16½ x 6½ in. (45.7 x 41.9 x 16.5 cm)
Collection: National Gallery of Art, Washington, D.C.,
Gift of Dorothy and Herbert Vogel
Photo: Ricardo Blanc

a painting or sculpture of the more usual kind, created a continuum with the everyday world of the viewer. While the wrapping was unique to Christo and evolved organically out of his experimentation with wrinkled and lacquered surfaces in his paintings of 1957 and 1958, it also fit into the larger context of the assemblage of found materials being done in the late 1950s and early 1960s by Dubuffet and the Nouveaux Réalistes in Europe, and Jasper Johns, Robert Rauschenberg, and the so-called junk sculptors in America.

If the loosely spilled paint on Christo's wrapped bottles and cans of 1958–59 still owes a debt to the surfaces of Dubuffet or the gestural abstraction of the French Tachistes and American Abstract Expressionists, that influence was over by the end

of 1959 when Christo stopped lacquering the fabric he used to wrap his objects and shifted to a looser style of wrapping. He finished *Inventory* in 1960. Meanwhile, Christo and Jeanne-Claude had begun a clandestine affair in the summer of 1959 and, in May of 1960, Jeanne-Claude gave birth to their son, Cyril. When Jeanne-Claude revealed her relationship with Christo to her parents, it caused a rift that lasted almost two years and resulted in a period of great economic stress for the young family.

The Beginnings of a Collaborative Practice
In June 1961, Christo had his first one-person show at the

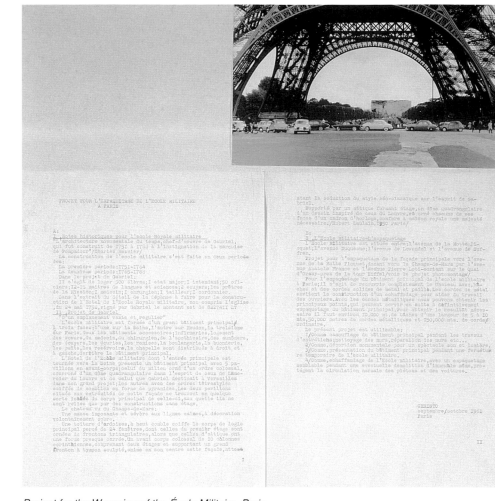

Project for the Wrapping of the École Militaire, Paris
Collaged photographs, 1961
Photographs by Harry Shunk and text by Christo
16¾ x 16¾ in. (42.5 x 42.5 cm)

Galerie Haro Lauhus in Cologne, Germany. The show included *Stacked Oil Barrels,* various wrapped objects, including *Wrapped Car,* and an installation assembled outside the gallery, on the quai of the river, called *Dockside Packages.* If one understands *Dockside Packages* as the forerunner to the increasingly large and public projects for which Christo and Jeanne-Claude are best known today, the three categories of work in this Cologne show announced what would continue to be the three dominant mediums of the artists' career: the wrapped objects, the oil barrels, and the temporary large-scale projects. In *Dockside Packages,* Christo and Jeanne-Claude stacked and draped oil barrels and industrial paper rolls on the docks in front of the gallery. Although Jeanne-Claude and Christo did not publicly acknowledge her role in the projects until 1994,

Dockside Packages is their first joint creation and the beginning of a collaborative practice that they have maintained to the present day. One of the hallmarks of the later projects, already evident here, was how the *Dockside Packages* fit naturally into the normal appearance of its setting; it seemed scarcely distinguishable from the goods unloaded on the docks every day. The surprising discovery was that it was a work of art, causing the viewer to look again—a device that Christo and Jeanne-Claude developed to great effect in their large-scale projects of the seventies and eighties, such as *Running Fence, Wrapped Walk Ways, Surrounded Islands,* and *The Pont Neuf Wrapped.*

The Shift to an Architectural Scale

Christo's wrapping of a Renault automobile, exhibited in Cologne, signaled his ambition to move to larger-scale works. In 1961, he also began making collages, some with explanatory texts, for proposals to enlarge his visions of wrapped objects to an architectural scale. *Project for the Wrapping of the École Militaire* and *Project for a Wrapped Public Building,* the first of these collages from 1961, suggest grandiose propositions, reminiscent of the Utopic photomontages of 1924 by El Lissitzky, for example, imagining futuristic skyscrapers on Nijinsky Square. *Project for a Wrapped Public Building* shows that Christo wanted to appropriate a parliament building—without indicating any particular parliament—as the paradigmatic "public" building. In *Project for the Wrapping of the École Militaire,* we look through the legs of the Eiffel Tower—a universal symbol of the grand project of European modernity in the foreground—to a Christo package, photomontaged onto the site of the École, itself one of the most powerful symbols of traditional authority in France.

Such concepts were as out of reach to an impoverished immigrant artist from Bulgaria in 1961 as Lissitzky's were to him in 1924. But, with Jeanne-Claude, Christo began systematically to move in the direction of realizing such projects. While Christo was in Cologne, the Berlin Wall was erected. Back in Paris, in the fall of 1961, he made a study for an *Iron Curtain,*

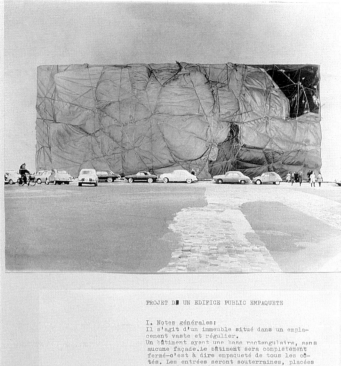

Project for a Wrapped Public Building
Collaged photographs, 1961
Photographs by Harry Shunk and text by Christo
16¼ x 9¾ in. (41.5 x 25 cm)

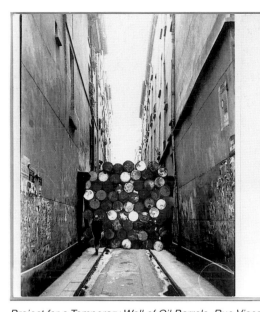

Project for a Temporary Wall of Oil Barrels, Rue Visconti, Paris
Collaged photographs, 1961
Photographs by Harry Shunk and text by Christo
9½ x 16 in. (24 x 40.5 cm)

Wall of Oil Barrels, Rue Visconti, Paris as a poetic response to the Berlin Wall. He then persuaded Pierre Restany to go with him to the police to apply for permission to install it—a wall of oil drums, fourteen feet high, that would completely close off the space between the buildings on either side of the street. Collaged to the bottom of this early study is a typewritten note that says: "This 'iron curtain' can be used as a barrier during a period of public work in the street, or to transform the street into a dead end. Finally, its principle can be extended to a whole quarter, eventually to an entire city."[25]

On June 27, 1962, a few streets away from Christo's first one-person show in Paris, at the Galerie J., Christo and Jeanne-Claude built the *Iron Curtain* out of 240 barrels, without a permit; Jeanne-Claude distracted the police. The multicolored wall of oil barrels went up around six o'clock in the evening, and they began to dismantle it around midnight. Jeanne-Claude's father was on hand to witness the event, and the next day the Saint-Germain police precinct summoned Jeanne-Claude and Christo, giving them a stern warning not to do it again.

During the early 1960s, Christo not only used photomontage to visualize his wrapping of prominent architectural sites but also refined the vocabulary and syntax of his wrapping—elaborating on the variety of cords, knots, and fabrics like a language of autographic brush strokes. He wrapped a range of objects from stacks of magazines to furniture, toys, and motorcycles, although the contents of his packages as often as not remained mysterious. When the Galleria del Leone in Venice exhibited the *Package on a Wheelbarrow* of 1963, which left the contents to the viewer's imagination, the archbishop of Venice sent the police to remove it from the gallery window and declared it obscene. The recognizable forms, however, from

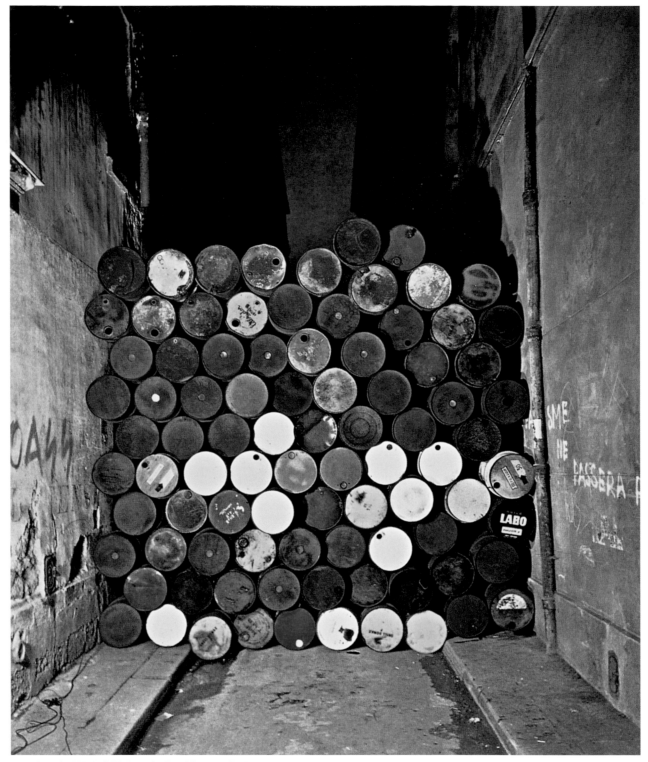

Iron Curtain, Wall of Oil Barrels, Rue Visconti, Paris, 1961–62 (June 27, 1962)
240 oil barrels
14 x 13 x 5½ ft. (4.3 x 3.8 x 1.7 m)
Photo: Jean-Dominique Lajoux

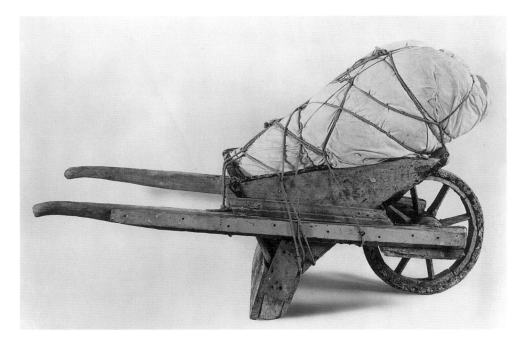

Package on a Wheelbarrow, 1963
Fabric, rope, and wheelbarrow (wood and metal)
35 x 60 x 23 in. (89 x 152.5 x 58.5 cm)
Collection: The Museum of Modern Art, New York
Photo: Ferdinand Boesch

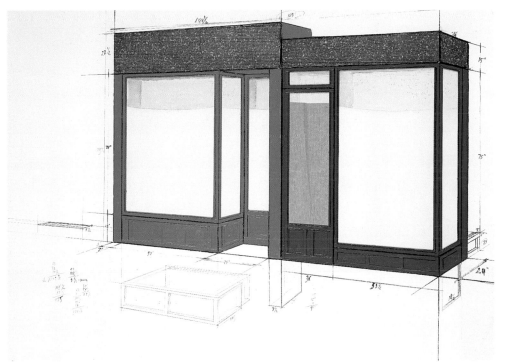

Double Store Front Project, 1964–65
(Orange and green; later built life-size in orange and yellow)
Collage on wood (pencil, enamel paint, charcoal, galvanized
metal, fabric, and Plexiglas on wood)
29 x 40 x 2 in. (73.7 x 101.6 x 5 cm)
Photo: André Grossmann

wrapped trees to the motorcycle, and the several live nude models that he wrapped for short periods (such as *Packed Girl,* 1963), all have a sensuous allure, more for what they don't reveal than for what they do. Like the drapery in classical statuary, the fabric or semi-transparent plastic sheeting suggests, rather than reveals, the forms.

Over the course of 1962, Christo had increasing success in showing his work, perhaps most importantly in October, when the Sidney Janis Gallery in New York displayed two of his *Packages* in its important *New Realists* exhibition. The Sidney Janis show included works by the French Nouveaux Réalistes, the English artist Richard Hamilton, and such newly emergent Americans as Jim Dine, Roy Lichtenstein, Claes Oldenburg, George Segal, Andy Warhol, and Tom Wesselman. In

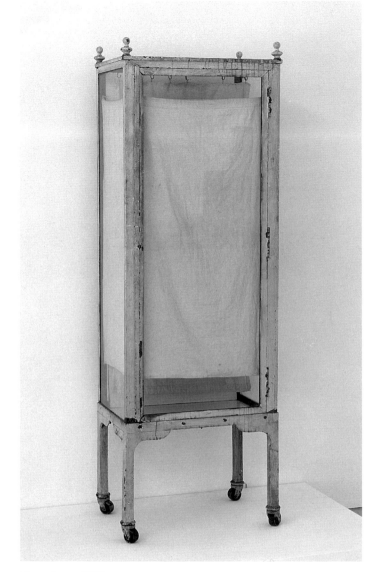

Show Case, 1963
Metal, glass, fabric, paint, and electric light
59 x 19¾ x 14⅛ in. (150 x 50 x 36 cm)
Photo: Courtesy A. Juda Fine Art

Christo wrapping one of the gilded statues on the place du Trocadéro, Paris,
February 14, 1961
Photo: Harry Shunk

1963, Christo had important one-person shows in Germany and Italy. In addition, Leo Castelli (the dealer for the great new Pop artists in New York) offered to include Christo in a show planned for May of 1964. Christo began making his *Store Front* collages early in 1964. They were in low relief and grew out of a series of small showcases that he had made with brown paper on the inside of the glass; in some there were interior lights, piquing the viewer's curiosity about the contents of the cases, which were hidden. He also created an unauthorized temporary work, *Wrapped Statue*, on the place du Trocadéro in Paris, and the event was filmed by Belgian television.

The Move to New York

Just as Christo was becoming known on the Paris art scene, the artists' landlord on the Île St. Louis evicted them in order to sell the apartment. This, combined with the promised show at Castelli in New York, prompted them to consider a radical move. In February, Christo and Jeanne-Claude left young Cyril and their greyhound dog with Jeanne-Claude's parents and visited New York for the first time. They stayed in the Chelsea Hotel on Twenty-third Street (which had a remarkable collection of artist residents at the time), and during March and April, Christo constructed the first life-size *Store*

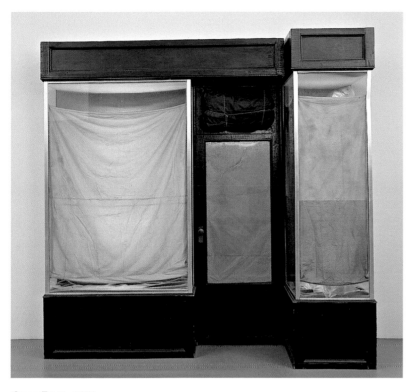

Store Front, 1964
Enamel paint, wood, aluminum, Plexiglas, fabric, plastified fabric, polyethylene,
rope, brass, brown wrapping paper, tape, and fluorescent light
104½ x 105½ x 46 in. (265.5 x 268 x 117 cm)
Collection: Hirshhorn Museum and Sculpture Garden, Smithsonian Institution,
Joseph H. Hirshhorn Purchase Fund
Photo: Courtesy Hirshhorn Museum

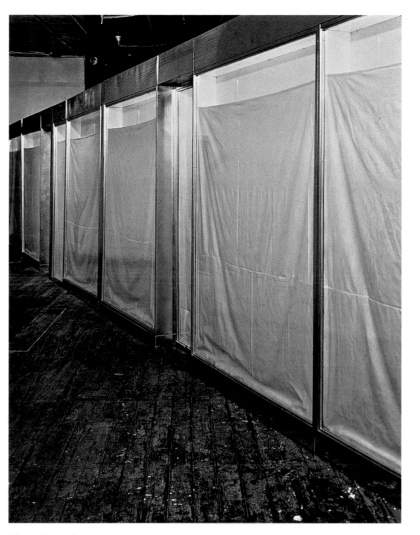

Three Store Fronts, 1965–66
Galvanized metal, aluminum, fabric, masonite, Plexiglas, and electric light
8 ft. x 46 ft. x 17 in. (2.4 m x 14 m x 43 cm)
Photo: Ferdinand Boesch

Front in their bedroom at the Chelsea. In May, he showed a life-size *Green Store Front* at Leo Castelli Gallery. The Christos were back in Europe in the summer and then, in September, Christo, Jeanne-Claude, and Cyril moved permanently to New York. At first, they again lived at the Chelsea Hotel, but by the end of the year they had moved into a decrepit loft on Howard Street, just above Canal Street. Claes Oldenburg, who also lived in the Chelsea, had a studio on Howard Street and told Christo and Jeanne-Claude about the building. They rented the top two floors, living on the fourth floor and using the fifth floor as Christo's studio. He still works there today. They patched holes and painted the raw industrial space to make it habitable, but pretended to stay on living in the Chelsea be-

cause they couldn't afford to settle their bill. The owner of the hotel finally heard about the dilemma and kindly allowed them to leave an artwork as a guarantee to cover the amount they owed until they were able to pay it.

Over the course of 1965–66, the character of Christo's *Store Fronts* shifted from a handmade look of scavenged materials to a more industrial aesthetic with metal and clean edges. Meanwhile, his reputation grew, and in May of 1966 the Stedelijk van Abbemuseum in Eindhoven, Holland, gave him his first one-person museum exhibition. Then in October he was selected for his first American museum group show, *Eight Sculptures: The Ambiguous Image,* at the Walker Art Center in Minneapolis. In Holland,

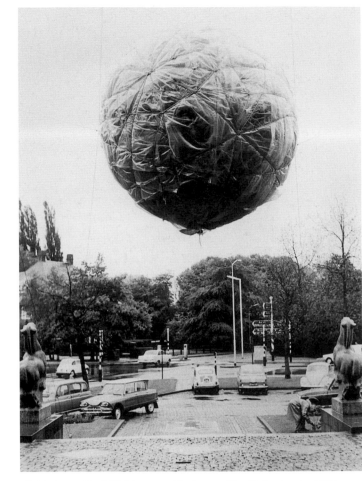

Air Package, Stedelijk Museum, Eindhoven, The Netherlands, 1966
Air, polyethylene, rubberized canvas, and rope, suspended
by steel cables
17 ft. (5.2 m) in diameter
Photo: Ab de Jager

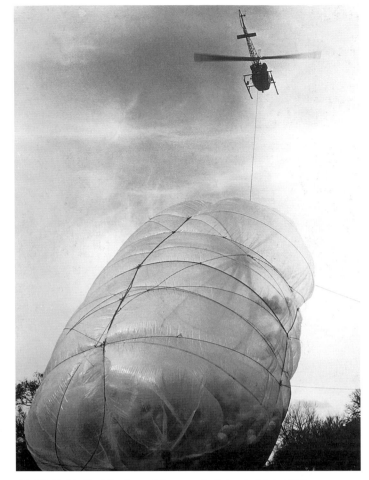

42,390 Cubic Feet Package, Minneapolis School of Art, 1966
Air, polyethylene, and rope
60 x 21 ft. (18 x 6.4 m)
Photo: Carroll T. Hartwell

Christo and Jeanne-Claude created an *Air Package*—a rubberized canvas ball, seventeen feet across and filled with air—to accompany his exhibition. In Minneapolis they enlisted a crew of art students and local faculty to help create the more ambitious *42,390 Cubic Feet Package,* which was a colossal polyethylene balloon, sixty feet long. With considerable difficulty in strong winds, they succeeded in raising the package and keeping it airborne above the treetops for three minutes. Meanwhile, Christo continued making collages and models for wrapped buildings; in his words, "to wrap a building became an obsession," despite the final rejection in 1966 of the proposal to wrap two buildings in lower Manhattan.[26]

A Turning Point

The year 1968 proved a turning point for Christo and Jeanne-Claude in their ambition to realize a work of architectural scale. Determining that their chances of wrapping a building were better with an art museum, they developed five separate plans, for the Museum of Modern Art and the Whitney Museum of American Art in New York, the Kunsthalle in Bern, Switzerland, the National Gallery in Rome, and Chicago's Museum of Contemporary Art. The Museum of Modern Art bought the *Package on a Wheelbarrow* early in 1968, and the museum's chief curator, William Rubin, suggested that Christo might do a project at the museum after the closing of the big *Dada, Surrealism, and Their Heritage* exhibition at the beginning of the summer. Plans for a wall of oil barrels on

Wrapped Sculpture Garden, Project for The Museum of Modern Art, New York City
Scale model, 1968
Wood, fabric, polyethelene, rope, twine, and paint
14 x 48 x 24 in. (35.5 x 122 x 61 cm)
Photo: Eeva-Inkeri

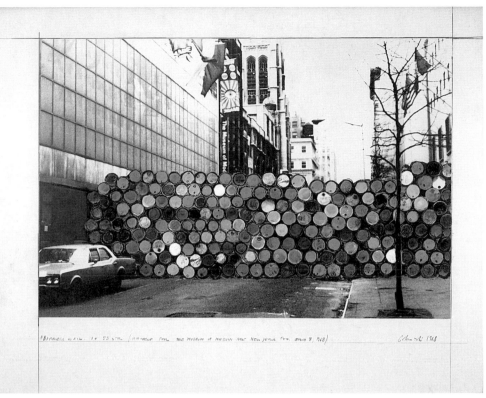

Barrels Wall at 53rd Street, Project for The Museum of Modern Art, June 9, 1968
Collaged photographs (photos by Paul Hester), 1968
Photograph, photostat, crayon, charcoal, and enamel paint
22 x 28 in. (56 x 71 cm)

Fifty-third Street in front of the museum didn't work out, however, and neither did proposals to wrap the sculpture garden or interior spaces in the museum, so they had to settle for an exhibition—*Christo Wraps the Museum . . . A Non-Event*—consisting of six scale models and ten drawings and photomontages depicting Christo's vision for wrapping the building in fabric, with a catalogue written by Rubin.

In the summer, though, the artists suddenly found themselves with permission for not one but three ambitious projects, all more or less at the same time. In June they began constructing the *5,600 Cubic Meter Package* (a package of air inflated by a powerful blower) for the *Documenta* international art exhibition in Kassel, West Germany. There was a small stipend from the *Documenta*, but it was principally three collectors—John Kaldor from Australia, John Powers from New

York, and Isi Fiszman from Belgium—who helped finance the project with their purchases of Christo's collages and wrapped objects. The *5,600 Cubic Meter Package* stood 280 feet high (about equal to the height of the Seagram Building in New York); it was the largest inflated structure without a skeleton ever made. The two artists thought they would finish that project and then move on to Bern and Spoleto, one after the other, but instead they had great problems elevating the Kassel air package, and it ended up taking most of the summer.

On the first try, the American-made balloon burst from a miscalculation of the air pressure. As Jeanne-Claude explained: "It had been calculated that for a given envelope, if you blow air in it, you create *x* amount of pressure, and if you blow twice as much, do you create twice as much pressure? Yes, only up to

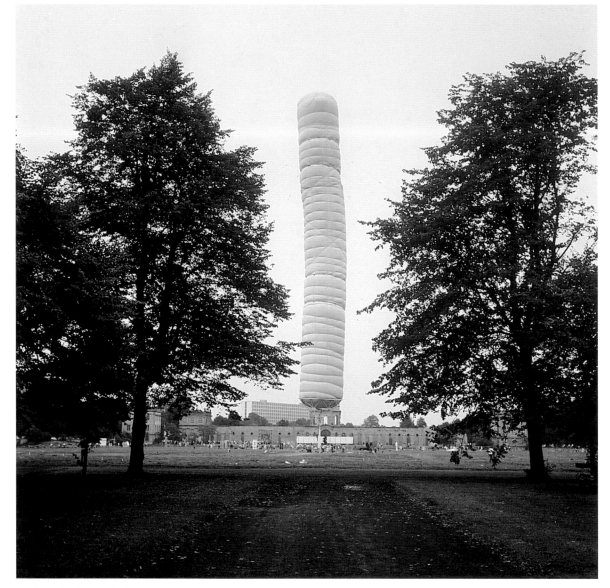

5,600 Cubic Meter Package, Documenta 4, Kassel, Germany, 1967–68
Height, 280 ft. (85.4 m); diameter, 33 ft. (10 m)
22,220 sq. ft. (2,000 sq. m) of fabric and 11,550 ft. (3.5 km) of rope
Weight, 14,000 lbs. (6,350 kg)
Photo: Klaus Baum

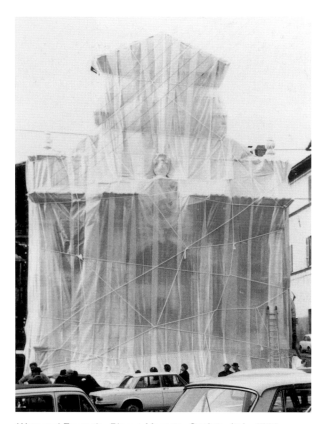

Wrapped Fountain, Piazza Mercato, Spoleto, Italy, 1968
White polypropylene fabric and rope
Photo: Jeanne-Claude

a certain point and a certain dimension, which, at the time, no engineer in the world had ever calculated." Frei Otto, a famous German architect-engineer who specialized in fabric structures, worked with Mitko Zagoroff, one of the artists' oldest friends and the chief engineer on the project, to figure out the problem, and "they invented a new formula that didn't exist before, because there had never been a need for it."[27] The artists had a new envelope made in Germany (even though

they scarcely had the money for the first one), but they decided not to wait for a second crane to raise it into position. In the process the wind threw the package against the crane, and it burst a seam. They repaired the seam and started a third time, now bringing in the two tallest mobile cranes in Europe (one from Spain and the other from Sweden), but they had to wait again, because the cranes could travel on the motorways only at night when there were few cars on the road. There were

Wrapped Medieval Tower, Spoleto, Italy, 1968
Woven synthetic fabric and rope
82 x 24 x 24 ft. (25 x 7.3 x 7.3 m)
Photo: Jeanne-Claude

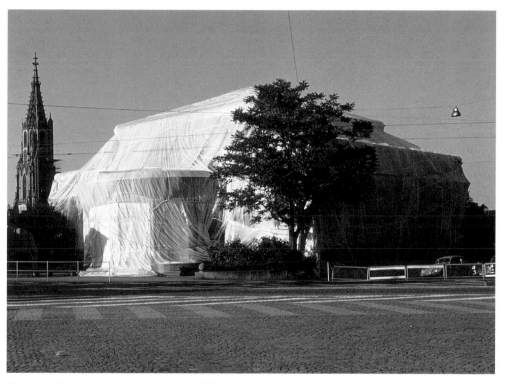

Wrapped Kunsthalle, Bern, Switzerland, 1968
27,000 sq. ft. (2,500 sq. m) of translucent polyethylene and 10,000 ft. (3,050 m) of nylon rope
Photo: Balz Burkhard

other problems, too, but they finally succeeded in getting the fourteen-thousand-pound structure into place, and it remained there, towering over the city, for two months.

In the midst of the unfolding saga in Kassel, Christo and Jeanne-Claude had to begin work on the two other projects they had set in motion for the summer. Jeanne-Claude went to Italy to select sites and create the *Wrapped Fountain* and *Wrapped Medieval Tower* for the Spoleto Festival; Christo

never saw the project except in photographs. At the same time, Christo and eleven construction workers spent six days wrapping the Kunsthalle in Bern, using the leftover fabric from the first, ruined air package in Kassel (twenty-seven thousand square feet of polyethylene); Jeanne-Claude never saw this project. These were Christo and Jeanne-Claude's first wrapped buildings.

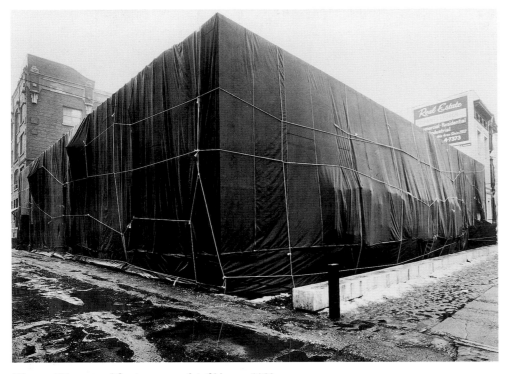

Wrapped Museum of Contemporary Art, Chicago, 1969
10,000 sq. ft. (900 sq. m) of tarpaulin and 3,600 ft. (1,100 m) of rope
Photo: Harry Shunk

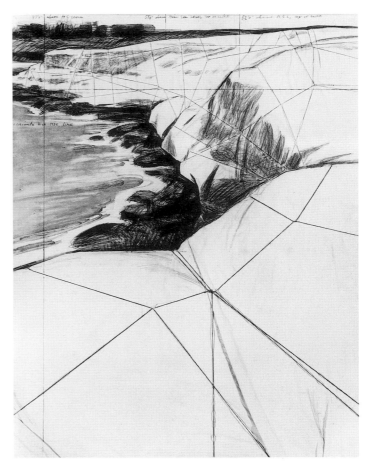

Wrapped Coast, Project for Little Bay, Australia
Collage, 1969
Pencil, charcoal, rope, and twine
28 x 22 in. (71.1 x 55.9 cm)
Photo: Harry Shunk

Wrapped Coast, One Million Square Feet

Only a few months later, in January 1969, Christo and Jeanne-Claude returned to the United States to wrap their first American building, the Museum of Contemporary Art in Chicago. They covered the building with a dark tarpaulin fabric, painted all the interior walls white, and covered the floor and stairway with an off-white cotton drop cloth, calling the work *Wrapped Museum of Contemporary Art, Chicago*. Inside, the effect was very sensual. The artists chose a dark fabric for wrapping the outside of the building, hoping that it would snow and create an impressive white-on-black contrast. It did snow, and the result was beautiful.

During the rest of the year, the artists floated a number of other ideas, which were not realized, but the next major project came very quickly, at the end of 1969. With a team of 15

professional rock climbers and 110 students, local artists, and teachers, Christo and Jeanne-Claude wrapped a mile-long section of the Australian coastline, just north of Sydney. In *Wrapped Coast, One Million Square Feet, Little Bay, Sydney, Australia*, completed in October 1969, they increased the scale of their work considerably, and they also set the work in a non-art context, which added a new dimension to Christo and Jeanne-Claude's process—the necessity of managing public relations. The land they wanted to cover belonged to a private hospital. The hospital's nurses thought the institution was paying for the work at the expense of things they needed for the patients, and they also assumed that their recreational beachfront would be closed. In fact, Christo and Jeanne-Claude paid for the project themselves, as they always do, and designed the work so that it didn't interfere with people walk-

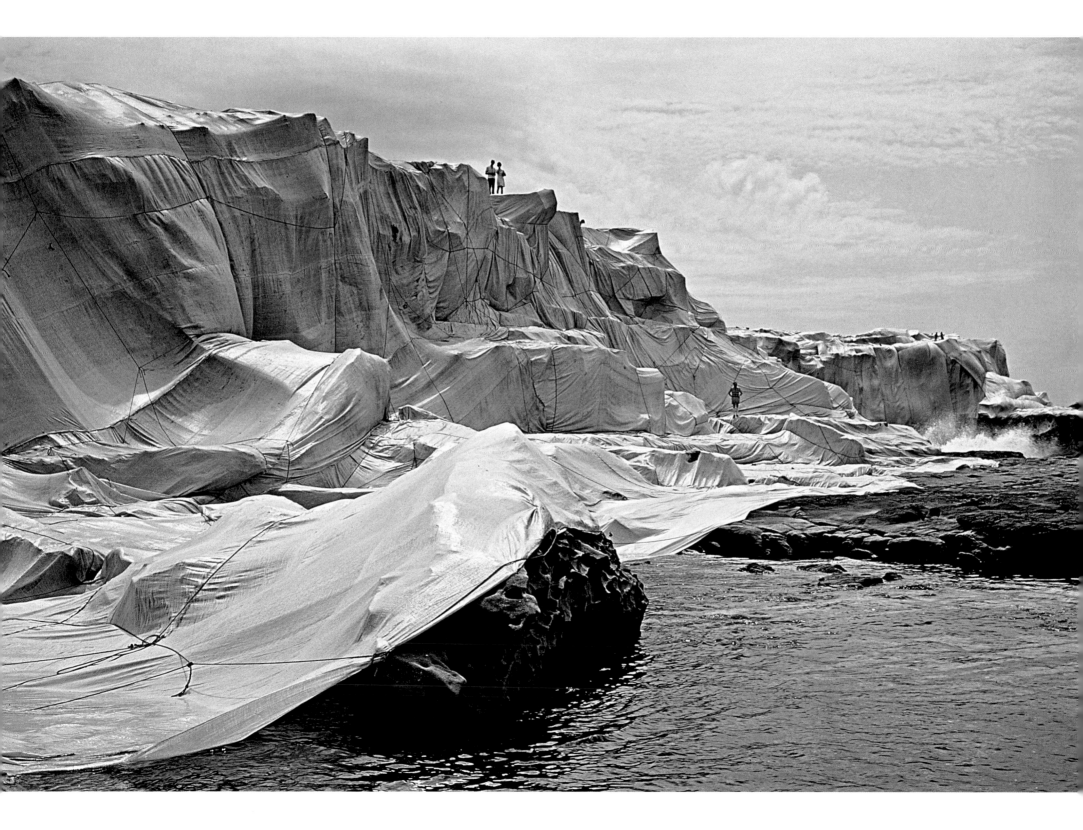

Wrapped Coast, One Million Square Feet, Little Bay, Sydney, Australia, 1969 (detail)
1,000,000 sq. ft. (93,000 sq. m) of erosion control fabric and 35 miles (56.3 km) of rope
Photo: Harry Shunk

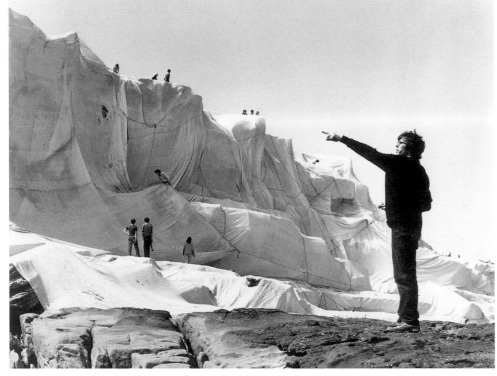

Wrapped Coast, One Million Square Feet, Little Bay, Sydney, Australia, 1969 (detail)
Photo: Harry Shunk

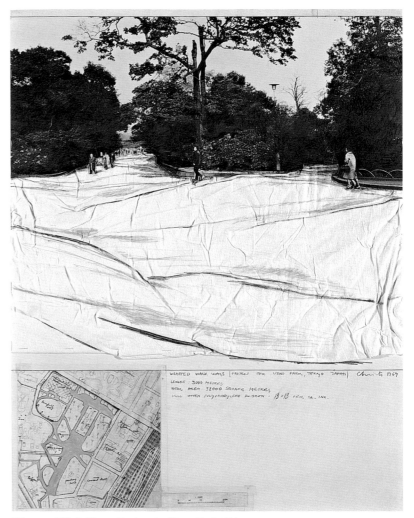

Wrapped Walk Ways, Project for Ueno Park, Tokyo
(Two-part project for Japan and Holland)
Collage, 1969
Pencil, fabric, photograph by Harry Shunk, crayon, charcoal, map, and tape
28 x 22 in. (71 x 56 cm)

ing and sunbathing on the beach. They failed to communicate this information sufficiently well, however, and the nurses threatened a strike that nearly scuttled the project. John Kaldor, the project director, managed to stop the nurses' strike. Another innovation that this project brought to the artists' process is that from this time forward they have always had Wolfgang Volz, a professional photographer, on hand, not only to give Christo material for his collages and drawings but also to document the history of each project as it unfolds.

Wrapped Coast was visually extraordinary. The artists used a light, straw-colored erosion control mesh, a loosely woven synthetic fabric normally used by farmers to keep soil in place while at the same time allowing crops to grow up through the weave. The movement of the fabric in this project created a surprising new aspect; even though there was movement in the fabric in earlier projects, the scale and the expanse allowed the wind to come up under the material and move around the rocks below it. "*Wrapped Coast* with the wind was one of the most spectacular moving things," Christo recalled. "You see those photos?" Jeanne-Claude added, pointing to spectacular photographs of the project. "It wasn't like that at all! The whole fabric was moving the whole time." Then Christo interjected: "It was an enormous beauty . . . unbelievable beauty. The wind was going underneath and the fabric was moving,

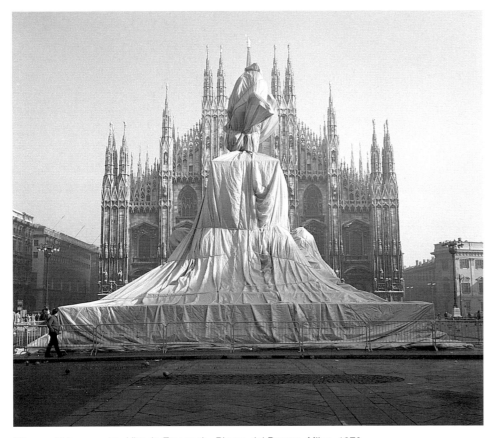

Wrapped Monument to Vittorio Emanuele, Piazza del Duomo, Milan, 1970
Woven synthetic fabric and rope
Photo: Harry Shunk

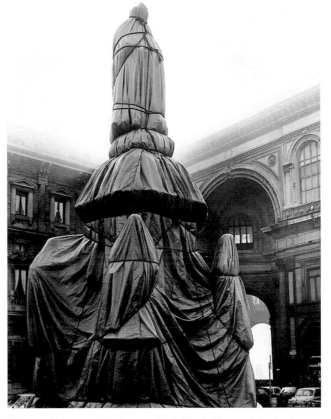

Wrapped Monument to Leonardo da Vinci, Piazza della Scala, Milan, 1970
Woven synthetic fabric and rope
Photo: Harry Shunk

but, of course, the areas where the fabric was tied around a rock the fabric was not moving. It was a beautiful contrast. We never expected that. Those images, I still see them today."[28]

Valley Curtain

Christo and Jeanne-Claude began discussing their idea for *Valley Curtain, Grand Hogback, Rifle, Colorado, 1970–72*, in June of 1970, eight months after *Wrapped Coast*. At the same time, Christo also made studies for *Wrapped Walk Ways,* a project that was intended to take place simultaneously in Ueno Park, Tokyo, and Sonsbeck Park in Arnhem, Holland, as well as a collage for a *Wrapped Island* (envisioned somewhere in the South Pacific). Neither of the latter two projects was ever realized, but both were forerunners of other major projects—*Wrapped Walk Ways, Loose Park, Kansas City, Missouri, 1977–78,* and *Surrounded Islands, Biscayne Bay, Greater Miami, Florida, 1980–83,* respectively. Meanwhile, as plans for *Valley Curtain* moved ahead, in November 1970, Scott Hodes, the artists' young lawyer, decided to create a corporation to build the upcoming project in Colorado, offering tax advantages and protecting them from personal lawsuits in case something went wrong. All subsequent projects followed this model.

Work on *Valley Curtain* intensified in January 1971 with the completion, by the engineers Lev Zetlin Associates of New York, of a structural feasibility study. The project in-

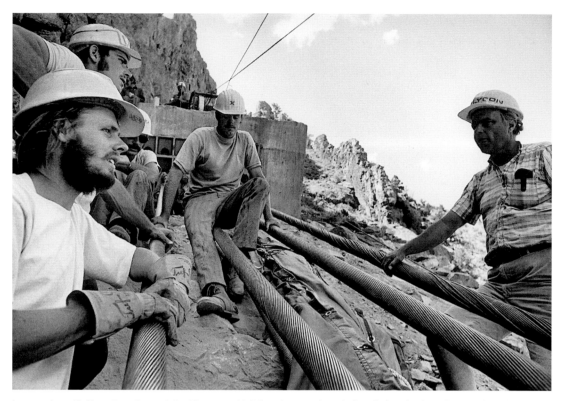

Iron workers (left) and engineer John Thomson (right) at the east foundation during the installation of the four main cables of the *Valley Curtain,* 1971.
Photo: Harry Shunk

volved hanging an enormous orange curtain, weighing eight thousand pounds, from a support system consisting of four cables, spanning more than 1,250 feet across Rifle Gap, over Colorado State Highway 325 (the design included an arched opening at the bottom of the curtain to allow traffic to pass through). In May, the construction company Morrison-Knudsen signed on as the building contractor for *Valley Curtain,* and in July, Philippe de Montebello (then director of the Museum of Fine Arts, Houston) organized a pre-project exhibition of *Valley Curtain* drawings, collages, scale models, surveys, and photographs. This is much the same as he is doing, in 2004, at The Metropolitan Museum of Art in New York for *The Gates.*

In October 1971, attempts to raise the *Valley Curtain* failed from a combination of bad engineering and lack of coordination; the wind caught the fabric during the elevation, before the workers had secured it, and the curtain shredded like tissue paper. Christo and Jeanne-Claude left Colorado in frustra-

tion, but they returned the following summer with a new engineer—they hired Dr. Ernie Harris, the engineering inspector for the State of Colorado—and a new builder-contractor, Theodore Dougherty, of A & H Builders, a local firm, and they completed the project on August 10—although the wind once again destroyed the work after only twenty-eight hours. All this was captured in a documentary film made by David and Albert Maysles, who thereafter filmed most of Christo and Jeanne-Claude's projects. *Valley Curtain* was the most expensive project they had done up to that time, costing around $800,000. Its dependence on highly skilled union steelworkers was also new. "*Valley Curtain* was the first time we really were . . . involved with American construction workers," Christo explained, "people who build things. Before, for the Chicago museum there were workers, but not really these professional workers who build skyscrapers and bridges and things. Since *Valley Curtain* we always have people who build things, steelworkers, carpenters, and machinists."[29]

Valley Curtain, Grand Hogback, Rifle, Colorado, 1970–72
142,000 sq. ft. (13,190 sq. m) of nyon fabric and 110,000 lbs. (49,500 kg) of steel cables

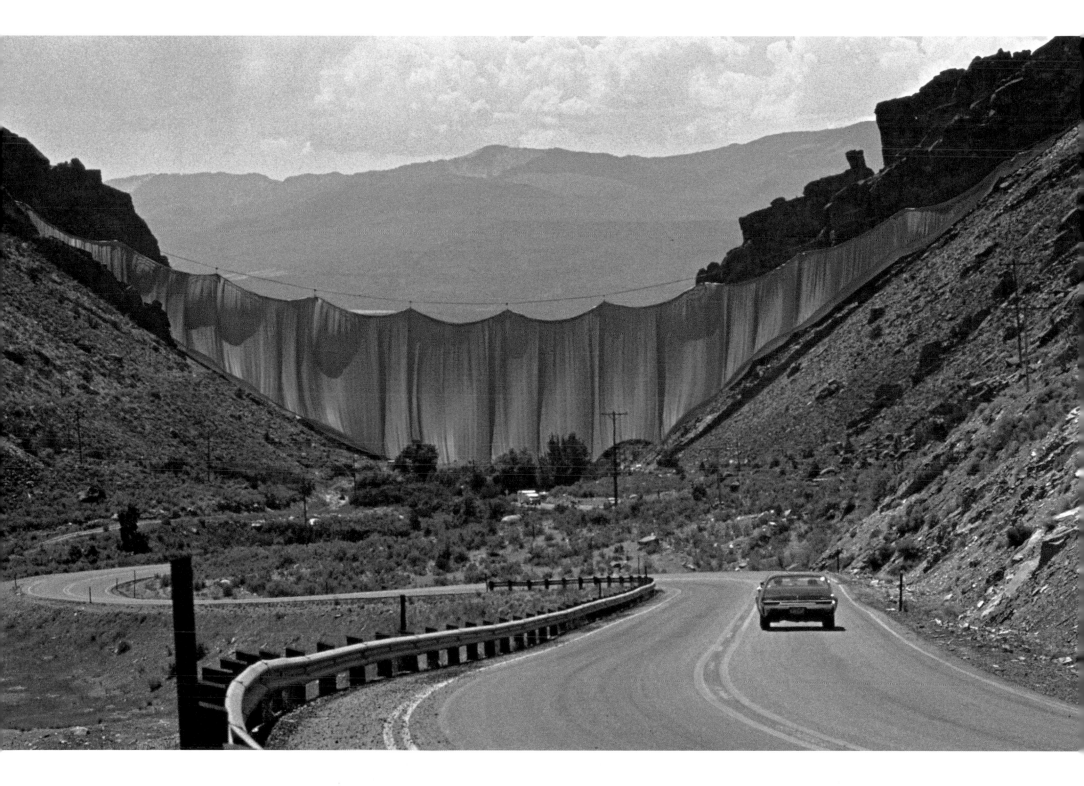

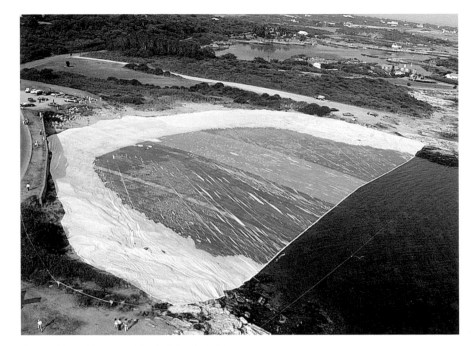

Ocean Front, Newport, Rhode Island, 1974
150,000 sq. ft. (14,000 sq. m) of woven polypropylene fabric floating on the water
Width, 420 ft. (128 m); length, 320 ft. (98 m)
Photo: Gianfranco Gorgoni

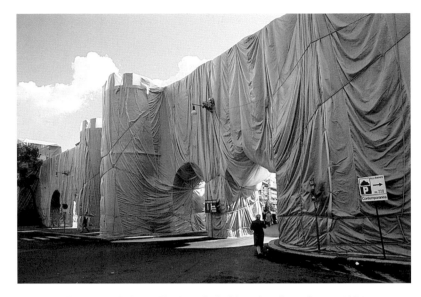

Wrapped Roman Wall, Porta Pinciana Delle Mura Aureliane, Rome, 1974
Woven synthetic fabric and rope
51 x 1,100 ft. (15.5 x 335 m)
Photo: Harry Shunk

Running Fence

Christo and Jeanne-Claude's next major project, *Running Fence, Sonoma and Marin Counties, California, 1972–76*, was a gleaming ribbon of white fabric panels, eighteen feet high and twenty-four and a half miles long, that intersected fourteen roads and U.S. Highway 101, ran across private ranches, beside subdivision homes, through the middle of a town, and into the Pacific Ocean at Bodega Bay north of San Francisco. It was so large that one could not see the entire project even from an airplane. *Running Fence* took four years of negotiations with the fifty-nine private ranchers who owned the land, required a 450-page environmental-impact statement, prompted eighteen public hearings (including three sessions of the Superior Court of California) to obtain the permits, and cost a total of $3.2 million.

Christo made the first drawing for what would become *Running Fence* in 1972 and titled it *The Divide*. During June and July 1973, Christo and Jeanne-Claude traveled to California, searching for a suitable site for *Running Fence*. Once they chose the site, the artists commissioned careful engineering drawings as well as topographical maps and scale models. They also had their photographers taking pictures of the landscapes they saw. Christo based drawings on these photographs, and, in some cases, he painted directly on the photographs to study his formal concepts in relation to the sites. As early as 1961, Christo had used photomontage and photo collage to visualize his projects, and in the course of the sixties he increasingly included photographic documentation in his collages, setting a formal precedent for the collage sections of Robert Smithson's *Nonsites* and other such documentary presentations by artists of the decade.

All the while that Christo and Jeanne-Claude were build-

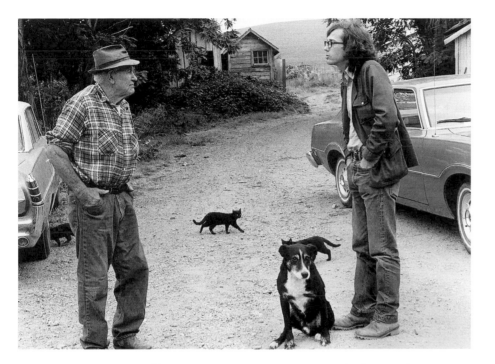

Spirito Ballatore, one of the fifty-nine landowners on whose property the *Running Fence* was installed, and Christo discussing the terms of the rental of the oceanfront portion at the western extremity of the fence, 1973
Photo: Gianfranco Gorgoni

ing *Valley Curtain* and *Running Fence,* they also continued to manage exhibitions, sales of works, and several smaller public projects. These included the *Wrapped Monument to Vittorio Emanuele, Piazza del Duomo, Milan, Italy, 1970; Wrapped Monument to Leonardo da Vinci, Piazza della Scala, Milan, Italy, 1970; Ocean Front, Newport, Rhode Island, 1974* (covering the water in a cove with six thousand pounds of white polypropylene fabric for eight days); and *Wrapped Roman Wall* of 1974, all of which demonstrates clearly the artists' remarkable energy and resourcefulness. But their determination was tested in *Running Fence,* where they met strenuous opposition in court and in the press; when I later asked Jeanne-Claude what was

one of the things that stood out as singular for her in *Running Fence,* she replied: "It was the first time we were sued."[30] Indeed, they were in court right up to the end. At the last moment before the unfurling was complete, it looked like the courts might issue a restraining order to stop the *Fence* from going into the ocean. So Christo and Jeanne-Claude went into hiding so that an injunction could not be served. But the judge sensibly concluded that such an order was pointless, since the *Fence* would come down in two weeks anyway, and he refused to issue such a demand. *Running Fence* finally went up on September 6, 1976, and remained for fourteen days.

36

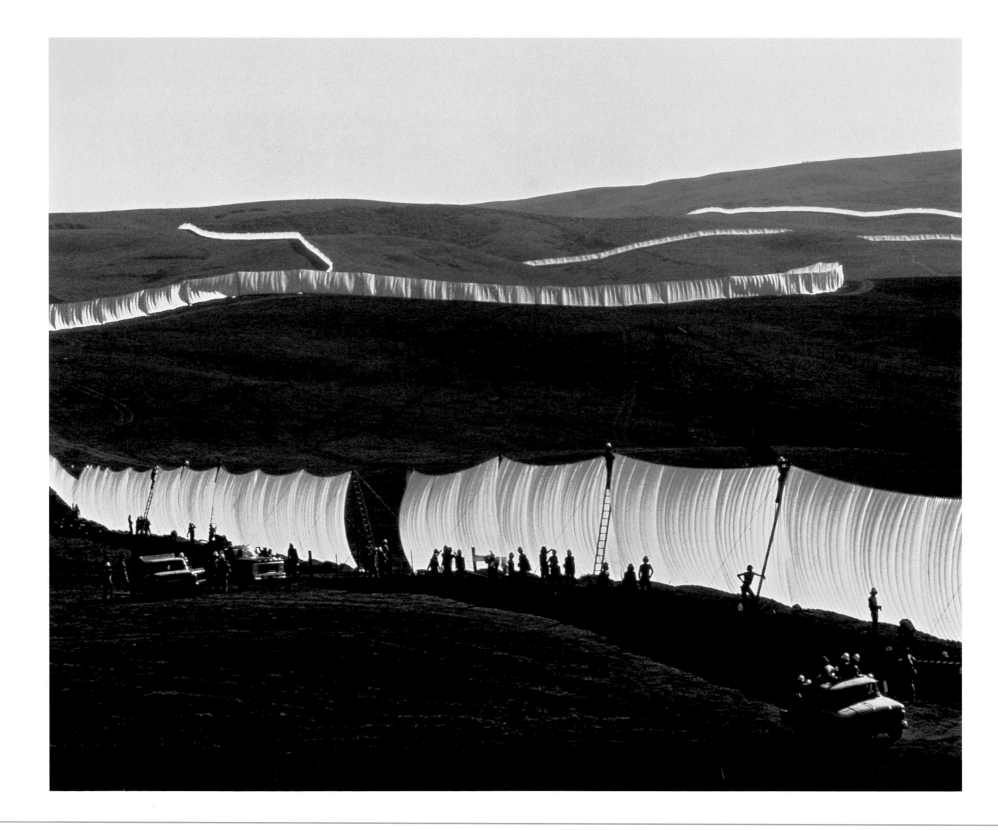

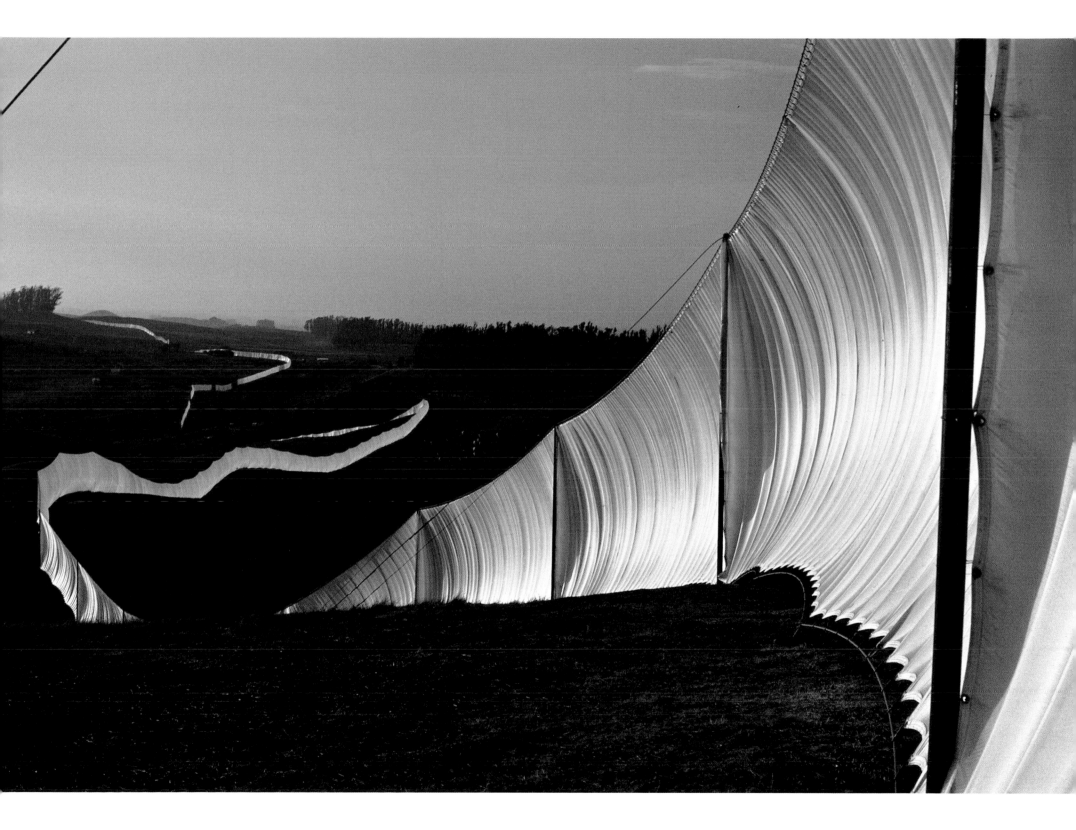

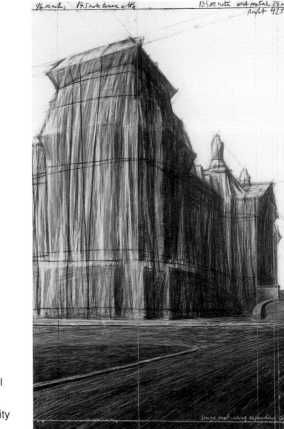

Wrapped Reichstag, Project for Berlin
Drawing, 1985
Pencil, charcoal, wax crayon, and pastel
65 x 42 in. (165 x 106.6 cm)
Collection: Timotheus Pohl, New York City
Photo: Eeva-Inkeri

Wrapped Monument to Cristobal Colón, Project for Barcelona
Collage, 1976
Pencil, fabric, twine, charcoal, and pastel

Wrapped Walk Ways

After *Running Fence* came down, Christo and Jeanne-Claude again worked on plans for a number of projects; a few, like the *Wrapped Reichstag, Berlin, 1971–95,* and *Wrapped Walk Ways,* the joint project for Dublin and Tokyo, had been on their minds for some time; others, like the *Wrapped Monument to Cristobal Colón* for Barcelona, *The Mastaba of Abu Dhabi* for the United Arab Emirates, and *The Pont Neuf Wrapped, Paris, 1975–85,* were relatively newer ideas. But none had yet been permitted when, in the early fall of 1977, the Contemporary Art Society of Kansas City invited Christo and Jeanne-Claude to construct a large-scale work. They accepted the opportunity and chose to cover the walkways of a large, heavily trafficked city park. In a remarkably short amount of time, with astonishingly little resistance, they installed one of their most beautiful projects on October 4, 1978: *Wrapped Walk Ways, Loose Park, Kansas City, Missouri, 1977–78.* "And that is why nobody knows about that project," Jeanne-Claude

pointed out. "There was no controversy on television, no battle in the newspaper, we were not sued in court, nobody knows about one of our most exquisite projects. It's amazing."[31]

In *Wrapped Walk Ways,* a shimmering gold fabric covered every footpath in the park, including Japanese gardens with wooden bridges, formal geometric gardens with an open pavilion (where the floor was covered), and meandering walks through vast expanses of meadow and English gardens. The *Wrapped Walk Ways* had a stronger connection to earlier concepts that involved covered floors than to the later *Gates.* Christo has said: "*Wrapped Walk Ways,* of course, was in a park. But it was covering the rough floor, it had more links to the wrapped floors that were in the Museum of Contemporary Art in Chicago." There had also been wrapped walkway proposals for Ueno Park in Tokyo and Sonsbeek Park in Holland in 1971, and "in 1976 there was a project for St. Stephen's Green in Dublin, and finally we did it in 1978 in Kansas City."[32]

Wrapped Walk Ways, Loose Park, Kansas City, Missouri, 1977–78
135,000 sq. ft. (12,500 sq. m) of saffron-colored nylon fabric covering 2.8 miles (4.5 km) of walkways

40

Opposite
Surrounded Islands, Biscayne Bay, Greater Miami, Florida, 1980–83
6.5 million sq. ft. (600,000 sq. m) of fabric floating around eleven islands

During the installation of *Surrounded Islands, Biscayne Bay, Greater Miami, Florida, 1980–83*

Surrounded Islands

From the time of *Running Fence* through the *Wrapped Walk Ways,* Christo and Jeanne-Claude juggled several major projects, all of which were hung up in frustrating political struggles. They had wanted to wrap the Reichstag in Berlin since 1972 and the Pont-Neuf in Paris since 1974. They had also proposed the installation of eleven thousand to fifteen thousand golden "gates" along the paths of Central Park in New York, but by the middle of 1980 they already anticipated the stinging refusal that they finally received from New York City's commissioner of parks and recreation in 1981. So, when an invitation came in 1980 to do a major project for a community-sponsored festival of the arts in Miami, it seemed a welcome relief. It wasn't long, however, before Christo and Jeanne-Claude decided against doing an outdoor project in the heat of June in Miami (the date for which the festival was planned), and they disassociated themselves from it. They nevertheless found the idea of creating a project in Miami exciting and quickly focused on the idea of surrounding eleven of the tiny spoil islands in Biscayne Bay with floating pink fabric. In 1936, the Army Corps of Engineers had dredged the bay to create a navigational channel for oceangoing ships and dumped the excavated material in fourteen piles that formed a chain of islands. These islands sat unnoticed for decades, between the cities of Miami and Miami Beach, in the midst of the heavy cross-bay traffic of boats and automobile causeways.

Over the next two and a half years Christo and Jeanne-Claude painstakingly studied the environmental issues as well as all the engineering problems and logistics. They found that the shallow bay contained a plethora of protected wildlife—endangered birds, manatees, and a variety of rare sea grasses. They did not use three of the fourteen islands because these had no beaches on which the fabric could be anchored. They tested different fabrics, anchors, and flotation booms, commissioned scientific studies of everything from the microorganisms in the sand to the birds, and they used high-tech instruments to locate the anchors and create computer maps for the fabric patterns.

Christo and Jeanne-Claude also met endlessly with lawyers, government agencies, and public groups to present the idea, win support, and negotiate permits. After numerous lawsuits in county, state, and even federal courts, and cliff-hanger hearings, they finally won the permits. They installed *Surrounded Islands, Biscayne Bay, Greater Miami, Florida, 1980–83,* the most expensive project they had ever undertaken, for eleven days in May 1983. Although the project sat nearly in the middle of a major city and stretched eleven miles from one end of the bay to the other, it nevertheless seemed oddly isolated and unreal. In addition, it so closely resembled the artist's renderings (as in all the large Christo and Jeanne-Claude projects) that, when anyone who knew the drawings saw the actual work, he or she had a sense of déjà vu, compounding the feeling of unreality. It was visually breathtaking and blended seamlessly into the surrounding environment. Here the idea prefigured in *Dockside Packages* reached a glorious climax. Not only did the project pick up on the pastels of the local architecture in this beautiful Latin city, but it even echoed the pinks and blues of the indigenous flora.

The *Surrounded Islands* was perhaps Christo and Jeanne-Claude's most photogenic work, and unlike any of their other projects the best view of it was either from a helicopter or on television. Most people experienced it through the media. Communicating an aesthetic idea to a mass-culture audience became one of the most important new issues in art of the late twentieth century, and Christo and Jeanne-Claude succeeded more than any other artists in developing the radical potential of mass media—including television.

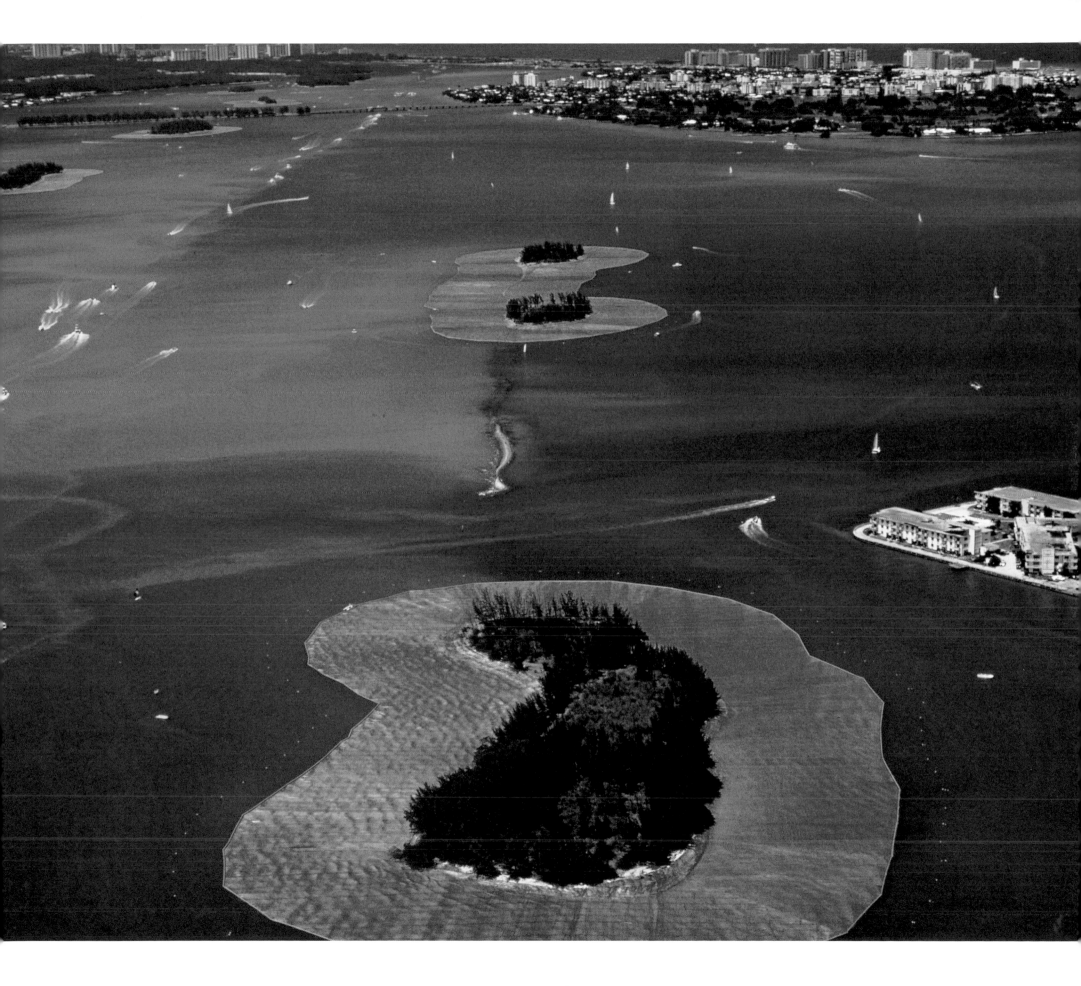

Christo and Jeanne-Claude speaking to Mayor Jacques Chirac in his office at City Hall, Paris, February 21, 1982. Left to right: Professor André Lichnérowicz, Christo, Johannes Schaub (partially visible behind Christo), Françoise de Panafieu, Jacques Chirac, Jeanne-Claude, and Henriette Joël.

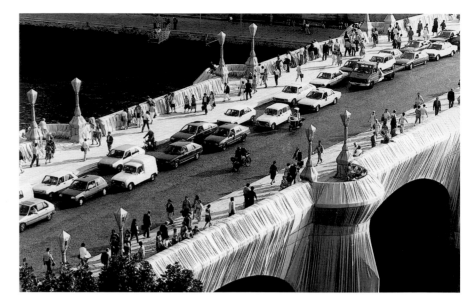

The Pont Neuf Wrapped, Paris, 1975–85
440,000 sq. ft. (40,000 sq. m) of woven polyamide fabric and 42,900 ft.
(13,000 m) of rope

The Pont Neuf Wrapped

Preparations for *The Pont Neuf Wrapped* began in 1979; Christo and Jeanne-Claude started lecturing about the project around Paris; and in October 1981, they put a scale model of the *Pont Neuf Wrapped* in a display window at La Samartaine, a large department store near the bridge. In February 1982, Christo and Jeanne-Claude presented their *Pont Neuf Wrapped* project to Jacques Chirac, then the mayor of Paris, who was not well disposed toward them despite the distinguished reputation of Jeanne-Claude's father and his personal intercession on their behalf. One of Chirac's aides, who favored the project, put a letter of permission at the bottom of a stack of papers for the mayor to sign, and Chirac went through and signed them all without looking, inadvertently signing the permit in August 1984, giving an official go-ahead for the project. But after the fact, the mayor sent a deputy to tell the artists that he was rescinding the permission. Jeanne-Claude retorted that she would give his letter to the press to show that Jacques Chirac's signature meant nothing. Chirac did not raise the issue again, and on September 22, 1985, Christo and Jeanne-Claude wrapped the bridge and all forty-four of the streetlights on it in a shimmering sandstone-colored fabric. The bridge remained wrapped for fourteen days. The result was astoundingly picturesque against the backdrop of Paris, and it drew some three million spectators. "The wrapped Pont-Neuf in Paris was much more based on an aesthetic motive because of the mar-

velous shape of the twelve arches," Jeanne-Claude noted. "The Pont-Neuf has those twelve fingers in the water."[33]

The Pont-Neuf itself, completed in 1606 under Henri IV, is the oldest bridge in Paris, and it links the Right Bank and Left Bank of the river Seine to the Île de la Cité, the heart of Paris for more than two thousand years. This solidly proportioned, historic monument—and indeed the perfectly preserved center of Paris as a whole—seems to embody the timeless identity of France. Yet for the duration of the temporary work *The Pont Neuf Wrapped, Paris, 1975–85*, Christo and Jeanne-Claude effectively transformed the context for viewing the bridge to underscore ephemerality and the power of an individual creative vision over the stable and anonymous monolith of social convention. It is a highly subversive message, and yet these artists were somehow able to work around the conservative mayor of Paris to create it. It is perhaps a commentary on the difference between the United States and the more tradition-conscious Europe that, in Europe, Christo and Jeanne-Claude have consistently chosen to wrap well-known public monuments (or common objects like the oil barrels)—in effect appropriating their form and undermining their stability as images—whereas in the United States and Japan they have created abstract forms that interact more freely with the landscape, as in *Valley Curtain, Running Fence, Wrapped Walk Ways, Surrounded Islands, The Umbrellas, The Gates,* and *Over the River.*

The Pont Neuf Wrapped, Paris, 1975–85
440,000 sq. ft. (40,000 sq. m) of woven polyamide fabric and 42,900 ft. (13,000 m) of rope

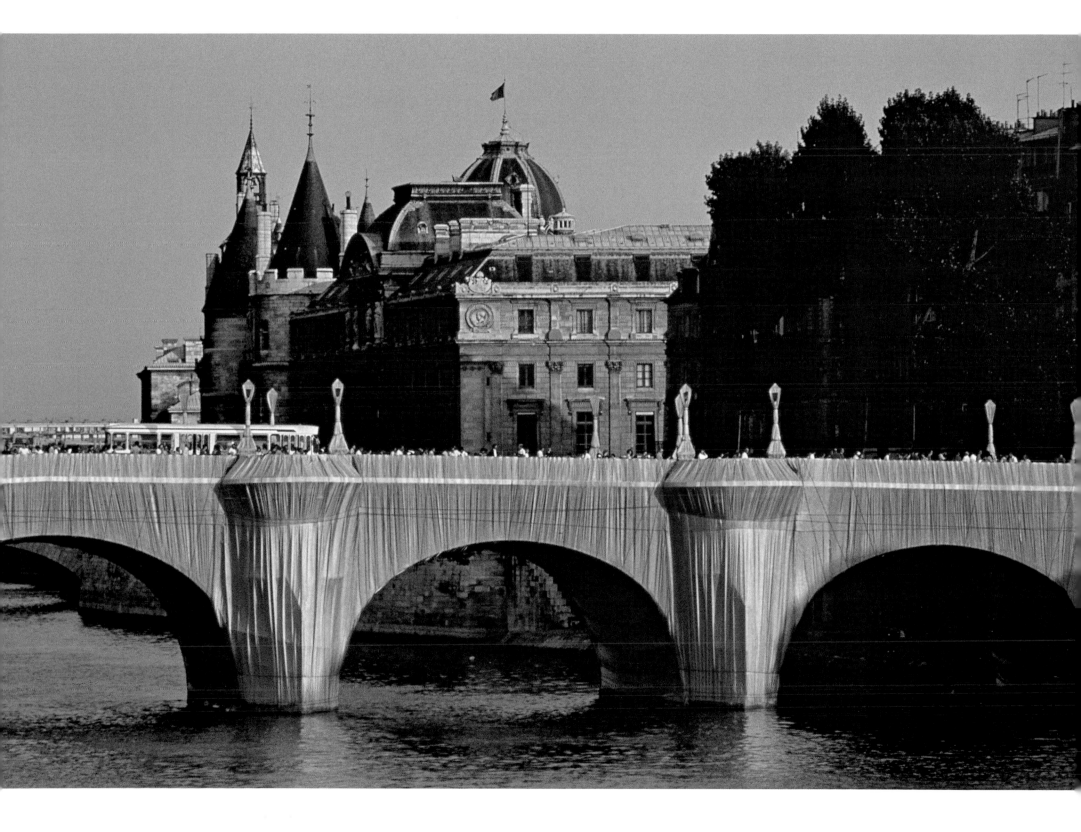

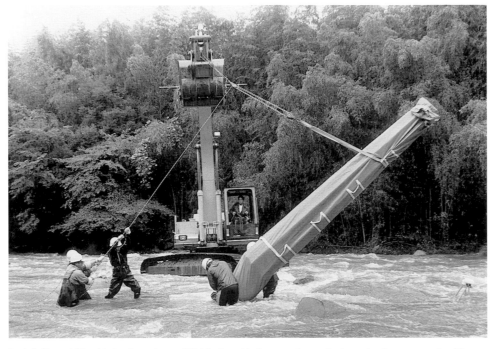

Installation of *The Umbrellas, Japan-USA* in Ibaraki, Japan, where ninety umbrellas were raised in the Sato River in October 1991

The Umbrellas

Christo and Jeanne-Claude's subsequent and even more ambitious project, *The Umbrellas, Japan-USA, 1984–91,* opened simultaneously in Ibaraki prefecture (about sixty miles north of Tokyo) and in California, around the Tejon Pass (roughly the same distance north of Los Angeles), on October 9, 1991, for just shy of three weeks. The project involved the seemingly random scattering of 3,100 specially designed umbrellas (1,340 blue ones in Japan and 1,760 gold ones in California) across twelve and eighteen miles, respectively, of the two inland valleys. *The Umbrellas* took five years of preparation and cost $26 million, more than what they spent for *Surrounded Islands* and *The Pont Neuf Wrapped* combined.

There was no shortage of difficulties to overcome, either. When the 1,340 umbrellas arrived in the harbor in Hitachi, the handles for the winches were not listed on the importation documents, and the customs officials refused to let them enter the port. Christo threw a screaming fit, saying (among other things), "When you import a Toyota car into the United States you don't have to list the keys on the documents!"[34] Eventually they decided to let the umbrellas through. That problem resolved, Wolfgang and Sylvia Volz opened one of the packages of what were supposed to be blue umbrellas, and inside they found a yellow one. The yellow umbrellas were intended for the California site and were simultaneously being readied for installation there, whereas the umbrellas that were to be installed in Japan were blue. Everyone panicked, wondering if the blue umbrellas had not been shipped, so they opened every single package in the harbor and found that there was only the one mistake.

Nevertheless, from the start this project benefited from a wide public admiration for Christo and Jeanne-Claude's work, both in California and in Japan, as well as the years of experience on which they had built a finely tuned organization. As drivers approached the project on the interstate highway in California, official motorist-information signs appeared carrying messages like "The Umbrellas viewing area, next 2 exits." Three million people on two continents came to see the project. It was clear that this was not the work of some anonymous avant-gardist overlooked by the authorities.

The Umbrellas took place on the property of 459 different landowners in Japan, and only 26 in the much larger area of the California site, underscoring real differences in the social character of the two countries. But in this project it was not the politics or the permitting process that seemed so revelatory: it was the sheer scale of the organization required to ne-

The Umbrellas, Japan-USA. The umbrellas are brought in by helicopter during installation at the Tejon Ranch in California, 1991.

gotiate that many contracts with landowners, all the logistics of fabricating and installing the umbrellas, not to mention the unique poetry of the work's relation to the landscape, that seemed really eye-opening. Christo and Jeanne-Claude coordinated more than two thousand workers (about evenly divided between the two venues), made extensive preparations for the more than three million visitors who came to see the project, and attended to a prodigious quantity of details in the design, manufacture, and delivery of the umbrellas themselves—all with remarkable finesse.

Each umbrella had 470 different parts, weighed nearly 500

pounds, measured 19 feet 8 inches high by 28 feet 6 inches in diameter, and was accompanied by a detailed file of careful engineering, calculated to ensure its accurate location and proper attention to the unique installation requirements of its particular patch of terrain. Setting an umbrella in a riverbed required a different kind of anchoring and leveling than that needed for placing one on a rocky hillside or near roads and towns with underground utilities. Nevertheless, "the project of Kassel, the project of the Pont-Neuf, the project of the Reichstag, they have a lot of engineering, a lot of technique. *Running Fence, The Umbrellas*, they are simple engineering," Christo explained. "You should understand that *Running Fence* and *The Umbrellas* and *The Gates* are modules, repeated a few thousand times."[35]

The aesthetic concept of *The Umbrellas* was completely new. Here, for the first time, Christo and Jeanne-Claude placed a collection of discrete objects into the landscape, rather than using fabric in a more receptive response to the forms of nature, as in *Running Fence* or *Surrounded Islands*. Compared with these earlier works, politics also seemed relatively less prominent than formal expression. One might almost say that *The Umbrellas* was unabashedly romantic in highlighting nature, using gold or blue accents to bring out the crest of a hill, much as John Constable dramatized his paintings of the simple English countryside with brilliant flecks of white.

Christo also underscored the way that *The Gates, The Umbrellas*, and *Over the River* "are very strongly linked with that inner and outer space. You can go *under* the umbrellas, you can go out of the umbrellas. You can go *under* the gates, you can go out of the gates. . . . Of course, the precursor of *The Umbrellas* was *The Gates* because *The Gates* was several years earlier than the idea of *The Umbrellas*." *The Gates* also prefigures *The Umbrellas* in its compositional principle; the structure is modular, relying on an nonaxial symmetry in which each unit can be substituted for any other. This concept implies a kind of open-ended freedom in the possibility of extending indefinitely in any direction. "*The Umbrellas* and *The Gates* have the similarity of that spreading quality," Christo said.[36]

The Umbrellas, Japan-USA, 1984–91
Ibaraki, Japan, site (below); California site (opposite)
1,340 blue umbrellas in Japan and 1,760 yellow umbrellas in the United States
Each umbrella: 19 ft. 8 in. high (6 m) and 28 ft. 6 in. (8.66 m) in diameter

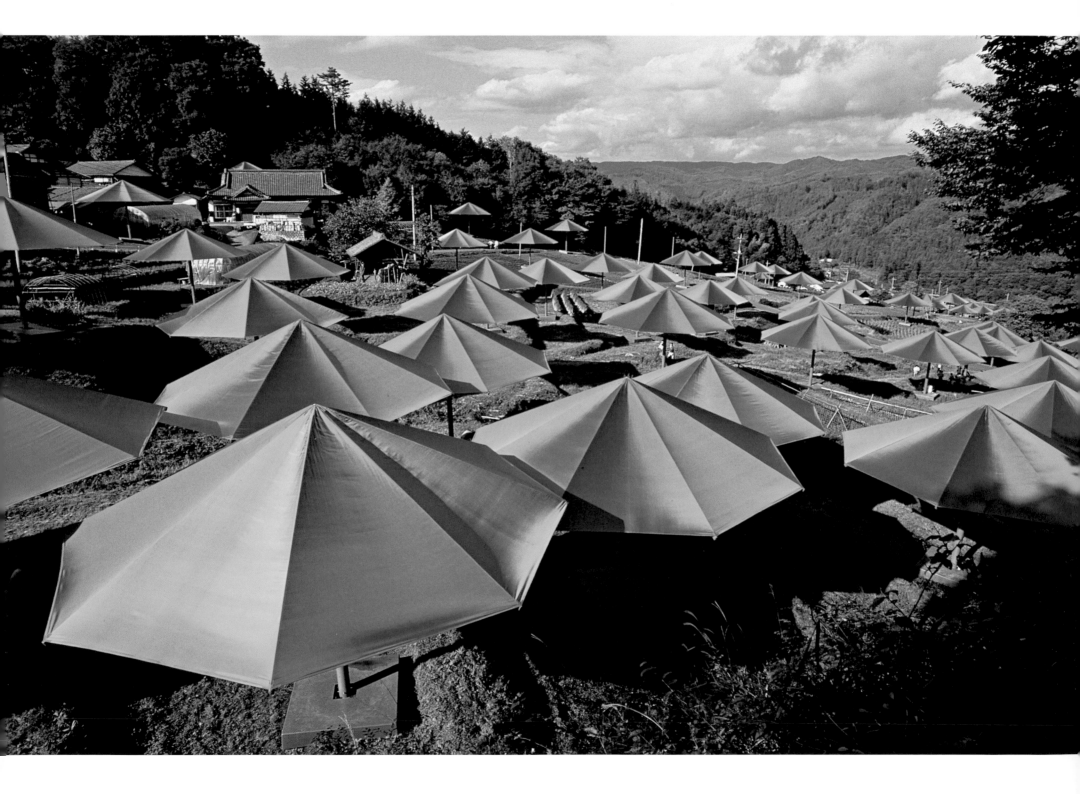

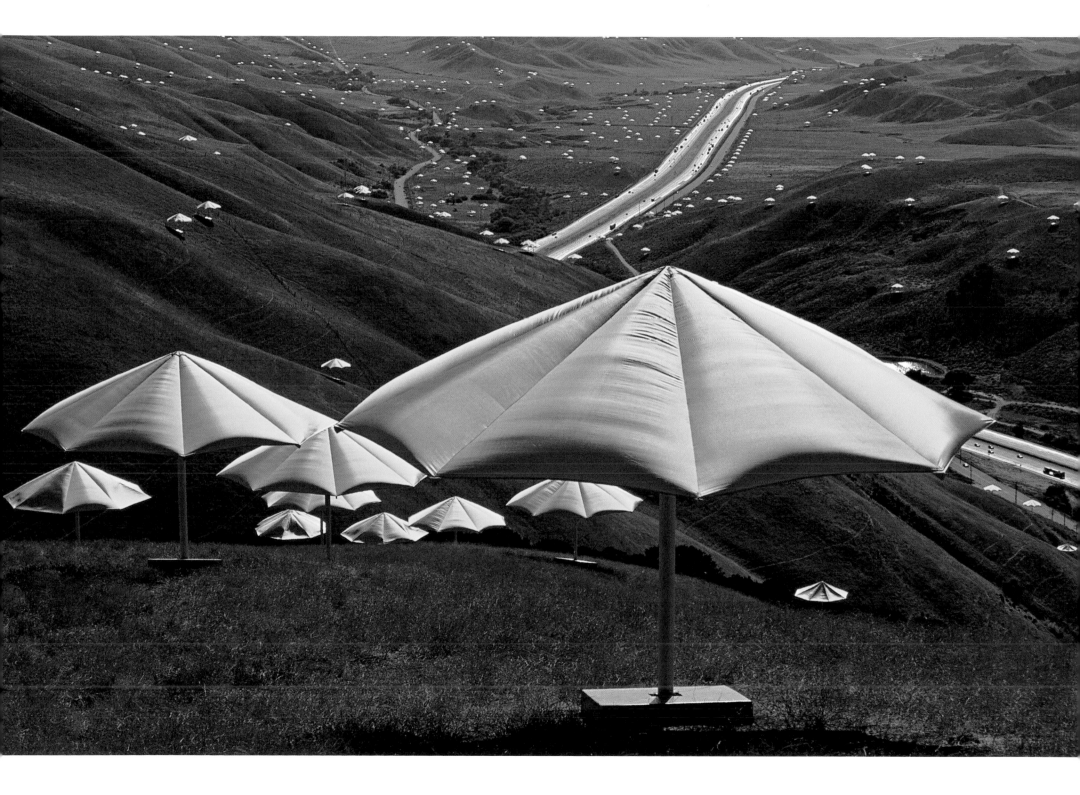

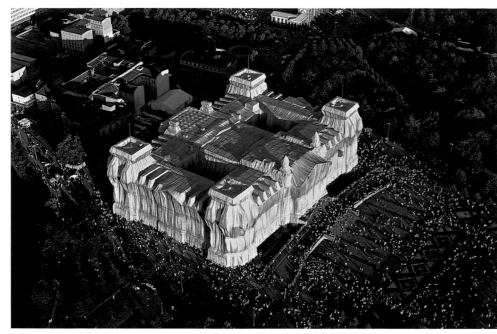

Wrapped Reichstag, Berlin, 1971–95
1,076,000 sq. ft. (100,000 sq. m) of polypropylene fabric and 51,181 ft. (15,600 m) of rope

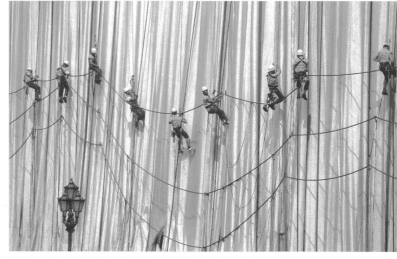

Workers installing the *Wrapped Reichstag* in Berlin, 1995
Photo: Sylvia Volz

The Reichstag

In April 1978, seventeen influential German citizens formed an organization called the Kuratorium für Christos Projekt Reichstag to build support for the *Wrapped Reichstag, Project for Berlin*. At the time, the German Reichstag sat literally on the boundary between communist East Germany and the British sector of divided Berlin. The building was erected as the future seat of the German parliament when Chancellor Otto von Bismarck united the nation in 1871; the Nazis burned it in 1933 when Hitler came to power (blaming the fire on communists); and then after World War II the structure was restored. The building therefore symbolizes some of the most deeply felt issues of German national identity. Its physical location meant that any project Christo might create involving it had to involve the cooperation of the Soviet, French, American, and British armies as well as both East and West German governments. Partly for this reason, his idea of wrapping the Reichstag immediately aroused considerable controversy at the highest political and economic levels in Germany, actively in-

volving Willy Brandt, the Nobel laureate and former mayor of West Berlin, Chancellor Helmut Schmidt of West Germany, and later Chancellor Helmut Kohl, as well as several of the most powerful industrialists in the nation.

Christo and Jeanne-Claude worked on this project for twenty-four years; only *The Gates* had a longer gestation. Trips to Germany interrupted work on *Running Fence, Wrapped Walk Ways, Surrounded Islands, The Pont Neuf Wrapped,* and *The Umbrellas;* there were dramatic moments when permission seemed so close, only to fall through again. It was a roller-coaster ride of political ups and downs. In retrospect, it is clear that the tide turned in 1989 with the election of Rita Süssmuth as president of the German Parliament. Shortly after coming to office she expressed interest in the project over dinner with an important supporter of Christo and Jeanne-Claude's idea. With the reunification of Germany in 1990, the artists realized that the building would soon be reinhabited by the parliament and, once that occurred, wrapping the building would be impossible. So the pressure was on. But Süssmuth proved a steady

Wrapped Reichstag, Berlin, 1971–95
1,076,000 sq. ft. (100,000 sq. m) of polypropylene fabric and 51,181 ft. (15,600 m) of rope

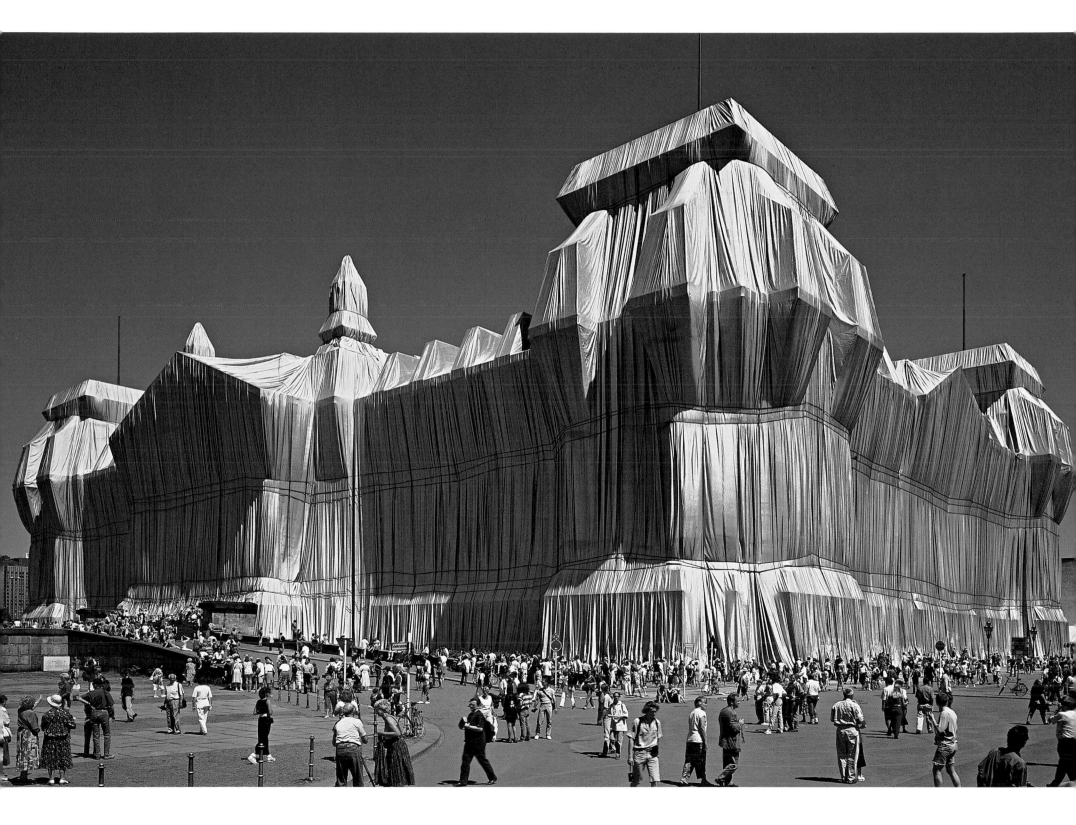

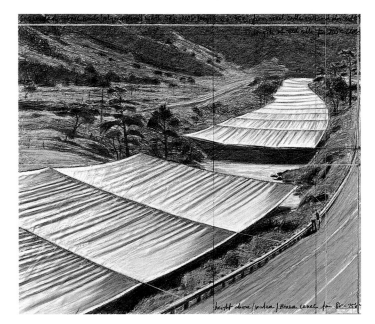

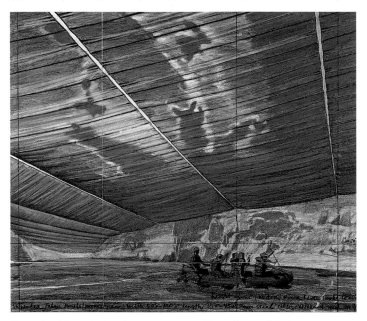

Over the River, Project for the Arkansas River, State of Colorado
Collage, 2000
Pencil, fabric, pastel, wax crayon, charcoal, enamel paint, and
topographic map; in two parts
12 x 30½ in. (30.5 x 77.5 cm) and 26¼ x 30½ in. (66.7 x 77.5 cm)

Over the River, Project for the Arkansas River, State of Colorado
Collage, 2002
Pencil, fabric, pastel, wax crayon, charcoal, and hand-drawn
topographic map; in two parts
12 x 30½ in. (30.5 x 77.5 cm) and 26¼ x 30½ in. (66.7 x 77.5 cm)

and skilled ally, reaffirming her intention to help them in a letter she wrote in December 1991. Twenty-five months later—against the wishes of the German chancellor, Helmut Kohl—she deftly guided the project through a parliamentary vote. In June 1995, at a final cost of $15,233,946, Christo and Jeanne-Claude successfully wrapped the Reichstag in Berlin. They covered the entire building with silver fabric that shone brilliantly in the early summer sun. More than five million visitors came to view the work, and although the artists, as usual, said nothing about the personal meaning of the work, it is hard to avoid the conclusion that it connected with Christo's personal history in the communist Eastern bloc.

Recent Projects

In the later 1990s, after the *Reichstag* project ended, Christo and Jeanne-Claude focused on four projects: *The Gates; Over the River, Project for the Arkansas River, State of Colorado; Wrapped Trees, Fondation Beyeler and Berower Park, Riehen, Basel, Switzerland, 1997–98;* and *The Wall, 13,000 Oil Barrels, Gasometer, Oberhausen, Germany, 1999.* Between 1992 and 1994, the artists looked at eighty-nine possible river sites in the Rocky Mountains for their *Over the River* project, and in 1996 they decided on the area of the Arkansas River between the towns of Salida and Cañon City, Colorado. *Over the River* will consist of a sequence of silver fabric panels, seven and a half miles long, stretched high above a forty-mile section of the Arkansas River.

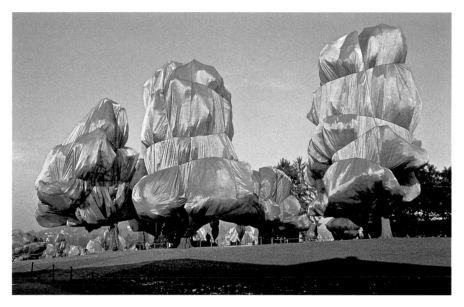

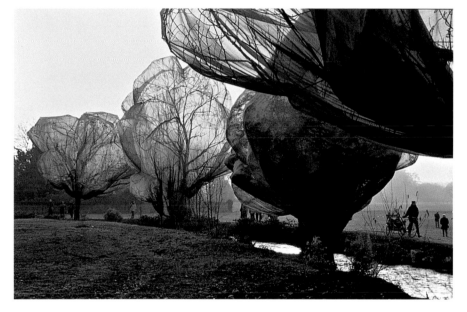

Two views, at noon and sunset, of
Wrapped Trees, Fondation Beyeler and
Berower Park, Riehen, Switzerland, 1997–98
178 trees wrapped with 592,034 sq. ft.
(55,000 sq. m) of woven polyester fabric and
14.3 miles (23.1 km) of rope

Interruptions in the fabric will appear in places where there are natural obstacles, such as rocks or trees, and in only a few places will it be possible to walk under the fabric, because the banks are steep. It will take one hour to see the project from above, by car, but six hours to see it from underneath in a raft.

In 1997, Christo and Jeanne-Claude began work on the *Wrapped Trees* at the Fondation Beyeler, in Berower Park, Riehen, Switzerland, in which they wrapped 178 trees in individual gossamer veils in November 1998. Depending on the position of the sun, the light sometimes passed through the fabric, revealing the branches of the trees in a variety of beauti-

ful ways, and at other moments the light reflected off the shining surface. The idea for this project went all the way back to an unrealized project for wrapped trees in 1966.

Then, just five months later, in April 1999, they installed *The Wall, 13,000 Oil Barrels* in a strange exhibition space made from a giant industrial gas-storage tank (a gasometer) in Oberhausen, Germany, built in the 1920s but long out of industrial use. This remarkable construction, made of thirteen thousand oil barrels configured around an armature, cut one of the large spaces of the gasometer in half with a wall of barrels 85 feet high and 223 feet wide. The concept refers retrospec-

The Wall, 13,000 Oil Barrels, Gasometer, Oberhausen, Germany, 1999
Stacked oil barrels
85 x 223 x 24 ft. (26 x 68 x 7.3 m)

The Mastaba of Abu Dhabi, Project for the United Arab Emirates
Collage, 1980
Pencil, crayon, photograph by Wolfgang Volz, charcoal, pastel,
technical data, and map
31½ x 23¾ in. (80 x 59 cm)

tively to the project for the rue Visconti in 1962, but it also has a connection to the scale of the *The Mastaba of Abu Dhabi, Project for the United Arab Emirates*—one of the major projects in play in the late seventies and early eighties.

The idea for *The Mastaba of Abu Dhabi* was to build an enormous structure in the desert, forty-nine stories high, out of 390,500 oil barrels, in the shape of a mastaba. A mastaba is an ancient architectural form, with two vertical sides, two slanted sides, and a flat top; this one would have been 492 feet high, 984 feet wide, and 738 feet deep, and the cost would have been in the hundreds of millions of dollars. Unlike any other project by Christo and Jeanne-Claude, this one would have been financed by someone else—in this case, the Sheikh of Abu Dhabi—and designed as a permanent landmark. An expendi-

ture of such magnitude is the kind that only an absolute ruler could make, and the artists saw the project as deeply related to an Islamic sense of permanence, as well as the kind of medieval autocracy that persists today only in that part of the world.

The Gates

On January 22, 2003, Michael R. Bloomberg, the mayor of New York City, announced that he had granted permission for Christo and Jeanne-Claude to install *The Gates, Project for Central Park, New York City* in February 2005. Once the official authorization was at long last given, more than two decades after it had been flatly refused, everything but *The Gates* had to go on hold. All the artists' energy focused on sell-

ing enough work to fund the project, manufacturing the parts, and preparing for the installation of *The Gates,* all of which had to be done in a very short time for a project of such magnitude.

The Gates brings together several career-long themes in the work of Christo and Jeanne-Claude, not least the aspiration to do a project in New York, the city where they have lived and worked for forty years, the art capital of the world, and the place that offers perhaps the greatest diversity of population and concentration of people in the world, as well as the most intense nexus of the forces—economic, cultural, social, political—that govern the emergent realities of the twenty-first century. In addition, *The Gates* brings forward the dialectical dimension that has been a part of the artists' projects from the beginning of their collaborative practice.

The Gates will be unfurled on a Saturday morning, weather permitting, and will stand for sixteen days—two full weeks plus an extra weekend (primarily so New Yorkers and tourists can have more time to see it, but also because the artists prefer to take the gates down on a weekday, when the park is less crowded). In addition to the engineering and manufacturing aspects of the project, the logistics are complex. Trucks, for example, are not permitted to travel on the bridges to Long Island with loads greater than eighty thousand pounds. So all the materials will have to move slowly over the course of a year to the assembly plant in Maspeth, Queens, where workers will cut the vinyl for the poles, drill the holes, bolt the sections of the gates together, and assemble the sewn fabric panels, which are being imported from Germany. At the same time, keeping the materials on hand in Manhattan is prohibitively expensive, and nothing can be stored in the park. The timing is also crucial, because all the materials will be reused or recycled (for which the artists will receive a refund), and it may turn out that everything must be returned to Germany within a year to avoid paying United States import duty. The actual time available for the assembly of the sewn parts and the installation and deinstallation of the project has to be calculated precisely.

But above the logistics and the money and the politics, it is the idea of *The Gates* that is important: its form and its implications. The aesthetic of the project has an organic relation to Christo and Jeanne-Claude's earlier work. "Remember that there, in Kansas City," Jeanne-Claude told me, "we were enchanted by the fact that there were so many people walking." And pointing to drawings that display similarities to the *Running Fence* in the distribution of poles, the scale, and the way the fabric hung from the cables, Christo remarked: "It shows how much of our work often comes from previous projects. *The Gates* was coming from *Running Fence.*"[37]

There is also a bodily corollary in all of the artists' projects and objects. "Fabric is like a second skin; it is very related to human existence," Christo says. "That fabric will move with the wind, the water, with the natural elements. . . . The fabric is moving, like breathing. The *Reichstag* fabric moves, the fabric of *Running Fence* moves. Of course, that energy of the wind is so much translated with *The Gates.* It's so incredibly present."[38]

Frederick Law Olmsted described the artistry of his park as aspiring "not simply to give the people of the city an opportunity for getting fresh air and exercise. . . . It is not simply to make a place of amusement or for the gratification of curiosity or for gaining knowledge. The main object and justification is simply to produce a certain influence on the minds of people and through this to make life in the city healthier and happier. The character of this influence is a poetic one and it is to be produced by means of scenes, through observation of which the mind may be more or less lifted out of moods, and habits into which it is, under the ordinary conditions of life in the city, likely to fall."[39] It should also be noted that the inspiration for the title of Christo and Jeanne-Claude's work for Central Park comes from Olmsted. The continuous stone wall enclosing the entire park periodically opens to create entrances to the green space from the surrounding city; Olmsted called these openings "gates."

In turning down the project in 1981—though he is now a great supporter of it—Gordon Davis, then commissioner of parks and recreation for New York, nevertheless expressed similar thoughts to those of Olmsted: "Over and over we have

observed that the work of contemporary artists in a park setting, the creative intellect let loose in a public open space, presents a unique challenge. It forces us—the 'public' in all its variety—to see not just the work of art, but also to see that space in extraordinarily different ways and exciting new alignments. . . . The experience has consistently been one of revelation. . . . This experience is the essence of what Christo's *Gates* may offer."[40]

Artists give form to the new realities of our lives before we have words to describe them. They create a language with which to explore what we perceive but don't quite have a way to talk about yet. One of the curious realities that will be debated through this project is that Central Park is "an entirely man made landscape," as Gordon Davis noted in his 230-page *Report and Determination in the Matter of Christo: The Gates.*[41] Central Park is a constructed experience of nature, in the tradition of the great "planned" natural landscapes of Romantic England. Between 1858 and 1873, the landscape architects Frederick Law Olmsted and Calvert Vaux hauled the boulders into place and sculpted the topography; they moved hundreds of thousands of cartloads of earth and rock, built drainage systems, constructed ponds and "rustic" buildings on the brows of hills with picturesque views, and planted more than five million shrubs and trees on the 840-acre site. So the idea of "discovering nature" in Central Park is a game of mirrors that cuts to the heart of something that is becoming an increasingly important issue our culture is trying to reckon with today.

The painter Fred Tomaselli reminisced recently: "Well you know, I have a funny relationship to nature, insofar as, the very first nature experience I had was at Disneyland. And basically the first authentic experience I had with nature, the first waterfall that I saw after hiking with my friends, . . . I actually had this problem, where I couldn't quite believe that the waterfall wasn't running with . . . you know, electricity, pumps and conduits." Jean Baudrillard pointed out, already in the early 1980s, that "abstraction today is no longer that of the map, the double, the mirror or the concept. Simulation is no longer that of a territory, a referential being or a substance. It is the generation by models of a real without origin or reality: a hyperreal. The territory no longer precedes the map, nor survives it. Henceforth, it is the map that precedes the territory."[42]

The Gates in Central Park is bound to bring this issue to the foreground—the idea that we live in an increasingly constructed landscape, in every realm of our lives. In television, films, even in the national parks, our experience of "nature" is so carefully managed and yet the management is kept out of sight. The media interpret nature to us as we become more and more accustomed to accept a blurring of the boundary between nature and culture, between "manufactured" news and real events. If you look at a map of Manhattan, Central Park is a perfect rectangle cut out of a solid grid of streets and buildings; the shape of the individual gates that Christo and Jeanne-Claude have designed for the park consciously alludes to that man-made rectangle on the map and the forms of the surrounding buildings. The fabric hanging from the horizontal poles will catch the light, pick up the memory of the colors of the fall leaves, move organically in the wind—in all providing a rich evocation of nature. But the form of the individual gates is also a metaphor for encapsulating unpredictable nature inside the controlled framework of the park.

The California artist Robert Arneson, who lived near *Running Fence* when the Christos created that project, observed: "When the *Fence* was up it was great! The checkout ladies in the supermarket were arguing about the definition of art!"[43] Such arguments about the definition of art have been fundamental to almost all the opposition that Christo and Jeanne-Claude's projects have engendered, because in that challenge to conventional definitions lies a metaphor for the loosening of other hierarchies as well, including the artificial distinction between "nature" and "culture" in the twenty-first century. The epiphany for viewers in all the Christo and Jeanne-Claude projects has everything to do with not only the dynamically changing cultural construction of experience but also the individual's mental evolution in relation to cultural constructions, our own internal parameters, and the dynamic environment of events. These works wake us up to the very life we're living.

Notes

1. John Cage, address to the convention of the Music Teachers National Association in Chicago, 1957, reprinted in *Silence,* 12; Christo and Jeanne-Claude, interview with Jonathan Fineberg, New York, April 16, 1983, in this volume.

2. Christo, session at the College Art Association, New York, February 27, 1982, moderated by Jonathan Fineberg, in this volume.

3. Christo and Jeanne-Claude, interview with Jonathan Fineberg, New York, July 25, 2003, in this volume.

4. Christo, 1982 interview, in this volume.

5. William L. O'Neill, *Coming Apart: An Informal History of America in the 1960s* (Chicago: Quadrangle, 1977), 3, cited in Sandler, *American Art of the 1960s* (New York: Harper & Row), 81; Dwight David Eisenhower, "Farewell Radio and Television Address to the American People," January 17, 1961, in *The Eisenhower Administration, 1953–1961,* edited by Robert L. Branyan and Lawrence H. Larsen (New York, 1971), 2:1375.

6. Christo and Jeanne-Claude, 2003 interview, in this volume.

7. Christo, lecture and interview with Jonathan Fineberg, University of Illinois at Urbana-Champaign, 1977, in this volume.

8. Christo, 1977 interview, in this volume.

9. Christo, cited in Alexander Tolnay, "Introduction," *Christo and Jeanne-Claude: Early Works, 1958–1969* (Cologne: Taschen, 2001), 7.

10. Christo and Jeanne-Claude, 2003 interview, in this volume.

11. Christo and Jeanne-Claude, 1983 interview, in this volume.

12. Christo, 1977 interview, in this volume.

13. Christo and Jeanne-Claude, 1983 interview, in this volume.

14. Christo, 1977 interview, in this volume, cited in Jonathan Fineberg, "Theatre of the Real: Thoughts on Christo," *Art in America* (December 1979): 96.

15. Christo, 1977 interview, in this volume.

16. Christo, 1977 interview, in this volume.

17. Christo, 1982 interview, in this volume.

18. Christo and Jeanne-Claude, 1983 interview, in this volume.

19. Christo, 1977 interview, in this volume.

20. Christo, 1982 interview, in this volume; Christo and Jeanne-Claude, 1983 interview, in this volume.

21. Christo and Jeanne-Claude, 1983 interview, in this volume.

22. Christo, 1977 interview, in this volume.

23. Christo, conversation with Jonathan Fineberg, New York, March 20, 1984. More details about the personal lives of Jeanne-Claude and Christo are found in Burt Chernow, *Christo and Jeanne-Claude: A Biography* (New York: St. Martin's, 2002).

24. Camilla Grey, *The Great Experiment: Russian Art, 1863–1922* (London: Thames and Hudson, 1962), 220.

25. Text translated in Chernow, *Christo and Jeanne-Claude: A Biography*, 104.

26. Christo and Jeanne-Claude, 2003 interview, in this volume.

27. Christo and Jeanne-Claude, 2003 interview, in this volume.

28. Christo and Jeanne-Claude, 2003 interview, in this volume.

29. Christo and Jeanne-Claude, 2003 interview, in this volume.

30. Christo and Jeanne-Claude, 2003 interview, in this volume.

31. Christo and Jeanne-Claude, 2003 interview, in this volume.

32. Christo and Jeanne-Claude, 2003 interview, in this volume.

33. Christo and Jeanne-Claude, 2003 interview, in this volume.

34. Christo and Jeanne-Claude, conversation with Jonathan Fineberg in the artists' loft, New York, August 22, 2003.

35. Christo and Jeanne-Claude, 2003 interview, in this volume.

36. Christo and Jeanne-Claude, 2003 interview, in this volume.

37. Christo and Jeanne-Claude, 2003 interview, in this volume.

38. Christo, telephone conversation with Jonathan Fineberg, October 7, 2003; Christo and Jeanne-Claude, 2003 interview, in this volume.

39. Frederick Law Olmsted, cited in Elizabeth Barlow, *Frederick Law Olmsted's New York* (New York: Praeger and the Whitney Museum of American Art, 1972), 25. See also Jonathan Fineberg, section IV.C.2., *Environmental Impact Study for Christo's "The Gates, Project For New York"* (San Francisco: Environmental Science Associates, 1980).

40. Gordon J. Davis, Commissioner, Department of Parks and Recreation, *Report and Determination in the Matter of Christo: The Gates* (New York: Department of Parks and Recreation, February 1981), 39–41.

41. Davis, *Report and Determination in the Matter of Christo*, 43.

42. Fred Tomaselli, filmed interview with Jonathan Fineberg in the artist's studio in Brooklyn, N.Y., September 19, 2002, in *Imagining America,* a film by Muse Film and Television, 2004; Jean Baudrillard, "Simulacra and Simulations," in *Selected Writings,* edited by Mark Poster (Stanford: Stanford University Press, 1988), 166.

43. Robert Arneson, conversation with Jonathan Fineberg, 1981.

The Gates

The Thousand Gates Project
Drawing, 1979
Pencil, charcoal, pastel, and tape
11 x 14 in. (28 x 35.5 cm)
Photo: Eeva-Inkeri

Through the years, the temporary work of art grew, and the idea was crystallized and refined:

- The gates were twelve feet tall in 1979; they will be sixteen feet tall in 2005.
- The thin steel poles were considered as only a means to suspend the fabric panels in 1979; the poles will be made of a thick saffron-colored vinyl and have a commanding profile (five by five inches) in 2005. The poles are no longer simply structural but an important part of the sculpture.
- The top of the fabric panel was attached by loops to a horizontal steel cable in 1979; the upper part of the fabric panels will be secured inside the bottom part of the horizontal pole in a "sail tunnel" in 2005.

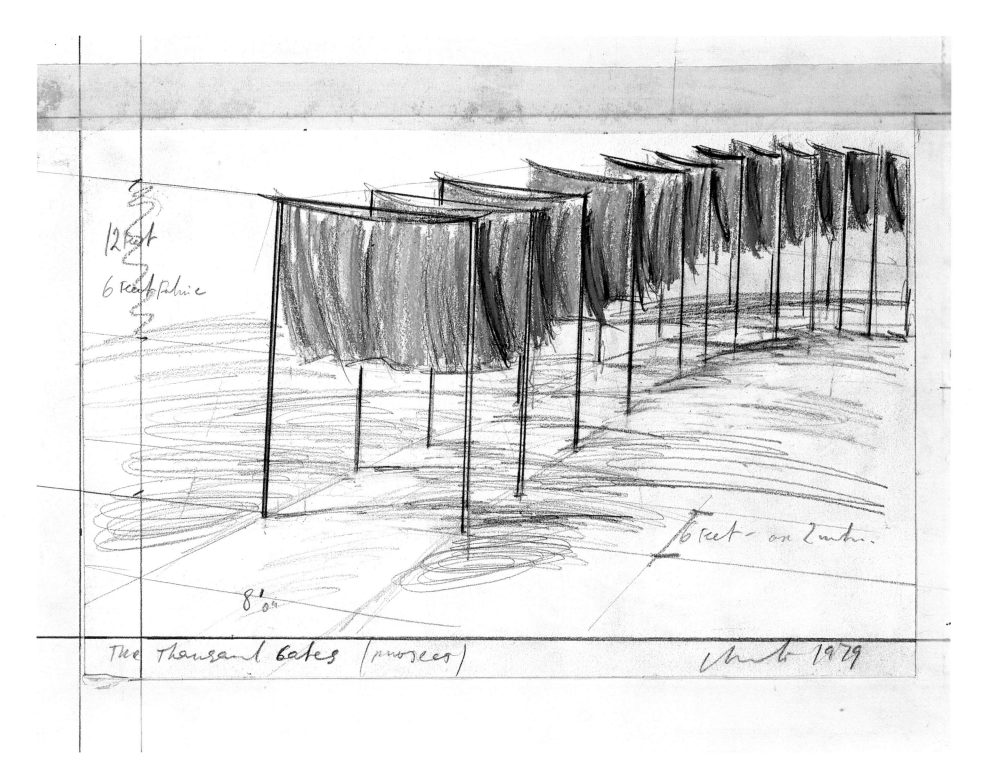

12 Feet
6 Feet of fabric
6 Feet - on Center
8' 0"
The Thousand Gates (project) Christo 1979

Jeanne-Claude and Christo, at left, along with their attorney Theodore W. Kheel, meet with Gordon J. Davis (far right), commissioner of parks and recreation for the City of New York, to explain *The Gates, Project for Central Park*. The artists brought original drawings of *The Gates* and books from some of their previous projects to the meeting on April 22, 1980, in Davis's office in the Central Park Arsenal.

Henry Geldzhaler (second from left), commissioner of cultural affairs for New York City and former curator of twentieth-century art at The Metropolitan Museum of Art, and his assistant Randall Bourscheidt (at left) meeting with Christo and Jeanne-Claude on June 9, 1980. Geldzhaler and Bourscheidt helped the artists navigate the complicated New York City bureaucracy.

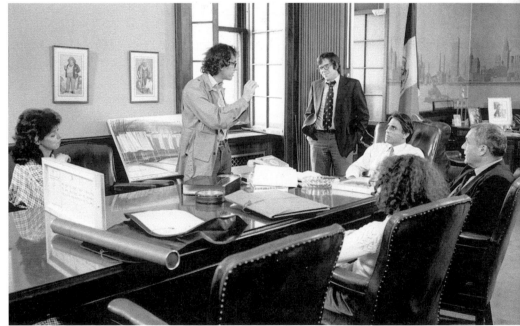

Jeanne-Claude, at left, listens as Christo explains the project to Manhattan borough president Andrew Stein (seated at the head of the table) in his office on May 21, 1980. At far right is Theodore W. Kheel, who arranged the meeting, and seated with her back to the camera is Stein's executive administrator Ellen Hay, who became an ally of the project.

Christo and Jeanne-Claude, at right, and Gordon J. Davis (left) at a meeting organized by Agnes Gund, a prominent art collector (seated on the couch), and Martin Segal (center), then president of Lincoln Center and a friend of the arts, in his office on April 29, 1980.

At the Museum of Modern Art in New York on September 9, 1980, Christo answers questions from guests invited by Gordon J. Davis and Andrew Stein.

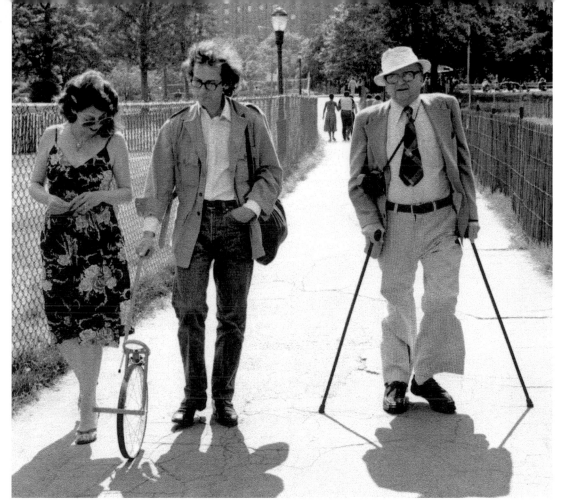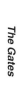

Jeanne-Claude, Christo, and Theodore L. Dougherty on one of their exploratory walks in Central Park during the summer of 1980. Dougherty was the builder-contractor-engineer who built the *Valley Curtain*, the *Running Fence*, and *Surrounded Islands*. In spite of deteriorating health, Dougherty also helped with later projects, including *Wrapped Walk Ways, The Pont Neuf Wrapped, The Umbrellas, Japan-USA,* and *Wrapped Reichstag* before he died on May 14, 1993.

Christo describes *The Gates* to fellow board members of the Architectural League of New York on June 25, 1980, as Jeanne-Claude watches at right.

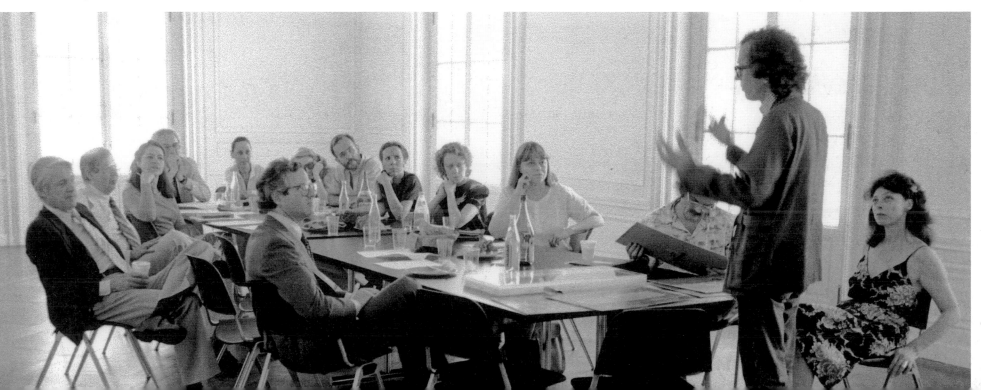

Gordon J. Davis explains to members of the Century Club the different opinions of the Central Park Conservancy on June 12, 1980.

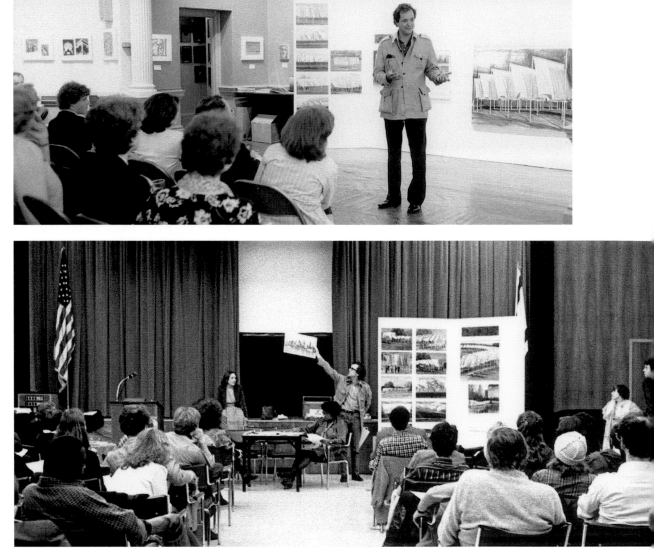

Christo and Jeanne-Claude giving a presentation to members of Community Board 7 on the Upper West Side on December 2, 1980, at the Jewish Family Home. Christo (right) holds an original preparatory work for *The Gates*. The board's chairwoman, Sally Goodgold (behind the table), presided over the session. Jeanne-Claude (below) answers questions. As with each of their meetings with Manhattan's community boards, the artists were accompanied by environmental experts who also answered the members' questions. The meeting resulted in a vote in favor of *The Gates*.

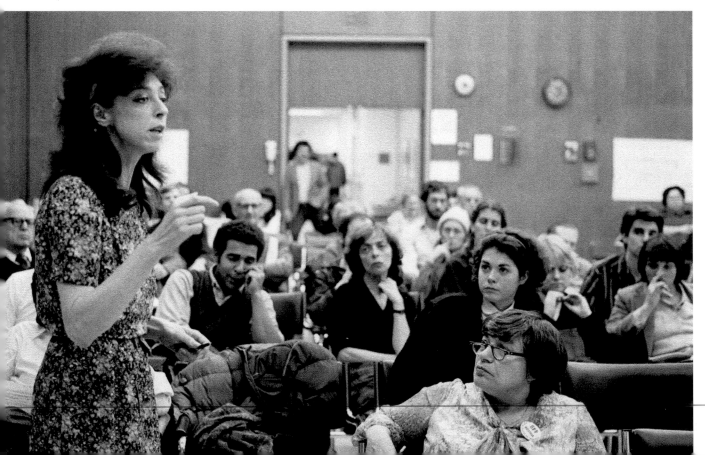

12'0" /steel pole 3" x 3" / Fabric panel (h. 9'6" x 12'0" + 15%) . high 15'0"

9'0" (Between each pole = Fabric hight less 6')

The Gates (project for 11.000 Gates in Central Park, New York City) hight 15'0" x 12'0" so 24in 39'0"
Christo 1980

The Gates, Project for 11,000 Gates in Central Park, New York City
Collage, 1980
Pencil, fabric, photograph by Wolfgang Volz, charcoal, pastel, and wax crayon
28 x 22 in. (71 x 56 cm)

In 1980, it was estimated that there would be 11,000 to 15,000 gates, a number derived by adding the total length of the walkways. This did not take into account the low branches above the walkways, which will limit the total number of gates to around 7,500 in 2005.

The Gates, Project for Central Park, New York City
Collage, 1980
Pencil, enamel paint, photograph by Wolfgang Volz, wax crayon, charcoal, and ink
11 x 14 in. (28 x 35.5 cm)

Opposite
The Gates, Project for Central Park, New York City
Collage, 1980
Pencil, fabric, photograph by Wolfgang Volz, wax crayon, charcoal, ink, and tape
14 x 11 in. (35.5 x 28 cm)

64

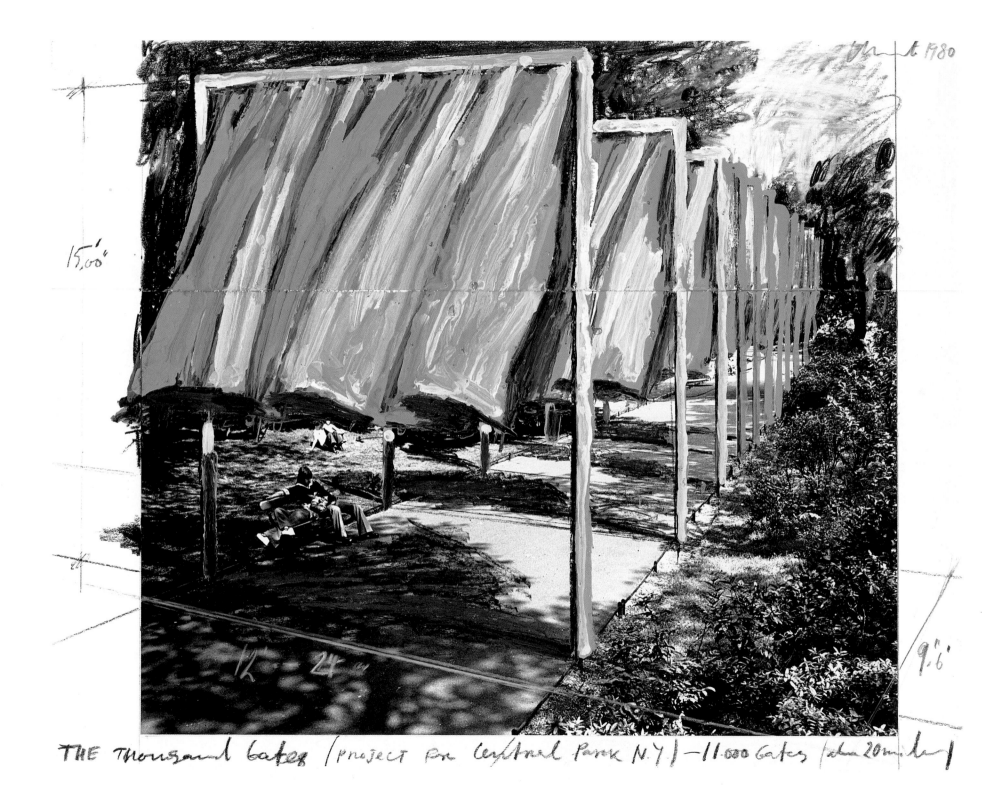

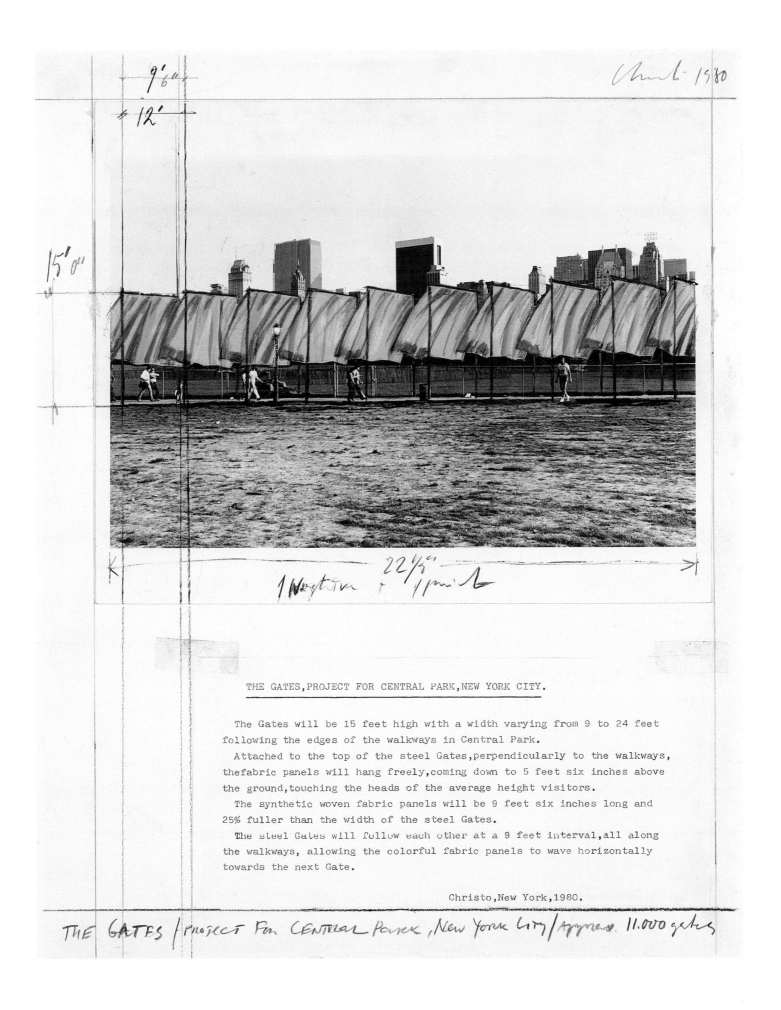

THE GATES,PROJECT FOR CENTRAL PARK,NEW YORK CITY.

The Gates will be 15 feet high with a width varying from 9 to 24 feet
following the edges of the walkways in Central Park.

Attached to the top of the steel Gates,perpendicularly to the walkways,
thefabric panels will hang freely,coming down to 5 feet six inches above
the ground,touching the heads of the average height visitors.

The synthetic woven fabric panels will be 9 feet six inches long and
25% fuller than the width of the steel Gates.

The steel Gates will follow each other at a 9 feet interval,all along
the walkways, allowing the colorful fabric panels to wave horizontally
towards the next Gate.

Christo,New York,1980.

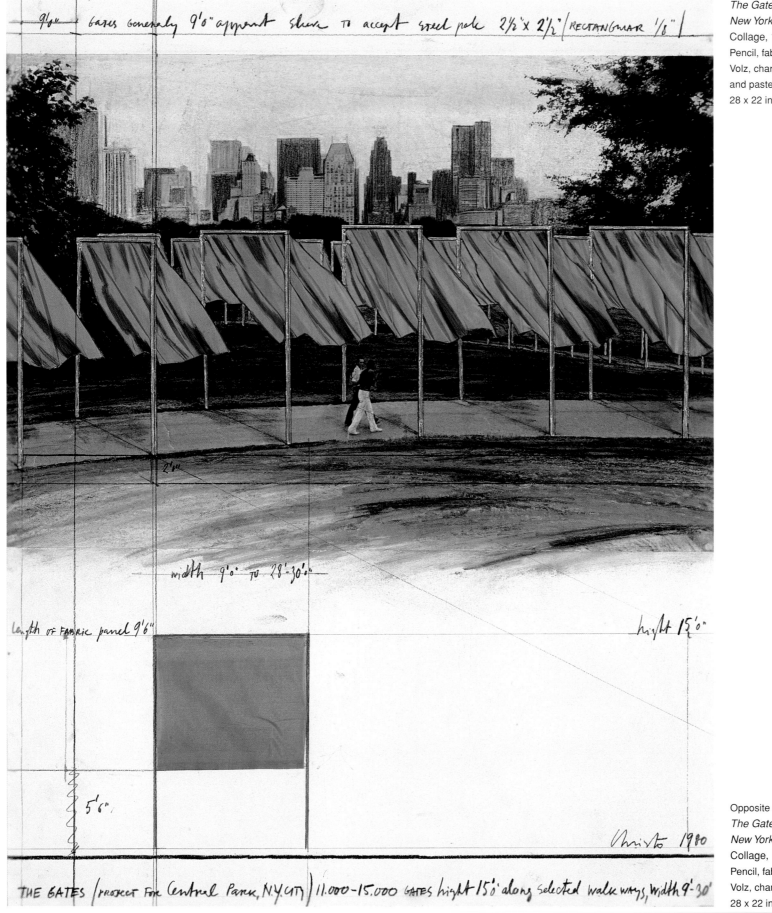

9'0" Gates generally 9'0" apparent sleeve to accept steel pole 2½" x 2½" | RECTANGULAR ⅛" |

2'6"

width 9'0" to 28'-30'0"

length of fabric panel 9'6" hight 15'0"

5'6"

Christo 1980

THE GATES (PROJECT FOR Central Park, N.Y. CITY) 11.000-15.000 GATES hight 15'0" along selected walk ways, width 9'-30'

*The Gates, Project for Central Park,
New York City*
Collage, 1980
Pencil, fabric, photograph by Wolfgang
Volz, charcoal, wax crayon, fabric sample,
and pastel
28 x 22 in. (71 x 56 cm)

Opposite
*The Gates, Project for Central Park,
New York City*
Collage, 1980
Pencil, fabric, photograph by Wolfgang
Volz, charcoal, wax crayon, and pastel
28 x 22 in. (71 x 56 cm)

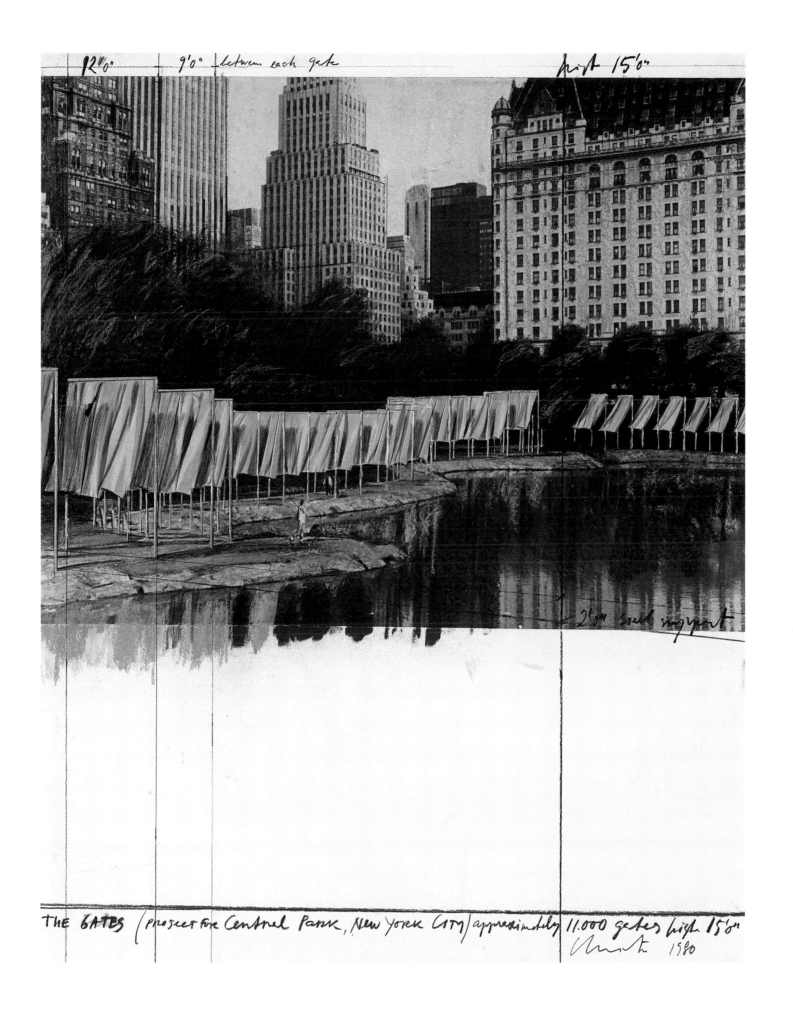

12"0" 9'0" between each gate high 15'0"

2'6" steel support

THE GATES (project for Central Park, New York City) approximately 11,000 gates high 15'0"
Christo 1980

hight 15'0" Fabric panel (h. 9'6" x 12"0" + 15%) 12'0" steel pole 3"x3"

150

9'0" + between each pole = fabric high less 6"

THE GATES / PROJECT FOR 11.000 GATES IN Central Park, New York CITY / hight 15'0" X 12'0" or 24' or 39'

Christo 1980

The Gates, Project for Central Park,
New York City
Collage, 1980
Pencil, fabric, photograph by Wolfgang
Volz, charcoal, wax crayon, and pastel
28 x 22 in. (71 x 56 cm)

Opposite
The Gates, Project for Central Park,
New York City
Collage, 1980
Pencil, fabric, pastel, charcoal, wax
crayon, and map; in two parts
11 x 28 in. and 22 x 28 in.
(28 x 71 cm and 56 x 71 cm)

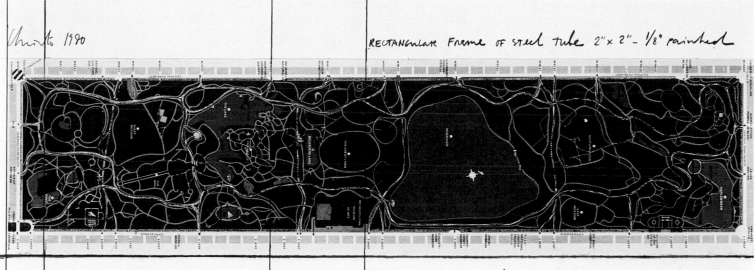

Christo 1990

RECTANGULAR FRAME OF STEEL tube 2" x 2" - 1/8" painted

THE GATES (PROJECT FOR Central Park, New York City) 11000-15,000 Gates hight 15'0" width from 9'0" TO 24'0" along selected WALK WAYS - steel 10k 2'½'

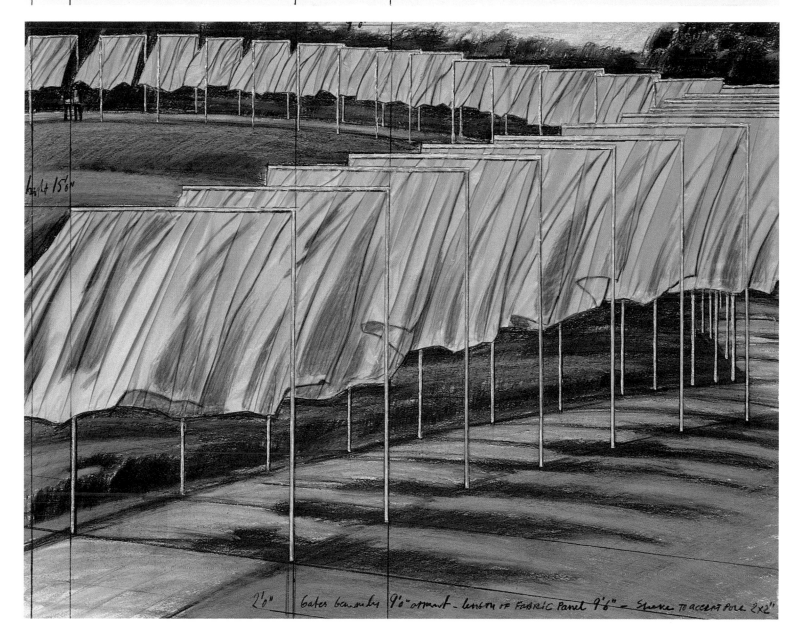

hight 15'0"

2'0" Gates Generaly 9'0" appart - length of FABRIC PANEL 9'6" - Sleeve TO accept POLE 2x2"

The Gates, Project for Central Park, New York City
Drawing, 1980
Pencil, charcoal, and pastel
22 x 28 in. (56 x 71 cm)

Opposite
The Gates, Project for Central Park, New York City
Collage, 1980
Pencil, fabric, pastel, charcoal, wax crayon, and map; in two parts
11 x 28 in. and 22 x 28 in. (28 x 71 cm and 56 x 71 cm)

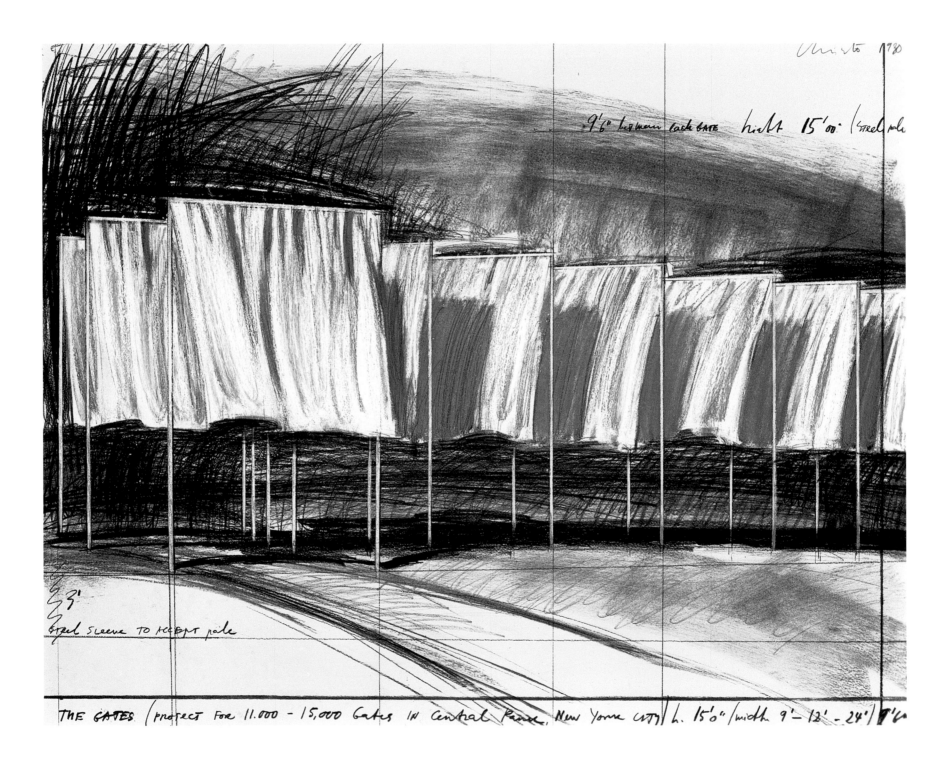

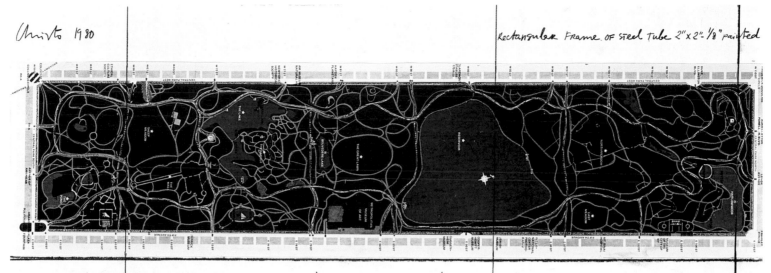

Christo 1980

Rectangular frame of steel tube 2"x 2"⋅ 1/8" painted

THE GATES (Project for Central Park, New York City) 11.000 - 15.000 Gates Hight 15'0" width from 9'0" to 27'0" along selected walkways

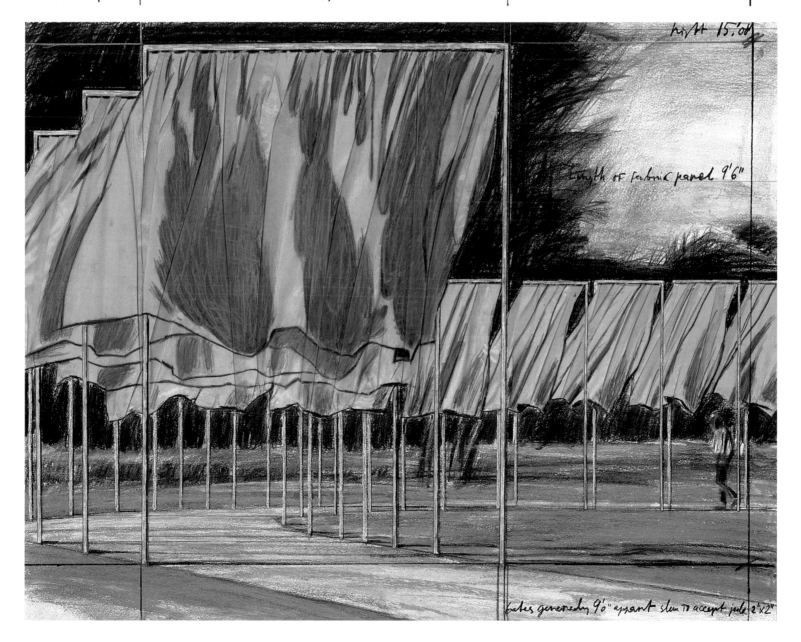

Hight 15'00"

Length of fabric panel 9'6"

Gates generally 9'0" apart stem to accept pole 2"x 2"

Christo, Jeanne-Claude, and Theodore W. Kheel (back to camera at right) meeting with four representatives of Community Board 11, from the area between Fifth Avenue and the East River. The vote from this meeting, in February 1981, was unanimous in favor of *The Gates*.

Christo giving a presentation to the members of Community Board 10, which covers the area between Central Park North and the Harlem River, in February 1981. The board voted unanimously in support of *The Gates*.

Christo at one of the numerous survey seminars that were held in the office of sociologist Dr. Kenneth Clark beginning in January 1981 to prepare a human-impact study for *The Gates*. At the request of Dr. Clark, Christo and Jeanne-Claude often did not attend so that the participants would not be inhibited by the artists' presence when asking questions.

In February 1981, the permit for *The Gates, Project for Central Park, New York City* was denied by the commissioner of parks and recreation.

The Gates, Project for Central Park, New York City
Drawing, 1980
Pencil and charcoal
42 x 65 in. (106.6 x 165 cm)

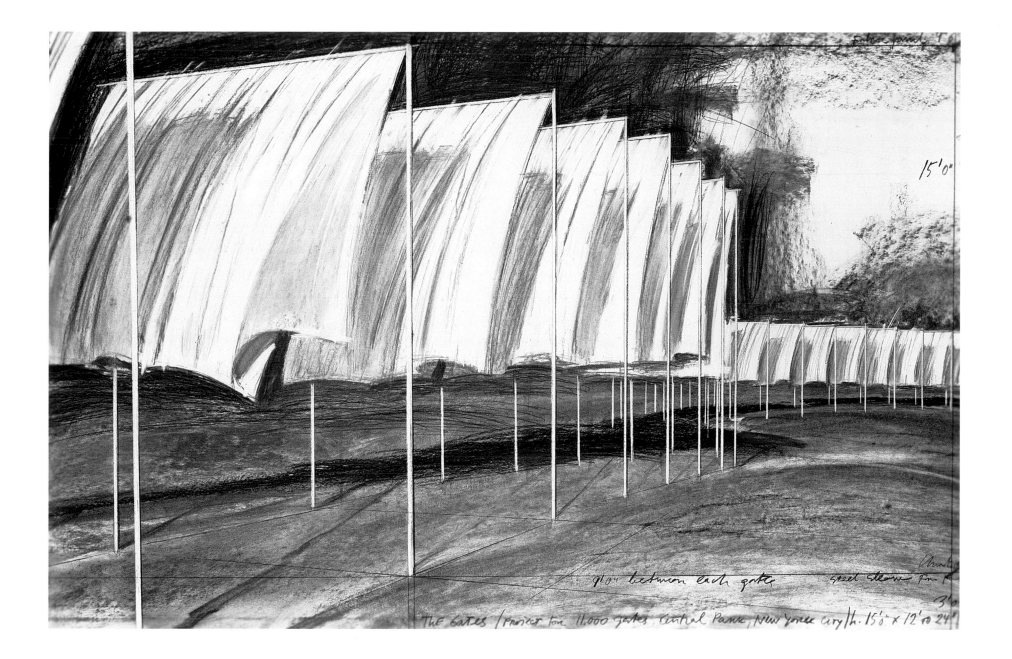

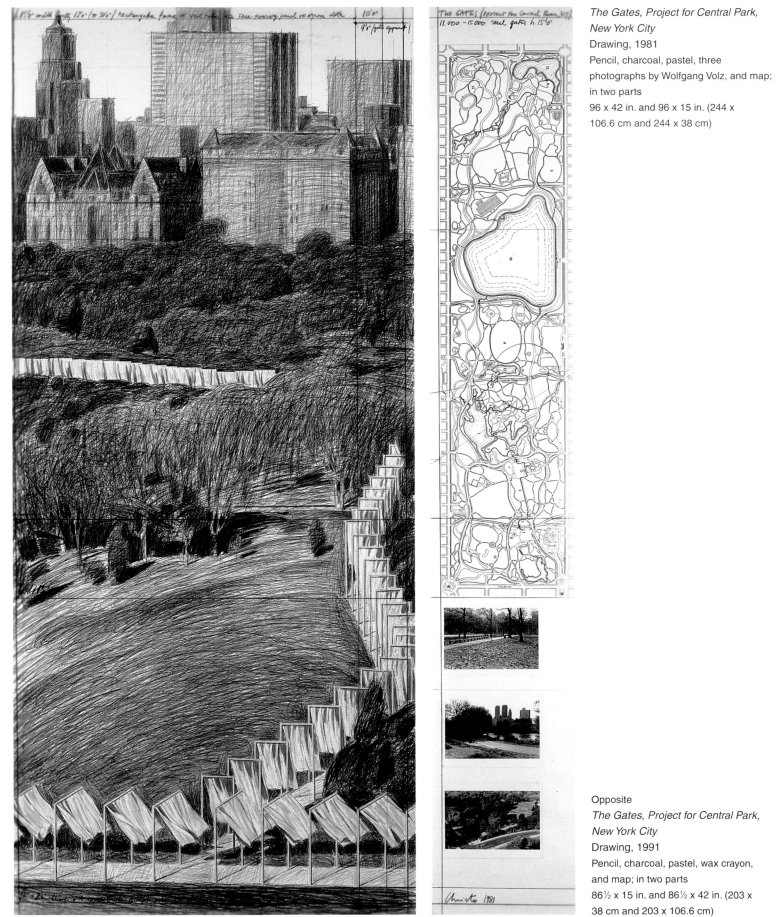

The Gates, Project for Central Park,
New York City
Drawing, 1981
Pencil, charcoal, pastel, three
photographs by Wolfgang Volz, and map;
in two parts
96 x 42 in. and 96 x 15 in. (244 x
106.6 cm and 244 x 38 cm)

Opposite
The Gates, Project for Central Park,
New York City
Drawing, 1991
Pencil, charcoal, pastel, wax crayon,
and map; in two parts
86½ x 15 in. and 86½ x 42 in. (203 x
38 cm and 203 x 106.6 cm)

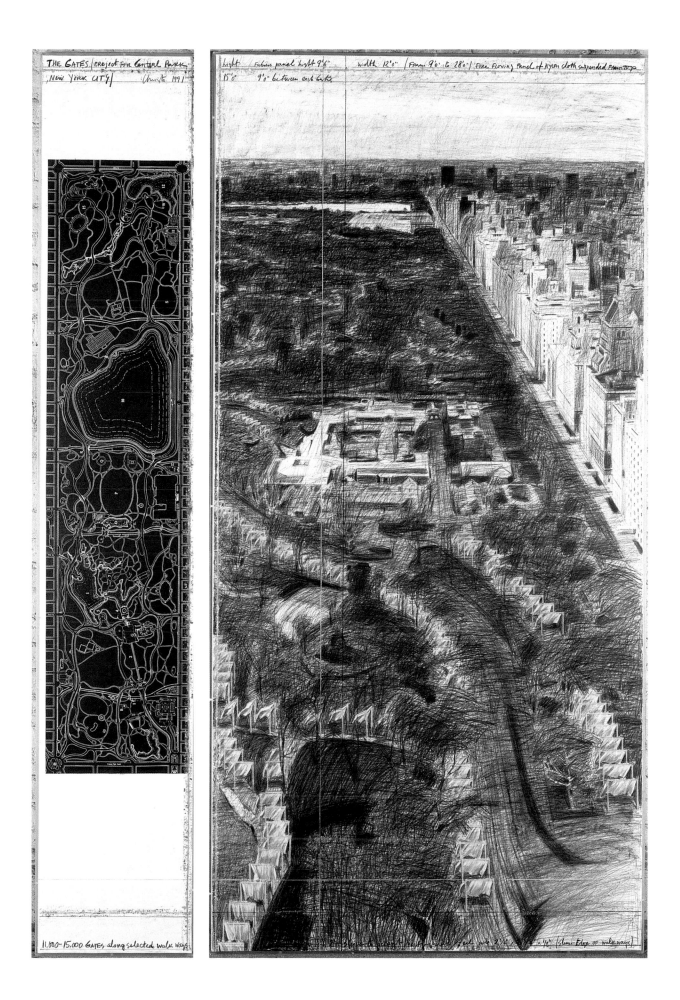

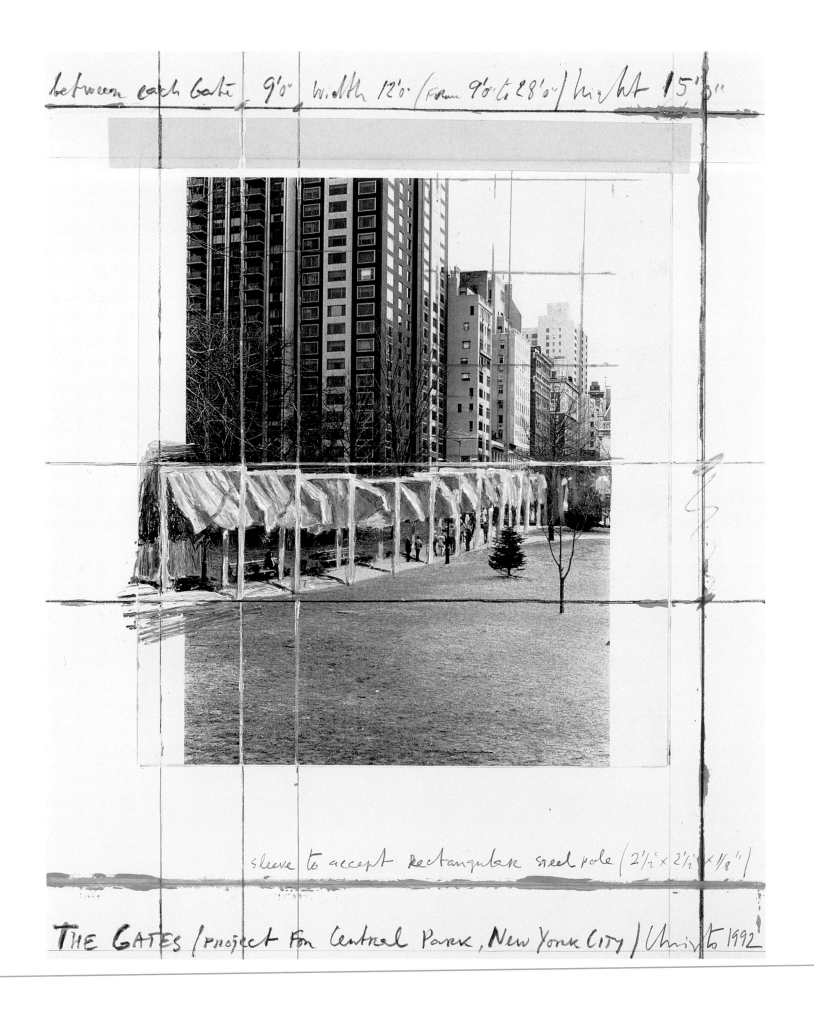

between each Gate 9'0" / width 12'0" (From 9'0" to 28'0") / height 15'0"

sleeve to accept rectangular steel pole (2'½" x 2'½" x ⅛")

THE GATES / Project For Central Park, New York City / Christo 1992

Opposite
The Gates, Project for Central Park, New York City
Collage, 1992
Pencil, enamel paint, photograph by Wolfgang Volz, wax crayon, and tape
14 x 11 in. (35.5 x 28 cm)

The Gates, Project for Central Park, New York City
Collage, 1992
Pencil, enamel paint, photograph by Wolfgang Volz, charcoal, wax crayon, ink, and tape
11 x 14 in. (28 x 35.5 cm)

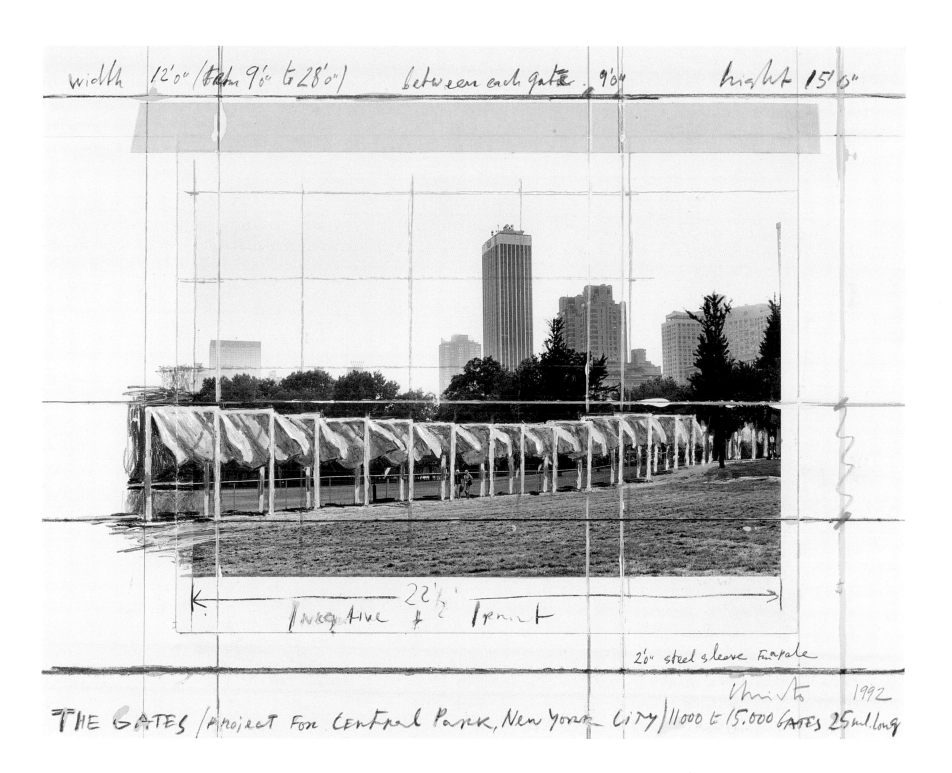

hight 15'0" Free Flowing Fabric panels / suspended from top / 9'0" between gates

The Gates, Project for Central Park,
New York City
Collage, 1996
Pencil, enamel paint, photograph by
Wolfgang Volz, wax crayon, map, and tape
14 x 11 in. (35.5 x 24 cm)

2½ sleeve to accept rectangular steel pole (3"x 3") Christo 1996

The GATES / project for Central park, New York City) 11.000 – 15000 Gates 26 miles

Opposite
The Gates, Project for Central Park,
New York City
Collage, 1997
Pencil, charcoal, photographs by
Wolfgang Volz, wax crayon, pastel,
and map; in two parts
15 x 65 in. and 42 x 65 in. (38 x 165 cm
and 106.6 x 165 cm)

The Gates (Project for Central Park, New York City) 11,000–15,000 Gates high 15'0" (steel poles) along selected walk ways. Christo 1997

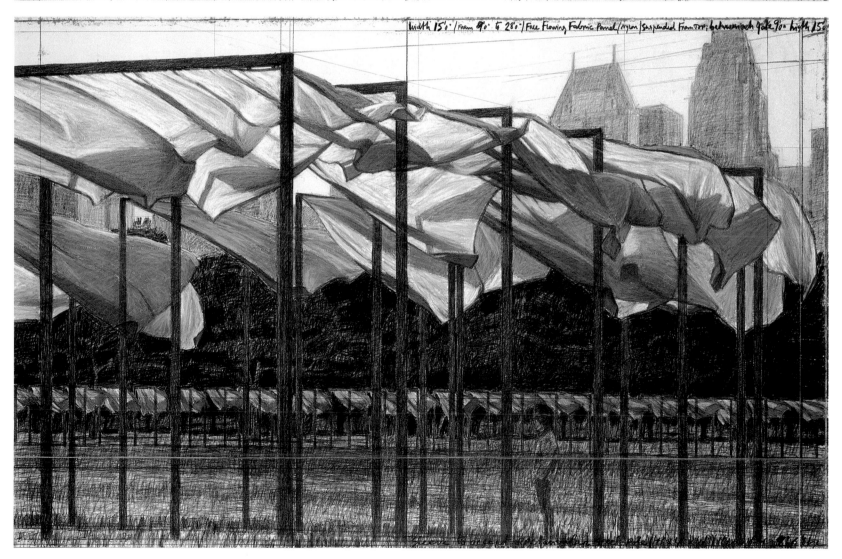

width 15'0" / From 9'0" to 28'0" / Free Flowing Fabric Panel / Nylon / suspended from Top; between each Gate 9'0" high 15'0"

The Gates, Project for Central Park, New York City
Collage, 2001
Pencil, enamel paint, photograph by Wolfgang Volz, wax crayon, and tape
16 x 19¾ in. (40.6 x 50.2 cm)

Opposite
The Gates, Project for Central Park, New York City
Collage, 1998
Pencil, enamel paint, photograph by Wolfgang Volz, wax crayon,
and tape (on brown board)
8½ x 11 in. (21.5 x 28 cm)

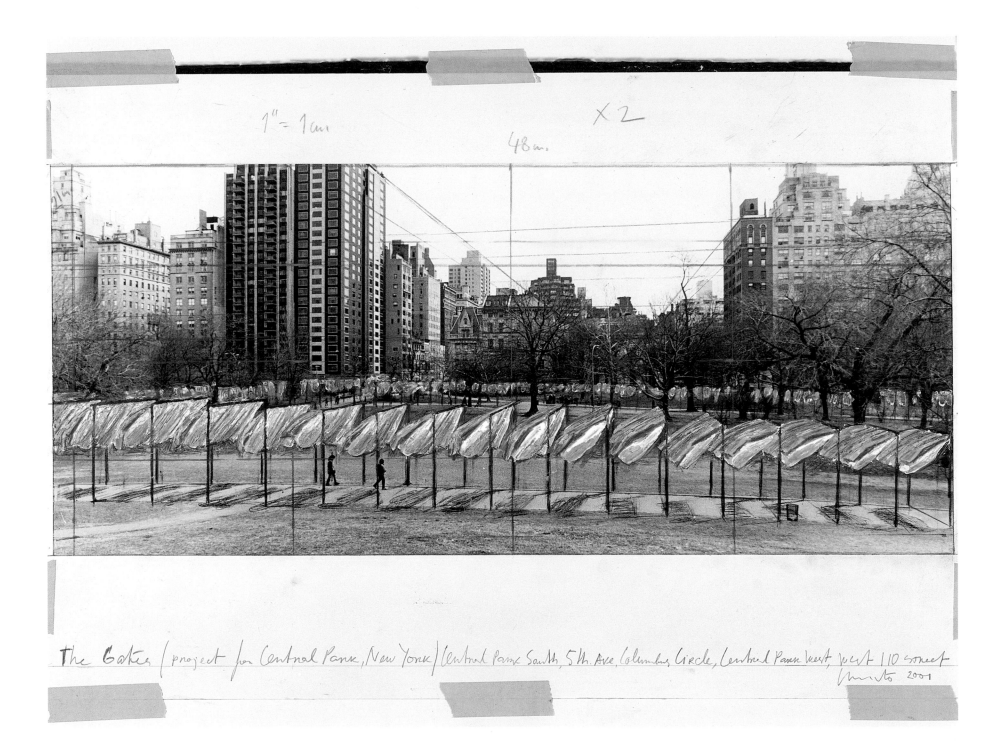

The Gates
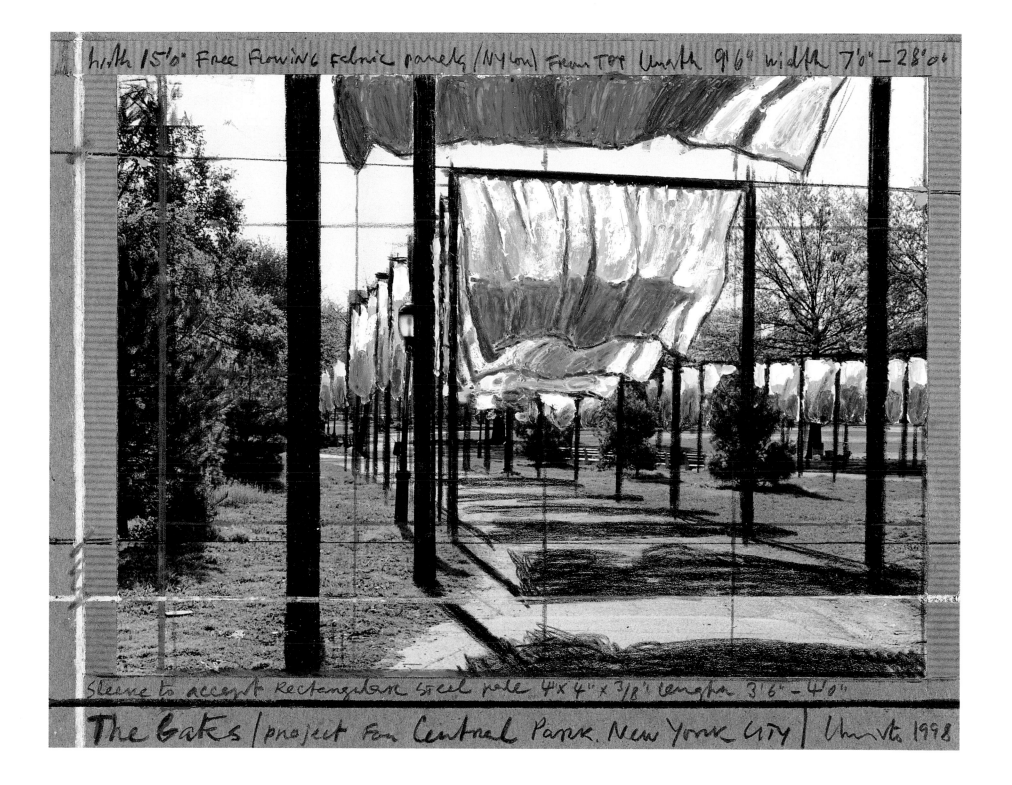

with 15'0" Free Flowing Fabric panels (Nylon) From Top Length 9'6" width 7'0" – 28'0"

Sleeve to accept Rectangular steel pole 4"x 4" x 3/8" length 3'6" – 4'0"

The Gates / project For Central Park. New York City / Christo 1998

The Gates, Project for Central Park, New York City
Collage, 1999
Pencil, enamel paint, photograph by Wolfgang Volz, wax crayon, and tape
8½ x 11 in. (21.5 x 28 cm)

Opposite
The Gates, Project for Central Park, New York City
Collage, 1999
Pencil, fabric, wax crayon, charcoal, pastel, and aerial photograph; in two parts
12 x 30½ in. and 26¼ x 30½ in. (30.5 x 77.5 cm and 66.7 x 77.5 cm)

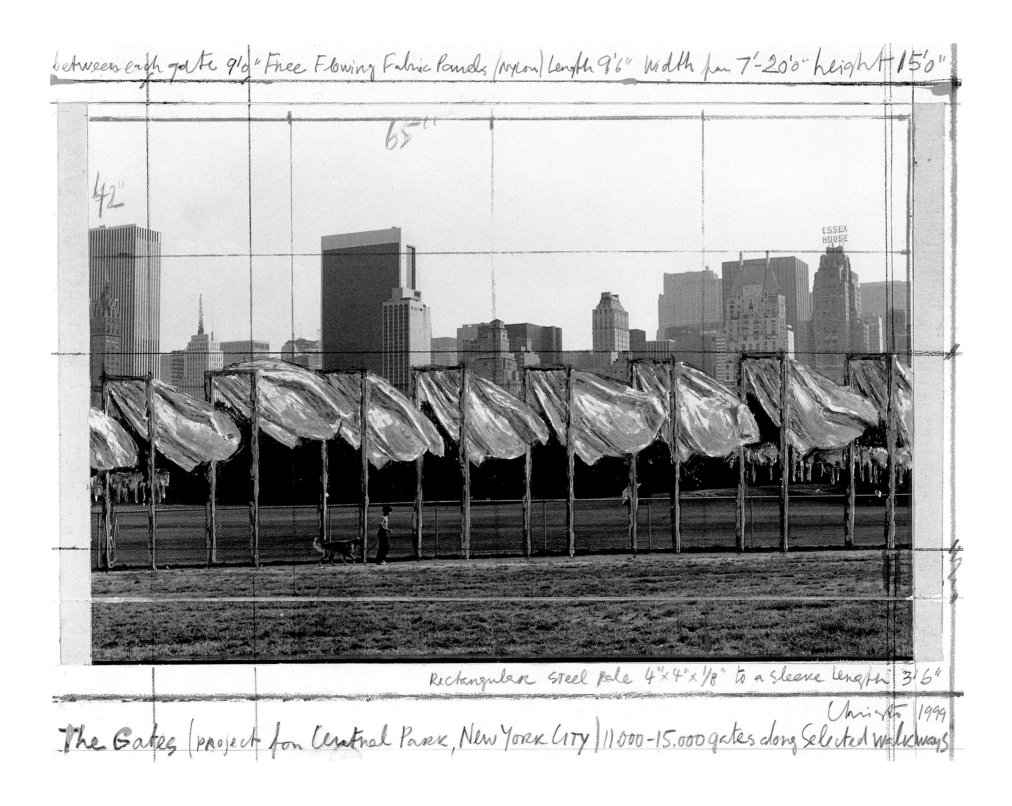

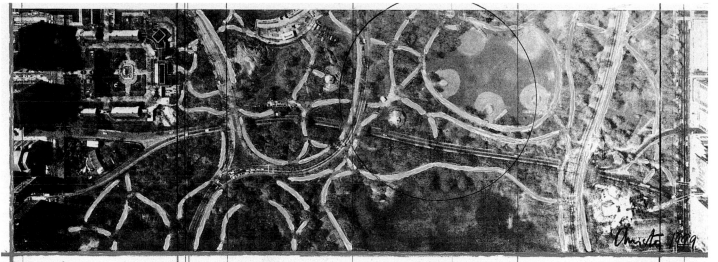

The Gates / project for Central Park, New York City / 11.000 – 15.000 steel gates along selected walkways

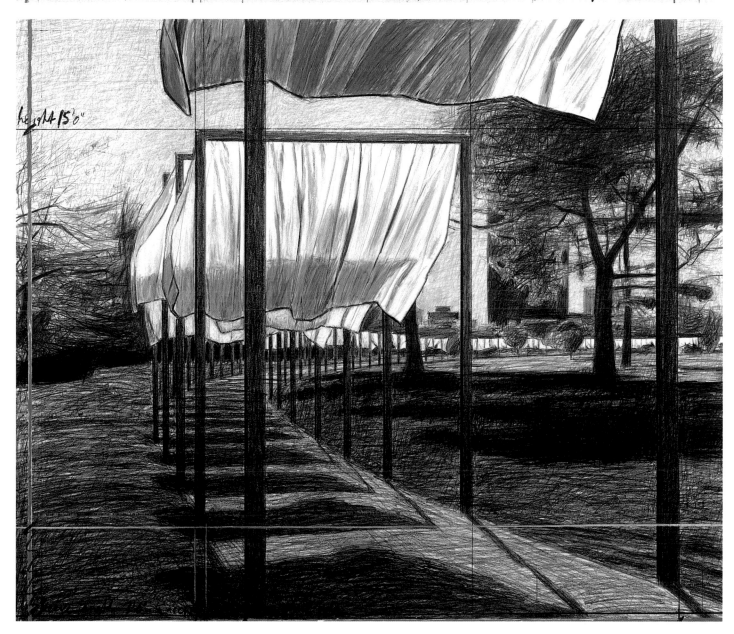

height 15'0"

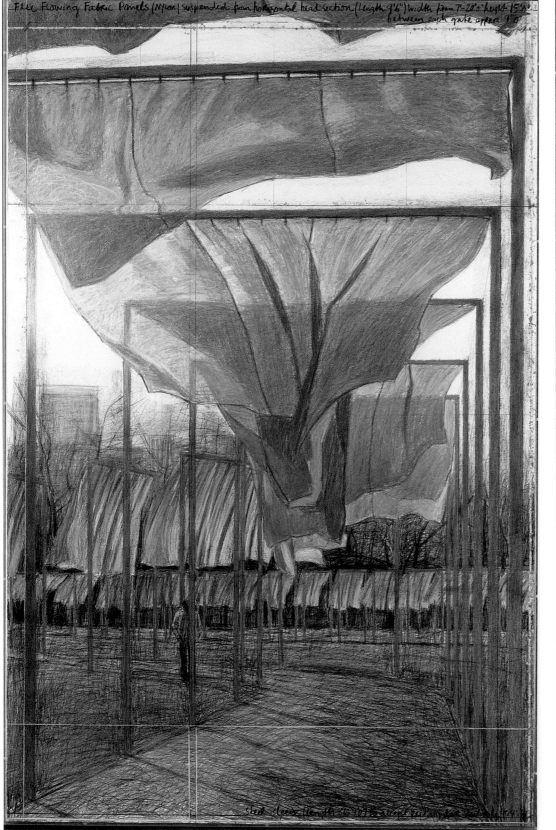

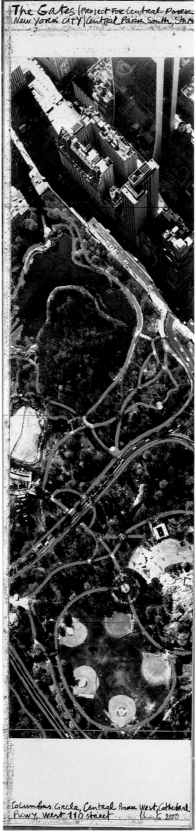

The Gates, Project for Central Park, New York City
Collage, 2000
Pencil, charcoal, pastel, wax crayon, and aerial photograph; in two parts
65 x 42 in. and 65 x 15 in. (165 x 106.6 cm and 165 x 38 cm)

Opposite
The Gates, Project for Central Park, New York City
Collage, 1996
Pencil, charcoal, pastel, wax crayon, and aerial photograph; in two parts
65 x 42 in. and 65 x 15 in. (165 x 106.6 cm and 165 x 38 cm)

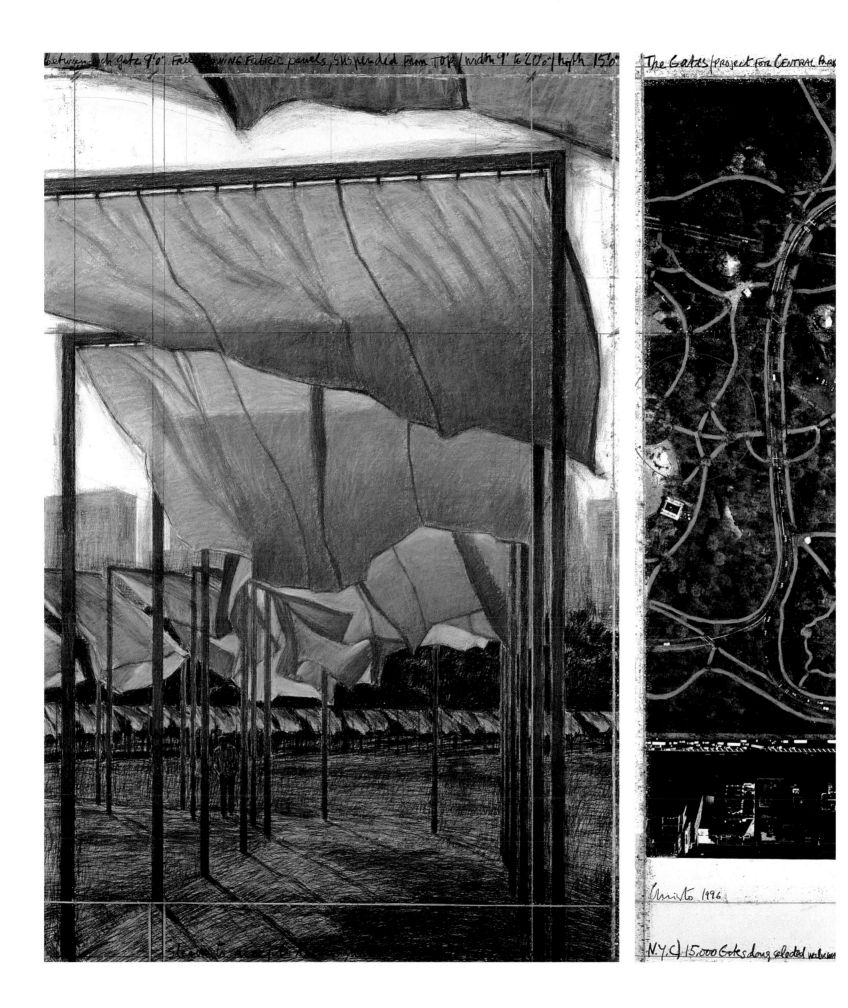

between each Gate 9'0" Free flowing Fabric panels, suspended from top / width 9' to 20'0" / height 15'0"

The Gates (project for Central Park

Christo 1996

N.Y.C.) 15,000 Gates along selected walkways

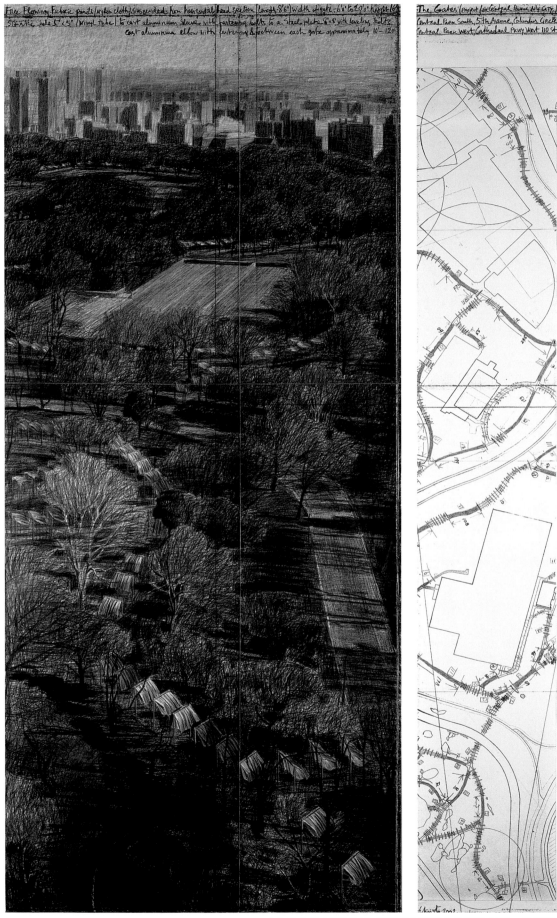

The Gates, Project for New York City
Drawing, 2002
Pencil, charcoal, pastel, wax crayon,
enamel paint, and map; in two parts
96 x 42 in. and 96 x 15 in. (244 x 106.6 cm
and 244 x 38 cm)

Opposite
*The Gates, Project for Central Park,
New York City*
Drawing, 2002
Pencil, charcoal, pastel, wax crayon,
technical data, and aerial photograph;
in two parts
96 x 15 in. and 96 x 42 in. (244 x 38 cm
and 244 x 106.6 cm)

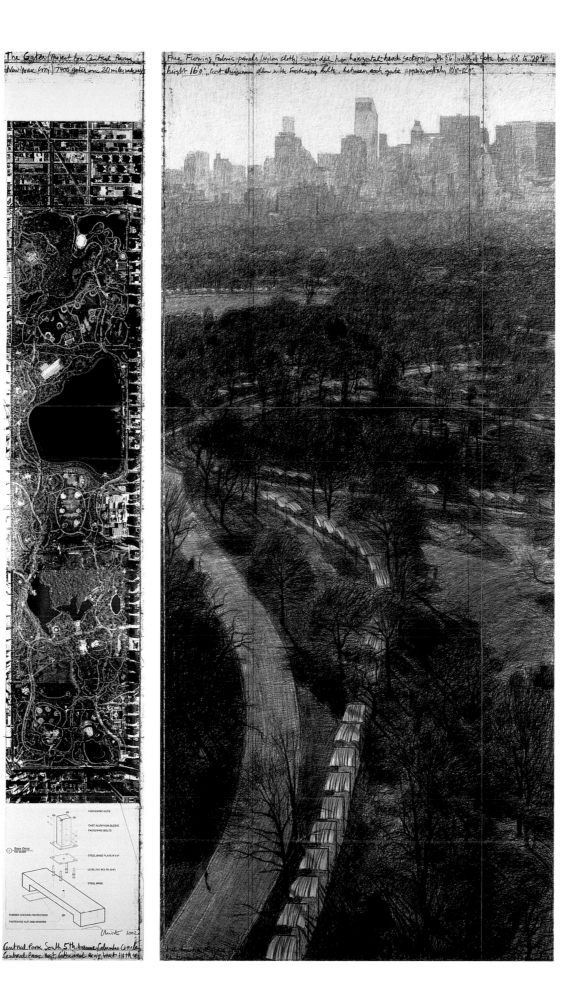

The Gates, Project for Central Park, New York City
Collage, 1998
Pencil, enamel paint, wax crayon, map, photograph by André Grossmann, and tape
14 x 22 in. (35.5 x 55.9 cm)

Opposite
The Gates, Project for Central Park, New York City
Collage, 2001
Pencil, charcoal, pastel, wax crayon, photograph by
Wolfgang Volz, and map; in two parts
15 x 96 in. and 42 x 96 in. (38 x 244 and 106.6 x 244 cm)

88

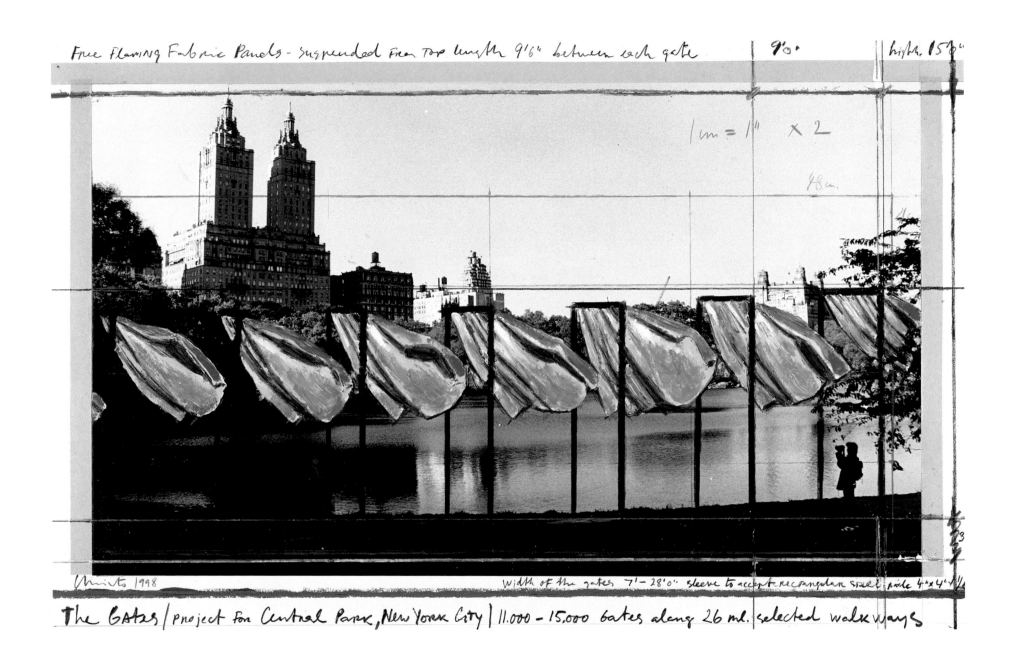

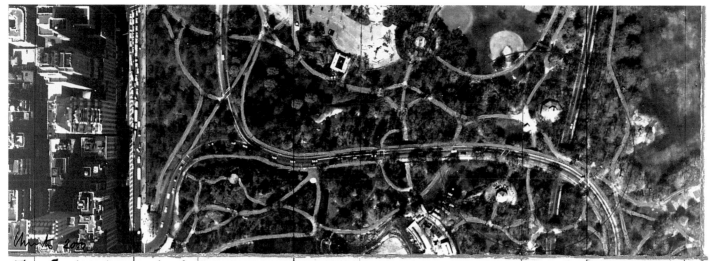

The Gates, Project for Central Park, New York City
Collage, 2000
Pencil, fabric, charcoal, wax crayon,
pastel, and aerial photograph;
in two parts
12 x 30½ in. and 26¼ x 30½ in.
(30.5 x 77.5 cm and 66.7 x
77.5 cm)

The Gates (project for Central Park, New York City) Central Park So. 5th Ave, Central Park W, Cathedral Pkwy, W 110 St.

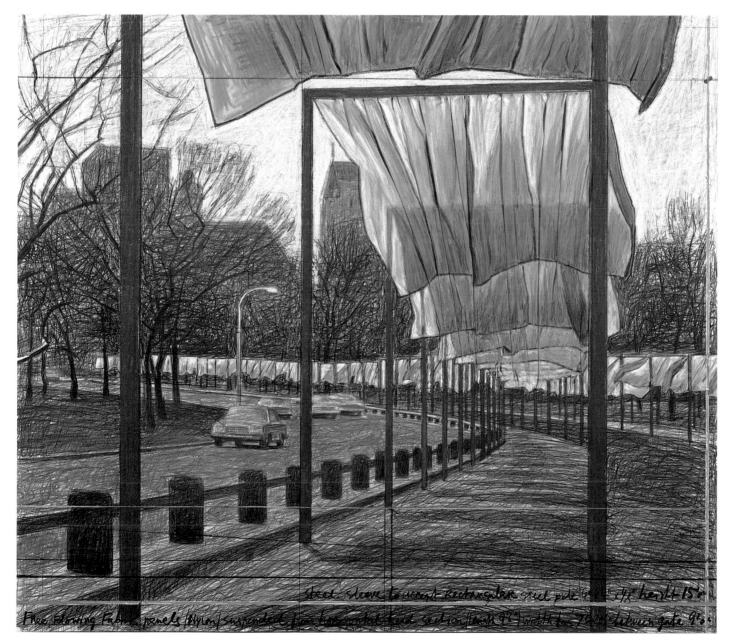

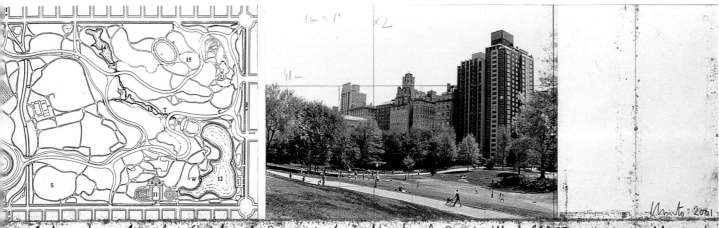

...e Columbus Circle, Central Park West, Cathedral Pkwy, West 110 Street, approx 11000 gates

...etween each gates 9'0" width of the gates - from 7'0" to 20'0" (acc to walkways) height 15'6"

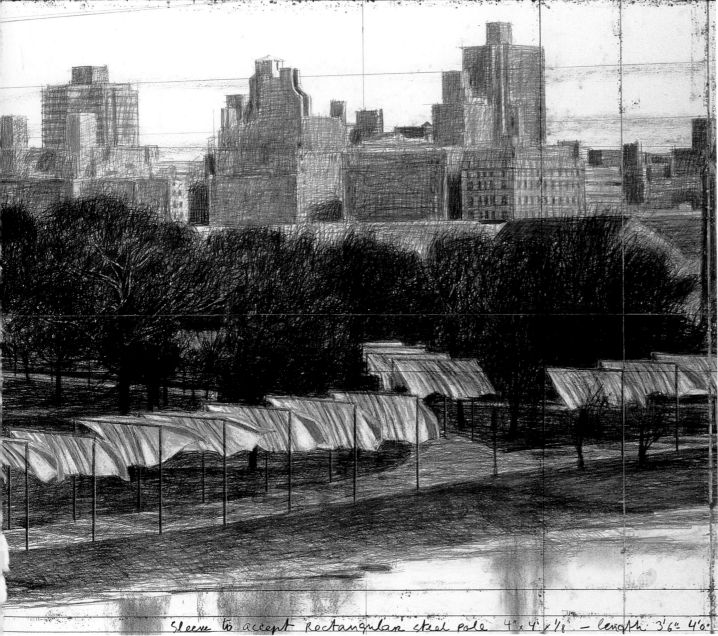

sleeve to accept rectangular steel pole 4" x 4" x 1/8" - length 3'6" 4'0"

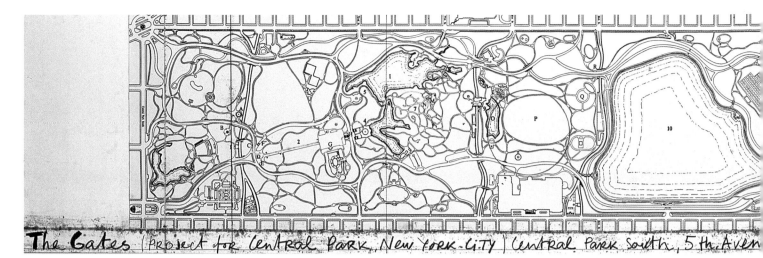

The Gates (Project for Central Park, New York City) Central Park South, 5th Aven

Free Flowing Fabric Panels / Nylon cloth / suspended from horizontal head section / length 9'6" /

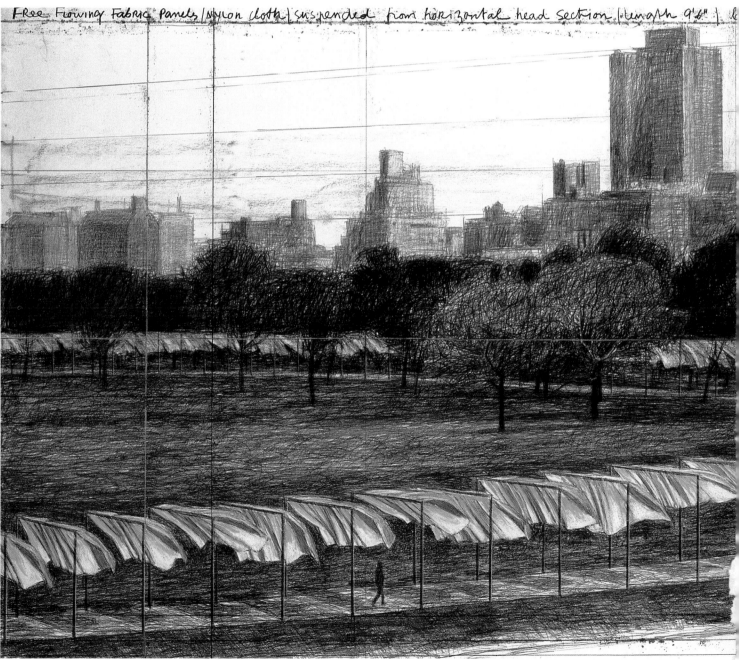

The Gates, Project for Central Park, New York City
Collage, 2001
Pencil, charcoal, pastel, and wax crayon
22 x 28 in. (55.9 x 71.1 cm)

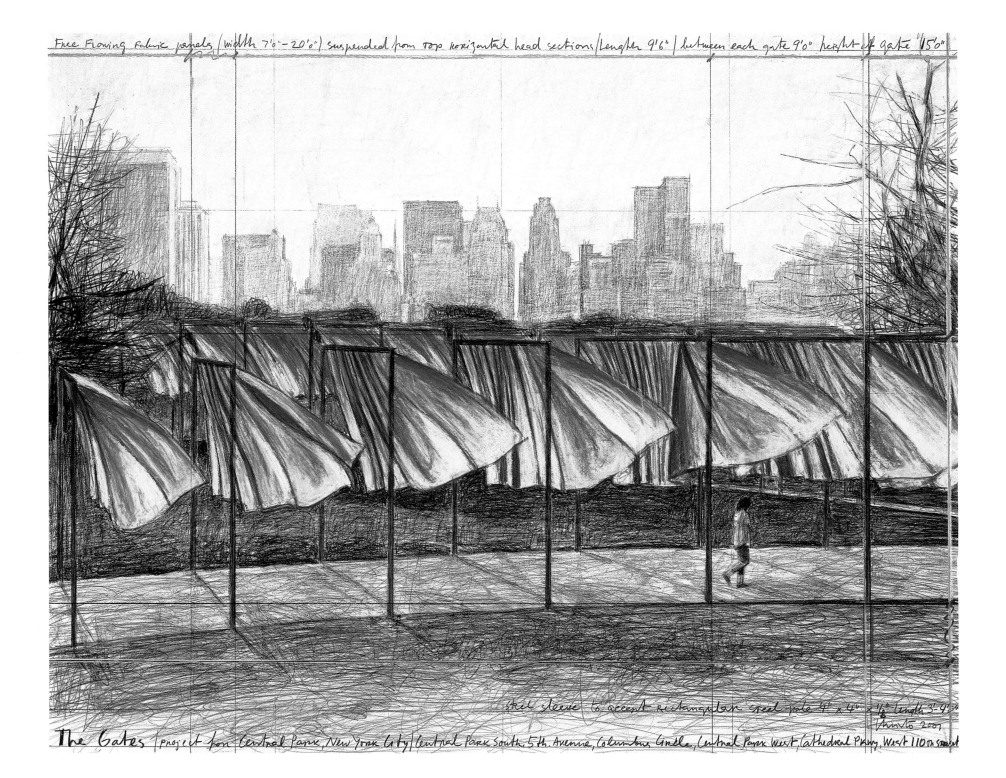

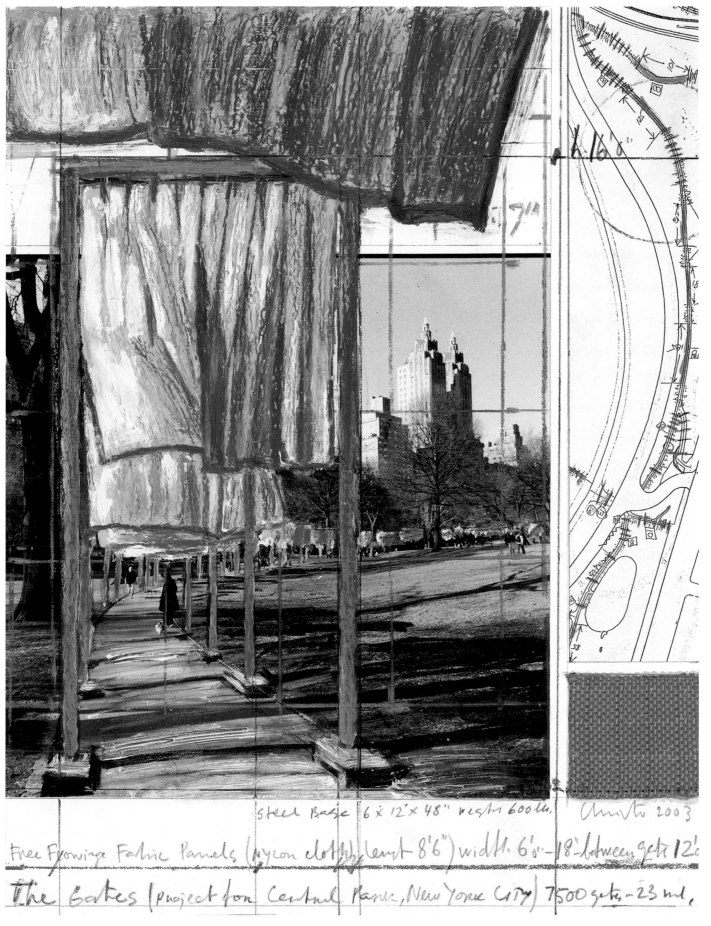

The Gates, Project for Central Park, New York City
Collage, 2003
Pencil, enamel paint, photograph by Wolfgang Volz, wax crayon, and fabric
11 x 8½ in. (28 x 21.5 cm)

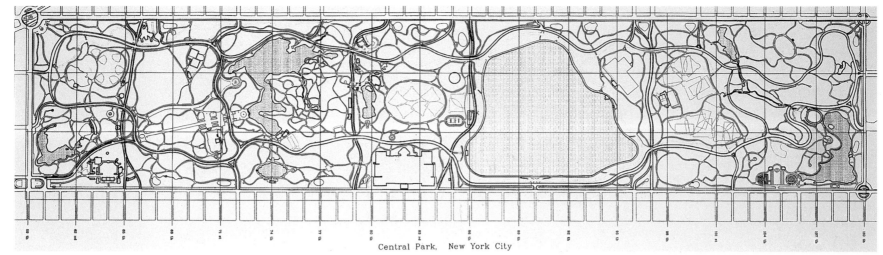

Central Park, New York City

Map of Central Park, 2003
9 x 31 in. (22.8 x 78.7 cm)
Photo: André Grossmann
The orange lines indicate the twenty-three
miles of walkways on which the gates will
be placed.

Map of Manhattan
36 x 13 in. (91.4 x 33 cm)
Photo: André Grossmann

The pink parts of the map represent
buildings, showing how Central Park is
completely encompassed by the regular
geometry of the surrounding city blocks,
isolated from any other natural elements.
The rectangular grid that contains the park
is reflected in the shape of each vinyl gate
being used to construct *The Gates,* while
the fabric panels moving capriciously in
the wind are in harmony with the serpen-
tine flow of the walkways. As designed by
Frederick Law Olmsted and Calvert Vaux,
Central Park is enclosed by a stone wall
with periodic openings for passage into
the park. These entrances are called
gates, providing inspiration for the title
of the work of art.

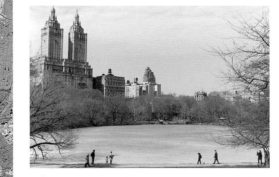

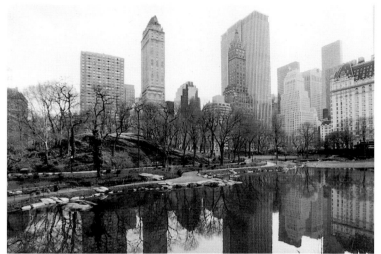

The month of February was chosen for *The Gates* to ensure that there are no leaves on the trees, allowing the saffron-colored fabric panels of the work to be seen from far away through the silvery gray branches.

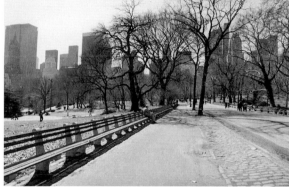

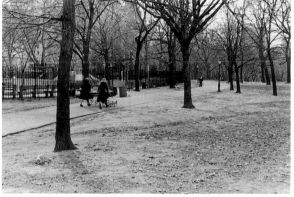

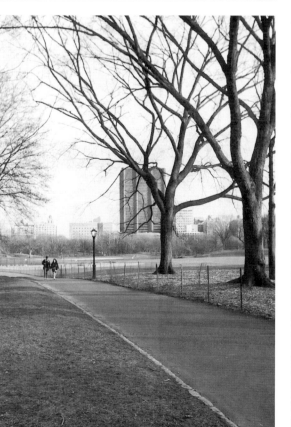

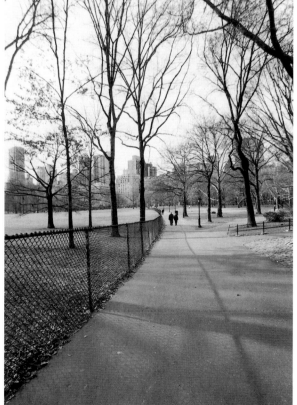

Vladimir Yavachev (far left), son of Christo's elder brother and project assistant since 1991, and Jonita Davenport (far right), a team member since 1991 and project director of *The Gates*, measure the width of a walkway in Central Park, June 2002. Between them are Sylvia Volz, Simon Chaput (team member since 1985), art historian and author Masa Yanagi (team member since 1983) holding the distance wheel, Jeanne-Claude, and project engineer and director of construction Vince Davenport marking the measurements on a map with Christo.

Project engineer Vince Davenport measures the height of one of the many low branches in Central Park, with Christo, Jeanne-Claude, Sylvia Volz (wife of photographer Wolfgang Volz), and Central Park administrator Douglas Blonsky, June 2002.

In June 2002, Adam Kaufman (at left), Central Park director of night and weekend operations, and Douglas Blonsky (right) show Christo and Jeanne-Claude where the sixteen-foot-tall gates will not fit because of low branches above the walkways.

Vince Davenport and Christo mark the location of some 7,500 gates on a map provided by the Central Park administrator. This work took three weeks and involved walking one hundred miles in Central Park in June 2003.

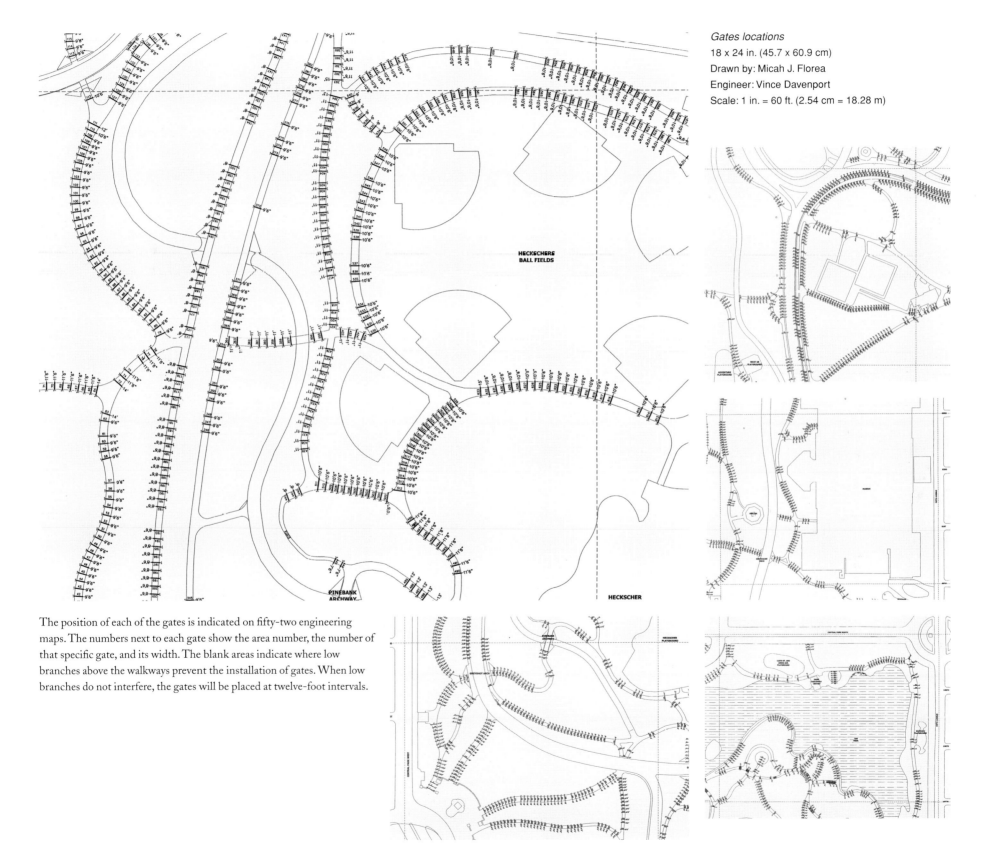

Gates locations
18 x 24 in. (45.7 x 60.9 cm)
Drawn by: Micah J. Florea
Engineer: Vince Davenport
Scale: 1 in. = 60 ft. (2.54 cm = 18.28 m)

HECKSCHERS
BALL FIELDS

PINEBANK
ARCHWAY

HECKSCHER

The position of each of the gates is indicated on fifty-two engineering maps. The numbers next to each gate show the area number, the number of that specific gate, and its width. The blank areas indicate where low branches above the walkways prevent the installation of gates. When low branches do not interfere, the gates will be placed at twelve-foot intervals.

Commissioner of Parks and Recreation Adrian Benepe (at left behind podium) and Douglas Blonsky answer questions about *The Gates* during a meeting they organized at the Municipal Art Society, January 21, 2003. At far left is Chicago art collector Scott Hodes, a friend of Christo and Jeanne-Claude and their attorney since 1965.

Theodore W. Kheel (left), Vince Davenport (standing), Jeanne-Claude, and Christo answer questions for Community Board 5 at the Fashion Institute of Technology on West Twenty-seventh Street, March 3, 2003. Photo: André Grossmann

Mayor Michael Bloomberg, at a press conference at the Arsenal in Central Park on January 22, 2003, announces that the City of New York has signed a contract with Christo and Jeanne-Claude (at left), giving the artists permission to create *The Gates, Project for Central Park, New York City*. To the right of the mayor are Adrian Benepe, Gordon J. Davis, Kate Levin, the commissioner of cultural affairs, Patricia Harris, deputy mayor, Regina Peruggi, president of the Central Park Conservancy, and Douglas Blonsky.

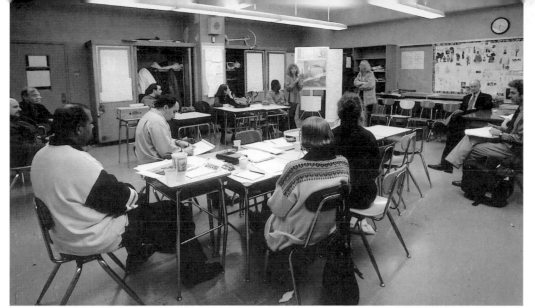

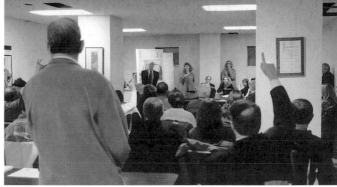

The Gates team explains the installation to Community Board 11 on March 13, 2003, at the Beacon Center, First Avenue and 120th Street (left). An hour later, the team hurried to its next meeting, with Community Board 7 at West Eighty-seventh Street (above).

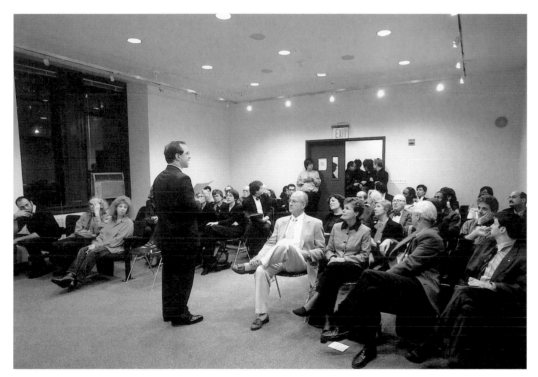

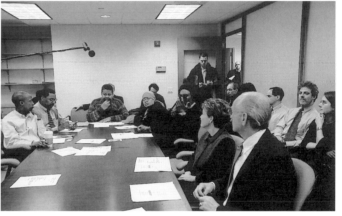

Adrian Benepe answers questions before the Landmarks Preservation Commission at the Municipal Building, 1 Center Street, on March 19, 2003 (left). The same night, the executive board of Community Board 10 (above), at West 125th Street, hears the presentation of *The Gates* team. Afterward, the team members had to rush to yet another meeting.

Deputy Parks Commissioner Jack Linn, at right, explains the details of the city's forty-four-page contract with the artists to Community Board 8, at East Sixty-seventh Street, on March 19, 2003. Albert Maysles (behind camera), who began his documentary on *The Gates* in 1980, filmed the meeting. Christo and Jeanne-Claude are behind the podium at left.

Press Release

On January 22, 2003, Michael R. Bloomberg, Mayor of New York City, announced that the city has given permission to New York artists Christo and Jeanne-Claude to realize their temporary work of art:

The Gates, Central Park, New York, 1979–2005.

The approximately 7,500 gates, 16 feet (4.87 meters) high with a width varying from 6 to 18 feet (1.82 to 5.48 meters) will follow the edges of the walkways and will be perpendicular to the selected 23 miles of footpaths in Central Park. Free-hanging saffron-colored fabric panels suspended from the horizontal top part of the gates will come down to approximately 7 feet (2.13 meters) above the ground. The gates will be spaced at 10 to 15 foot (3 to 4.5 meter) intervals allowing the synthetic woven fabric panels to wave horizontally toward the next gate and to be seen from far away through the leafless branches of the trees. The temporary work of art *The Gates* is scheduled for February 2005, to remain for 16 days; then the gates shall be removed and the materials recycled.

As Christo and Jeanne-Claude have always done for their previous projects, *The Gates* will be entirely financed by the artists through CVJ Corporation (Jeanne-Claude Javacheff, President) with the sale of studies, preparatory drawings and collages, scale models, earlier works of the fifties and sixties, and original lithographs on other subjects.

The artists do not accept sponsorship of any kind.

Neither New York City nor the Park Administration shall bear any of the expenses for *The Gates.*

The Gates will provide employment for thousands of New York City residents:

- Manufacturing and assembling of the gates structures
- Installation workers
- Maintenance teams around the clock, in uniform and with radios
- Removal workers.

The 5-inch (12.7 centimeter) square vertical and horizontal poles will be extruded in 65 miles (104.6 kilometers) of recyclable saffron-colored vinyl. The vertical poles will be secured by 15,000 narrow steel base footings, 600 pounds (272 kilograms) each, positioned on the paved surfaces. There will be no holes in the ground at all.

The off-site fabrication of the gates structures and the assembly of the 1,076,426 square feet (100,000 square meters) of fabric panels will be done in local workshops and factories.

The on-site installation of the bases, by small teams, spread in the park, will disturb neither the maintenance and management of Central Park nor the everyday use of the park by the people of New York.

The final installation of the gates will be done, in five days, simultaneously by hundreds of workers.

The unfurling of the fabric panels will bloom in one day.

A written contract has been drafted between the City of New York and the Department of Parks and Recreation and the artists. The contract requires the artists to provide, among other terms and conditions:

- Personal and property liability insurance holding harmless the City, the Department of Parks and Recreation, and the Central Park Conservancy
- Removal bond providing funds for complete removal
- Full cooperation with the Department of Parks, the Central Park Conservancy, the New York Police Department, the New York City Arts Commission, the Landmarks Commission, and the Community Boards
- Clearance for the usual activities in the park and access of rangers, maintenance, cleanup, police, and emergency vehicles
- The artists shall pay all costs of the park's supervision directly related to the project
- Neither vegetation nor rock formations shall be disturbed. The gates will be clear of rocks, tree roots, and low branches
- Only vehicles of small size will be used and will be confined to the perimeter of existing walkways during installation and removal
- The people of New York will continue to use the park as usual
- After the removal, the site shall be inspected by the Department of Parks and Recreation, which will be holding the bond until satisfaction.

For those who will walk through the gates, following the walkways and staying away from the grass, *The Gates* will be a golden ceiling creating warm shadows. When seen from the buildings surrounding Central Park, *The Gates* will seem like a golden river appearing and disappearing through the bare branches of the trees and will highlight the shape of the footpaths.

The 14-day-duration work of art, free to all, will be a memorable joyous experience for every New Yorker, as a democratic expression that Olmsted invoked when he conceived a "central" park. The luminous moving fabric will underline the organic design of the park, while the rectangular poles will be a reminder of the grid pattern of the city blocks around the park. *The Gates* will harmonize with the beauty of Central Park.

Christo and Jeanne-Claude
The Gates, Central Park, New York City
1979–2005

Map of the seven work areas
in Central Park
36 x 48 in. (91.44 x 121.9 cm)
Drawn by: Micah J. Florea
Engineer: Vince Davenport
Scale: 1 in. = 500 ft. (2.54 cm
= 152.4 m)

AREA 7: 713 GATES

AREA 6: 1196 GATES

AREA 5: 707 GATES

AREA 4: 1051 GATES

AREA 3: 961 GATES

AREA 2: 1407 GATES

AREA 1: 1481 GATES

Total Gates This Sheet:		7516	
Size	Qty	Size	Qty
5'6"	6	12'	268
6'	13	12'6"	73
6'6"	14	13'	374
7'	70	13'6"	46
7'6"	395	14'	157
8'	311	14'6"	78
8'6"	380	15'	137
9'	517	15'6"	72
9'6"	1603	16'	43
10'	433	16'6"	2
10'6"	414	17'	54
11'	1075	17'6"	0
11'6"	700	18'	281

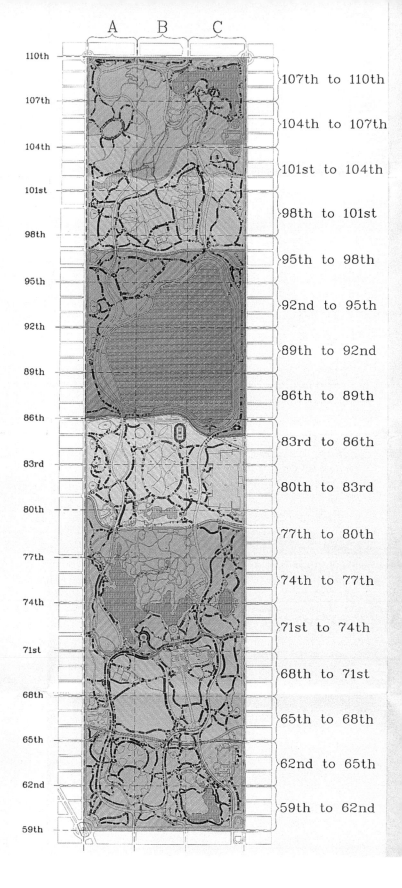

A B C

110th

107th to 110th

107th

104th to 107th

104th

101st to 104th

101st

98th to 101st

98th

95th to 98th

95th

92nd to 95th

92th

89th to 92nd

89th

86th to 89th

86th

83rd to 86th

83rd

80th to 83rd

80th

77th to 80th

77th

74th to 77th

74th

71st to 74th

71st

68th to 71st

68th

65th to 68th

65th

62nd to 65th

62nd

59th to 62nd

59th

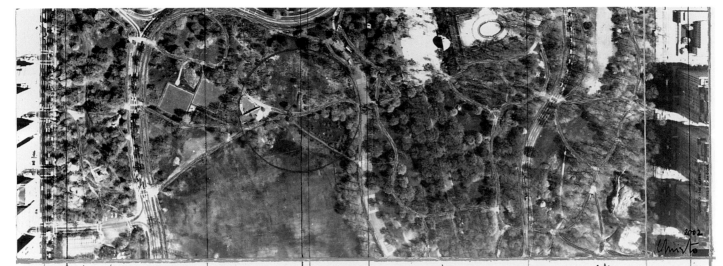

The Gates, Project for Central Park, New York City | Central Park S, 5th. Avenue, Central Park W. Cathedral Pkwy, W. 110 St.

The Gates, Project for Central Park,
New York City
Collage, 2002
Pencil, fabric, charcoal, wax crayon, pastel,
and aerial photograph; in two parts
12 x 30½ in. and 26¼ x 30½ in. (30.5 x
77.5 cm and 66.7 x 77.5 cm)

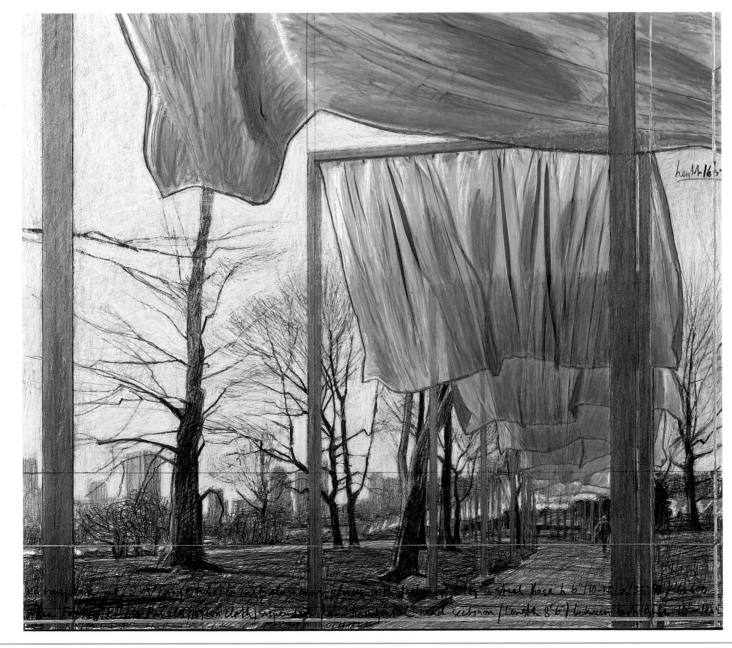

Opposite
The Gates, Project for Central Park,
New York City
Collage, 2002
Pencil, fabric, charcoal, wax crayon, pastel,
and aerial photograph; in two parts
12 x 30½ in. and 26¼ x 30½ in. (30.5 x
77.5 cm and 66.7 x 77.5 cm)

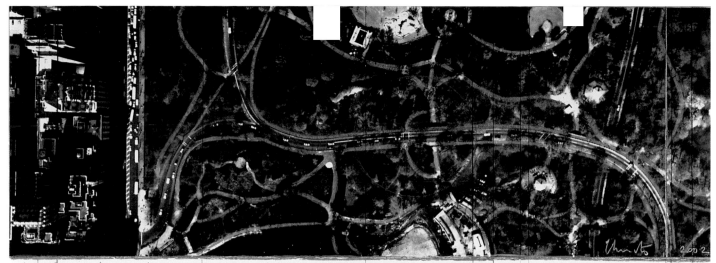

The Gates (Project for Central Park, New York City) Central Park S. 5th. Avenue, Central Park West Cathedral PKWY, West 110

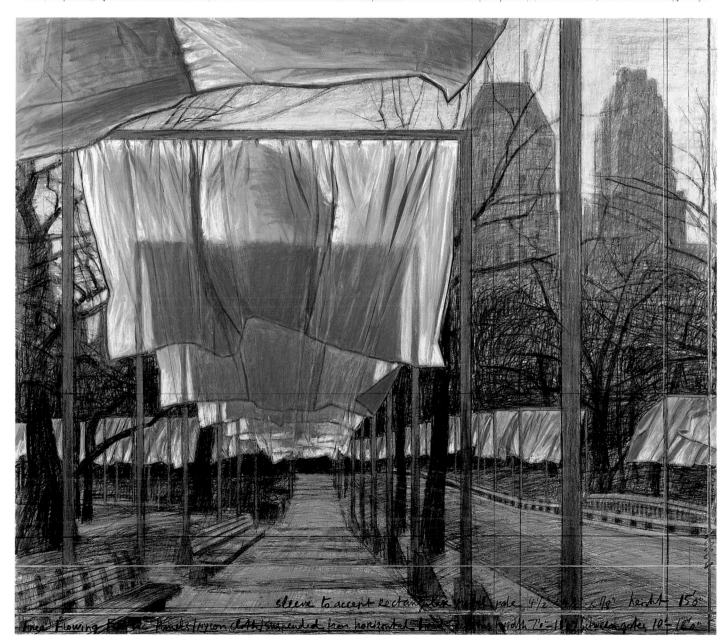

sleeve to accept rectangular steel pole 4/2 x 4/2 x 1/4 height 150"

Free Flowing Fabric panels/nylon cloth/suspended from horizontal width 7'0"-1 between gates 10'-18'0"

*The Gates, Project for
Central Park, New York City*
Collage, 2002
Pencil, fabric, charcoal, wax
crayon, and pastel
17 x 15¼ in. (43.2 x 38.3 cm)

Free Flowing Fabric Panels (Nylon Cloth) suspended from horizontal head section length 8'6" h.16'0"

Rectangular Pole (5" vinyl tube) to a cast aluminum sleeve, steel base plate 8"x8" to a steel base 6"x10"x36"

width of gates - 6'0" to 20'0" between each gate 10'0" to 12'0" Christo 2002

The Gates / project for Central Park, NYC). Central Park S, 5th Ave. CPW, West 110 St.

Opposite
*The Gates, Project for
Central Park, New York City*
Drawing, 2002
Pencil, charcoal, pastel, wax
crayon, enamel paint, and map;
in two parts
65 x 42 in. and 65 x 15 in.
(165 x 106.6 cm and 165 x
38 cm)

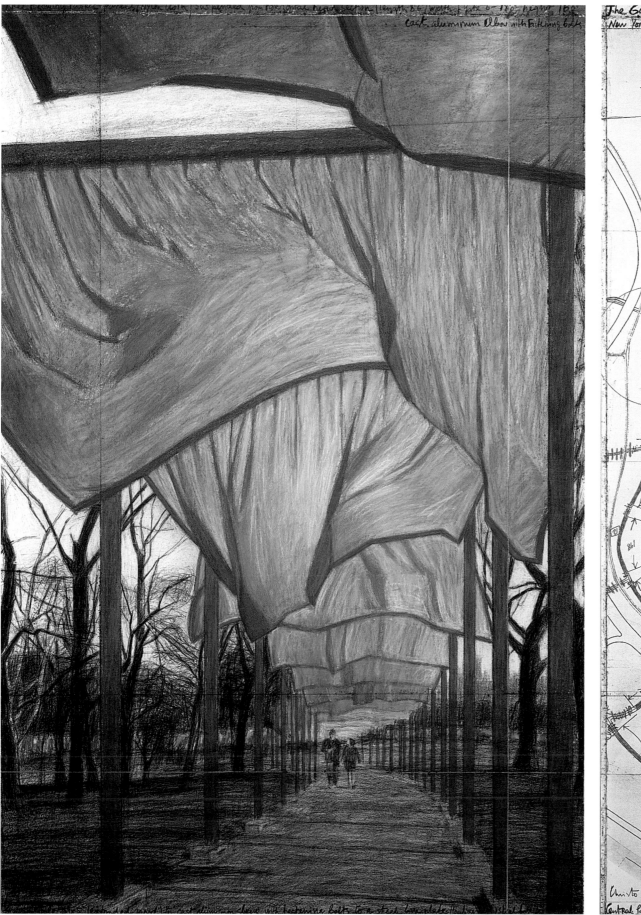

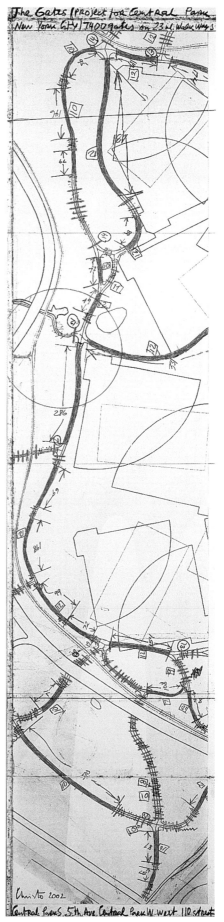

The Gates, Project for Central Park, New York City
Collage, 2003
Pencil, enamel paint, photograph by Wolfgang Volz, wax crayon, map, tape, and fabric
17 x 22 in. (43.2 x 55.9 cm)

The Gates, Project for Central Park, New York City
Collage, 2003
Pencil, enamel paint, photograph by Wolfgang Volz, wax crayon, and fabric
8½ x 11 in. (21.5 x 28 cm)

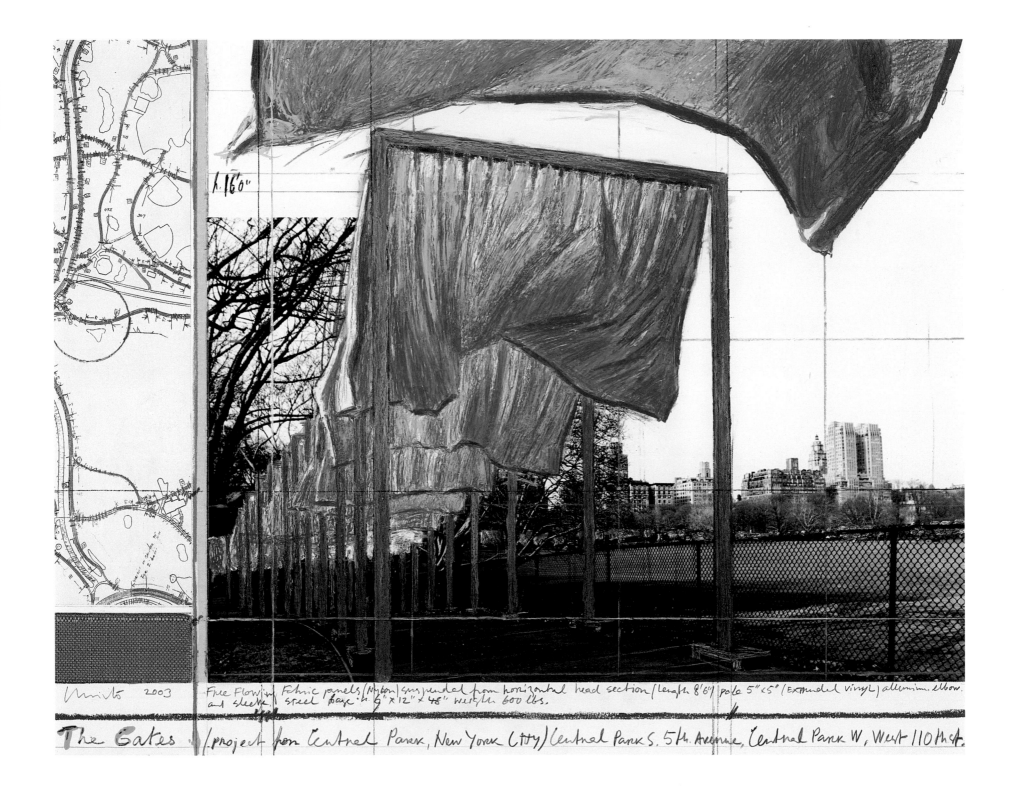

Free Flowing Fabric Panels (Nylon cloth) length 8'6" between each gate 12'0" width of gate 6'0"-18' h.16'0"

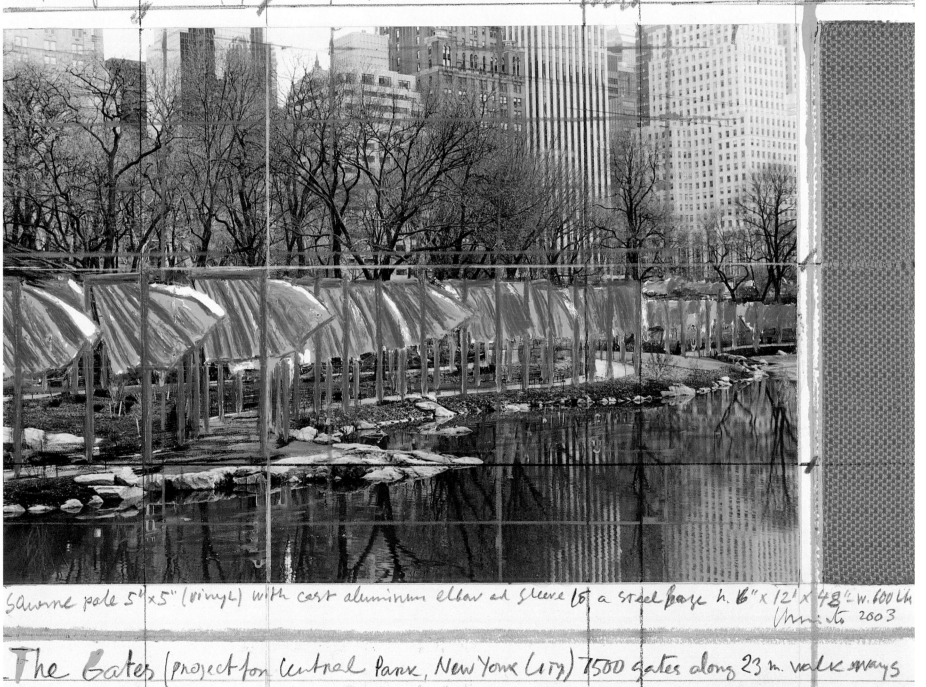

Square pole 5"x5" (vinyl) with cast aluminum elbow and sleeve to a steel base h.6" x 12' x 48" w.600 lb
Christo 2003

The Gates (project for Central Park, New York City) 7500 gates along 23 m. walk sways

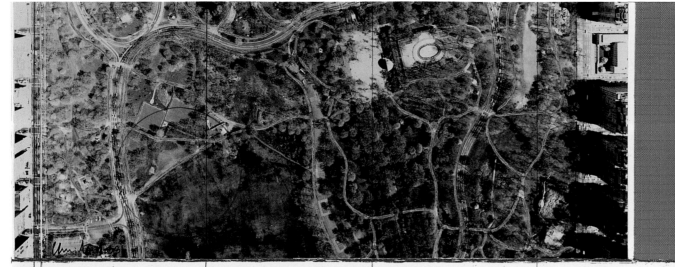

The Gates, Project for Central Park, New York City
Collage, 2003
Pencil, fabric, wax crayon, charcoal, pastel, enamel paint, and aerial photograph; in two parts
12 x 30½ in. and 26¼ x 30½ in.
(30.5 x 77.5 cm and 66.7 x 77.5 cm)

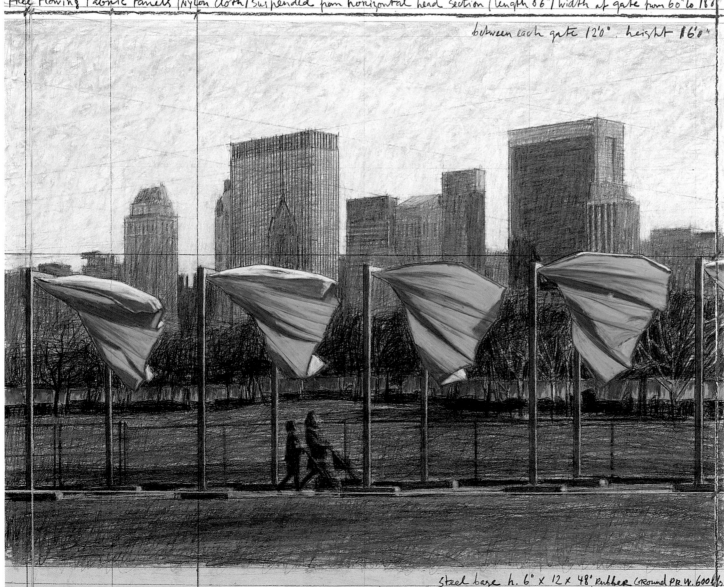

Opposite
The Gates, Project for Central Park, New York City
Collage, 2003
Pencil, fabric, wax crayon, charcoal, pastel, enamel paint, and technical data; in two parts
12 x 30½ in. and 26¼ x 30½ in.
(30.5 x 77.5 cm and 66.7 x 77.5 cm)

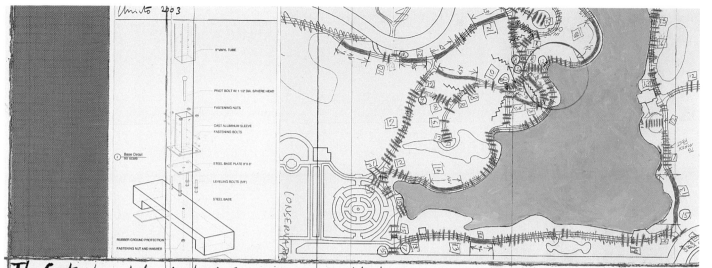

The Gates (Project for Central Park, New York City) Central Park South, 5th Ave, Central Park West, West 110th St

Free Flowing Fabric panels (Nylon cloth) suspended from horizontal head section (Length 8'6") between gate 10'0" - 12'0" height 16'0" width of gates from 6'0" to 18"

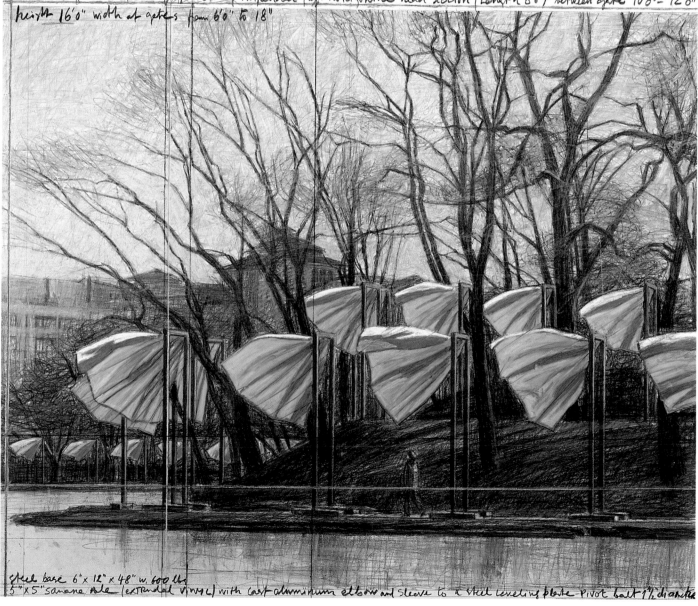

steel base 6" x 12" x 48" w. 600 lbs
5" x 5" square pole (extruded vinyl) with cast aluminium elbow and sleeve to a steel leveling plate. Pivot bolt 1½" diameter

The Gates, Project for Central Park, New York City
Collage, 2003
Pencil, enamel paint, photograph by Wolfgang Volz, wax crayon, and tape
8½ x 11 in. (21.5 x 28 cm)

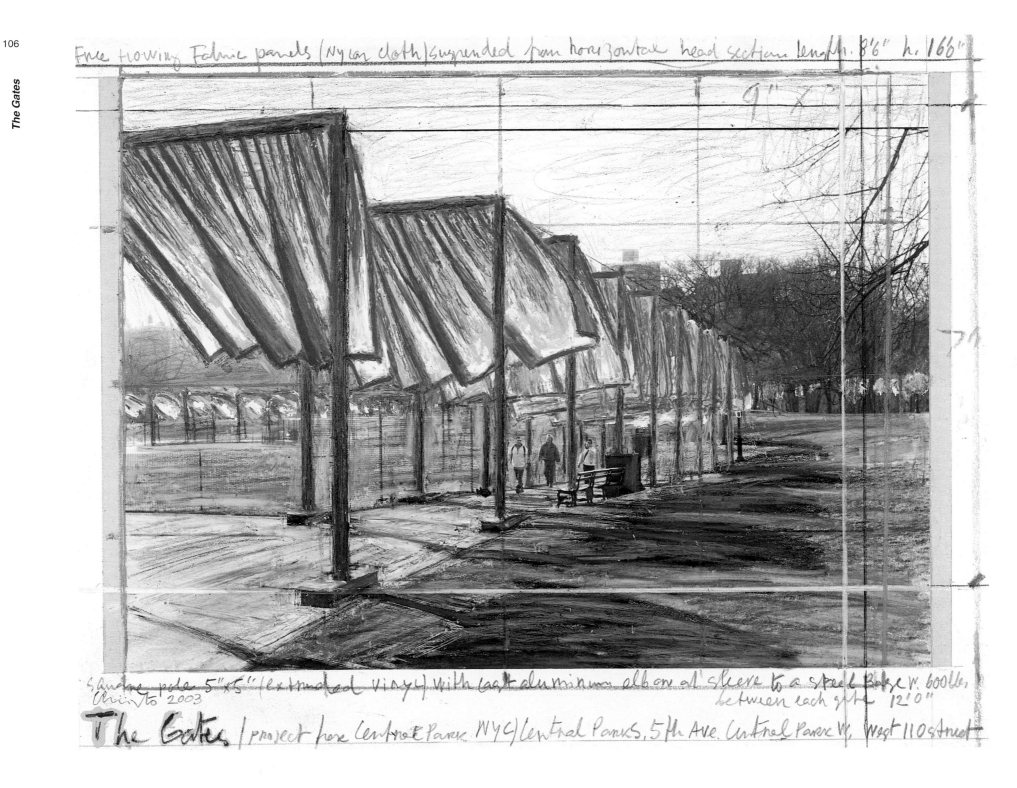

The Gates, Project for Central Park, New York City
Collage, 2003
Pencil, fabric, wax crayon, charcoal, enamel paint, pastel, map, and fabric sample; in two parts
30½ x 12 in. (77.5 x 30.5 cm) and 30½ x 26¼ in. (77.5 x 66.7 cm)

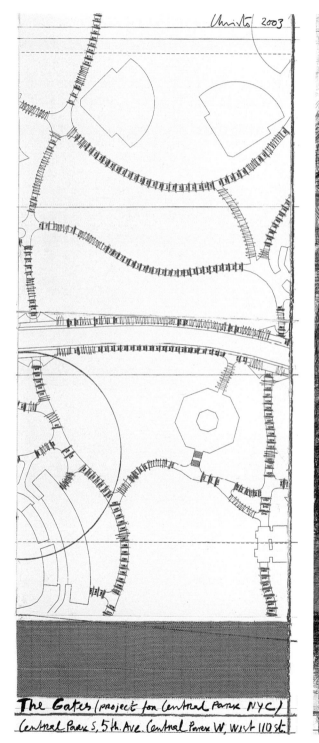

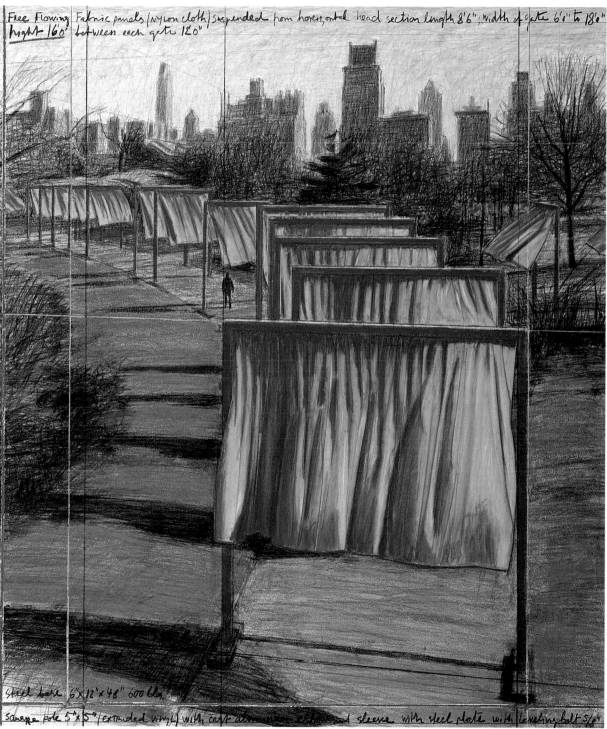

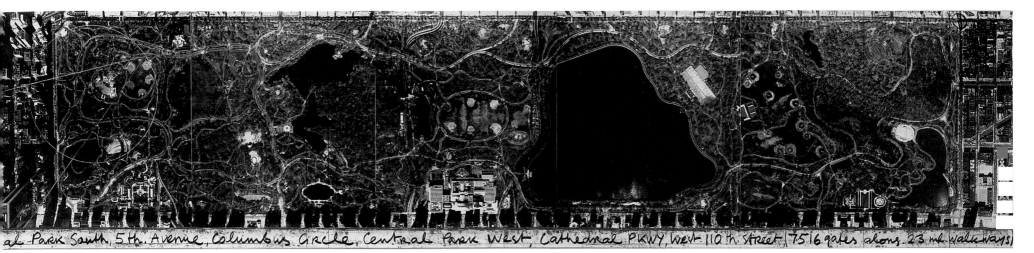

al Park South, 5th Avenue, Columbus Circle, Central Park West, Cathedral PKWY, West 110th Street (7516 gates along 23 mt walkways)

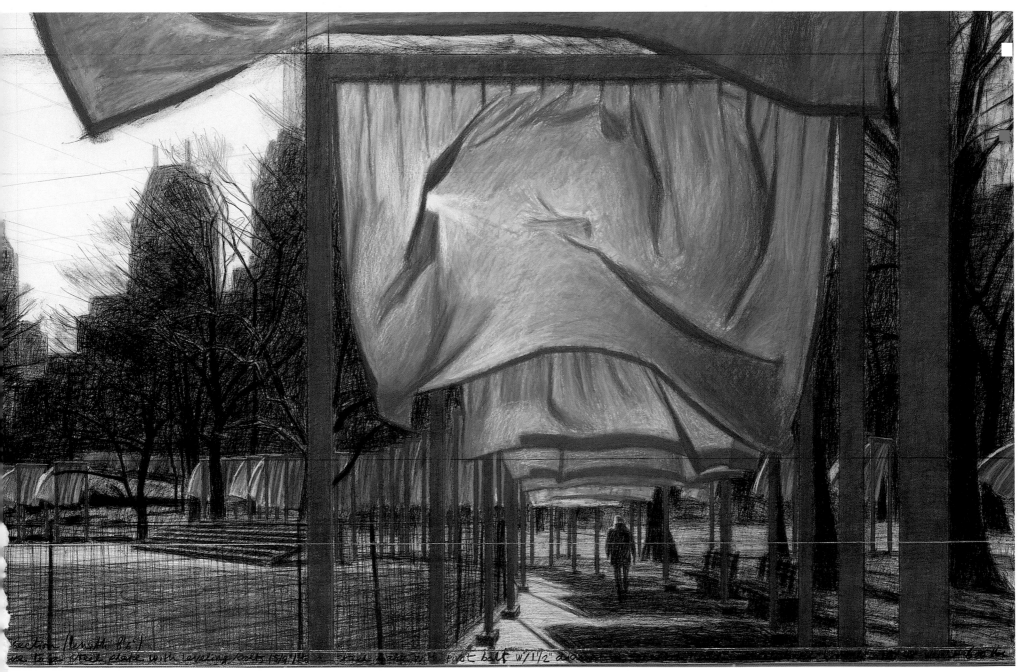

Section (length 86") ... steel plate with leveling bolts 13/4" ... steel plate with pivot bolt w/ 1 1/2" ...

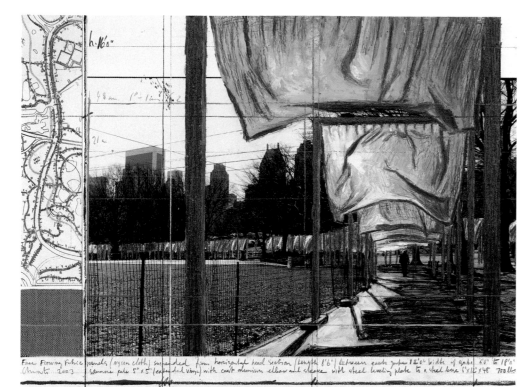

The Gates, Project for Central Park, New York City
Collage, 2003
Pencil, enamel paint, photograph by Wolfgang Volz, wax crayon, fabric, and map
17 x 22 in. (43.2 x 55.9 cm)

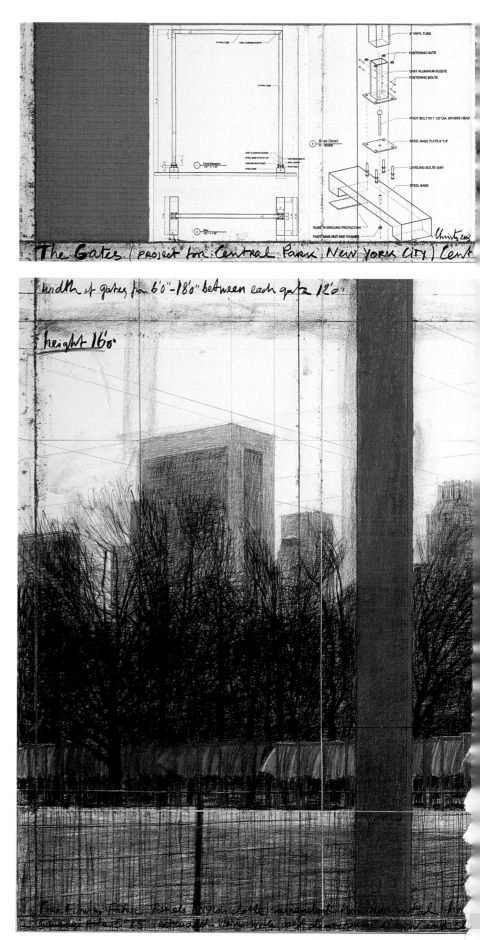

The Gates, Project for Central Park, New York City
Collage, 2003
Pencil, charcoal, pastel, wax crayon, technical data,
fabric, aerial photograph, and tape; in two parts
15 x 96 in. and 42 x 96 in. (38 x 244 cm and 106.6 x
244 cm)

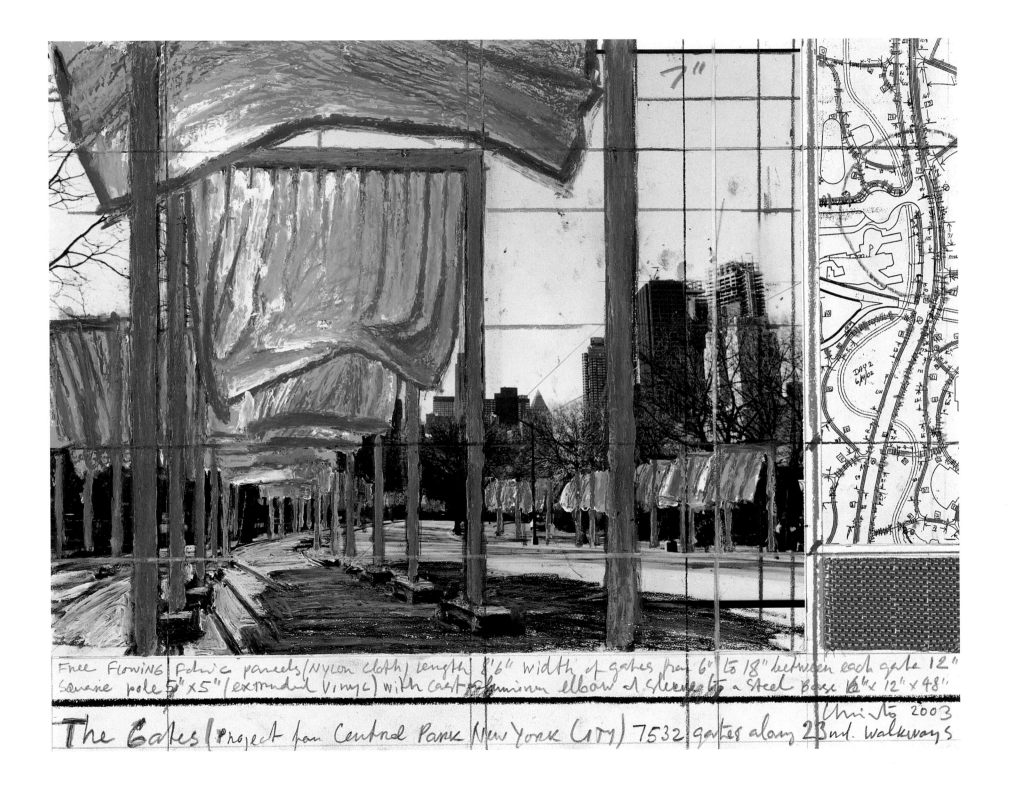

The Gates, Project for Central Park, New York City
Collage, 2003
Pencil, enamel paint, photograph by Wolfgang Volz, wax crayon, and tape
9 x 13 in. (22.8 x 33 cm)

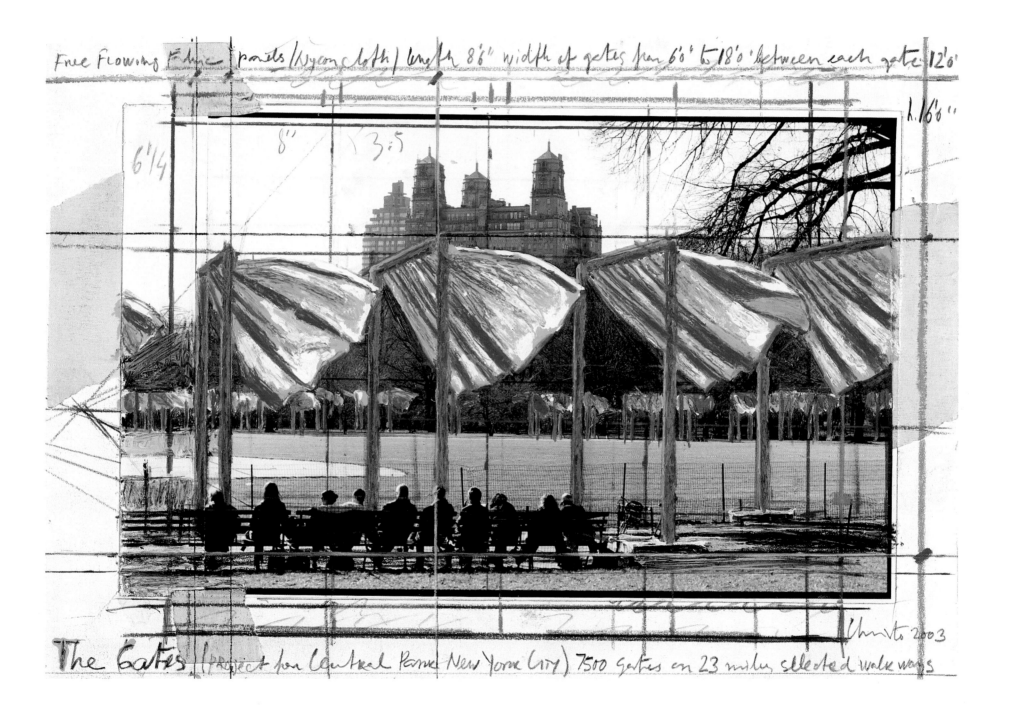

The Gates, Project for Central Park, New York City
Collage, 2003
Pencil, enamel paint, photograph by Wolfgang Volz, wax crayon, map, tape,
and fabric sample on brown board
11 x 14 in. (28 x 35.5 cm)

The Gates, Project for Central Park, New York City
Collage, 2003
Pencil, fabric, charcoal, wax crayon, pastel, enamel paint,
hand-drawn map, fabric sample, and tape; in two parts
30½ x 12 and 30½ x 26¼ in. (77.5 x 30.5 and 77.5 x 66.7 cm)

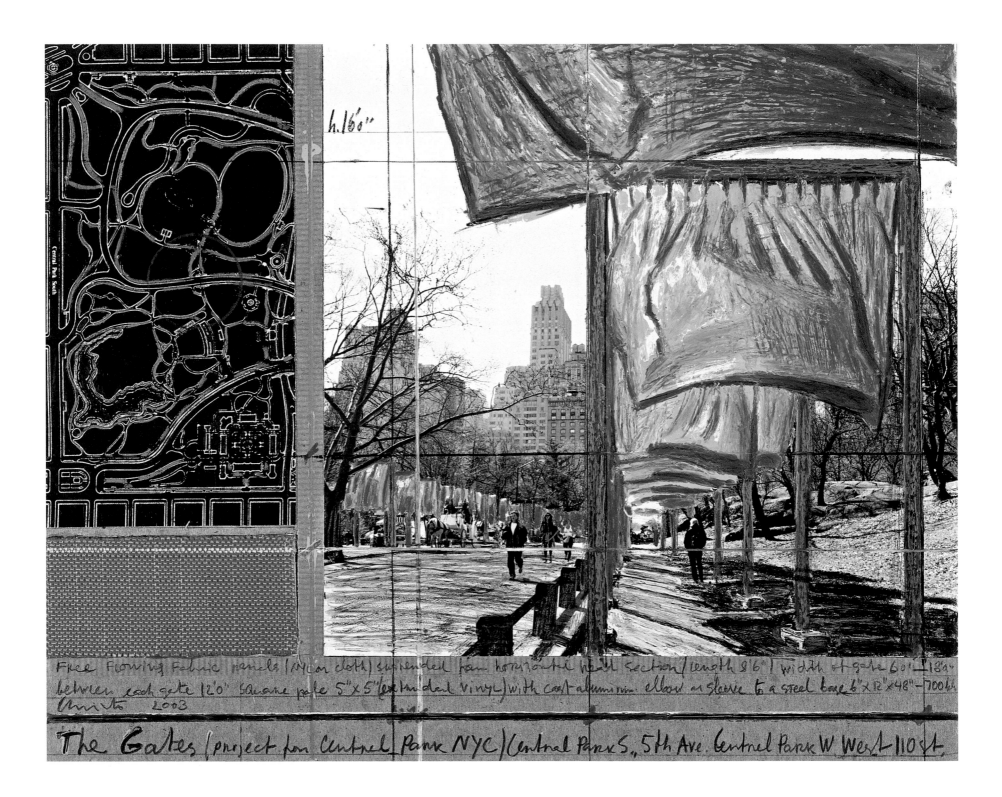

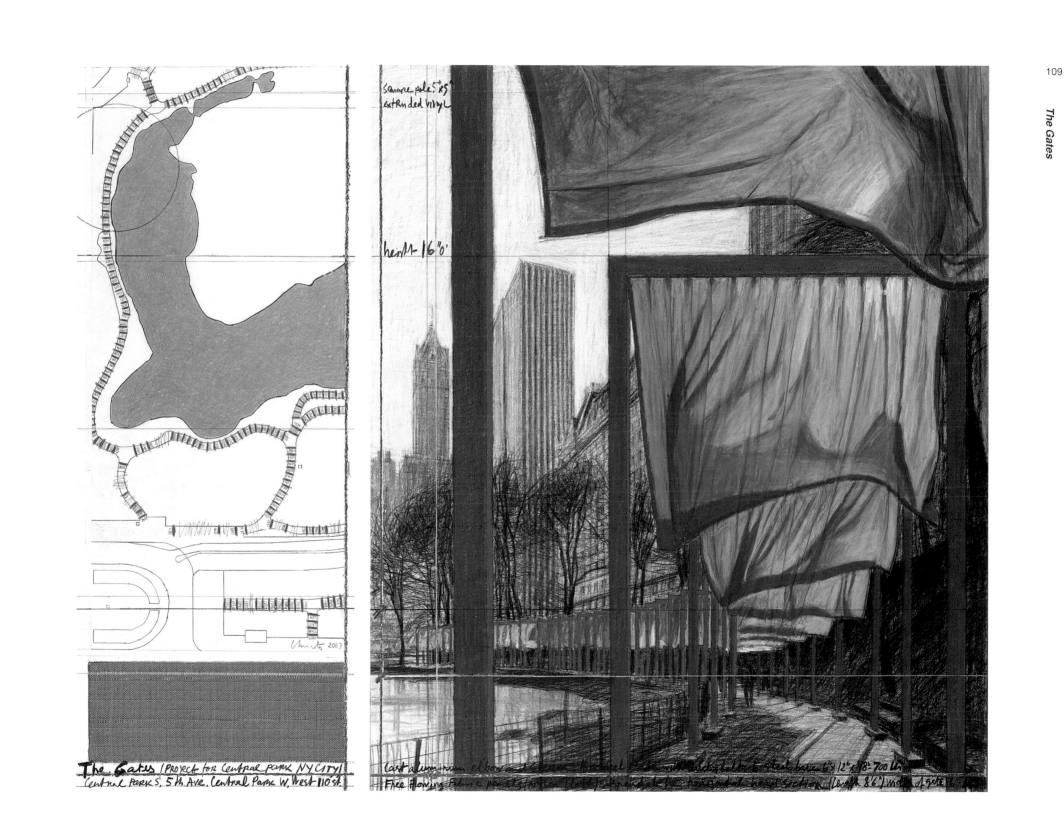

square pole 5"x5"
extruded vinyl

height 16"0"

The Gates (project for Central Park NY CITY)
Central Park S, 5th Ave. Central Park W, West 110 st.

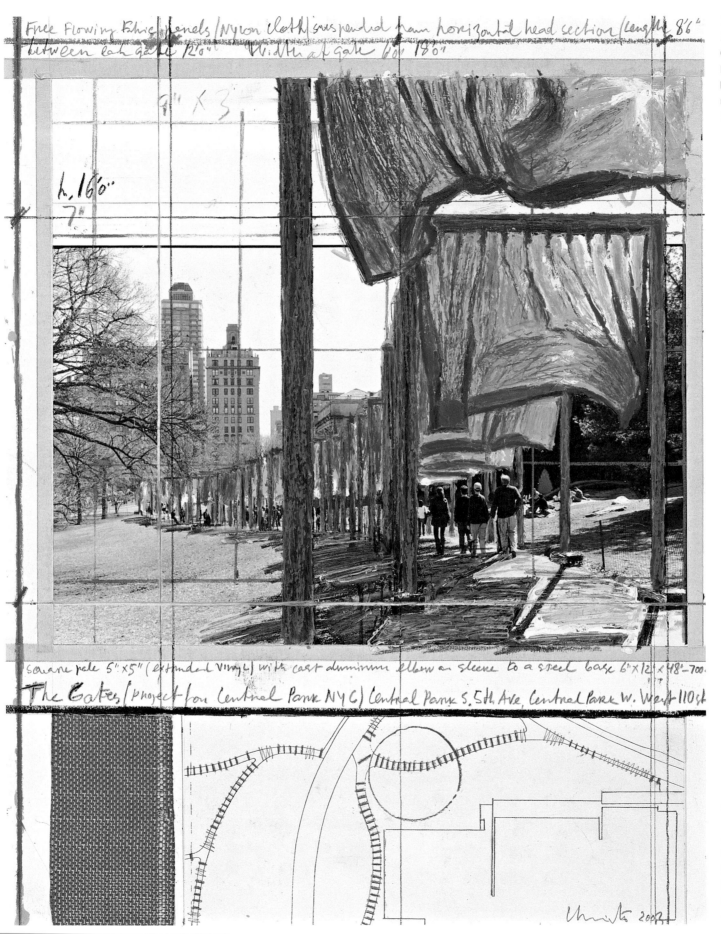

Free Flowing fabric panels (Nylon cloth) suspended from horizontal head section (length 8'6"
between each gate 12'0" Width at Gate 6'0" 18'0"

8" X 3

h. 16'0"
7"

square pole 5" x 5" (extruded vinyl) with cast aluminium elbow or sleeve to a steel base 6" x 12" x 48" - 700.

The Gates (Project for Central Park NYC) Central Park S. 5th Ave, Central Park W. West 110 st.

Christo 2003

*The Gates, Project for Central
Park, New York City*
Collage, 2003
Pencil, enamel paint, photograph
by Wolfgang Volz, wax crayon,
map, tape, and fabric sample
14 x 11 in. (35.5 x 28 cm)

Opposite
*The Gates, Project for Central
Park, New York City*
Collage, 2003
Pencil, enamel paint, photograph
by Wolfgang Volz, wax crayon,
map, tape, and fabric sample
14 x 11 in. (35.5 x 28 cm)

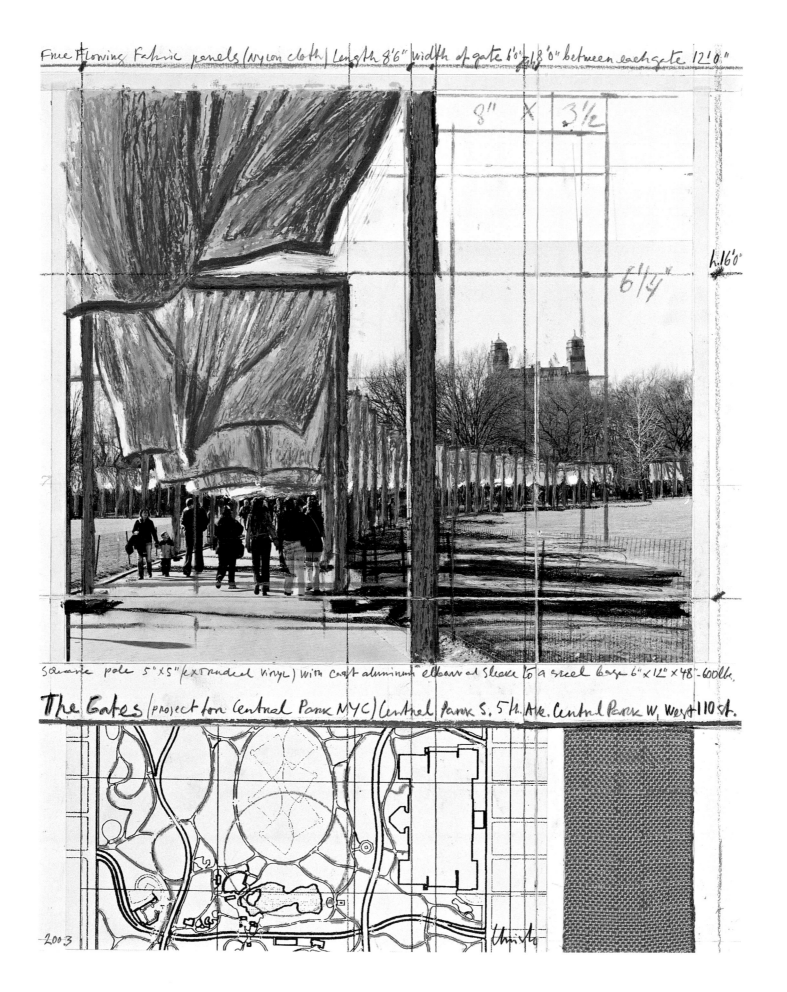

Free Flowing Fabric panels (Nylon cloth) Length 8'6" width of gate 6'0" to 18'0" between each gate 12'0"

8" X 3½

h.16'0"

6'4"

Square pole 5"x5" (extruded vinyl) with cast aluminum elbow at sleeve to a steel base 6"x12"x48"-600lb.

The Gates (project for Central Park NYC) Central Park S. 5th Ave. Central Park W. West 110 St.

2003 Christo

The Gates, Project for Central Park, New York City
Collage, 2003
Pencil, enamel paint, photograph by Wolfgang Volz, wax crayon, and tape on brown board
8½ x 11 (21.5 x 28 cm)

Opposite
The Gates, Project for Central Park, New York City
Collage, 2003
Pencil, fabric, charcoal, wax crayon, pastel, enamel paint,
hand-drawn map, fabric sample, and tape; in two parts
12 x 30½ and 26¼ x 30½ in. (30.5 x 77.5 and 66.7 x 77.5 cm)

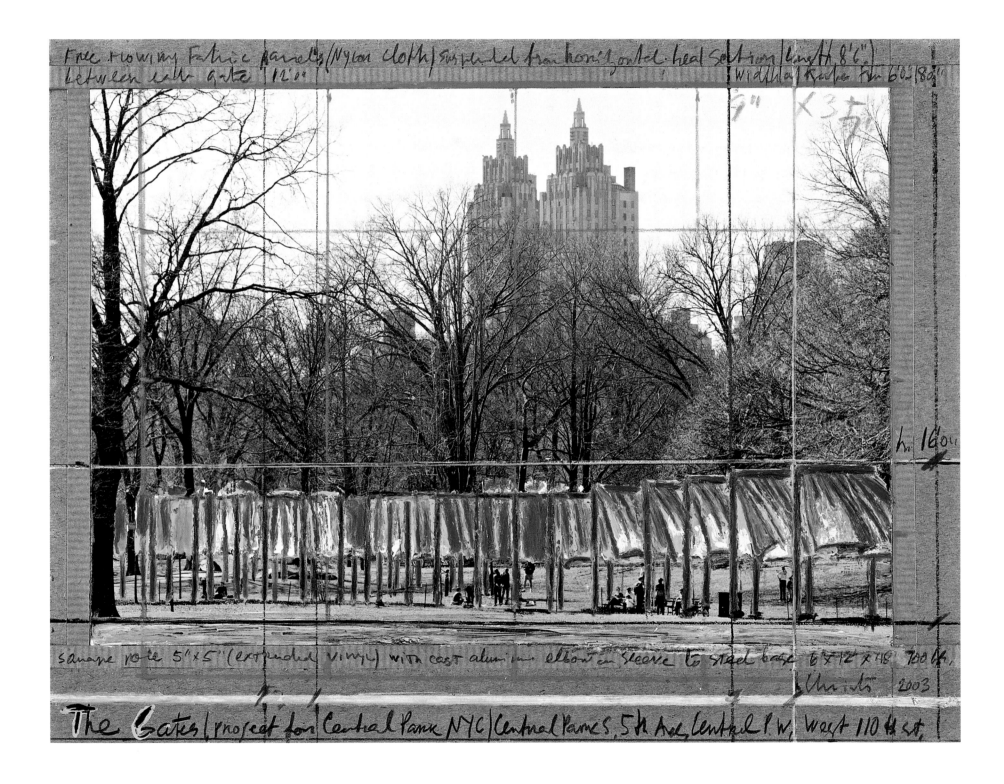

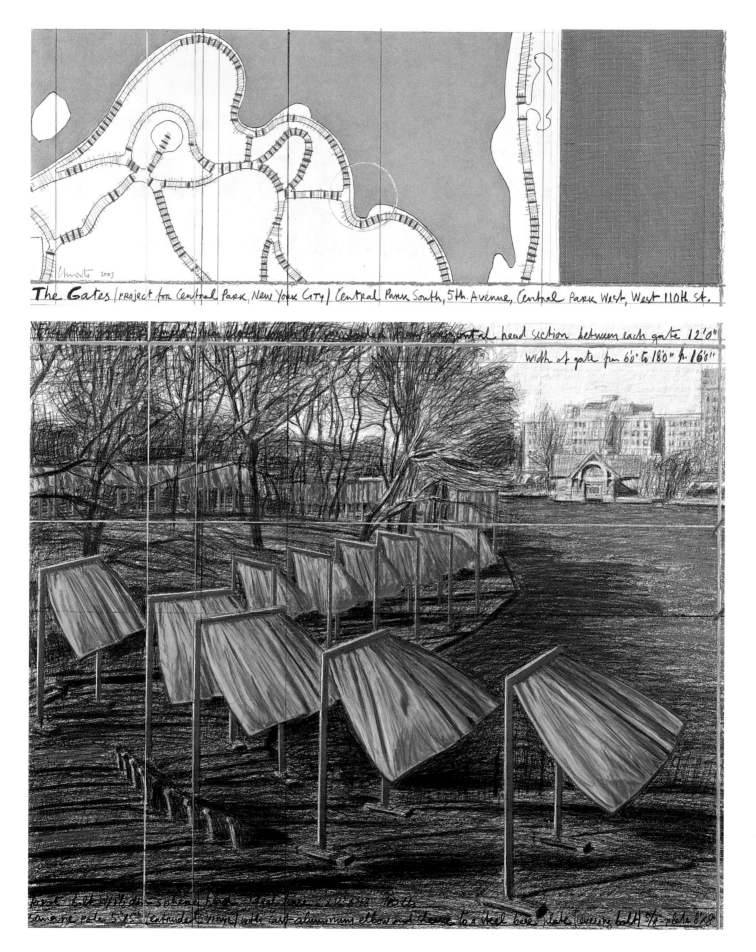

The Gates (Project for Central Park, New York City) (Central Park South, 5th. Avenue, Central Park West, West 110th St.

head section between each gate 12'0"

Width of gate from 6'0" to 18'0" h. 16'0"

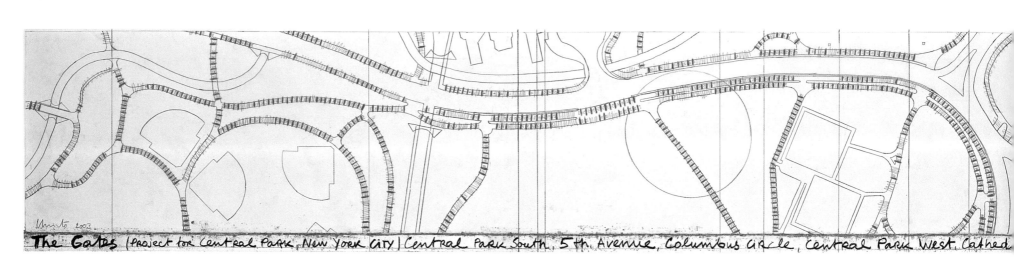

The Gates (Project for Central Park, New York City) Central Park South, 5th Avenue, Columbus Circle, Central Park West, Cathed...

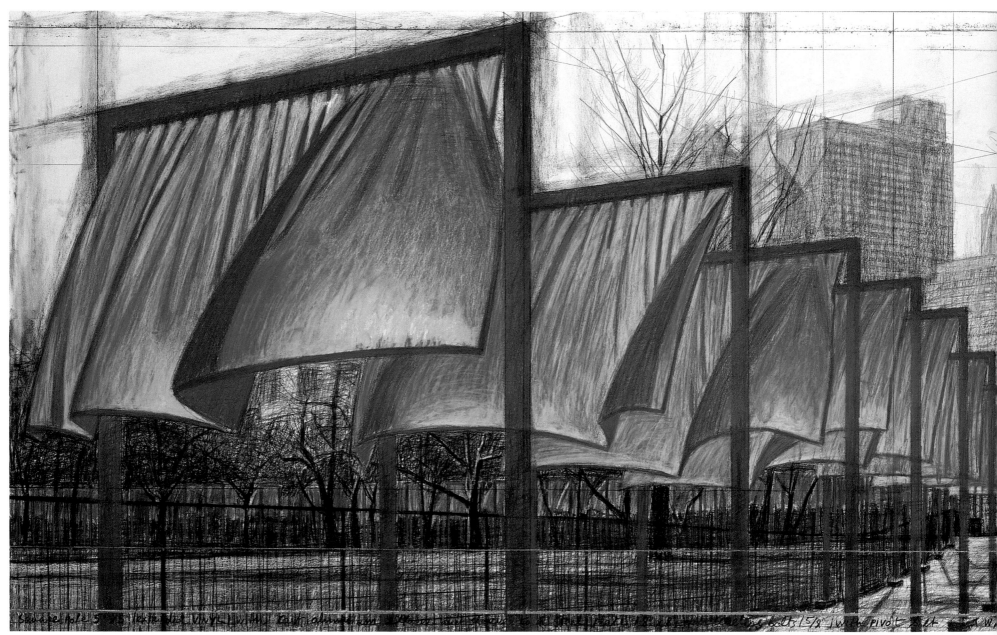

The Gates, Project for Central Park, New York City
Collage, 2003
Pencil, charcoal, pastel, wax crayon, enamel paint, hand-drawn map,
fabric sample, and tape; in two parts
15 x 96 and 42 x 96 in. (38 x 244 and 106.6 x 244 cm)

KWY. West 110 street (7500 gates along 23 ml. walk ways)

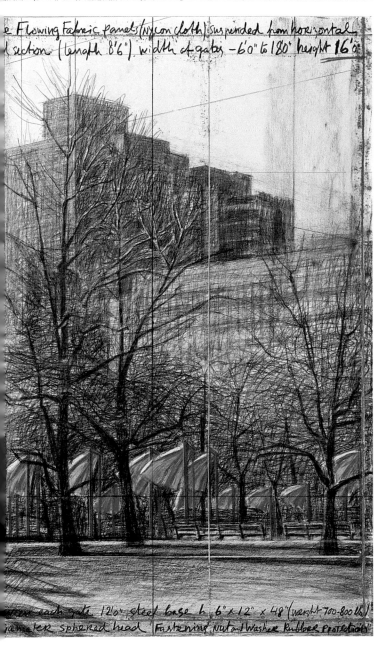

e Flowing Fabric panels (nylon cloth) suspended from horizontal section (length 8'6") width of gates – 6'0" to 180" height **16'0**

each gate 12'0" steel base h. 6" x 12" x 48" (weight 700-800 lb.) iameter sphered head (Fastening Nut and Washer Rubber protection)

Technical drawing showing details of the components of a gate.

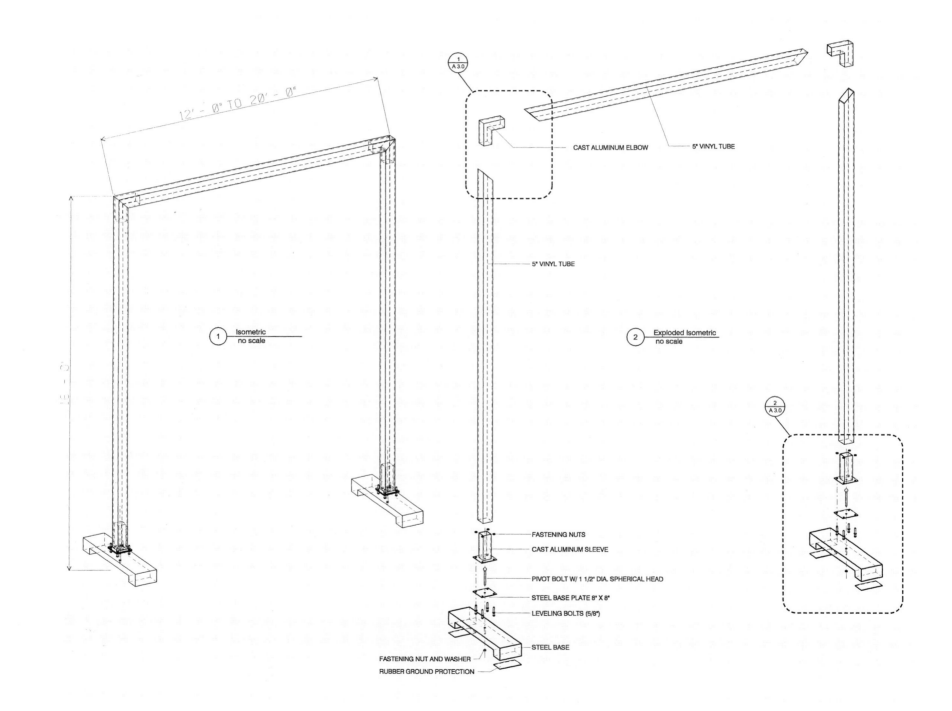

12' - 0" TO 20' - 0"

① Isometric
no scale

② Exploded Isometric
no scale

CAST ALUMINUM ELBOW

5" VINYL TUBE

5" VINYL TUBE

FASTENING NUTS

CAST ALUMINUM SLEEVE

PIVOT BOLT W/ 1 1/2" DIA. SPHERICAL HEAD

STEEL BASE PLATE 8" X 8"

LEVELING BOLTS (5/8")

STEEL BASE

FASTENING NUT AND WASHER

RUBBER GROUND PROTECTION

Specifications List

Some of the material that will be used in the gates:

- 5,290 tons of steel (4,799 metric tons) for the approximately 15,000 specially designed steel base weights, which weigh between 615 and 837 pounds each (279–379 kilograms), depending on the width of the gate. The weights rest on the hard surface of the walkways; no holes will be dug in Central Park.
- 315,491 linear feet (60 miles, or 96.5 kilometers) of extruded vinyl tubing, 5 x 5 inches square (12.7 x 12.7 centimeters), specially designed, recyclable, in saffron color. The vertical sides of each gate are 16 feet long (4.87 meters), and the horizontal tops are from 6 to 18 feet long to suit the varying width of the walkways.
- Approximately 15,000 specially designed, recyclable, cast-aluminum upper-corner reinforcements, which hold together the vertical and horizontal poles.
- Approximately 15,000 base anchor sleeves, which will be bolted to the steel base weights.
- Approximately 15,000 steel leveling plates, $\frac{1}{2}$ x 8 x 8 inches (1.27 x 22.8 x 22.8 centimeters). The leveling plate fits between the base anchor sleeve and the steel base and contains a pivoting bolt for making the gates perfectly vertical.
- More than 165,000 bolts with self-locking nuts.
- Approximately 15,000 vinyl leveling-plate covers, to hide the bolts, 5 $\frac{1}{4}$ x 10 $\frac{1}{4}$ x 8 $\frac{1}{2}$ inches (13.3 x 26 x 21.5 centimeters).
- 116,389 miles (187,311 kilometers) of nylon thread to be extruded in saffron color and specially woven into 1,092,207 square feet (98,298 square meters) of recyclable ripstop fabric, and then shipped to the sewing factory to be cut and sewn into approximately 7,500 fabric panels of various widths, including 46 miles (74 kilometers) of hems.

All materials can be recycled.

On January 3, 2005, weather permitting, professional workers will enter Central Park. Using forklifts and pallet jacks they will place the 15,000 steel bases at their specific positions on the edges of the walkways, usually at 12-foot intervals, unless there are low branches.

On Monday, February 7, 2005, weather permitting, approximately 600 non-skilled workers (in teams of seven) will elevate the gates assembly (one horizontal and two vertical poles, the upper and lower aluminum corners and base assembly, and the fabric panel in a cocoon, attached to the upper horizontal pole). The fabric panels will not be seen because they will be restrained in the cocoons, which will remain closed until Saturday, February 12, when all the cocoons will be opened, in one day (maybe one morning), weather permitting as with previous projects.

The Gates will remain in Central Park for 16 days, then the removal will start.

The 5,290 tons of steel that will be used for the base weights in *The Gates* are being manufactured at the ISG steel mill in Coatesville, Pennsylvania, where the volcano-like furnace produces deafening roars as it spits tons of red-hot liquid steel in a cloud of steam and dust (above). Visitors to the mill are required to wear hard hats, goggles, earplugs, and worker's smocks. The red-hot steel plate is rolled many times, elongating and thinning it to the necessary three-inch thickness. Below, a mill technician checks the thickness of the steel.

From the air-conditioned, automated control room, Gary Layton (right) and Stacy Jones operate the mill to roll the steel slabs and ingots into plates, using horizontal and vertical rolls to meet the desired dimensions.

 At the C. C. Lewis plant in Springfield, steel plate is cut with a bandsaw into twelve-inch-wide sections for the base weights.

A total of 809 steel plates will be manufactured at the ISG mill and then shipped to C. C. Lewis steel plants in Springfield, Massachusetts, and Conshohocken, Pennsylvania. Here, a steel plate (12,252 pounds, 3 inches thick, and measuring 60 by 240 inches) is delivered to the C. C. Lewis plant in Springfield.

The C. C. Lewis steel plant in Conshohocken, where steel plates have been received from the ISG mill.

Under the supervision of Jeff Jarosz in Conshohocken, the steel plate is cut lengthwise for the steel base weights. A circular saw twenty-nine inches in diameter, with carbide-tipped teeth, takes twelve minutes to make one cut.

Dave Cahoon operates a Kasto K3 cutoff saw, which simultaneously drills a hole into the steel weight and cuts off one of the feet for the base.

Michael Hall welds the three-inch-thick steel feet to the steel base weights. Only the feet will rest on the surface of the walkways in Central Park.

Ian Smith removes snag from where the bases and the feet have been welded together.

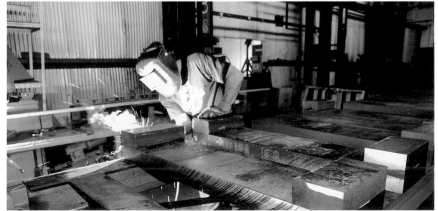

Steel feet being welded to the base weights at the Conshohocken plant. The length, thickness, width, and weight of the bases, including the feet, vary with the width of the walkways. Most of the weights are 48 x 6 x 12 inches and weigh an average of 750 pounds. Where the walkways are eighteen feet wide, the base weights have to be bigger and heavier: 60 x 6.5 x 12 inches, and 837 pounds.

Greg Cizek overseeing the job of painting the more than 15,000 steel base weights at the C. C. Lewis plant in Springfield. Greg is the son of Ken Cizek, vice president of operations at the plant.

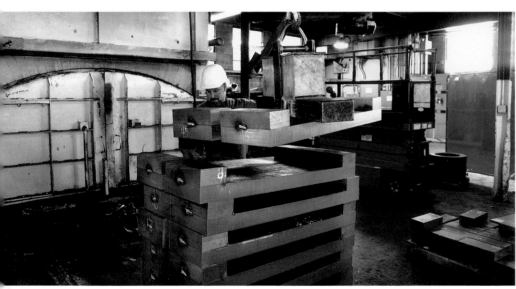

After the paint dries, Greg Cizek and Sean Hall, son of welder Michael Hall, apply a piece of thick rubber to the underside of the feet of the base weights. The weights will then be protected with thick cardboard in preparation for shipping to the assembly plant in Maspeth, Queens.

Using a five-thousand-pound magnet, Michael Cormier, programmer and welder, transports a steel base weight onto a stack.

At the Gupta Permold plant, outside Pittsburgh, Pennsylvania, Dan Hancock pours liquid aluminum at a temperature of 1,400 degrees into a mold for the aluminum corner sleeves. Thirty-three-pound Wabash aluminum ingots are periodically added to the boiling liquid, where they melt within minutes.

Hugh McShane grinds off the gates and risers left from the casting process. (Gating is excess material that flows into the cavity and hardens, and risering is the portion left from where molten metal was fed into the mold.) The finished corner sleeves will be shipped to the assembly plant in Maspeth, where they will be bolted to the horizontal part of the gates in preparation for securing the vertical and horizontal poles together.

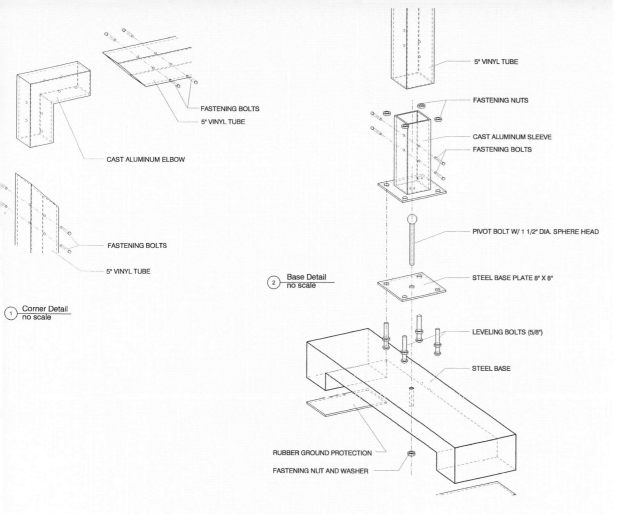

CAST ALUMINUM ELBOW

FASTENING BOLTS
5" VINYL TUBE

FASTENING BOLTS

5" VINYL TUBE

5" VINYL TUBE

FASTENING NUTS

CAST ALUMINUM SLEEVE
FASTENING BOLTS

② Base Detail
 no scale

PIVOT BOLT W/ 1 1/2" DIA. SPHERE HEAD

STEEL BASE PLATE 8" X 8"

LEVELING BOLTS (5/8")

STEEL BASE

RUBBER GROUND PROTECTION

FASTENING NUT AND WASHER

Technical drawing showing details of corner assembly and base assembly.

Diane Aschenbrenner oversees quality control for the fifteen thousand steel leveling plates. The leveling plates, one-half inch thick and eight by eight inches square, will be secured between the base anchor sleeve and the steel base. A central pivoting bolt will ensure that the gates are perfectly vertical even when the walkways incline.

Dan Falco welds the two aluminum parts forming the lower base anchor sleeve. Later, at the Maspeth assembly plant, the sleeves will be inserted into the bottom of the vertical vinyl poles before being transported to Central Park. There, the poles will be secured to the steel footing weights using bolts and self-locking nuts.

Mark Simko pours liquid aluminum into the mold for the base plate. The base plate will be welded to the aluminum lower sleeve and bolted to the base weight.

Russell Bowen inspects the specially designed, recyclable, cast-aluminum upper-corner shoulder sleeve reinforcements. After he finishes grinding the rough edges, he will make sure that each piece fits into the short test sample of vinyl tube on the table. Then he will prepare a stack of sixty-four corner sleeves into a pallet, ready to ship to the assembly plant in Maspeth.

At Bieri-Zeltaplan, Maria Lehmann joins the folds of a sewn panel to the "boat rope" (a piece of it is on her shoulder). The boat rope is the part that will be inserted into the sail tunnel of the horizontal vinyl pole of the gate.

At the J. Schilgen Company in Emsdetten, Germany, 119,556 miles of saffron-colored thread are woven into more than a million square feet of recyclable ripstop nylon fabric. The fabric will be shipped to the Bieri-Zeltaplan factory in Taucha, Germany, where it will be cut and sewn into panels, resulting in 46 miles of hems. Fabric samples will be given away to visitors of *The Gates* in February 2005, as has been done for all of Christo and Jeanne-Claude's previous projects.

Andrea Marks and Roland Eilenberger have rolled the sewn fabric panels around a thick cardboard tube and inserted them into a cocoon, closed with Velcro, ready for shipment to the assembly plant in Maspeth, Queens, New York City.

At the North American Profiles Group plant in Holmes, New York, outside Poughkeepsie, the vinyl poles are being manufactured nonstop, twenty-four hours a day, seven days a week. Jade Wu, a machine operator, here plunges the end of a vacuum hose into the powdered PVC compound, which is then carried to the extruder where it will be processed.

Brad Porter, assistant production manager, and Nicholas Mongelli, maintenance manager, supervise production in the extruder as it heats the vinyl compound to 375 degrees and pulls the material into the calibrator, where it is formed into the right size and shape and then cooled.

The five-by-five-inch square pole emerges from the machine. The keyhole shape at the top is the sail tunnel, where the boat rope will be inserted to attach the fabric panel to the upper part of the gates. The poles are cut automatically to the various lengths that will be used to fit the different widths of the walkways. Weekly truckloads deliver the roughly 22,500 finished poles to the assembly plant in Maspeth.

Interviews

Lecture and interview,
University of Illinois at Urbana-Champaign, 1977

Christo: I would like to show some slides of the *Running Fence* project. The *Running Fence* started in late 1972. I had wanted for many years to do a project in California. For me, California was one of the most typical American states, a par excellence American state. I tried in 1968, but I failed to do the *Wrapped Coast* project there. What is very strange in California is that living is mostly expanding horizontally, in this fascinating relation with the urban, suburban, and rural life; mixed up together, in conflict. There is a very strong awareness of the coast, producing a coastal culture.

My wife, Jeanne-Claude, and I started to look for a *Running Fence* site with friends in late 1972. But actually, only in 1973 with Jeanne-Claude, we drove about six thousand miles, and we located that area, about sixty miles north of San Francisco. The project was public, and the only way to see these twenty-four and a half miles was to drive by a network of forty miles of roads, all types of public roads.

The twenty-four-and-a-half-mile length of the *Fence* comes from the fact that I wanted the *Fence* to cross a major freeway, which was the [U.S. Highway] 101. The *Fence* was extending five hundred and fifty feet into the Pacific Ocean at Bodega Bay, and also it crossed in the middle of the small town of Valley Ford. The height of the *Fence* was eighteen feet, because this is the average height of the barns, the garages, and the farmhouses; the span between each pole is sixty-two feet. The *Fence* was, like all the previous projects, temporary. The various parts of the project were designed and built in a manner that could be removed from the land without too much difficulty.

Basically, the *Fence* was built like all fences, with poles, but the portion between each pole was filled with woven nylon fabric, and the structure of the pole was secured with a type of earth anchor. We put fourteen thousand anchors to secure all the twenty-four and a half miles of *Running Fence*.

The hills in the north part of California are grazing land for cattle and sheep, and there is very little vegetation, except some high eucalyptus trees brought from Australia. They have this marvelous situation of the summer mist, because they have two seasons, the rainy season and the dry season. Not this

Christo and Jonathan Fineberg at the informal discussion with students at the University of Illinois, Urbana-Champaign, 1977

year! This year only dry season! [This talk took place in the year of the 1977 California drought.] The land is very warm during the summer, and the ocean is still cold and you have this white mist coming from the ocean each afternoon and going west with the sunset.

The little town of Valley Ford with one hundred and twenty-five inhabitants is crossed by State Highway 1, and the *Fence* was crossing just near the food store and on the other side at the post office. There is a larger town of thirty thousand called Petaluma, just south of Freeway 101. We located all that area in 1973. In late 1973, we started to convince fifty-nine ranchers and their families, about two hundred and forty people, to let us do the project. It was not an easy job.

Jeanne-Claude and I spent about eleven months, hours and hours, working, talking with the ranchers like Mr. and Mrs. Kirkland, Mr. and Mrs. Mickelsen, Mr. and Mrs. Titus, and many others. The greatest of the ranchers was Spirito Ballatore. He was the oldest rancher, over eighty years old, maybe

eighty-five; he was the rancher that everyone was listening to. He is a great character. By the end of September 1974, we have the permission of all the fifty-nine ranchers to put the *Fence* on their land, but the exact path of the *Fence* was not finalized. It took us about two weeks with the surveyor, Bob Floyd, our builder-contractor, Ted Dougherty, and Hank Leininger. Ted and Hank had built *Valley Curtain*. Hank is the man with the loudspeaker in the *Valley Curtain* film. In those two weeks when we designed the path of the *Fence* I walked about a hundred miles, because the only way to design the path of the *Fence* was by walking all those twenty-four and a half miles several times, and find ways and solutions, and work with the ranchers. The *Fence* was divided in twenty-three segments. Each pole was calculated so that they would be sixty-two feet apart, and every one had its own reference file: what type of soil, what kind of degree of slope, and like that, so that when we move with the building machinery, the process of building will be faster.

Meanwhile, we started also the sewing of two million square feet of fabric, for the 2,050 panels. In a factory in Smithville, West Virginia, they worked one year to sew all these panels. They were sewn by twenty-two workers, mostly women. These panels were not only sewn, they were also folded in a special manner and placed in individual bags, because the panels should be opened only at the site of the *Fence*, when the *Fence* would go up sometime the following year. That takes us from late 1974 into August 1975. Sometime in early 1975 we started one of the most spectacular, perhaps the most painful but most lively, period of *Running Fence:* getting the permissions of fifteen government agencies. We went through seventeen public hearings and three sessions at the superior courts. Ranchers and citizens talked about the project at the public hearings; I also testified. At that moment, the project was really involved with two large counties, Sonoma and Marin Counties, about one half million people. Through the media, writing in the newspapers, because all these hearings were held in public, and because the supervisors, congressmen, and senators were asking the people to come to express their

views on the *Fence*, the project built a tremendous power, a public power. By the time of the second hearing, there was a Committee to Stop the Running Fence, created by some local artists and citizens. The project became tremendously complex, involving high political relations with a lot of people, senators, supervisors, governor, and lieutenant governor. It also involved the government in Washington because the *Running Fence* was going into the ocean. Anyway, the State of California and the federal agencies decided that we should have an environmental-impact statement. The United States government decided, in the late sixties, that each human activity which has a great impact on human behavior should have an environmental-impact statement. The Alaskan pipeline has an environmental-impact statement, the Dallas Airport too. *Running Fence* is the first and only work of art with an environmental-impact statement. The report was written by fifteen scientists, it took eight months, and cost us $39,000 and was finally produced into a book of 450 pages. Everything was discussed from marine biology to economics and traffic. When that book was printed two hundred copies were sent to different governmental agencies who made comments on that book, and finally the environmental-impact statement was certified by the Board of Supervisors at the end of a long public hearing in Sonoma County. This gives you an idea of how complex an environmental-impact statement is. That is tremendous—I think it is one of the best documents of modern art.

Anyway, there was a discussion on several pages in the environmental-impact statement how the *Running Fence* will affect the counties' management for the people. For example, that the people would drive to see the *Running Fence*, that they would discover the beautiful hills in Sonoma and Marin Counties, that the next year, or in the next two or three years, they will move to Marin and Sonoma Counties, how they will imbalance the tax in the county, how many new schools, how many new kindergartens, and what else should be built because of the *Fence*.

By spring 1976, we finally have the approval from the agencies and we start the building of the project. In the middle of

the *Fence*'s route, about twelve miles from the ocean, we rented a yard from one of our ranchers and we were using it as the headquarters of the project. It was important that each of the parts we used for building be inexpensive, fast, and not harmful to the land. An engineering company in Wyoming designed special trucks; they developed a machine to build the *Running Fence*. This type of truck was not existing. In 1975, they tried to convince Hughes Tools Corporation in Los Angeles to build these trucks; they refused because it was a recession year. Finally, we built four trucks, which drove fourteen thousand of the special anchors equipped with special sleeves. They were driven hydraulically into the soil and after the anchor had been driven, which was the longest working process, the anchor was locked into position by twisting it. How deep it was driven into the soil had been pre-calculated. They were driven from five to sometimes seven feet into the soil. That is the way the *Fence* was structurally secured. The "pigtail," which was the part that was sticking out, was attached to the lateral guy wires of each pole. When these anchors were installed, which was the slow part of the story, then we started to unroll the ninety miles of steel cable, which was securing all the poles and all the fabric in the final installation of the *Fence*. The three-and-a-half-inches-diameter steel poles, twenty-one feet long, were set only three feet in the ground, with no concrete. The holes were only four inches in diameter. The poles were simply sitting in the soil and had a pair of steel "shoe-angles," bolted, to prevent sinking. We had about sixty people working on the project from the end of April to early September. Most of these people were ranchers themselves and their sons, and their laborers. The people involved with the *Running Fence* construction during the hardware working period were very knowledgeable of the terrain, where the machinery was going, and they were also familiar with the cattle. By the way, the cattle all around were using the cables and poles as scratching posts.

That work took us about four and a half months, until the first days of September. The fabric panels installation of the *Fence* was planned by our engineers so that it should be a fast operation. It was important for the impact of the project that

the *Fence* be installed, like you saw in the *Valley Curtain* film, in a short span of time. I lectured at many universities and colleges during that time in California to give enthusiasm to young people to work at the project. By the end of August about 360 young people came to Petaluma. We rented the Petaluma fairgrounds, and we built prototypes with which the students were trained to put up the panels. The process of installing the panels was very simple. All the panels of fabric were secured with 380,000 hooks, like a giant sail, in sailboats. After these hooks were installed, they unfurled the fabric, pulling horizontally. There was a specially planned timing, a different timing for each operation. Each team of three young people was in charge of installing about twenty-two panels. It took us about three and a half days to install twenty-four and a half miles.

Here is how the process went. They had a young man at the top of the ladder putting on the hooks and on the ground they are securing the bottom hooks. Three hundred and sixty people worked, using a hundred and eighteen ladders, one ladder for three people. That was a long process, you see, they are securing both panels left and right. The ocean part of the *Fence* was installed with an upper cable, a five-hundred-foot fabric panel, about two thousand five hundred feet of another cable with three thousand pounds marine anchor. The last twelve poles around the ocean part, for which we could not use machines because of the steep terrain, were all installed by helicopters and by hand work.

The fabric of the *Fence* was in full motion all the time. It is difficult to explain, but the fabric was wider than the space between the poles. The poles space was usually sixty-two feet, the fabric was sixty-eight feet and was working at taking the wind first, before the steel structure started working. I remember the movie director, David Maysles, and Albert, his brother, were doing the *Running Fence* film; one night I ask him why did you fly down from Sweden this sound operator. And David said, because he has the best ear in the world, that's what makes a sound engineer. The *Fence* was doing the most beautiful sounds. The 380,000 hooks were moving constantly,

and the poles were hollow, and were doing sounds like the Buddhist monks' bells in the Cambodian forest.

Fineberg: What are the boundaries of the artwork, where does it begin and end for you? With the *Valley Curtain,* would the discussions of people who watched its progress every day from their golf course down the valley be an organic part of the work? And the first concepts in your own head two years before construction began, do you regard them as preparatory for the final work or is the work of art the whole process and event beginning with your first idea about it?

Christo: I hope you understand that looking at the *Running Fence,* the *Valley Curtain,* other projects before, that all these projects are thought in a dynamic situation. Now, the work of art is the two and a half years of *Valley Curtain,* three and a half years of *Running Fence.* Two years of *Wrapped Coast,* one and a half years of the German project, the *5,600 Cubic Meter Package* in Kassel, in 1968. All the work of art is a matter of dynamics, and involves many parts. The work is first the idea and drawings, and it is put in a very fertile soil. Not one of these projects is commissioned, not one of these projects is done where the ground is prepared, the ground is only thought by me, by some friends who know my way of thinking, and in the end we try to do something that we believe basically would be beautiful and a very subversive action. The project starts to live its own life, a little bit like a child out of our reach. We hire all types of specialists, but the project builds its own reality, which is beyond anything I can imagine. It is so much richer, so much more powerful than anything in my imagination when I started the work or when I do the drawings, and I believe in that.

When the work is finished, again the work is so complex (and of course I am already busy with another project) that I have no time to lose to investigate how much the work is affecting half a million people in Sonoma and Marin Counties or several thousand people in Colorado and Australia. In a way, the work has its own life, which is related to the enormous number of people of different places, of different lives. There is

not one single element of make-believe. There is not one situation that is staged or orchestrated. I remember there was one public hearing in front of the lieutenant governor of California in Sacramento and I told the lieutenant governor, "I did not ask you to review the project. I will gladly do without you. It is not your option to accept or refuse. You will be involved, you will be related, and you will consider and you will judge, and you will be, in all levels, part of a work of art and its aesthetics. And you are part of the *Running Fence* no matter what you can tell me." What happens, the project is teasing society and society responds in a way, as it responds in a very normal situation like building bridges or roads or highways. What we know is different is that all this energy is put to a fantastic irrational purpose, and that is the essence of the work. Those are the things that make the people off-balance and make the real poetry of the work: when we can put 240 ranchers and a huge number of workers who do seemingly normal things, but put together in some kind of irrational attitude.

I don't think any of the museum exhibitions have touched so profoundly three hundred people (as our ranchers), or three hundred thousand cars who visited *Running Fence,* in a way that half a million people in Sonoma and Marin Counties were engaged with the making of the work of art for three and a half years. Through all these public hearings, through all this dialogue with Jeanne-Claude and me and engineers and all kinds of friends, we caused a big discussion in which everyone was discussing what is a work of art and the making of the work of art. In the end, this is some kind of built-up climax. And because that climax is built and can raise opposition (this project created its own opposition, you see the Committee to Stop the Running Fence), there is a suicidal attitude that, when the project is started, the ultimate object is the end of the project, the completed physical object. And if that physical object does not materialize, it is a failure. And that is beyond my power. It is something for which we fight, day and night, we hire specialists, but at no time we are sure. Perhaps near the end we think we shall do it. But all through these years there were crisis after crisis, and that suicidal atti-

tude is one of the elements of the energy of these projects.

It is a little bit like if you are a sportsman, if you climb the Himalaya. In a way it is the unrepeatable experience. It cannot be substituted with anything, not the film, or the photographs, nor books, nor records can substitute that art experience. That art experience, three and a half years of my life, with that relation of numbers, of things, and people, would never be the same again. Each project is different and unrepeatable.

Fineberg: If you had put all the energy that you did into this project, spent all those years and for some reason it didn't get built, would you consider it not to have been a work of art at all or would the documentation still stand as a work of art?

Christo: No. It would be an unfinished work of art, a failure. I had many failures.

Fineberg: Wouldn't there still be an artistic experience in the preparatory work?

Christo: There would be an artistic experience, but it would not be finished. I would be cheating myself if, while preparing the *Running Fence*, I would walk away after two years of hurdles, declaring I have enough conceptual experience and the work of art is done. Because that was not my intention and I like to do my intention. It was very important that the end object was the end of the work, that the dynamic motion would be ended with that object. If at any moment I would stop that dynamic motion, I would act like a conventional artist. I don't see any difference between the abstract, conceptual artist and nineteenth-century artists, sociologically. They are one artist with his own method, one-to-one, no matter if he is doing painting or is writing something, or working in video. The question is, they hold this one power decision, when should the thing be done. In my projects, the power is out of my reach. The project builds up its own dynamic inertia by being placed in the reality. These projects are built outside of the art system. The art system is about a hundred thousand people who are knowledgeable about contemporary

art. It is their mutual understanding; mutual values which build that art system dictating where and how and when you do things. They are on safe grounds, protected by museums, or institutions, or art councils, or governmental cultural agencies; all this works in the art system. This California project is put in a wild reality, made of real active politics, social and economic problems: real situations from which the project benefits or is hurt or is enriched and those are the roots of these works.

Fineberg: Well, how do you feel about those beautiful collages and plans, aren't those works of art on their own?

Christo: They are works of art on their own. Like in the past, it is not difficult to understand that when they did their frescoes in the Renaissance they had drawings and sketches. They are also works of art completely separate from the fresco. I have these big drawings of preparation done in that span of time and they reflect the evolution of the project, they are changing through the process of making the *Fence* or through the period of preparing the *Valley Curtain*.

Fineberg: I'm very struck by the purely visual power and quality of the *Fence* and of the *Valley Curtain,* too. How much importance do you attach to the visual impact of these works?

Christo: Absolutely all. You know, when I approached these ranchers or other people, I tell them before everything it will be a very beautiful thing, at least for me. That work, the *Fence,* or the *Valley Curtain* through all the process of doing were considered beautiful and exciting things—not a wind breaker or agricultural fence or anything else. All the time I was thinking it will be a very beautiful thing and I tried to communicate that to the ranchers.

All the people, through all these eighteen years of these projects, many became part of my friendship and they feel the beauty of the projects. We are putting now an exhibition of *Running Fence* in many European museums starting on the eighth of July at the Boymans [Museum in Rotterdam]. Those

very same people who were so hard to convince four years before, they have chartered a plane from San Francisco to fly to the Rotterdam exhibition. There are some strange links, I take *Running Fence* because it is closer to me right now. The ranchers, a little bit like artists, are people with no unions, a little bit crazy, and they work with the elements. Of course, this was the way to approach them, to present the project in that way. I remember we spent a day with Ed Pozzi, he is one of the great ranchers down there, in Marin County. Ed understood very well the project. One Swiss journalist, Dominik Keller, visited Ed, living in an average farmhouse, all prefabricated. His wall has a reproduction of a painting of a sunset on the ocean, but through his window he was seeing the hills. After Ed tried to explain *Running Fence* to the journalist, he showed him the sunset on the painting and he said: "You know, Dominik, that painting is make-believe, the *Running Fence* is not make-believe, it is true art, it is up on the hills."

In a way, the ranchers believe very strongly in real experience, fear, emotions, which are not fake, not make-believe. I remember another rancher made his children go to the public hearings instead of going to school because they would be learning more in public hearings than in school about how their life is run. In a way, all that process involved enormous give-and-take relations. It was not only that I was not taking something from the hills, there was the mutual feeling of understanding built through the presence of the project. And, in the end, the work was extremely exciting. I remember when we installed the fabric over the Labor Day weekend, it was impossible to handle the media and we decided the best people who can talk about the project were the ranchers. The ranchers became our P.R. They were talking to the television, to the journalists, receiving people on their land, taking them to the hills, showing them the *Fence,* showing what the *Running Fence* was for them. That type of excitement cannot be explained except with the enjoyment of the work itself.

Fineberg: The learning experience that comes through examining the documentation as well as through witnessing the documented events themselves—the court proceedings, the dealings with the ranchers, and so on—seems to play an intrinsic role in the aesthetics of your works. Should one conclude that the purpose of the work as a totality has chiefly to do with its didactic effect?

Christo: I should give you some details on my background. I was educated Marxist. I believe in dialectic. I think there is no way to separate the *Fence* from all the things that the *Fence* carries in itself. In the *Running Fence* project or the *Valley Curtain* there is no way to see formal separate parts. For me, the *Running Fence* (or the *Valley Curtain*) is one total thing. I cannot see any other work of art in a different way. No matter if it is a contemporary work or a Renaissance work it is related to a very specific social, economical, and political moment when it is done. We're not capable to appreciate any art, as it should be, without this specific knowledge. From the moment we are born, in a civilized world, we are educated in some way where we build and we grow some relations and we cannot have any aesthetic or philosophical perceptions without carrying the baggage of our education at the moment of appreciation.

Fineberg: The enormous visual impact of the *Running Fence* seems to have won over many different segments of society, and this promoted the social interaction that interests you. The *Fence* ran over a highway, through a town, across the ranchers' lands, and so on; it united all these different groups of people in part because it has such an incredibly startling visual effect—people looked at it and were taken into some common experience that broke down the usual barriers. What happens in a project like *Ocean Front* where the visual impact didn't come across as strongly? Was there a different kind of result or just a difference in magnitude?

Christo: Yes, about the *Ocean Front* project, I can say this. Each project carries the properties of the places where it is done. And is enriched by the situation in which it is done. I did that project during the preparation of the *Running Fence.*

The *Ocean Front* project was like a giant sketch for a project I would like to do in a huge scale someday, and in some other place. It would involve several miles of coastline and a different situation, but that's another matter. The *Ocean Front* was related to Newport. Some projects are physically more restrained, they have different impact, they touch less people. I found this a different visual experience. Most people have difficulty visualizing from drawings. I remember, many of my potential buyers, collectors who bought many of the orange *Valley Curtain* drawings, were very disappointed by the early white *Running Fence* drawings, at first because they thought it will look awful, they thought it will not be interesting. All along, I believed it will look good. It is very hard to visualize, the drawings do not show well how the project will look, and I really cannot separate the visual excitement from the community excitement. I could have built the *Running Fence* in South Africa or Australia, where I have wealthy friends, they own hundreds of miles of hills, and I could put my fence there with no problem but that would have been cheating. That is my idea about what the work of art should be. I cannot separate the involvement, the enormous energy and electricity built up around the *Fence* during this great Labor Day weekend, and it certainly was affecting the minds of those people seeing the *Fence*. I cannot talk about the *Fence* as an object alone, or only as a structure.

Fineberg: You mentioned a moment ago that the critics and museums and people involved with art in a regular way belong to an art system, a sort of closed, safe ground. Does your art relate to this system in a different way than previous art? Have the roles of the museum and the critic changed in this case and do you see a future direction for art or the art system in this?

Christo: I don't know, really. My pleasure to work in this type of situation comes from my education. I was a student in a communist country, and I was working, like the Red Guard, in propaganda art. I was doing all kinds of things which have developed my flavor to work with workers in a collaborative effort. I find

also this is a living source in the work, and it could not become a routine. I do not know how the state or the museum or the institution could add to that. The institutions could help more artists in a better way, but I don't think it is good that the state would be involved with art, it is a frightening thing. On another hand, I have seen in Holland relatively good relations between state and art, where the museums are run by professional people, it really can be done if it is not linked with some kind of state obligation. I was recently in Paris, it was an example where the state is backing huge cultural activities and centralizes them, it kills art activities in the provinces and builds this enormous bureaucratic system where you see such favoritism, all kinds of relations which have nothing to do with art.

Fineberg: Your training in a communist art school obviously had a positive impact on the kind of projects that interest you, yet you also have misgivings about that education. Can you say something about what you think an art school should do for a student?

Christo: I think when I was in Bulgaria and Czechoslovakia I learned, or perhaps not learned, I was involved with a thousand things. I remember, I went to college during the early fifties, and I did propaganda art. I don't know if you are familiar with propaganda art. I was not making billboards, but I give you a typical example: In Bulgaria, one of the most communistic states of the East bloc, they were very conscious that the only way the Western people were passing through was by the Orient Express. It was the train traveling from Paris to Constantinople and the state was very anxious that all the cooperative farmers around both sides of the railroad tracks for about four hundred miles should look prosperous and dynamic. Each student from the Art Academy was sent by the school on Saturday and Sunday to show the farmers how to stack properly the hay, the machinery, and to make the land look visibly active. That was one way I spent several semesters, on Saturdays and Sundays, "giving my time to the party and the proletarian revolution." But that also developed my sense

to work with the land and open spaces, and to communicate with people outside the academic world.

Another thing, because everything is owned by the state all the film productions were obliged to hire artists. The artist was the man who was choosing the location and films were shot mainly on location; there was little staging. The artist was choosing the location for feature films, sequences in the street, in houses, or gardens. I was training to be a painter and a sculptor but I was doing many side things that have nothing to do with basic art in a common way. All these interests in learning all different type of things were involving. During that time, when all the Russian Constructivist art was forbidden to us, Mark Donskoy, the Soviet movie director (he did *How the Steel Was Tempered,* a 1942 film) came to the academy and he made an unofficial class for the students about Russian art of the late twenties and early thirties. I started to know about [Vsevelod] Meyerhold, [Vladimir] Tatlin, [Nataliya] Goncharova, [Mikhail] Larionov, in that class, while I was eighteen, nineteen. I was also interested in Russian Constructivism and German Expressionism. I am also from Czech origin. In Prague, I met [Emil F.] Burian, the producer and director, at his theater. He did a number of plays of Brecht in Leipzig in the thirties. All these things are part of what I am today. And this is why I can't tell you what schooling should be, perhaps it should be involvement.

Fineberg: You mentioned at another time that the *Running Fence* and the *Valley Curtain* brought up essential life problems and also that each person saw these projects in terms of his own thoughts and concerns. Could you say something about the kind of life problems that the *Fence* or the *Valley Curtain* raised?

Christo: You cannot say that a work of art is representing only what you think it is representing. The *Running Fence* and *Valley Curtain* and previous projects have this very broad relation. The ranchers in California or the cowboys in Colorado understood that the work of art was not only the fabric and the steel

cable, but there was the hills, rocks, the wind, the fear, they really cannot separate all these emotions. The work of art was that life expedition of a few months or years. It is rewarding to see that the ranchers' appreciation of art was in a complex way. That is, not only a formal way and not only a human way but all these pieces put together, that they can find that a part of *Running Fence* is their cows, and the sky, and the hills, and the barns, and the people.

Fineberg: Let me ask you something about the imagery of packaging—the way in which the *Fence* and the *Curtain* have to do with packaging materials or wrapping things. What are your associations to the packaging? What does it mean?

Christo: I really don't think it is packaging. This is something curious through all these projects, I work with a very fragile material and the fragility becomes an important aesthetic matter. The fabric, as Engels was saying, to weave, is one of the oldest man-made activities. It helped the primate become the primitive man. The fabric is like an extension of our skin, it is very related to human existence. You see in Tibet the nomads walking on the hills and they stop late afternoon and they erect their fabric tents, their houses for a few hours. The impact of these temporary structures is so staggering that it lasts, not like the Howard Johnson's here. The next day they were removed and disappeared, the fabric is part of their scheme, it is their action of movement, of moving through the landscape. Because my projects are temporary, dialectically, fabric becomes part of the work. This is a way to express the temporary character of motions, by using fabric material. That material becomes an obstruction or separation, dividing. Really, it is not just packaging. The packaging can also be obstruction, but it is different. The material, because of the fragility, is very active; it makes you want to go through, like you can break it (and it is breakable, it can tear apart). All this going-through action has become a major part of the project.

In the early sixties when I was doing objects they were more related to the form—like there was the wrapped chair

with the non-wrapped chair, they were always compared to each other. Or there were the things entirely bundled. The fabric was aesthetically interesting, sometimes a rough material, sometimes a more silky material. But the formal interest was working in an ambiguous way.

You see very well the evolution moving through these objects: concealed forms, really obstructed objects, to some visible objects, to the storefronts, to this separation, and to the human-scale relation. This is why fabric is used, to exist a short time to be related to the way the work is thought. The fabric came naturally, the most convenient material.

Fineberg: Does it bother you that a work like *Running Fence* is up for such a short time? Would you like to see one of these major pieces stay up?

Christo: No. I should tell you that I don't believe any work of art exists outside of its prime time, when the artist likes to do it, when the social, political, economic times fit together. After that moment, there is the matter of deviation or change or deterioration on all levels, of course physical but also social and historical. When the work is displaced it is interpreted in a different way and therefore damaged. Not damaged physically, but damaged philosophically. You know the Sistine Chapel's ceiling was almost in darkness when Michelangelo was painting it. Today, you go there, you have thousands of electric watts making the work totally visible. I have extremely enjoyed the lecture Leo Steinberg gave a year or two ago about the *Last Supper* of Leonardo. In discussing it, Steinberg avoided the color slides of the so-called original work. Actually no slides exist, only color slides of the ruins they repaired after the war. He was discussing the *Last Supper* through the gravures of witnesses closer to that time, like Dürer or El Greco or Rubens who actually were interpreting the *Last Supper* in their own way. Through their interpretation we can learn how the *Last Supper* was affecting them. These gravures of contemporary artists were acting like contemporary photographs of the *Last Supper;* the photographers were Dürer or El Greco inter-

preting the work in the way they liked. The *Last Supper* was most effective during its prime time when there was an affinity between the artists.

Fineberg: It is a very Hegelian view that the work of art, after its time, enters the history of ideas and the object becomes just an artifact. Does this consciousness change the function of a work of art and your job as an artist? Are they different now than in the past? Or are they the same despite the development of the culture and the consciousness of such ideas?

Christo: Perhaps something that can be compared with art is religion. Perhaps art is in man all the time, a different way of interacting with his society, or with humanity. If you say that the function of humanity will never change, of course art will never change. But that is too broad a discussion to get into tonight. We know very well that the function of society, of humanity, of our existence on earth is changing all the time. We cannot separate art from society, art is the product of humanity and society, and of course I cannot admit philosophically that society does not change.

Question from the Audience: How did you choose the sites for the projects and do you work them out ahead of time?

Christo: It is not choosing the site, it is choosing the project, or making the project, or succeeding in doing the project. It is a very long process of things built up little by little and crystallized. It is not as if I finish *Running Fence,* now I go run around choosing another project. I already said why I was interested to do the *Running Fence*—because of my desire to work in California, that is a long story. Because I had not succeeded to do a project in California, I felt a very strong need to deal with one of the most sophisticated American states, in a way, the craziest, the most polarized American state. I was extremely fascinated with California because it is completely irrational. In the hills of Marin County there is a former general of Vietnam in a villa, the Symbionese Army was running around, just re-

cently the Dalai Lama chose to build his headquarters just above the site of the *Fence*. I could do the project in Texas, they also have the ocean, or in some other place, but to have this vibration, this enormous energy up there, this is why the project found its own place in California.

With *Valley Curtain* it was the same thing. I needed mountains. There are many mountains in the United States, but more and more in my mind I was struck by Coloradan behavior (and I went three times before in Colorado). Colorado people are very sensitive about their mountains. They turned down the Olympic games because they want to keep their mountains not involved with anything. The Rocky Mountains are rich in variety; in four hundred miles they have a fantastic span of different types of mountains from alpine to desert. The location of *Valley Curtain* was not found right away. I wanted to experience people with an active relation to their mountain.

In the same way, when I started an urban project about six years ago—I was looking for a strange city, a fascinating city, enormously curious city, like a ghost, not New York or London or Paris, and I am working now on a project in Berlin. This project evolved completely different from *Running Fence*. Instead of ranchers I have the whole German parliament, the Soviet army, the British army, the French army, and these people create a new span of relations. I am trying to wrap the former German parliament, a large structure called the Reichstag. Perhaps I will never do this project because I have not obtained the permits yet. But again, that building has a huge power.

About the second part of the question: All these big projects take a long time to prepare and build, three or four years. In three and a half years of *Running Fence* I produced about three hundred and fifty original works, all types of works—very small sketches, collages, large drawings, big scale model (we have a sixty-foot scale model showing about five miles of the *Fence*). They are all done during the preparation and they change because I change some parts of the path of the *Fence* and the engineers change some details. The drawings don't show each hundred yards or each two hundred yards, they reflect only some parts of the project and anticipate only some aspects. One thing I never imagined, for example: that the *Fence* would have that linear magnitude. That is something I only understand now. But when I was designing the *Fence* by placing the wooden stakes I couldn't see how much the *Fence* was far away. I tried to visualize what the *Fence* will be with topographic maps but I never could have a true vision.

Fineberg: If you manage to bring the *Wrapped Reichstag* project off you will really change some people's sensibilities, and there the political implications could be enormous. The *Fence* affected observers this way. I am thinking of that story that Jeanne-Claude told me about the policeman who observed the traffic accident. What were the details of that?

Christo: The *Running Fence* was planned to stay two weeks but the Highway Department of California had the ultimate power to remove the project at any time. All these projects have huge logistic problems and bonding conditions, like the insurance policy, not for the project, for the liability for people watching the project, and possibly breaking their necks, that is enormous. There were two policies of one and a half million dollars each, per occurrence. The Highway Department was worried that the project would become a giant Woodstock. They had the ultimate power to remove the project even twenty-four hours after we installed it if the roads were blocked by a huge traffic jam. They put a counting device and they knew that if there was forty thousand cars in addition to the normal traffic per day that we should remove the *Fence*. Finally, the *Fence* was seen by three hundred thousand cars in two weeks, it was not too much.

They asked us to hire off-duty sheriffs, police, helicopters and police on motorcycles, which was creating this forty-mile network of roads as nonstop, no parking zone. Through the two-week period there was not once an accident except one day the police lieutenant on patrol arrived at the headquarters of the project and told my wife, Jeanne-Claude: "You know, I never saw, in all my life such thing." And Jeanne-Claude said: "What's happening?" "There was a car and a motorcycle

slightly hit by the car, the motorcycle was on the road, and the two people, the motorcycle driver and the car driver looked at each other, then they looked at the *Fence,* and they started laughing, and helped each other, and went their own ways."

Question from the Audience: How do you raise the money for the projects, where does it come from?

Christo: As I have already explained, these projects are paid by myself, they involve no grants, no governmental money, no other funds than my own money, which comes from the selling of my original works to collectors, museums, and dealers around the world. The projects are entirely self-financed. Each project is done by a corporation. My wife is president and treasurer of the corporation, and the corporation exists for the lifetime of the project—from the very beginning, one of the first moments when we think we would have a chance to do the project. When all the bills and loans and debts are paid then we shall not need the corporation.

Now, there is some irony in that because actually people are buying these "commodities," the drawings about these projects, about something nobody can own, and no company can possess. But we could not sell so much if these people who are interested in my work did not know that it is important to do that project. Perhaps not all of them, some of them are buying my works for speculative reasons, but at least a good number of dealers and collectors and museums are genuinely interested to see the work happen. I remember during *Running Fence,* many of them came to the site, to California, long before the *Fence* went up; they came to see how we are negotiating with ranchers and how we are working. They were interested, and when the *Fence* was installed, about two hundred friends came from Europe. I could never have done my projects if I did not use the art system, because the only money I have comes from selling my work in the art system.

Also, Jeanne-Claude is really doing half the work. Without Jeanne-Claude, I cannot do these projects, because she is selling my work, she is organizing and scaring everybody, and

is shouting in the phone, and makes arrangements. It is not only one thing she does, she is doing hundreds of things; she has related and negotiated a hundred things. I do too, but there are so many, she relieves me of many things, at least some parts of the project so I can have more time.

Question from the Audience: Is the Berlin project the first that would involve different national governments?

Christo: Yes, this is the first time I involve East-West relations, that is, international cooperation. Also, this is a matter of human relations, of people living in different ways. There is the political and social aspect, of course they are different.

Question from the Audience: Why do you choose more tame, urban landscapes, instead of something which is wild and far out like the Smithson projects?

Christo: I think every perception we have is related to human experience. We don't exist another way. The human being is the very vital force in all these projects. I don't think Smithson's Salt Lake project is totally in the desert. It would like to be isolated but the only totally deserted place is on the moon and on Mars.

All my projects deal with very casual, almost banal situations. The *Valley Curtain* looks very spectacular, but this type of valley exists by the hundreds in Colorado, this type of hills exists in many places in California and in other countries. It was important that they be very casual, ordinary, not staggering landscapes, for these banal, almost idiotic type of projects. That is very simple to explain: the *Running Fence,* a fence who runs; the *Valley Curtain,* a curtain across a valley; the *Wrapped Coast,* a coast that is wrapped. They are simple things, they demand simple work, they are not technological, there is only mechanics involved. We have friends, engineers who try to simplify all things to the least possible manipulation. The project should be easily understandable. Because it is done by people. There was a mass of people involved in making the *Fence,* there was

no other way. This simplicity is the guiding line of the project.

Also, these projects were involved with human interaction. The human interaction is the essence of the work. In the case of Smithson and the *Spiral Jetty*, it is a large garden-type sculpture like those done in the time of Louis XIV. My projects have a different relation. Of course, taken formally, you can maybe say that they look similar, but this is simplistic. My projects involve this inner content which cannot be disassociated or removed.

Question from the Audience: In light of your statement that art shouldn't exceed its prime time, I was wondering what your response would be to an earthworks artist like Robert Smithson who was concerned with entropy and left his pieces to die a natural death. How do you feel about just leaving something?

Christo: I understand Smithson's idea, it is perfectly legitimate. When I talk about prime time it is not only about the physical part of the object. I mean prime time when things are fitting together. Perhaps the physical object's deteriorating or changing is one aspect of the prime time passing, but the prime time is also the state of consciousness at the moment when the work is done.

I think art is impulsive pleasure, some kind of organic part of our existence, and it is very complex, not only a formal pleasure, which is a recent attitude—completely Victorian.

Going to San Marco monastery in Florence, where the beautiful frescoes of Fra Angelico are, there was no way to do this art without being a profoundly religious man. To do valid work then it was necessary to be profoundly religious. Religiosity was the essence of those centuries. We can make analogy today, we live in an essentially economic, social, and political world. Our society is directed to social concerns of our fellow human beings. Everything of our evolution, of the twentieth century, shows that the essence of this century is this economic, political, social mind—through everything from the Third World in Africa to the misery that exists in every country. That, of course, is the issue of our time, and this is why I think any art today that is less political, less

economic, less social, is simply less contemporary art.

Fineberg: Does it also have to do with its reception?

Christo: Yes, with its reception, during the prime time. It is not only that the work is physically damaged, less or more or not. Smithson takes that deterioration as part of the work of art, but the human perception of the work is not the same. A hundred years from now, there will be a hundred years of culture between the sixties and the year 2060. There will be people with a hundred years' more knowledge; we don't know what their perception of the *Spiral Jetty* will be. For the *Spiral Jetty*, the prime time was exactly 1969 or '70 when it was done.

Question from the Audience: But the object remains, one can still visit the site even though unfortunately that work is under water.

Christo: Of course, there are many objects which are remaining from the old times for us to interpret with our knowledge of today.

Fineberg: Is this the value of having all the documentation after the project and its prime time have passed?

Christo: About the afterlife of the piece: everything is "reference," it is "about" the project. There can be no substitute for the project itself. We have the archives of the project and I like to keep records for reference and accuracy.

When a project is finished, I am anxious to keep at least as much as possible, all the facsimile documents. If you are familiar with the *Valley Curtain* book or the *Wrapped Coast* book, there we reprinted in original form not all the documents, because all the documents would be thousands of pages, but at least a good number of documents where the references will be historically accurate. In the *Running Fence* book, there will be no written interpretation by me, there will be the original letters from the lawyers, engineers, professionals, and all those dif-

ferent people so that you will go through those papers and see how this project was growing through the months and years.

For the photography I rely on the photographers. For the last twenty years living here I have some friends, photographers, interested in my work and they have an affinity, I think they understand what the project is about. They follow and they take photographs, hundreds, thousands of photographs in three and a half years. The photographs show their own relation to the project. Not only the final object but through all these public hearings and meetings with ranchers and all aspects of the work. You cannot have a perfect idea of the project through photographs because they are an interpretation of the real life work.

The film is also the result of the trust between me and the Maysles brothers. They are friends. I met them almost eighteen years ago. I admire their work, and they were interested to record these projects in their own view. I do not tell them what the film should be. They are working like writers, only instead of writing they are doing a film. And their films, the *Valley Curtain* or the *Running Fence* films, give us a part of what was in motion; for the project there is more relevance, but that cannot "be" the project. Those twenty-eight minutes are some idea of the work. When the work is finished, we put together an exhibition showing original documents from the engineers, lawyers, letters, a piece of the cable, some anchors, how the *Fence* was done, a pole, a sample of the fabric, scale models, my drawings, photographs, color slides, the film, all kinds of documents. That documentation show is really like a Xerox copy of the project. We try to give some idea watching the film, looking at photographs, touching the fabric, and seeing materials. It cannot be the project, but some decent reference. This is how I see this material, it is like a library, for reference material.

Question from the Audience: Do you sell the documentation to help pay for the projects?

Christo: I do not sell the documentation. The people who buy my works buy original work. The cost of the project is paid by the sale of my original works. About 60 percent of the works sold are preparation work for the *Running Fence,* 10 percent are from lithographs editions, and 30 percent from earlier works—packages and drawings.

When we started years ago, there was less people interested in my work, actually the project built its own interest, not over two or three months, but over many years. Eighty percent of all the sales happen in Europe. One of the biggest part of my collectors is in Scandinavia and Switzerland. This is understandable. When a society has developed a uniformly high standard of living there is a large number of people with a more relaxed behavior toward art. When a country has big social differences, art is considered with guilt, "should give money for that and that" instead, but in a country where the standard of the life is very even, there are many collectors interested in art.

Question from the Audience: How did you turn out financially at the end of this project? You spend so much money, obviously, you must get something.

Christo: No, we don't have anything. We still owe loans. For each project all the money is spent on the project. The only thing left to us are the debts we must pay. Of course for us, since we haven't got any, money is the least important thing. That we did the project is the greatest capital, something that money cannot buy because that will help me in my next project to sell and to convince people to let me do the work. But, you know, money is not the problem. I give you an example: In 1969 the *Wrapped Coast* project cost $125,000. In 1972 when I finished *Valley Curtain,* it cost $850,000. We started late in 1972 and we finished a few months ago *Running Fence;* we spend $3 million on *Running Fence.* Do you understand that each project builds credibility, that we can do these works, that we can proceed, fight, realize them, and that is our biggest capital, there is no money back, but it is better than money.

Question from the Audience: In the *Running Fence* project

was it necessary for the people, especially the ranchers, to believe that they were involved in the work of art or was it sufficient for them just to tolerate it?

Christo: I don't know how much the work meant to the people, there were all kinds of different levels and you cannot tell which tolerates or should be opposed. But they all were related to the work of art no matter how their behavior was toward the project. With the *Running Fence* I would never be able to do that project if the ranchers were not backing emotionally and actively the project, at least at the public hearings. I would never win the public hearings if the ranchers were not coming to fight for the project.

Fineberg: Do you think that because these works have important political and social implications, that the prime time is more focused?

Christo: The work is in a dynamic existence and this is why it is more focused. It is in the right time when these forces are running strongly through all these two or three years, and it builds up a climax and momentum like a run. Of course those forces are not all political. There are a hundred other forces: they are humans, they are wind and natural forces, and organization, but that buildup is the work of art of two and a half years. It can slow sometimes to less strong velocity, but always that work should be finished. It is the energy we put in with friends; it is not only the political matter, but also some kind of human relation or human want.

All these works are public. They are public in the very broad sense not only because they are visible in a public place, but because they engage huge numbers of people in some kind of decision. We are not only one or three or a few people doing everything; we are many kinds of people working together.

That public project will involve the ranchers and the governmental agencies, surveyors, engineers. It makes the motion of the work and the impact of the work extremely visible in that community.

Question from the Audience: When you were working on the *Fence*, why did you simply break the *Fence* at a road instead of dropping it down into the ground or arching it over the road?

Christo: The *Fence* was like a real fence. The real fence of a farmer never goes over the road, never goes under the ground. It stops near the road, to the side of the road. The project was thought in a very simple way. Like a fence stops and starts on the other side, except it was running.

Question from the Audience: Does the *Fence* get smaller as it goes into the ocean?

Christo: Yes, the ocean panel was one single fabric panel, 550 feet long, and had been sewn to follow the contours of the bluff and beach. At its highest it was 45 feet and it went on decreasing until it reached the anchored raft. It was suspended to a separate ocean cable.

Question from the Audience: Is it true that when it came to the *Running Fence* going into the water that you did not have permission to do that?

Christo: Now, that is another matter that I should explain. That is part of the subversiveness of the project. It is a long story, but to make it short: The coastal part of California is under the jurisdiction of the State Coastal Commission, on all kind of levels. We had permission from the Regional Coastal Commission, but that permission was appealed in front of the State Coastal Commission by the Committee to Stop the Running Fence. From the year before, we knew that the State Coastal Commission was against the project. Meanwhile, we had the environmental-impact statement, which was done by all these specialists for the State of California. That appeal, that decision of the State Coastal Commission, was not coming at the proper time and we did not wait for the decision of the State Coastal Commission. At the demand of the State Coastal Commission, the attorney general issued a temporary

restraining order, and asked a judge in Marin County to sign it because that part of the coast was in Marin County. Judge Menary refused to sign the temporary restraining order, and he set a date for a full hearing, on October 14—long after the coastal portion was scheduled to be removed!

Question from the Audience: What were the objections to putting up the *Fence*?

Christo: There was objections from the Committee to Stop the Running Fence. The most sophisticated objection of some supervisor was that not only the *Running Fence* but all my works show the arrogance of man over nature. And that is the most sophisticated attitude! One of the lowest objections was that I am a communist spy and the *Fence* will be used as intercontinental missile targets. Basically, two oppositions were built up. Some citizens were upset that the county was not doing enough work for their roads. They were near the *Fence* and they were afraid that when the *Fence* would be up the road would be full of people and dirt and garbage. Another group was some artists who were saying that I am not an artist, that I am a commercial front runner for the land developers.

Question from the Audience: How did you convince people to do the project?

Christo: The only way is to build up a very strong credibility and show sincerity. There is no way to convince people if you are not sincere to tell them that what we are doing will be a work of art. Through all this process of getting permits, of doing that project, I never said the *Fence* or the *Valley Curtain* or the *Wrapped Coast* was anything except a work of art, that the whole purpose was only to be itself, to enjoy for a few hours, a few days, and then we will remove it.

That was irrational, but it was very simple. When Jeanne-Claude was trying to convince the ranchers she started with the wives of the ranchers because the wives can talk to their husbands afterward. We were drinking coffee and wine with these ranchers so many times, there were several visits, after a while we became like family—we would kiss each other, we would give news of one uncle we saw, etc. . . .

I remember Leo Ielmorini, one great supporter of the project, who is an incredible rodeo fan. He built his own rodeo in his own place. Sunday afternoon after milking the cows he jumps in the rodeo. One afternoon before we signed the contract to build the *Fence,* and the Maysles brothers were filming (fantastic footage), we were watching his rodeo. We tried to see everything those ranchers were doing because there was no way to convince those ranchers if we did not understand their business or their hobbies. We were watching Leo Ielmorini on his horse. He would jump off after the cow with the rope and the poor little roped cow was in the ground, he was in soil and dust, dust all over, dust everywhere, and as Leo was coming toward us, tired and suffering, Jeanne-Claude told him: "You act like a child, what are you doing? How is it important to rope that poor little cow, explain to me, please." The *Running Fence* is the same thing. For us, coming from New York, roping a little cow is a very stupid thing, as you maybe think building a *Running Fence* is stupid. This is the way we started to communicate. There was no other way.

Question from the Audience: What do you do with all the material you use?

Christo: All is recycled. The materials are going to the ranchers, in the case of *Running Fence;* the material was a kind of compensation. The ranchers would keep the material that was on their land. They used the cable and the steel for their barns, gates, and fences, and the fabric (because it is synthetic) to cover their hay, manure, and machinery in winter, or they sell the material. In the case of *Valley Curtain,* the steel was taken by the builder-contractor and he used it for his own purpose. Everything was used by the people on the land, all in different ways.

Question from the Audience: Was the Australia coast similar to the area of the *Fence*?

Christo: In Australia about 80 percent of the people live on the coast. The coast is forty thousand miles long. They are much more scattered, it is not busy like the California coast. There is some similarity, but there are great differences.

The *Wrapped Coast* was done only nine miles from the center of Sydney. Actually, just north of Botany Bay. The land was owned by a state hospital, Prince Henry Hospital. In early 1969, when the press discovered that we had rented the land, the nurses of the hospital went on strike. We almost lost the project because the trustees of the hospital were very nervous that the nurses would go on strike again and would make problems. There was all kinds of confusion, they were thinking that the project was financed by the state, and by the hospital. One morning there was the delivery to the door of the hospital a very sick man on a stretcher who was blaming that the state was paying for that project instead of caring for the people. All kinds of confusion.

We tried to explain through the media that the project was financed by myself. But all this was our fault because we did not take care sufficiently of clarifying the project to the community and to the public. The nurses went on strike because they were worried about their beach. They had not understood that when the coast was wrapped they could still use the beach. The beach was wrapped but allowed swimming and walking over the fabric, it was not a problem.

Question from the Audience: How long was it up for?

Christo: The project stayed quite a long time, about seven weeks. It was finished by early November, it stayed until just before Christmas. It was planned from the beginning that we rent the land and have a working period and a display period, and remove it by Christmas time, and the materials were recycled.

Fineberg: You mentioned the Russian Constructivists earlier. They expressed a strong desire to change the value system of the society they lived in through their art. Do you also want to transform the values of your society through art? Is this a principal objective of yours?

Christo: They were working in a very specific historical time, their performances used what was happening on the street, the railroad stations, and even at the front. I don't know if you are familiar with the director, he was also involved in the street work, Meyerhold, who did work in the railroad stations. During that time, several organizations of artists were involved in helping, during the civil war, and were going to the front. They were working to boost the morale of the soldiers, to create some kind of activity using the situation there, and doing performances of street works.

Perhaps this was a time with strong correlation between the arts, when the Constructivism or the Expressionism was also apparent in literature and was linked with the philosophy of the new way of art. Tatlin was thinking that the Bolshevik revolution was like Dada in politics.

Fineberg: But the Dadaists, with the exception of the Berlin Dadaists, didn't really offer any sort of solution for what you do after you destroy the old values, whereas the Constructivists *were* concerned with what you do afterward.

Christo: There was a positive attitude through all that time, a new society was born and new values should be set in place.

Fineberg: Are such new values and new social forces central to what you do?

Christo: Historically, in 1918, 1920, many things were done, at least until 1929, in all directions that cannot be simplified. Unfortunately, it stopped with the taking over by the Stalin dictatorship. It had been the sources of enormous energies in art, in architecture, design, urban planning, and literature. There was a political speech of Maxim Gorky, made after he came back to the Soviet Union, in which he was discussing how the individual can act in a collective society. He was using

the metaphor of a pyramid; if the top of the pyramid is weak it is because the force from the bottom is missing.

In a way, there was not an understanding that all the energy to do the work was coming from the friction forces that were happening in that particular time in the Soviet Union. After that, the Soviet Union became a normal, totalitarian state. I try to use the reality, outside in the world, from outside the art system, to be the resources of my projects or to use the structure of society to be the force of the project.

Question from the Audience: You mentioned last night that you give the materials you use to the people in the area. Is this true for all the projects, and do you think that it helps along the cooperation with the project, knowing that they're going to come out with something, as well as being involved with the project?

Christo: In Australia, the fabric was an erosion control mesh, a much different type of fabric. It is used by the farmers to keep the good earth from being swept away by the strong winds or the typhoons. We also used about forty miles of rope to secure the fabric. We made a contract with some farmers to come help us remove the project and they kept the fabric for their own agricultural uses. The rope was removed by fishermen, they got the rope and they used it for their purpose. You know, there is always some kind of arrangement that will make the project less expensive and help everybody with recuperating the materials.

I cannot say that giving them the material helped convince the ranchers, I don't think so, because the materials were very hard to visualize. Perhaps it helped later to make them more interested in some way when they saw the poles, what they were; but for the cables and the fabric, that was much later, they did not have a chance to see them until we installed the *Fence.*

Question from the Audience: Have the ranchers been selling pieces of the *Fence*?

Christo: Yes, the ranchers have a lot of material. I heard that some ranchers are selling, others were making wedding dresses out of the material, some were selling the panels for souvenirs. Of course the fabric is not a work of art, it is only fabric.

Question from the Audience: In the *Valley Curtain* film the workers seemed very involved. Were they enthusiastic about the artistic idea from the beginning?

Christo: Not all the workers. The blue-collar workers are more colorful, and the film shows them only in the last few days of the project. Their enthusiasm did not happen right away. The *Valley Curtain* took two and a half years to prepare. Of course there was a lot of difficulties to overcome in these years, skepticism from the workers and not only the workers, all kind of labor was involved with the project. You cannot invite one morning all the workers to explain art. It was basically a one-to-one relationship. All these projects were done with many teams. We started with engineers, and after that a builder-contractor, and a project manager. It is a long process of personal relations. In these last projects we had to work with elements, not make-believe, fear and courage and strength, and not be afraid of sun and water and wind. It creates some understanding that a work of art is not just intellectual but also a physical relation. Then starts a friendship with the blue-collar workers or with the ranchers, with any working people. I'll give you an example about the *Valley Curtain:* We hired seven ironworkers who were extremely expensive. There were also other workers from other unions working on the project as carpenters, etc. Actually, the ironworkers are not supposed to help the carpenters and the carpenters should not touch steel, but all through the project everybody was doing the next work to be done, whatever was needed to advance the work no matter which kind of work—wood, steel—it had nothing to do with what union they belonged to. Not because we asked them but because they understood that the work is beyond their usual rules. All the things that happen on my projects are not ordinary. One of our ironworkers, Don Jenkins, risked his

life to complete the project; he knew he had lost a curtain the year before, and when the outer cocoon got stuck, he went up on the cables all by himself (the safety rules forbid going up alone) and saved the *Curtain*. But when he came down the boss (the job's superintendent) told him: "Thank you, Don. You are fired." The only way for him to be hired back was through our support, which we could not give because we had put the boss in charge and could not go over his head. So we told the other ironworkers: "Go to the boss and tell him that you are all quitting, that you will not be on the job tomorrow for the unfurling of the *Curtain!*" They did just that and it worked. Don was rehired. The rules had been observed on both sides. With *Running Fence* there was another situation. There were about sixty professional workers; some were the ranchers and their sons, some were retired hippies. I don't know if you are familiar with this: One of the first communes in Sonoma was the Wheeler Ranch and many of the Wheeler Ranch hippies were living there around 1965, not far from the site of the *Fence*. For them, the *Fence* was the best thing to happen since the time of the Wheeler Ranch. All that mixture of different kinds of people, building the *Fence* together, it was working extremely well.

Question from the Audience: Earlier you mentioned that you had the ranchers argue for you, support you in all the different public hearings and so forth. How did you start getting the ranchers sold on the idea, and what kind of effect did your Marxist point of view have on them?

Christo: When we located the land in the fall of 1973, there was nobody I knew in the area except the surveying company we hired from Walnut Creek. I thought the way to do it was to start some kind of contact with the community. Because the town of Rifle, Colorado, had given me the key to the city, I asked the Rifle Chamber of Commerce to write to Petaluma, saying that I would like to invite the Petaluma Chamber of Commerce, the president, and some community leaders to lunch with me on October 5, 1973, at the restaurant Sonoma

Joe's on Freeway 101. My English is extremely poor and I had asked our friend, builder-contractor Ted Dougherty, who had built *Valley Curtain,* to join me because he looks conservative—a good typical American—and it will help convince them to back my idea. We arrived at that lunch and there was about seven people. We had the property sketch map showing where we would like to use the land and the reception was glacial. They told me I have one chance in a thousand to do anything there, that I should go back to New York or Colorado because the agriculture and ranching business is a nine-billion-dollar industry in California. "You are completely in the wrong place, this is not Colorado, it is not the East Coast, you don't understand the country." Of course it was very disappointing, terrible! The president of the Chamber of Commerce (a lawyer who became one of our lawyers, later) was watching the properties sketch maps with the names of all the people who owned the plots and he saw the name of Mr. Raven and said: "Why don't you go see Hans Raven? I just saw him at his accountant's office in town, perhaps you can talk to him." We rushed to the accountant's office and met Hans Raven. He is a Scandinavian, I think, born in Denmark, handsome man, late forties. He had his cowboy hat on with his boots on the desk and he was laughing. He was the only man who knew about me because he also has a ranch thirty miles from the *Valley Curtain* in Colorado. He said I was crazy but perhaps he can think it over to help me with a few things. Hans is a big hunter and he was going to hunt in Alaska. He said to call after he came back, perhaps he could do something.

From New York we talked on the phone many times with Hans; he was really trying his best to help us. Meanwhile we went back to California a few times, and one day Hans suggested that we give a big dinner party. For the first time in our life Jeanne-Claude and I had a dinner for 215 guests—all the ranchers, their children, their aunts, uncles, and schoolteachers. We had rented the fairgrounds in Petaluma. We had very good food (a rancher prepared the dinner and drinks) and we put name tags on the people when they arrived so when you

were talking you knew who they were—schoolteacher, rancher, like that—because many of these people I never saw before.

But, there was not only me with Jeanne-Claude, we had decided that we were not enough to negotiate the project with 215 people and would not have time to talk with these people personally. We had asked all our engineers, the builder-contractor, the project managers, their wives, their children, to come to that dinner, and we spread through the tables and we tried to talk to all of them. That was in January of 1974. We showed them the film of *Valley Curtain,* we had big blow-ups of drawings, and we talked, and the engineers talked, everybody was excited. But, you know, between excitement and signing your name on five or six pages of legal contract, there is a big difference. Hans Raven succeeded to convince ten or twelve of his very best rancher friends to sign, including himself. But, for the others (about forty-eight or forty-nine ranchers) there was no way to make them sign. To make a rancher sign was like taking him to the dentist, not because he did not like the project, but because he could not understand the words (we did not understand much of the words either). We asked him to go to his lawyer, and his lawyer was busy, the rancher was busy, he was milking. The only way was to go and spend days and days on the site and with the ranchers in the field, with them and the stock at the livestock auction, learn how they were living and know their business and know the price of milk and the cattle and the meat and feed.

Actually, some kind of relation built up between us and the ranchers. Also, these people were extremely isolated and the twenty-four-and-a-half-mile project became a link. Some of these ranchers have brothers or uncles they had not seen for a long time. We gave them news of their uncles, because we were using the land of the uncle too, and who married who, and who had a baby, who sold land, who bought land. We started to be friends, to talk about more things. We started to be invited to parties and family gatherings, and by September 1974, we had all the ranchers signed.

Question from the Audience: Did you find right at the end

that they all fell in a hurry or were there a few holdouts who gave you a real problem about their signature right until the end?

Christo: It was very complicated. Sometimes, the land was owned by some people who lived somewhere else and we needed their signature and then one of the people who rented that land. Not only the ranchers who use the land but the real owner of the land and in the case of an estate it involved lawyers. If somebody had died, it complicated things but was not impossible. It only made much more signatures necessary, more signatures than the fifty-nine plots of land. But that was not the real problem. The difficulty was to make the ranchers believe us, that we meant well. We tried to go through the project with the entire safety of the land and the cows always in mind. It was very important that they would see not only me and Jeanne-Claude, but also the builder-contractor, the engineers, and people who are very real.

In Colorado we had already built the machines for building the project and we brought one of these trucks to California to show them how the poles will be built. We really tried to explain what it is about. When we started to build the project we needed them to work because they were aware about the land condition, the hills and roads, and rocks, and that was ideal because they needed the jobs.

I remember the son of one of our ranchers, Spirito Ballatore, was one of our greatest workers. He was a young man about twenty-one, everybody loved him along the forty miles, and he was in charge of delivering materials, filling the trucks with gasoline, he was all the time opening gates and closing gates, never forgetting to close those important gates which enclose the cattle. He was our best public relations in the project. We could never have built the *Fence* if the ranchers were not with us in preparing and building the project.

Question from the Audience: Were the farmers and the people in the area sorry to see the whole thing end? Is there nostalgia for the project now?

Christo: Yes, some people were sad and somebody told me that he cannot watch the removal of the *Fence*. But when the *Fence* was removed he started to live with the missing *Fence*. Many of our ranchers wrote to Jeanne-Claude at Christmas that the *Fence* will run forever. The State of California made *Running Fence* a landmark. They kept one pole at State Highway 1, and *Running Fence* became landmark number 24 in Sonoma County. Someone painted a large mural on the front wall of the food store in Valley Ford, a landscape with *Running Fence*. Perhaps it is nostalgia.

Question from the Audience: How did you choose the color for the projects, was it purely functional?

Christo: For the outdoor projects, generally I use synthetic fabric because synthetic fabric changes less its properties with atmospheric conditions. If we use organic fabric it will become heavy with water and we need to work with a constant structural quality. Nylon looks like any woven fabric, but unlike wool and linen it is a synthetic fabric. They are different in each project. In the *Valley Curtain* film you saw some early drawings where the color of that project was white because I had not considered color in the first drawings. It was not something important then. Later, we understood that the site where *Valley Curtain* was to be built was over six thousand feet above sea level and nylon is very sensitive to the infrared rays of the sun. That color was important to the fabric, to be like a suntan lotion, it should not be yellow or green but red or orange to be protected. This is why I chose that copper orange for the *Valley Curtain*, in the State of Colorado, which means "red" in Spanish.

The *Running Fence* was near the sea. It again involves a synthetic fabric differently woven than *Valley Curtain*. It is very silky because it was important that the fabric would make the project visible. The white color became more and more related to the life of the ranchers there; their barns and their fences are painted white and the hills are brown gold in the summer (we did the project during the summer). There was also this white mist coming from the ocean. Nylon is a light

conductor and if it was dyed it would be less conductive. This is why the *Fence* had this extreme visibility through the landscape like a topographic line because the fiber was not only reflecting the sun, the light was traveling through the fiber. In surgery they use a nylon filament like this; they put it in your mouth and do surgery in your stomach with the light passing through the thread. In the same way, the sunlight was traveling through the fiber. This is why the *Running Fence* was like a ribbon of light in the landscape.

Question from the Audience: How involved were you with the engineering aspects of the construction?

Christo: I don't know very much in engineering but I have friends who are engineers. The engineer works with a very imaginative approach. Two kinds of engineers were involved: some with the soft part of the project like the fabric and another engineer was working with the steel and hardware. I remember when we had meetings for *Valley Curtain* with the engineers involved with the fabric in Boston; they're very imaginative people and they asked in that meeting to have one bird watcher and one gardener because they can give us some simple ideas.

The projects should be done simply. That was basic. That is very difficult for engineers who might be used to complications. Because it involves human efforts, almost no machinery. Manpower was the most important part of this project. Because everything was done by many people, they should have very little chance to do a mistake. All should be extremely simple like on the tall ships where they have a lot of people working together with fabric. Wind cannot be controlled by machines, every detail is related to the fingers and must be manipulated simply and safely.

Question from the Audience: Could you tell us a little bit more about the Berlin project?

Christo: I come from the east country and I still think that we

live in a two-values system. The world has two values, not only political, but also for moral and aesthetic value and all the differences related to man's existence. I was fascinated by Berlin because I was interested to do an urban project. For me Berlin became more and more the city most evidently touched by twentieth-century history. It is not like New York, London, and Paris, but a divided city: one nation lives in two different places, experiences different problems, and is highly explosive because it is beyond the everyday life problems which involve all historical reminiscence and future historical consequences. All together that is a fertile soil for a project. I try to use a structure of situation that has a meaning for the whole of Germany the same way it has a meaning for all the European cultures. The Reichstag became important in that idea. As I said before, the formal object cannot be disassociated with what it means at present to the human intellect. And remember that I wanted to wrap a public building since 1961.

The Reichstag was built in the nineteenth century and was intended to become the first democratic parliament. It was, but only for fourteen years during the Weimar Republic. It was used by Bismarck and the kaiser, burnt by Hitler, demolished by the Second World War, and then rebuilt by the Germans now at a $75 million cost. They cannot use it because if the actual government uses the building that would create the reviving of German nationalism and the Soviets would be nervous. I remember I was telling the mayor of Berlin that we can use it now for a few days to become a work of art, at least it would be used for something!

The building is not only under the jurisdiction of the Bundestag, the parliament who sits in Bonn, but it is also in the English occupation zone and two meters from the limitation zone with some upper parts of the building sticking out in the air zone of the Soviet army. When they divided Berlin the Allies put an imaginary vertical line in the sky and of course everything that is sticking on that side is in the other occupation zone. I created a dialogue situation. I was aware of it. I was not aware it would start to move such a large number of Ger-

mans, especially Willy Brandt, who is seeing the project as a step in the dialogue between the East-West Berlin relations because, for the moment, the only dialogue they have is about the telephone system and the sewer system!

We don't know if we will succeed; we try hard and we have a fifty-fifty chance. I go next Saturday to Bonn and Berlin. The landlord of the building is the president of the Bundestag, who is a member of the opposition party, a Christian Democrat. The SPD and the Free Democrats are in power.

Question from the Audience: What part of the projects do you like best?

Christo: I don't know. Oh, I think perhaps the most hectic time, when we negotiate; it is very rewarding and fascinating to see. I was in Bonn four weeks ago when Willy Brandt took two hours to talk with me. He does not think I am crazy. He was genuinely interested and he started to think how to proceed to get the permit. I talked with other people, [Helmut] Schmidt the chancellor also, and I see that people start to think that it's possible. Perhaps it is very difficult, but there is a chance to do something and I find that dialogue is in itself creative. They have perhaps their own ideas why they would like me to do the project but also it cannot be overlooked that in the end it is for the wrapping of the Reichstag that all the energies are put up. This building of magnetism and forces is not visible but very real for the friends and people who are involved. For this project, too, I don't go alone. I never can approach these people if some friends don't help me. It is the same way as in California and all my projects.

Fineberg: Suppose you got to the place where the project had so much credibility that you experienced no resistance. If, for instance, you could just go somewhere and say I want to do such and such a project and everyone would say yes. Would that then make your project not worth doing?

Christo: Not worth it, and anyway, it cannot happen because

my projects are thought out to be controversial and subversive.

Fineberg: So it has to stay novel in a sense?

Christo: Yes. In all the projects that failed, I blame myself, because I did not understand the particular problems. I tried to do a two-part project in Japan and Holland, it failed because I didn't really care enough or was not enough aware of the complexity of the social life and the different cultural values of Japan and Holland.

Question from the Audience: If you had to choose another career, what would it be?

Christo: I cannot see myself except as an artist.

Question from the Audience: In the early wrappings that you did, did you later unwrap them, take them apart like the *Fence*?

Christo: No, except for the wrapped women, these objects remained wrapped. It was related to the object which was manipulated. They were everyday objects—a chair or a motorcycle. The objects done in the early 1960s or late 1950s all related to objects which were not wrapped, like often the wrapped chair was together with another chair for comparison. Later, the wrapping became more transparent, the object was visible. The movement was from objects you can manipulate to the human scale of the *Store Fronts,* which was really an interaction, to walk around something, which had the height of man and a door and movement. You cannot go through, the door is closed; you cannot see through its windows, they have a curtain or they are painted.

Question from the Audience: In your barrels, did you hire people to put those up, too?

Christo: Yes, that was in the rue Visconti, June 1962.

Question from the Audience: Do you ever get mad or lose your temper?

Christo: Oh yes, you see it in the *Valley Curtain* film.

Question from the Audience: Do you ever get tired of explaining what you're doing?

Christo: No, it is very exciting, I enjoy to do it. I'm nervous and I'm furious sometimes, but it is part of the work. Anyway, all these problems I created myself, nobody asks me, I can blame only myself. It is my problem that I am involved with those projects.

I was saying before, it is really a matter of communication in all these things, and I owe it to my work, not only to *Running Fence,* but I owe it to my work to have that communication, I can't say understanding, because not everybody understands me. Perhaps my English is poor, but the communication is important.

Question from the Audience: Are your ideas changed by the engineering problems?

Christo: We fight sometimes with the engineers because my idea is there and the engineer's considerations should not harm for one moment the original idea. I prefer to take a chance to keep the idea working to the end. We try to work in that way. It is also with the idea that the work involves risk, and fear; there are no insurance companies to insure a project itself because it is designed without precedent.

Question from the Audience: You have vast expenses, there must be some kind of a profit principle to work with. After you are through, are you just as broke as you originally started? How do you keep paying for these materials, these salaries, these efforts?

Christo: We are more broke than when we started. I am rich

with my work. I was telling already that I collect my work and I have four storages of my works and I buy back sometimes. Nobody gives us money, they buy my art just as they buy other artists' works.

Oh, look, I don't like to talk about that. I remember for the *Running Fence,* when we started to build it, we were thinking that the work should cost us twenty thousand dollars a week. Each week cost us about fifty thousand dollars. That was some hectic moment to match the payroll, it was not easy but we managed. For *Running Fence,* half a million came from bank loans and individual loans that we are now paying back plus interest. I do not have to tell you what the interest is on half a million dollars. The income does not exist since there is no money back; we gave the material to the ranchers, we did not charge admission, we do not sell photographs, and we have no royalties on any of the "after-items" such as the books, films, posters, etc.

Question from the Audience: How far in advance of a project do you conceive the idea for it?

Christo: I don't know how a new project comes. For the idea of the *Running Fence,* retrospectively, I can find that during these projects many things attracted me. Perhaps they lay in my subconscious and sometimes they became the origin of new projects or gave impulses. When we were in Australia in 1969, I was using the erosion control mesh fabric which was usually used to cover the land so that grass can grow there without being taken away by the wind. But the fabric was also used by local farmers to build small fences, three feet high. Those fences were all along the dunes near the coast in Australia and when the earth was moving it was stopped by the little fences. They are published in my *Wrapped Coast* book with the technical description of the fabric I used. That certainly struck me, but I never was thinking at that moment to do a *Running Fence.* So many visual elements are going into these projects; I never know how they will affect my work. There are a hundred things around

and I cannot tell you how something is starting to crystallize.

Question from the Audience: So, when was the day you announced to your wife "I'm gong to build a *Running Fence*"?

Christo: We were driving from Colorado just after *Valley Curtain* was over in the fall, with our builder-contractor. We stopped in a small town, Leadville, and I talked about the *Fence.* It was in October of 1972.

Fineberg: Regarding your idea of "prime time," if the prime time of a work is over, as in the case of something that is two hundred years old, does it then have no important value?

Christo: It is only recognized that the art value is a dynamic situation.

Fineberg: Do you mean that the "work of art" is the relationship of the object with its own time?

Christo: Yes, that is the cue, that is the point of starting. If you don't have that perception, you have the extremely formalistic perception, which is anti-dialectic.

Fineberg: Is it essential for there to be some recognition or some interaction between the public and an artist's work in order to make it art in your terms?

Christo: It is really irrelevant who recognizes an artist, nobody can stop an artist from doing his work. The artist is always doing work that eventually will be public and the artist always wants it to become public. But even so, the artist can do his work for himself and show it to the public or not. There are group affinities with artists and those who enjoy his work, his friends. The recognition is a group of people. There is always some recognition or understanding, some kind of affinity of people to an art experience, or else the artists never do their work. That public cannot be delimited; one cannot say that

Artforum or *Art in America* is the public of modern art. There are different types of public. Of course, some people always try, they need to install the imperial attitude in art, when an American critic can tell you that the sublime evolution of Western art is the flatness and that flatness is the greatest contribution to the Western culture! There is perhaps an official art that does not deal with the real problem of art.

Fineberg: The contribution of art then has to do with the ongoing development of ideas and not with the permanence of the object?

Christo: When I'm using the words "prime time" I try to say that the work of art is a dynamic situation. There is no way to say that a physical object can be immortally equal. Immortality is in the mind. That commodity attitude was basically created by the capitalistic society, which is so much against progressive thinking today; it is amazing to think that progressive artists are so interested in the object.

Anyway, this type of veneration of objects is something basically reactionary, because it involves static attitudes. This is why I try to explain that the mind is the thing that never disappears. Our minds will be as long as man exists on earth, and that is the only eternal thing, the mind of humanity. All other matters are transitory, or frame of reference. Before *Running Fence* there was no *Running Fence*; when there was a *Running Fence*, I think that was the "prime time." It was when I wanted to do it, when the ranchers were willing to let me do it, when conflicts were created. But there is no way to repeat that, there was no way to restore that.

Question from the Audience: Do you think that this could carry over into religion, in that some of the values dictated in the Bible were only relevant to the prime time?

Christo: I think our mind is the most valuable thing in the world. I cannot imagine enough how important our mind is. I was in Israel recently and I went to Jericho. I was driven from Bethlehem to Jericho on small dirt roads to the Jordanian border and everything looked like any other desert, with only one difference: that I can never forget that this was one of the oldest things in the world, that seven thousand years ago people were building all our memories on three hundred kilometers. There is only earth and rocks, there is no evidence, but you know it. It is absolutely anti-dialectic to say that it is not different from any Arizona desert area. You cannot separate things because our whole perception of the world comes from our mind. You cannot disassociate some kind of formal existence from the mind existence, they are working and fit together.

Excerpts from a session at the College Art Association, New York, February 27, 1982, moderated by Jonathan Fineberg

Christo: Sorry for my English, I'm not born American, I'm a Bulgarian and I have been in the United States since 1964. I lived eighteen years in New York City and always tried to do a project in New York City. Of course the first thing that impressed us in 1964 was the skyline. The 1964 project for New York City involved wrapping two lower Manhattan buildings. The project remains only in drawings, photomontages, and a few scale models; we talked with some of the owners at number 2 Broadway and they thought I was a lunatic. In 1968 we almost did that project. That was the ending of a large exhibition at the Museum of Modern Art, and Professor [William] Rubin and some friends, we tried to convince the insurance company, the police, and the City of New York to let us do the *Wrapped MOMA* project. The summer of 1968 was very hot, there were a lot of problems in the street, and we never got the permission and the project again stayed only in scale models, drawings, and photomontages.

One project we almost did in 1968 was wrapping the Allied Chemical tower in Times Square. It was a perfect building—very narrow and only twenty-two stories in height and separate, an entire triangle. It was a perfect situation. We worked hard with the corporate people to convince them but they failed to understand my proposition.

All my time in the seventies was in the west and the West Coast and my interest in architectural buildings and the city skyline started to refocus onto the fantastic amount of people walking in the streets. We were fascinated by how many thousands or sometimes hundreds of thousands of people were walking in the street. We were thinking if we did some project in New York it would be related directly to the human scale. Initially we were thinking of using the sidewalk, but the sidewalk was too busy and too used for rational purposes and probably we would never get the permission. The only place really where the people walk casually after working hours is in the parks. From this came the idea, a proposition of almost two years now, called *The Gates*.

This proposal would involve using almost the entire Central Park, using about twenty-five miles of walkways in Central Park, and it will involve building rectangular portals that will be fifteen feet high. They will be varied with the width of the walkway, they will be built in steel, and from the superior part of the gates there will be hanging free fabric coming down almost six feet above the ground. You can easily touch it with your hand if you're tall. The distance between each gate is smaller than the length of the fabric. That allows the fabric to touch the next gate and become a golden ceiling above your head. *The Gates* start from the openings of the Central Park and continue to the intersection of several walkways and then they start a new departure. There are different starting points of *The Gates*. Everyone knows Central Park was a man made park. It acts like a giant pillow against the concrete structure of the city, which is built entirely on a grid pattern. The walkways were designed by Mr. Olmsted and Mr. Vaux in a nineteenth-century, Victorian attitude of this promenade idea and the very roundish, arabesque patterns. The project will allow us suddenly to see this incredible network of walkways popping through the trees, becoming like a golden chain, shining through the trees. There's always a situation between the open vista and the closed surroundings of the trees. Actually the park was designed with this organization in mind—a processional walk through the park. Mr. Olmsted named several gates to the park with symbolical names like the "gates of the immigrants," of "the soldiers," of "the children." The park is surrounded by a stone wall with very precise entrances—they're called gates. There are sixty gates and about thirty of them have names. And you have continuous movement from the open vista to the closed vista, very much like paintings.

What we try to do with this project, using the space that has never been used aesthetically—this gray, concrete or asphalt space of the walkways. The lampposts are about twelve feet high; the gates will be about three feet higher than the lamp poles. All the work is designed in the space that has never been activated. That space is framed by the corridor of portals, six feet of empty opening and you can walk through

that and above your head you have this very sensual disorder of the fabric moving in all directions. It's a very tactile project because it's quite intimate, and it's very easy to touch. You will feel the organization of the promenade and the space. We would like to do this project in the fall, sometime in October for fourteen days. This is why I choose the saffron apricot color in which we painted the three-inch steel rectangular frame and also the fabric. Some of the walkways were originally designed by Olmsted, but some were designed in 1933 and of course Central Park is full of an incredible variety of walkways. We hope to convince the park to let us use a great number and we're still in the process of negotiation. There's always a casual use of these walkways, you can easily get to the walkways, there's not some kind of gate to protect them. There are many occasions where the walkway goes along the roadway, so the gates can be easily seen from the roadway.

In the fall of 1980 we built prototypes in the midwest to study with our engineers how to build these gates. These are the prototypes of ten gates, twelve feet high and twelve feet wide. In this particular prototype each profile of the steel is different—round, square—and finally we decided to use square because it's a much more handsome connection to the ninety-degree angles and also different ways of attaching the fabric. When the wind starts, the fabric will move more and more until the gates will completely touch together. From the high-rise buildings you will have these golden leaves, one after another, touching together. You can also create an incredible amount of transparency of that color against the very dark background of the surrounding trees. It's much more prevalent than the sky in the midwest, because Central Park has high vegetation and this translucent material is extremely painterly against the background of the trees. This is again fifteen feet high, the last prototype is twenty-four feet wide. This is quite interesting because this is one of few projects of mine where you have a different way of perception walking through the project. You can imagine if you have hundreds of gates like that with the continuously moving fabric above your head.

Question from the Audience: I would like to ask about the Central Park project. I wondered why it was not conceivable for you to choose another location that would cause fewer problems. Say, down near the Battery, a whole new area, it might even be a permanent installation that would be very beautiful. Is that not conceivable?

Christo: No. I never do commissions. All my projects are invented by myself and actually this is part of the source of the energy of the projects. One of the extraordinary parts of the Central Park project is that it's central. It's rich with different types of vitality all around that park from north, south, east, and west, and also by this incredible, surreal situation that the park is framed by concrete blocks, not diluted with the bay, or the Battery Park, or diluted like the Prospect Park with the small gardens and houses around the Prospect Park. Central Park is completely defined by this incredible, almost unreal place. By being so defined, the movement in the park is extremely organized, very precise. It's not like in Battery Park where you have an opening vista to all the bay and the Verrazano Bridge and you see it and watch like that, it's a completely different perception. In Central Park you have all motions in all directions, north, south, east, west, and of course that's one of the most important parts of why I like to do the project in Central Park. The way the park is used by the community, the five community boards and all of Manhattan, is also enriching for the project. The project was denied in a 237-page report. It took eight months for the Park Commission to write that report. We're in the process of reapplying. We're preparing a profound study to reapply for permission for that project. One study was just finished two or three days ago called "Human Impact Statement" by Dr. Kenneth Clark, a leading sociologist. Another study, probably the most comprehensive study ever existing on Central Park, never been done before, is the environmental-impact study, involving the production of the fifty-eight-foot map and one-foot elevation with 157 pages, with the location of forty thousand trees. A never-existing map of Central Park. Of course that study also

involved all the many aspects—the project, the park, the people, everybody is involved. When that study will be finished, probably in the next one and a half to two years, we will reapply for permission. The study is extremely consuming in time and extremely costly, it costs nearly $600,000.

Question from the Audience: The reason I was having a problem at this point is because it appears to be somewhat frivolous to spend all that money for kind of a terrific hype for two weeks when a lot of people are hungry. There is no support from the government for art projects that are permanent installations. It'll be great fun to have this, but I'm not so sure that a lot of people without jobs are going to find it so amusing.

Christo: I'm very pleased you asked this question. I would like for everyone in the room to know that I finance these projects myself. There are no grants, no state money, no anything in this project. The money comes from my original works. You've seen many sketches and drawings. All these original works are sold and we finance our project with our own money. The money does not exist, if the City of New York does not give me permission, I will not accumulate the $6 million, I will not be spending $3 million in payroll in New York City if the project does not happen. The project will only happen if we get the permission. If we don't get the permission I'll do other projects. Anyway, I cannot do the Central Park project in the next four or five years because our schedule is very full for the next four or five years. But you understand that the work is financing itself. The money is entirely the cost of the artwork, we try to save any dollar we can on the project, but if you are a painter and you buy canvas and wood, it will cost you only $100 to do the painting. If you're a sculptor, you have to weld, that costs already $1,000. But when we do these projects, many parts of these projects, which are like building bridges or houses—big construction—and they are in the range of how much it costs, how much material, how much labor in a capitalist society to build that. All the money goes directly to payrolls, to materials, to factories. All the materials after that are right away recy-

cled because they're very new, they stay up for a short time. They're not special materials. All these materials, fabric and poles and cable, exist in construction and are used back right away to public works, to different governmental agencies, and they reuse the materials right away for their own purposes. In a way the material is not lost, it's entirely recycled. Certainly, the irony is the money question. The amusing thing is that if I say that with $6 million I will make $30 million, I would be perfectly acceptable in our capitalist society. But I cannot say that because I cannot charge tickets to Central Park, we cannot make money like an exhibition, there are no ways to have money back. If you do any entrepreneurial work in our society, even make films—how many films ever make money? They spend millions of dollars on films that never make money but that is perfectly normal because it was made to make money. And of course that is actually the biggest problem because the people cannot understand how we cannot make money. One important thing, the City of New York unfortunately is run mostly by the welfare politicians who do not understand that they can make a lot of money with that project, even before it is realized and we're very glad to offer to the City of New York the rights to franchise things, I was willing to give everything to the City of New York, especially Central Park. Central Park can make quite a lot of money, even before the project happens and that money goes directly to Central Park. It's a matter of having creative, inventive people around the Parks Department to find that they can make money.

Fineberg: Really, the project has already generated that in the sense that it has created tremendous consciousness about the park, people are now starting to study environmental aspects of the park that had been ignored before. The environmental study that you're making is something which they couldn't afford to do.

Christo: Yes, for example, the study that we're producing for Central Park for my project is very important because it will be the most finely detailed topographic study of Central Park, but

also it will be everything under the ground and above the ground that the park has ever had. The last map of Central Park, which was much less profound, less accurate, was in the 1930s. The City of New York will save about $7 million with my map when the map is ready. Because with that map they can do all kinds of work after that because they will have the 155 large sheets and any work they do, like preparing some water pipes or something, they will know where it is. The project will produce a great amount of beneficial parts that the city can use at a later date.

Question from the Audience: Is there any part of the Central Park project that they accepted and, if so, would you be willing to work with that core and possibly generate something?

Christo: With the walkway system, the network of the walkways, I was not precise. I would like to use a great part of the walkways, I don't say we have to use all of the walkways, anyway I don't like to use all the walkways, but something between 55 and 70 percent. I will not do it with only a thousand feet of the gates, not only a little thousand-foot stretch of the walkways. I like the park to entirely become a network of the gates, it will have that feeling that you walk through the marvelous things. It would be very pointless to do only one area and, of course, this will also be the first time that a work of art in Central Park is entirely through Central Park, not only some location, which is usually what happens. They locate it mostly on the south end or in the middle of the park.

Question from the Audience: Is your work controversial? [Laughter]

Christo: Other questions?

Comment from the Audience: I would find a 230-page document a very intimidating refutation and you seem inspired by it.

Christo: I find it very inspiring in a way that is like abstract poetry. You have a man who is very serious, he's a lawyer from Harvard and he's in that job and probably he'd like to become secretary of state later and he's involved in discussing that project very seriously. You have a lot of humor and it's refreshing, I feel honored to have that printed and distributed to many places like City Hall and to have it evaluated. He adds a dimension to the work, no matter what he thinks. It's a new dimension because I never think the way he thinks. That enriches the project, it gives it all kinds of angles of perception. It's very revealing. I would be very arrogant if I knew everything about the project. Today, after two years with *The Gates* project, we know much more about it; it would be a lie to tell you that in 1980 we were aware of all that. That is the inspiring part of these works, each work is like a great university for me and Jeanne-Claude and for a number of our friends. Like an expedition, it is enjoyable, frustrating, and is not boring because it's always new. It would be very boring if all my life I was doing projects in New York City. But I'm doing projects in California, and Miami, and Berlin, and Paris, and the Middle East. That keeps it very stimulating.

Question from the Audience: You said about the New York project being a possible source of revenue for New York. You have the funding for the Florida project and I understand it will be completed by next year. How could Florida or Miami make money from the project?

Christo: The Miami project is also financed by the drawings and collages you saw here. My dear wife sells them to dealers and collectors around the world. The funding is in the process of being accumulated, with the cost of $1,250,000 for the Miami project. Basically, you need permission to do things in Central Park, even selling postcards, t-shirts, things like that. People can do a lot of those things. I am not in the business of exploring this, but this can be done by any company in the United States. In the Miami situation, I don't know how the

City of Miami can do this, only I know that we spend around $1,200,000 and probably around $600,000 in payroll, we hire people in Miami, we directly hire some young people, and we make almost the entire project, the physical making of the project will happen in Miami, the fabrication of the fabric, and the whole installation.

Question from the Audience: It has been reported in the Miami press that the money was raised privately by the citizens. Several private citizens have contributed a million dollars to the project. This has been in the press.

Christo: This is not true.

Interview in the artists' loft, New York City, April 16, 1983

This interview took place about two weeks before the completion of the *Surrounded Islands* project in Miami, which was foremost in Christo's mind when we spoke.

Fineberg: How much control do you really want to have over the use of television and media and films in relation to your projects?

Christo: Do you mean to include the post-object situation of the work, like the film of the Maysles brothers?

Fineberg: I'm including that.

Christo: Anything after the thing is done, when it's removed and it's gone, everything after that is a matter of interpretation. Even though we publish those big books and we select thousands of documents, again, they are a selection, you can't print every little document, I cannot print three days of the Superior Court record. That would be impossible. The selection is our interpretation. I cannot print all the minutes of all the hearings; we select some hearings. It's very human. Also I will mount an exhibition and it will also be a selection. All the material is really cues for reference, if I do it myself and we do it very freshly, right away after the project, while I remember all the original documents, so we forget less things. This is why always the exhibition and the book we like to do it very fast, when we're very fresh with the work. I cannot return back to the Miami project next year, imagine, and start editing the book. I'm not a moviemaker, I'm not even a photographer. Really I trust enough professionals. I like the work of Wolfgang Volz, and I am satisfied with the thousands of materials he has supplied for the book. With the film, much more I really don't want to be involved with the film, and the Maysles brothers are doing the films in a way like they are writing, like you write. In a way it is their interpretation, like it is your interpretation. This is your work of art, you interpret it. I am rewarded that it is written that way, but I am not involved with it, I am not in that media. These are things that are directly related to me and to the project. There will be hundreds of other official and nonofficial people involved with recording the project, like the young students, or schools, or video, people like to do film for their own reasons, officially for television, for some channel of the news, or for their private uses, and I cannot really police that, and even I don't want to police that. Very much in the same way, we can't police how the project affects the people. Even the filmmakers, they are photographing, they are making illegal t-shirts, they are making all kinds of things. It's impossible to police, physically impossible. You can stop them, you can sue everybody if we are not happy with the way they use the image, technically we can stop them, but that's baloney, we have the copyright, but who can do that? Nobody can do that. The work is a public image. An open space can be used by anybody for anything. Now, if that is harmful to the project, it's part of the sociology of our time. . . . For example, nowadays, three locations, Hialeah, Opa-locka, and Interama [the locations of construction sites in greater Miami where fabrication of booms, sewing, and assembling were being done by Christo's workers], none of the media are permitted to go there except our people. I don't want to disturb the workers, and I think it's a private space when I come there, it's like my studio, the home. The moment the fabric is in the water it's impossible . . .

Fineberg: But on the other hand, for example, you did make an agreement with *Life* magazine or *Stern* that they would have an exclusive right . . .

Christo: Not exclusive, we make an agreement, this is another thing. We're very cautious when we do a project that some influential or important newspaper or magazine will have good, firsthand information. . . . When *Life* magazine or *Stern* magazine, a year ago, asked us to do the photographic story, they are basically image magazines. That is more related to the visual dimension of the work. That's why we were agreeable and

happy they were interested. There are very few visual magazines that have a circulation like *Life* or *Stern,* apart from the art magazines, which are professional or trade magazines. That is a very natural thing. We were very eager. I work for twenty-five years around the world and I feel very responsible, I care about some publications, not only that they have a better critical understanding of my work but, in another way, it's important economically, to support my work. Like in Germany, and England, and Switzerland, in places like that where we're selling. This is why we care about that, like *Die Zeit,* making stories, *Frankfurt Allgemeine,* making stories. That is part of our responsibility to the project. That is not coming from a public relations man, that is coming from a long relation with some people at that press. It's not like we are screaming, "Come to see the project." Werner Spies will come, even Professor [Tilmann] Buddensieg is coming, people who are involved in some way, like Buddensieg is involved with the Reichstag project, he's a member of the Kuratorium [an organization formed by a group of prominent Germans to help obtain the permit for the *Wrapped Reichstag* project], and different things. I know that for example last week I was in Miami and the UPI was very upset because we did not let people go to the site, to our factory. We have never, Jonathan, had so much pressure by the press like on that project. Nobody was photographing our hills in California before when we were putting in the steel cable. Nobody was interested to photograph our yard or our fabrication of the things in Colorado. Practically, these places are very private, they're closed areas. There's no reason to be open to the media. The media, now, I understand that the pictorial magazines, they are very eager to have full access to sites because the moment the fabric is in the water, everyone can photograph it. The UPI was screaming, saying that we're manipulating the press.

Fineberg: So, you're saying that you aren't attempting to control anything about the life of the project in the press—you only want to maintain the privacy of your workspace so that your workers can do their jobs without interference?

Christo: We don't make the control. The project is in the public domain. Like Philip Morris opening the midtown branch of the Whitney Museum. Philip Morris has its public relations agencies, they send press releases, they send people, they call newspapers, they invite them. We don't do things like that. We have a press buffer on the project. But we never do any of these things except as a courtesy when the people ask us, such as *Nightline,* or ABC or CBS calls, we try to give some information. If there was some movement on the press this year around the project, that was completely generated by the conflicts the project had with the opposition. The project carries its own public dimension, in the trials, in the public hearings, exposed to criticism of the south Florida media. We were not very flattered by the press in Florida. For example, this week the *London Centennial* magazine published a story, but the *Miami Herald* has a Sunday magazine but they didn't even approach us to do a story. Now they cannot do the story because there are all the pictures in *Stern.* The funny thing is that the media were ignoring us, probably they were selling more papers with the opposition's hysteria, but that is their problem.

Fineberg: My question has to do with something really a little different. There's something different about the way an artist has to function now as a result of that awareness, and you are, in a way, the most extreme example. I guess what I'm asking is that, are you aware as you plan a project, or think about what it is as a visual thing, as an aesthetic object, how much does your awareness of the way most people are going to perceive it through television, films, and pictures affect what you do?

Christo: I think it's all mixed together, Jonathan. You cannot separate that object formally like it exists in a pristine situation. It's on the real site, what does it mean the real things? A sunny day, a gray day, the late afternoon, early morning. There are many things in that project working visually. It's not like a Brancusi sculpture that can be put in an absolute vacuum. By being involved with so many natural elements like a garden, the project is so varied, so complex, the perception of the ob-

ject itself, even if you're there for two weeks, for ten days. From that moment, everything becomes much broader. There's not one vantage point that should be seen or a unique point of perception. If you never take the helicopter, you will see in a different way the project, you will see only very near or the window view, it's not that you don't see the project. Psychologically what's the meaning of seeing the project? If you were living in Miami for two and a half years and you were exposed to so much information and different views, you really can see the project in an abstract way there in the water, and if you live in Miami you become familiar with a tropical life, if you're from the north you're coming down, or from Europe, or South America. All these things are different. On top of that comes the interpretation of the media, who transport the image by electronics, at the same moment, at the same hour, and of course journalists control this presentation. They're all slices of different types of interpretations. I think this is how the work is. Even while we're in Miami and we go to see the project and everything is going well and in the evening we see it on the television and we are just five hundred feet away from the project. All that is a part of perception. We can't ignore that.

Fineberg: I want to be clear about the relationship between what the project is as a visual, aesthetic object and what it is as a media concept.

Christo: I think it's very simplistic to say "media concept," what is a media concept? You can say that the war with Vietnam is a media concept. The war in Vietnam is *used* by the media for their own purposes, but it's not a media concept.

Fineberg: Well, it has a dual existence.

Christo: Yes, it's a dual existence but you cannot separate it, I really cannot separate it. Even if you were really in the war in Vietnam and some reports cannot match the horror or it's not reported correctly, still, it's a comparison between the misinterpretation and the reality. That comparison creates thinking.

That reinforces the real thing because it was badly interpreted or misinterpreted. That reinforces the real object.

Fineberg: Do you think that idea was already a part of what you were thinking about in the early packages, the comparison between packages where an object is wrapped and not wrapped?

Christo: I really was not aware and the electronic news was not so powerful at that point. For the moment, we really like to forget everything else, and we are bombarded by problems; the only thing is to complete the project. Five, six months ago it was more relaxing and valuable to consider some television and newspaper coverage but today, we don't want to think about that. It's very exciting to see the way the project builds this energy at the very last moment. The most important thing is to make the object, this is the key thing. All other things become secondary. That is how the press is excited, because they become secondary to the project. They don't exist before. We want to be cautious, they might report something wrong. But then it's already over, we're at the end of the object. That creates the power of the work, that the work is controlling them. We try to put away the media to make the object.

Fineberg: What is the rate of production of the collages? How many do you make?

Christo: In two and a half years, we could probably estimate one piece per day but this includes small painted photographs, everything from the very small sketches to the big drawings. I know there will probably be about 140 collages by the twenty-fifth of April; I'll come back around to finish some work. There are around 65 large drawings, and there are about 25 medium-size drawings, not very much. They're all numbered, and the single collages I have not counted, there are maybe 30 to 35 single collages—the ones not in two parts. There are about 260 pieces total. This is much less than *Running Fence*, which was about 500 pieces, because of the length of time we

worked on that project, and physically there were a lot of changes. I have hundreds of pages of these photographs; I don't calculate them, they are only materials. Later I work on some of them and incorporate them into collages. It's not much in thirty months.

Fineberg: So the fact that the project has taken thirty months means that you make fewer collages and drawings than a project that has a longer gestation.

Christo: It's difficult to generalize, you cannot say that the project in Kansas City, technically it was realized in Kansas City but if you go through all the ideas of the walkways, the early things from Sonsbeek park and Tokyo park and St. Stephen's Green and all that put together probably you can get much more, Kansas City is only a small part, the end of an idea. It depends, some projects have more elaborate thinking, as in the case of the *Pont Neuf* or the *Reichstag*. It's often a slow process to work out. For example, I don't think I did so many of *Surrounded Islands* because in the beginning it was very difficult to sell, nobody liked them.

Fineberg: I see, so it's the economics too.

Christo: They just didn't like it. It's always like that. When a new project starts formally, a new project, I remember *Running Fence,* people were used to the orange curtain, no one wanted to buy the white *Running Fence*. We need to build up that consciousness. The same thing with *Surrounded Islands,* there was not an understanding of the water and the fabric, it was too informal, there was no form in that, no structure. With *The Pont Neuf* or *The Gates* there were more visible elements, more structure. All these things are very curious. That visual understanding comes from a long exposure of the idea through the media and through public hearings. It's important to have the time for the project to become a reality. It's always necessary to have much more time to do the project not only because we need time to get the permission but also the people

understand what is the project, and the project will suffer if it is done right away because there will be not enough understanding. The *Surrounded Islands* took more than a year, you remember it was supposed to be part of a festival last summer in 1982, and actually we benefited because not only it was not possible to do the permits and get the material ready, but also because there was not enough in the minds of the people. There was not enough time to put the project in the minds of the people. The project will be less important if it's done right away. The people need enough time to have an understanding of the idea, and develop some kind of relationship with it.

Fineberg: How do you see the collages? Obviously they're a means of financing the project, but to what extent do you find yourself really learning new things about the project through them? Or are they more about disseminating the idea of the project?

Christo: All these things. First, the first collages are awkward, very simplistic, people even don't like it right away. Even for myself the idea was not clear how to visualize it. I was not capable of visualizing it. In the last collages, people can see that there was a long process of understanding the physics of the project. And that happens not only because I read books and I go through all the technical drawings, but because I was exposed to the real things, through the evidence of the real material, to the structure of the design of the engineers, to the life-size tests, to understanding the power of the color, of the structure of the surface. The collage and the visual impact is developed through the making of the project. It's always the same thing. If the project was canceled two years ago there would be only twenty collages, twenty drawings, it would be only a very loose proposition.

Fineberg: How much of that change in your understanding of the project was actually affected by the collages themselves? Are the collages only a reflection of the evolution of the idea? Or do they help you understand the idea?

Christo: I never begin with a precise idea. The proposition is very loose, even formally, for myself. I don't come like an architect to design all the formal things to give to the engineers. Only by sketching a very loose proposition, I try to correct and organize a formal vision of the project, more beautiful, more exact by working together with reality, how the project should be done. For example, in the early drawings for *Running Fence* I designed very heavy poles; later the poles became much thinner. In a way, they became more handsome. For *Surrounded Islands,* the very outline of the fabric edge of the material in the water was of no importance with the first collages. The fabric was finished 200–250 feet away. But there was no thinking of how the fabric would finish. Later, after being at the islands, I understood to refine that edge, to create an artificial separation between the water and the fabric, and it would become this 100-foot-long section. All that is something not because of my drawings and asking the engineer to do it, but because I was there, and I tried to learn things.

Fineberg: Did making the collages substantially contribute to your formal conception of how it should be? That is, when you thought out more carefully how the project would terminate in the water, is that something that you thought out because of trying to work it out in the collage or is it something you thought out and the collage was affected by the reality of the test?

Christo: This is the importance of the real thing. This is the very essence, they are not concepts. This is why it is so important that the project is realized.

Fineberg: So they're not really preparatory studies then?

Christo: In nature, I cannot install that thing, it was impossible to install it. I only have the idea by being there and it transforms into a collage. I draw it to see. In nature, I cannot make that edge. I became sensitive to that in the real place. From there, I come to put it on paper to see how it will look. In the real place, I cannot have hundreds of pieces of material to do that. It's impossible. It's all before the test.

Fineberg: But then when you put it on to the paper . . .

Christo: I visualize on the paper what I've become sensitive to in nature.

Fineberg: So in other words, there really is some kind of a thinking process about the ultimate effect and the ultimate object which is going on in the collage itself. It's not simply just an illustration of where your thinking is in that point of time—it's actually something being worked out in the collage?

Christo: Yes, I work it out in the collage because I'm not aware how big will be the booms, and all these things. It's not ideal things that I propose here and impose there. That is not only with the *Surrounded Islands*—with all the projects, the reality was the most resource rich inspiration for improving, if this is the right word, or developing the idea of the project. The concept was there basically. But many things, like why two hundred feet, in the early collages and drawings, for example, they weren't two hundred feet. These two hundred feet arrived because I was on the islands and went around to check the width; these real things are very important in how things develop. Even the color, the color became so pink—that came from seeing the tests. The collages have some kind of private relation, it's almost like my diary, in a way. In the studio, this is the only time when I'm alone. I have no engineers, not anybody. I like to work alone with no assistant. I like having this privacy and I can only hope that this project can happen by making visual art and photomontages and collages. Of course, I need not only to make the money but I need to assure myself that things can happen.

Fineberg: So you're not thinking of the collages as important for the dissemination of the idea to people?

Christo: How much can 260 works in an exhibition do? Even if you publish a book with 500 copies, how many people have that?

Fineberg: Another aspect of the projects has to do with the way they short-circuit the normal consumerism in art. Collectors cannot buy a project. There is some kind of exploitation of the situation of capitalism, and yet the project negates the central idea of capitalism, which is the accumulation of capital. You're not making any money from the project directly, you're spending tremendous amounts of money to do it, and in the end, what you have is the realization of the project and the perception of that project and of you as an artist by the public. In the normal sense of enterprise in a capitalistic system, you should end up with a huge sum of capital, which you don't have.

Christo: The project addresses many issues of reality, many things. The visual, the formal, the aesthetic. At the basic level, I think the projects have a subversive dimension, and this is why I have so many problems. All the opposition, all the criticisms of the project are basically that it puts in doubt all the acceptable operations of the system that we should follow normally. If the project was a movie set for Hollywood and we spent a million dollars for the movie, there would be no opposition, they could even burn the islands to be filmed and there would be no problems. The great power of the project is that it's absolutely irrational. And that disturbs, angers the sound human perception of a capitalist society. That is also a part of the project, this is the idea of the project, to put in doubt all the values of everything. Of course, this is also the objection of Gordon Davis. He cannot see how five or six million dollars and human energy can be spent for only two weeks. It's not even for money. It's not a good example, it's almost obscene that so much human energy, including my own energy, should be wasted in such a stupid way. That's the very exciting part of the project, it creates such a unique relation with the community. I think the basic problem of the work comes from there.

Fineberg: One of the big differences between you and, say, Muhammad Ali, who brings in so much money on a single night, is that in the end he has the money, he goes and puts it in the bank and that's normal, in capitalism. But you don't have any money when it's over, you spend it all on building the project.

Christo: That drives them berserk. First because they think it's not true. They think we have some hidden resources, that we're lying. Secondly, if it *is* true that is almost imbecile, stupid, impossible. And really probably this is the most powerful trigger part of the project. This is why affluent people living around Central Park were so upset with the project, because they think that generosity is only the privilege of the wealthy. They cannot understand that. For example, it was very funny to see that the CVJ Corporation, our corporation, which is a normal for-profit corporation, is the third largest corporate spender in the United States for the visual arts after Exxon and Philip Morris. All my difficulties in the art system come from this individualistic attitude we have, myself and Jeanne-Claude. We have problems, we suffer that we don't sell here because we are outside the way that art is practiced here. The difficulties we have in Miami are a part of that, a continuation of that relation. The money situation is a very important part philosophically, not just in some kind of pragmatic way, the realization of the work is much more than the money. To realize the work is beyond everything we can count in money and everybody will understand that the money counts for nothing. It's much more the things you do that counts, the things people believe you can do, the things you can achieve, but not money. Of course, in American society, everybody is calculating "he is worth a hundred million dollars or three hundred million dollars," but I don't think this is calculated when you talk about Kissinger, no one asks him how much he is worth, but how much he can do.

Fineberg: In the American version of capitalism there's a kind of credit power that you have by virtue of the public awareness of what you do and how successfully you do it, that is even

more valuable than the money. Your celebrity as an artist has become bankable.

Christo: Still I think the money is irrelevant. The question is that these projects give us much greater capital than money, that we can continue to negotiate the Berlin project, or have a chance to do the Pont-Neuf project, all these things. Probably I would never do these negotiations if I had not been capable to do the *Valley Curtain,* or *Running Fence.* The credibility is so much more than money. It's immeasurable.

Fineberg: Does this issue of credibility, especially with the new role of the media, together with the finances of projects like yours mean that to be an avant-garde artist now is altogether different from what it was in 1920?

Christo: Yes, of course. But the avant-garde in 1920 was an invention of the twentieth century. It was really involved with the shocking attitude, contradiction attitude. Art in the seventeenth and eighteenth centuries was really not based on contradiction, art of the kings and the Renaissance. There was certainly a lot of jealousy and competition based on commissions, but there was not really this type of aggressive, shocking new attitude which started to develop in the mid nineteenth century with a new philosophical thinking, . . . starting with Courbet or Delacroix or Turner, these are the first artists who really created something that the people saw as not art, as mockery, and they were spitting on their paintings in the salons. That was something that probably historically happened, but never in that way, and it developed this type of very peculiar movement of art directions. It was always that friction with the vision of society, of art. I think this is continuous. In the 1920s the other human activities were more turbulent . . . there was the Bolshevik revolution, and the fall of the Austro-Hungarian Empire and all these things were happening in Europe. I think art was reflecting that huge burst of confrontation. Today it's really different. In the twenties, art was practiced in very small circles.

Fineberg: Do you think it consequently had very little effect?

Christo: No, it had a great effect. It was practiced in intellectual elites in a very private situation. Overall the human relations were still very private during that time. Because of the media, the communication, the services of the electronics age were not there. Human existence today is so much exposed to affect other relations beyond the closeness of a small group of people not because we like to know more but because we're capable of producing all those elements that are all around us. In 1920 in Moscow, Zurich, and Berlin the documentation was in such a different way. Now we're confronted with the enormous immediacy of information, of knowledge. It's a different kind of chemistry and I think this is very important to the understanding of contemporary art, the type of evidence that surrounds us all the time. It makes for adventurous behavior, romantic, secret . . . I think that is because society is like that. And of course there is always an avant-garde because there are people who try to do new things, it is irrelevant how more new or less new they are. But the trend is still there, since the mid nineteenth century there was always that provocative attitude vis-à-vis the public and it continues.

Fineberg: Did you learn about the Russian avant-garde when you were very young, from your mother? Did she tell you about Mayakovsky, Meyerhold, Tatlin, Goncharova, Lissitzky?

Christo: My mother was an administrator in the Fine Arts Academy in Sofia in the twenties, around 1922, '23, until she married my father. Of course, that was the moment of the immigration of the White Russians from Bulgaria to Paris. Most of the people who escaped to the West escaped from the south part, through Ukraine, Romania, and Bulgaria and after that to the West. Or from the East, like Tatyana Grosman, they escaped to Mongolia and China and Japan, coming to America. My mother was born in a Macedonian revolutionary family, and she was very keen on the socialist movement. She was very close friends with many people as a young girl. This is why, in

the early time of the Bolshevik revolution in 1917, she had a great amount of literature and material coming from the Soviet Union. There were a number of Soviet people in Bulgaria who went back to the Soviet Union. All that was activated by her interest in art and working in the Fine Arts Academy in Sofia, where she met a number of Soviet artists, theater people, actors and movie directors who were passing through there, some of them were teaching. We had a lot of literature, and it was beautiful, actually, it was all burned. Many great poets with woodcut illustrations, Lissitzky, Malevich, . . . We had these books until the Germans arrived in Bulgaria in 1940, thousands were arriving, it was called "blockade." It is where they block the town and they were searching home by home. I think somebody told them my parents had these books, and my father burned them before the German army arrived at home. Later, in 1945–50, a number of these artists, a lot of them were old people, they all lost their revolutionary ideas, like [Sergey] Vasilyev, the movie director, and people like that who became Stalinist. . . . These are the things I learned through the material my mother had, and some of her friends were still living in Bulgaria. In the wartime I was very young. Bulgaria was allied to the Germans and we had to evacuate to the mountains. The schools were closed, the theater was closed, and much of the artist friends of my father were living with us up in the mountains, while the city was bombarded by the Allied forces. I remember a Russian director was there. This is how I gained some kind of understanding about the Russian avant-garde. Later I learned much more when I became older, like fifteen, sixteen, there were a number of these artists teaching at the art academy while I was there. Many of them became "artists of the people," the official title of the socialist regime.

Fineberg: So they did talk about the old days?

Christo: Yes, and of course much of the visual material was very poor because they were old books and old photographs. But the ideas were there, the architects, artists working together and doing things.

Fineberg: That's an interesting parallel to your way of thinking about art as being an idea that's created in the mind more than in real objects.

Christo: Yes.

Fineberg: Tell me about [Emil] Burian.

Christo: Burian, I don't know when, but I know he was very close friends with Brecht in the thirties. When he was in Leipzig, I don't know. He was half Czech and half German. He was a very powerful communist. And he was favored by the progressive, or less dramatic, Czechoslovakian communist party. They allowed him to have his own theater in Prague. This was before the heavy times in Czechoslovakia, he was one of these who was using the theater to revive the mystic or Gothic play, or a Mayakovsky play of the twenties, and some other writers. It was highly expressionist theater, with no stage, no central focus, using a format that would go all around the room.

Fineberg: So the audience was right in the middle of the action?

Christo: Yes, it was going all around the room. Mostly it was involving some kind of links between the audience and theater. There were themes from the media of the time, and probably some of the plays of Mayakovsky and Alexander Bloch. I got to Prague to see this when I was twenty years old. After that, it was very difficult to go there, because of Stalin. After Stalin until Khrushchev, during the defreeze of the situation, they permitted you to move between the socialist countries. Before, the movements were controlled. Several times I tried to go earlier but they would never let me pass until 1956. When I asked for permission I mentioned that theater, which was not permitted to come to Bulgaria, I like to see original works of modern art because in Bulgaria there was not anything, except the Skira books, I remember, and even they were not permitted to be seen, but I had a friend in the French

embassy where I could see the Skira books. The National Gallery in Prague had a very good collection of early-twentieth-century art. It had taken me three or four months until the Academy in Sofia agreed to let me go to Prague, it was very difficult to get the visa. Finally I got the visa just two days before the revolution started in Hungary. When they started the revolution, they closed the borders of all the socialist countries.

Fineberg: But by that time you were already in Prague?

Christo: Yes.

Fineberg: What was the content of those plays?

Christo: I remember a Russian one, by Mayakovsky, called "Cloud in Pants," or something like that. A lot of satirical, a lot of expressionism. I vaguely remember the story, but there was not really a story, it was mainly about marital indiscretions or the involvement between two characters.

Fineberg: So it was the form mostly that you were interested in?

Christo: Yes.

Fineberg: Had you been reading Brecht?

Christo: No. I knew a little about him but I was never greatly affected by him. Through my brother who was an actor, I was close with a lot of theater directors and movie directors. Most of the movie directors were much more exciting. Visually, there were much more physical images, great expressionist films. That was very exciting to see some of these films. Some of these films were not permitted. Even some of the films that had very political, propagandistic ideas were still visually powerful.

Fineberg: You had a Marxist training but you don't consider yourself a Marxist, right?

Christo: I don't. It's very difficult—what is Marxism? Certainly, I should give credit that I learned many things about the capitalist system.

Jeanne-Claude: Do you mean "Marxist" the way it has been deformed in today's deformation or really what he wrote?

Christo: Marx was a very good writer. Every writer from the Soviet Union, or China, deformed it in their own way, and I'm not familiar with the new writing and interpretations but overall Marx and his pupil Mr. Engels, . . . I can say that it was a very enlightening training.

Fineberg: In what way?

Christo: We were learning Marxism and hating the capitalist system. We were also learning the socialist system as paradise, the writing of Lenin and Stalin, or other theoreticians of the Soviet vision. Because the capitalist system was so criticized in depth, probably it was very helpful in my understanding it better when I came here.

Fineberg: Is there any influence from the Marxist-Hegelian idea of thesis, antithesis, and synthesis in the way your projects are conceived?

Christo: No, the project is much more organic. I don't like to think in that way. You can find some reference. I find the most exciting thing about this project or other projects is the creative process. I think the creative process is the essence, the most stimulating thing for me and for Jeanne-Claude and for our friends.

Jeanne-Claude: When Christo says "friends" he means "collaborators," we don't have any friends who are not our collaborators.

Christo: It's fabulous. I was down in Miami, to see these incredible things—the things became real. A thousand pieces

from the last two and a half years, all kind of little contacts, physical elements, and all kind of connections moving to that end and we were two weeks before that very end. It's absolutely unbelievable to see how the things work out. They're human things, they're not really like objects. It's not like the fabric or the rock, it's not a job. It's some great thing, some kind of chemistry. I find it so exciting. That is why it cannot be dissected into pieces. It's too organic and unique, because it cannot be repeated. It would be too unfair to schematize these elements.

Fineberg: So everything tends toward that end, the realization of the project, the excitement of the moment when all the hypothetical details become real and merge into the actuality of the completed project, which is so much more than the sum of its parts. I understand that it's a multidimensional human experience, not just a physical object, and it is not theoretical or based in a theory. But, on the other hand, your approach is influenced by certain important things you have read, and I recall that you mentioned to me one time an article that Engels had written on the fabric mills.

Christo: He was discussing the different actions of humans, . . . Engels was saying that the evolving process of making a fabric was one of the greatest milestones, it was like agriculture, actually, because humans put together several times the fiber to make a cloth. It was like primitive man who created the agricultural society, he learned the repetitive process of producing, of creating. I don't know what book that was in. I mentioned that in some lecture, that cloth is very close to humans. My projects have some kind of hidden primitivism, a primitive attitude, like a tribal attitude, a tribal situation. There's a very tribal attitude in the way my project is realized, put together by many people.

Fineberg: Is it really the idea of the interweaving of the fabric that makes it . . .

Christo: The fabric is fitting in very well, it almost comes

down through a nomadic, tribal situation, that use of the fabric is working with that, not because it's fabric. Overall, by injecting that nomadic type of form one can have a link, or some kind of teamwork or collective work, or tribal work. [Here Christo refers to the nomadic tribes of the Middle East who suddenly appear out of the desert and create tent cities, and then disappear just as quickly and mysteriously as they came; this relates to the intriguing evanescence of his projects.]

Fineberg: I've often heard you say—and it's one of the worst things you can say about someone from your point of view as I understand it—that a person or an idea is "anti-dialectical." This seems to me to come from a Marxist perspective. It implies a belief in progress, and a faith that ideas have an effect on the collective evolution of thinking at a given point in time. You've also said that works of art have a prime time when all the forces come together that make them happen, and that their impact is greatest at that moment but that over time they lose their impact. Doesn't the intended permanence of the *Mastaba*, the project for Abu Dhabi, make it anti-dialectical, since it wouldn't come down after a brief viewing period?

Christo: No, I don't think so. Nothing comes down, even the projects don't come down, that is the story of the temporariness of the projects. But that is philosophy if really the removal of the object is the removal of that project. That's not true. Because most of the project will stay there, the hills, the water. The fabric of *Surrounded Islands* is a small part of the project. You cannot say that the fabric *is* the project, that wouldn't be fair to the project. The same with the *Running Fence*. The fabric is removed but overall all the other elements of the project are still there.

Fineberg: But there's a difference with the *Mastaba* in that it's a permanent structure?

Christo: The *Mastaba* is a very archaic project in some ways. The form is not invented by me, the situation is like a land-

mark or a focal point. You can find some idea of that, for example, in the project in Kassel or in *Valley Curtain*. *Valley Curtain* is much more an object there than *Running Fence* or *Surrounded Islands,* or *Wrapped Coast*. The *Mastaba* acts more like a thing in itself, in a way like Kassel or *Valley Curtain* were acting. By using very humble, ordinary industrial packaging material, barrels, and metamorphose them and interpret and arrange them in different ways. I like the idea that the project can happen in a place where there is some kind of indisputable understanding of permanence. Because here, in the West, nothing is permanent. But there it is, not in the physical way, but in a philosophical way. I don't think this is against that because even that project could come down. But also they have a lot of anachronisms. It can happen only there. We need to have a king, a supreme, absolute power. It's incredible, unbelievable but also believable because it can probably only happen now and not later. All that is why I think the project is important. It's like the object, also, the wrapped objects—do you find them an anachronism? They stay: they're not like onsite sculptures.

Fineberg: Can you talk about how the projects begin? Do you first have a visual idea and then find a particular situation in which it might work?

Christo: Sometimes we choose a site we know like the Pont-Neuf and we wish to wrap it. Sometimes we have an idea and we must go find the site for it, like for *Valley Curtain* or *Running Fence*. You cannot separate the idea, there are a lot of affections between the place and the idea. Probably I would never do a project in California if I was not so affected by California since the early time I was here, in 1969. It was very curious. There are the elements I am interested in—the water in Miami, things like that. It's a very slow process of putting things together. It's not clear for me. It's not that I have hundreds of ideas in my drawer and I try to find a location. For ex-

ample, I like Japan but I don't know what I will do in Japan. I tried to do the walkways in Ueno Park as part of a two-part project with Holland. I like many things in Japan. Somebody asked would I wrap something in Japan? Probably not. Probably one day I'll do a project but I don't know what it will be formally. It will have an affinity with the space, with the artificiality of everything there and this is key for me. But I can't say I will do something that will be like that . . . this is a growing relation to that place.

Fineberg: How do you feel about seeing something that grows as an idea in your head and all of a sudden it becomes a reality on a huge scale, affecting real people?

Christo: That's an enormous joy. We have never seen it and we only get two weeks to see it. It's an enormous fascination. In the same way a project becomes very private. I want to see it only for myself probably. It's almost like when I draw. It's very difficult to anticipate how people will act. I know that I will be confronted with incredible things. We had a foreman's meeting when I was in Miami Wednesday night and we took two or three hours, we were really knocking our heads to invent what will happen, we cannot think about it all in advance, not just all the rational, pragmatic things, but all kinds of crazy things. This is the most beautiful thing, you cannot believe it. It's always related to how people will move through the space. First, we want to do the project safely and we don't want to have the project damaged. We don't want to have problems. It's very curious, all the discussion was about how the people will react because it's in the public domain. We need to do that every day, to think about what will happen. Of course, it's very beautiful to see all that growing energy the work develops, a kind of anticipation. Probably lots of these things won't happen, probably they'll move in a different direction. The energy is probably the most rewarding.

Interview,
New York City, July 25, 2003

The similarities of Christo's views in this interview to those expressed in the 1982 interview that appears earlier in this book show the remarkable consistency of vision in *The Gates* over the project's long genesis.

Fineberg: I want to talk about the origins of *The Gates*.

Christo: The first time we arrived in Manhattan, in 1964, coming from Europe, the skyline of Manhattan was so impressive, we had never seen so many tall buildings, great blocks of buildings and high rising structures.

Jeanne-Claude: From the prow of the S.S. *France* at 5 a.m., passing underneath the Verrazano Bridge, not yet finished, suddenly we saw it, there it was, standing in front of us, the postcard of downtown Manhattan and we were most impressed.

Christo: I remember, we were in the Chelsea Hotel and we had a friend, a photographer called Raymond de Seynes, who was photographing New York, who took many of our pictures in the early sixties, and I asked Raymond de Seynes to go on the Staten Island Ferry with me and we took pictures. And this is really the first proposal to do something in New York City, 1964, wrapping two lower Manhattan buildings, number 2 Broadway, number 20 Exchange Place. And we were living at the Chelsea Hotel, I did drawings, the scale models, and photomontages, using a photograph of the scale model and gluing it on a photograph of the landscape. Later when we came back in autumn 1964, I did more work on that. We started talking to the two owners of the buildings, through friends of John Powers, who introduced us. Those people thought we were out of our minds. The last studies after the refusal are from 1966. Of course, having these drawings, we always showed them to potential collectors. I remember talking with John Powers, who became one of our first collectors, who bought a 1958 wrapped bottle while we were staying at the Chelsea Hotel. John was telling me, "I would be glad to help you but I don't know anybody downtown in those buildings."

Ileana Sonnabend [a prominent New York collector and gallery owner], I remember, told us when we were living in the Chelsea Hotel that one of the important things that we should do is to go to Times Square because for all the foreigners Times Square was the most important, and we spent time in Times Square in the mid-sixties.

Jeanne-Claude: As tourists.

Christo: After the last refusal in '66 of the *Lower Manhattan Wrapped Buildings*, the [idea to wrap] number 1 Times Square, at Forty-second Street and Broadway, came right away because it was even better than these two other buildings, because the two other buildings have buildings adjacent to them, it's not so separately cut out. Number 1 Times Square was completely cut out, isolated and standing alone. The building is very thin and tall, and the chairman of the board of the Allied Chemical Corporation was the friend of John Powers. And this is why I started to make the drawings, the scale models in '67 to '68. The idea was always to do a building, and it was very natural. The first proposal to wrap a public building was in 1961, a small photomontage made in Paris. We still had not yet wrapped the Kunsthalle in Bern. The Kunsthalle Bern was in the summer of '68. It was very natural that an art institution would be the first wrapped building. During that time, to wrap a building became an obsession. There were difficulties with number 1 Times Square. We also knew the director of the Galleria Nazionale d'Arte Moderna, Rome, the very beautiful director, Palma Bucarelli. She wanted her museum to be the first wrapped museum and she made us believe that she would succeed, but we never got the permission. Also in '67 I did studies for the National Gallery in Rome. I was working '67, '68 in Times Square and, of course, desperate to wrap a public building, this was the main issue, and finally we did Kunsthalle Bern in 1968.

Fineberg: What kind of costs were involved in doing a project like the *Lower Manhattan Wrapped Buildings* then?

Jeanne-Claude: I believe that we absolutely had no idea. It's very lucky that it was refused. Because we definitely would never have been able to afford it.

Christo: I don't know, we wrapped the Kunsthalle Bern, which was a small museum.

Jeanne-Claude: But we didn't have to buy the fabric because we used the bad envelope of the air package, which had been made in Sioux Falls, South Dakota, for us for the giant air package in Kassel [the *5,600 Cubic Meter Package* of 1968]. That fabric was very bad for anything to be inflated with air but it was perfect to be put on a train, sent to Bern, and wrap the Kunsthalle with it.

Fineberg: That was enough fabric for the whole project?

Christo: Yes, the fabric was enormous—the package was the height of a twenty-eight-story building.

Jeanne-Claude: It's the same height as the Seagram Building on Park Avenue.

Christo: Two hundred and eighty-five feet tall. But we needed to spend some money to recondition the building, because the building had a very fragile roof. We needed to build a structure to support the fabric. We spent money but it was a modest amount. Now, people start to know that we're looking to wrap a building in New York, and we start to meet the curators of the museums there. Bill Rubin wanted MoMA [the Museum of Modern Art] to be wrapped, the first public building. This is why he borrowed the first study for the wrapped lower Manhattan buildings of 1964 for his landmark exhibition, *Dada, Surrealism, and Their Heritage*. That exhibition was in early '68, and Bill was saying that when the exhibition closed in May, we would wrap the MoMA and that would be the first wrapped building. This is how we started to negotiate. And for that we had the money because many collectors, Armand Bar-

tos, John Powers, Mrs. [Dominique] de Menil, many collectors, trustees of the MoMA, were very eager and they bought many works and we had the money for the wrapping. After the end of the Dada exhibition, they were saying the museum will be closed anyway for three weeks, and we can have that project for ten days and remove it.

Fineberg: So within a fairly short period of time in 1968 and 1969 you actually wrapped a number of things of an architectural scale.

Jeanne-Claude: You know that I have never seen the Kunsthalle Bern, you know that? I was in Spoleto, wrapping the medieval tower and the fountain, which Christo has never seen.

Fineberg: Let's talk about that a little bit, because there's an example from 1968 in which both of you were directing two different projects going on at the same time.

Jeanne-Claude: Three, two in Spoleto one in Bern, but we were meeting in Kassel.

Christo: Kassel was a problem, a technical problem. We had a collapsing, technical failure. Finally Kassel went up in August.

Fineberg: So construction was happening on three projects in different places at the same time?

Jeanne-Claude: Yes—oh, that was a good summer.

Christo: Yes, all in the same summer. The Kassel project should start first, but the Kassel project never went up. There was a total failure with the fabric and we could only make this huge amount of fabric in Germany.

Jeanne-Claude: We had to order a new fabric.

Christo: And that fabric was ordered, it took almost one month,

and there was no way that project could be put up again before late July, early August of '68. Meanwhile, in that same year, we were planning technically that Kassel would go up. From there I went to Bern, I wrapped the Kunsthalle in Bern, and Jeanne-Claude went from Kassel to Spoleto, we did all these things.

Fineberg: So the original plan was that both of you would be in all three places sequentially?

Christo: Yes.

Fineberg: And it ended up with Jeanne-Claude doing Spoleto, you did the Kunsthalle . . .

Jeanne-Claude: And in the meantime the new envelope is being manufactured in Kassel.

Christo: We had two failed attempts in Kassel. The first envelope never worked, the American envelope. The second, German envelope was made, but we had no time to bring the two tallest cranes in Europe to help us elevate the project. We were so in a hurry to elevate it and we had only one crane. That crane broke that envelope, the new envelope. We need to repair that envelope, waiting for these two tall cranes, one coming from Spain, one coming from north Sweden; because of their giant size, they were allowed on the highway only at night.

Jeanne-Claude: Because they were the two tallest cranes in Europe, we hired them but we had to wait until they both arrived in Kassel. Then it could be done with the two tallest, not cranes, but auto-cranes on trucks, they were on wheels with tires. . . . It was raining every day. And the first time the crane went into that meadow, it sank into the mud.

Christo: David Juda had to go to the British army in Patterborn to ask them to lend us steel mats, which they use for the tanks, they unroll them so they don't sink in the mud.

Fineberg: How many engineers did you have for that project?

Christo: Mitko [Zagoroff] was the chief engineer, but there were other engineers who fabricated the steel and different parts.

Fineberg: What is the difference in terms of the technological aspects between the Kassel *5,600 Cubic Meter Package* and something like *Running Fence*?

Christo: The project of Kassel, the project of the Pont-Neuf, the project of the Reichstag, they have a lot of engineering, a lot of technique. *Running Fence, The Umbrellas,* they are simple engineering.

Fineberg: And *Surrounded Islands*?

Christo: *Surrounded Islands* is mixed. More engineering. You should understand that *Running Fence* and *The Umbrellas* and *The Gates* are modules, repeated a few thousand times.

Jeanne-Claude: But on a technical point of view, the Kassel air package is the most interesting because it had been calculated that for a given envelope, if you blow air in it, you create x amount of pressure, and if you blow twice as much, do you create twice as much pressure? Yes, only up to a certain point and a certain dimension, which, at the time, no engineer in the world had ever calculated.

Christo: Frei Otto, a very famous architect-engineer from Munich who is a pioneer of suspended fabric structures . . .

Jeanne-Claude: He helped Mitko, and they invented a new formula that didn't exist before, because there had never been a need for it. The air package in Kassel was the largest inflated structure ever done on planet Earth without a skeleton.

Christo: Still today.

Jeanne-Claude: And nothing that large has been done since. This was without a skeleton inside and therefore the equation of the air pressure is not constant, at a certain point it changes. Mitko and us, we could not understand why suddenly it would burst, it wasn't supposed to. But it was because the equation is not constant.

Christo: Anyway, that was technically very different.

Fineberg: And the helium was only the first try?

Jeanne-Claude: Yes.

Christo: You know the story of the helium? Helium was a military secret.

Jeanne-Claude: It is still today.

Christo: Only two countries in the world have helium: the United States and the Soviet Union. In the United States it is in the area of Amarillo, Texas. And I remember we bought that helium, there had never been such a large shipment of helium to Europe because it was a military secret, and when it arrived the press, everybody was around photographing this . . .

Jeanne-Claude: Forty thousand cubic feet of helium coming, and Christo and I did not know of course how come they were willing to sell it to us and to export it. By what miracle? We discovered afterward that the United States government had a contract with an Indian reservation there that if, by such a date . . .

Christo: . . . they do not extract helium from that lease, the helium goes back to the Indians. And they were desperate . . .

Jeanne-Claude: they used us . . .

Christo: to show that they are using the helium.

Jeanne-Claude: And they exported it. . . .

Christo: Mitko designed the helium only to elevate the package. But it was not working, it was stupid.

Jeanne-Claude: But you see the helium . . . was inside the package, . . .

Christo: In the end, in the big package.

Jeanne-Claude: We thought, well the whole thing is going to go up like that, but it didn't work.

Christo: It did go up but there was not enough power to lift it all the way, it was a huge thing, 280 feet, . . .

Jeanne-Claude: Do you know who was in Kassel?

Christo: Dorothy Miller [curator at MoMA] and Alfred Barr [director of MoMA].

Jeanne-Claude: Alfred Barr, holding me, and he was crying, because that thing wouldn't go up. He was crying.

Christo: I was very touched, they stayed a long time. Dorothy Miller, and of course Bill Agee [then curator at the Whitney Museum of American Art]. . . . Right after that, I went to Bern and I want to give credit to Harald Szeemann, Victor Loeb, and Paul Jolles, the director and two trustees of the Kunsthalle. It was the fiftieth anniversary of the Kunsthalle, and things came together perfectly so that we could wrap the Kunsthalle. And that stayed for one week. A few months later, the idea for the Whitney [Museum] came into the picture. We also never succeeded to wrap the Whitney.

Fineberg: What happened?

Christo: After the MoMA project was not realized, we came

back from Kassel, we met with Bill Agee, a curator from the Whitney Museum. He said we might do the Whitney Museum in autumn '68. I did the scale model, drawings, and we didn't get the permission. I think it was not interesting to the trustees, nothing happened.

Jeanne-Claude: But Bill Rubin at MoMA was very fair.

Christo: Yes, he made an exhibition.

Jeanne-Claude: He exhibited all the preparatory works.

Christo: After the project failed . . .

Jeanne-Claude: And the preparatory works were not only about wrapping the museum, that was not the whole project. It was the museum . . .

Christo: . . . the wrapped garden, the wrapped floor . . .

Jeanne-Claude: wrapped trees, oil barrels, and close Fifty-third Street with a wall of barrels.

Christo: It was a huge thing we tried to do, like in the rue Visconti. Because they bought many drawings, sketches, studies, actually Mrs. de Menil bought almost the entire exhibition.

Jeanne-Claude: Yes, Dominique de Menil bought them and gave most of them to MoMA.

Christo: After we failed to get permission, I realized some important things, one about our dream in the United States. Jan van der Marck became the founding director of the Museum of Contemporary Art, Chicago. We had met Jan before because he showed the *Package on a Wheelbarrow,* now in the MoMA collection, and *The Four Storefront Corner,* which was exhibited at Leo Castelli [Gallery] in 1966, he showed them at the Walker Art Center. There was an exhibition he organized called *Ambiguous Image,* with me, George Segal, and other artists I cannot remember. That exhibition also went to Emily Rauh, she was a curator of the St. Louis Art Museum. And Jan moved to the Museum of Contemporary Art in Chicago. . . . We already had friends in Chicago, Bill Copley, the artist and collector, great collector, introduced us to Barnet Hodes. He was the lawyer of Duchamp and very close to Magritte, Max Ernst, and he had a huge collection of surrealism and Dada. And Barnet Hodes brought some collectors already in '66–'67.

Jeanne-Claude: And he brought us his "little boy," Scott Hodes. [Scott Hodes has been Christo and Jeanne Claude's lawyer since 1969.]

Christo: There was already a group of people in Chicago who were keen on our work, and Dick Bellamy [owner of the Green Gallery in New York] sold one work to [collector] Dr. Forman in Chicago, the *Orange Store Front,* 1964–65, life size. Basically, Jan found support by the trustees for that proposal. They said we could do the wrapping of the museum but they insisted on having an exhibition inside. We said no, we won't do an exhibition, we'll do a wrapped floor. We painted the walls all white and we covered all the floor with drop cloths, and the stairway. . . . And this is how the Chicago museum became the first American museum to be wrapped, January 1969. It was a winter project and we used a very heavy tarpaulin. Of course, we were not interested in using a fine soft fabric. This is why in 1968 I bought dark-color tarpaulins in Brooklyn and I did several packages, my last single packages, just before the Chicago wrapping.

Jeanne-Claude: To see what kind of folds that thick tarpaulin was creating. . . . You did two.

Christo: Of course they were done because the fabric I used was much heavier fabric than I had used before.

Jeanne-Claude: To study the color and the shape of the folds.... The reason why we wanted it dark is that we thought, if we are lucky enough that it snows, it would be very beautiful with the white snow. And it did snow, and there was snow on the ropes ...

Christo: ... and on the folds also. It was very nice. The building itself was very boring, I remember it was like a shoe box.

Jeanne-Claude: [Art critic] David Bourdon described the shape of that museum before it was wrapped as having as much charm as an old shoe box.

Christo: I think it was given by Hugh Hefner, it was the old Playboy building.

Jeanne-Claude: Now, for the opening, Mr. and Mrs. Bergman, big Chicago collectors, gave a big party for us and told our little boy, nine years old, "You should come also," and Cyril answered, "Oh, thank you very much but my Mummy and Daddy have already asked for a dinner to be delivered for me in the hotel and I'll watch television." And she said, "You know, I have a big dog." Cyril said, "You have a big dog? I'm coming." We arrived there with Cyril and immediately he says, ask where is the dog? "Oh, the dog is outside and he cannot come inside," and it was raining. Cyril said, "But you said I could play with the dog." "No, you can't. But you can go upstairs and watch television." So we didn't see Cyril the whole evening, everything was fine, and only a few weeks later we learned that Cyril had taken every object in their twenty or thirty [Joseph] Cornell boxes and changed their position. Taking an object from one box and putting it in another box. It took weeks for two curators to reconstruct from photographs exactly what objects should go in which box.

Christo: But another sexy story about the floor. You know the Chicago people were worried that the drop cloth, the painter's drop cloth we used on the floor inside the museum, would be very slippery. All the visitors of the museum were obliged to remove their shoes ...

Jeanne-Claude: Not slippery, but they could catch in the folds and trip.

Christo: They created a special antechamber area to remove the shoes, ... It actually looked very nice and they walked barefooted on the fabric.

Jeanne-Claude: There was also a stairway and the stairway too was covered with fabric.

Christo: And, one night when the museum guard was closing the museum ...

Jeanne-Claude: He heard some strange noise and he found a young couple making love on the drop cloth under the stairs.

Christo: Very sensual.

Jeanne-Claude: He said he had never seen that in his entire life.

Christo: Very sensual project ... we have a beautiful photograph of the drop cloth. I put furniture and the tables, the benches all against a wall.

Jeanne-Claude: And he covered that, and the package that you have seen in Christo's studio, that piece which extends out ... the drop cloth continued on the floor....

Christo: From 1968, all activity we tried to prepare was for outdoors ...

Jeanne-Claude: In '68 we wrote to three museum directors whom we hardly knew in California, in three separate museums, explaining that we would pay for it, all we ask is to give us

their help in locating a coast to wrap. All three answered the same thing, a coast cannot be wrapped. That's why we went to Australia.

Christo: John Kaldor [the Australian industrialist and collector] helped us to do the Australia coast, so it was very natural that we moved outdoors. I remember Maurice Tuchman [curator at the Los Angeles County Museum of Art] years later was preparing some exhibition about art and technology, and he even used our letter in his catalogue. Anyway, the *Wrapped Coast* was done in 1969 and, of course, all the projects originate in New York, they are planned in New York, but of course, there was no way to do anything in New York. There was just no possibility, no support. Probably, after *Running Fence*, we felt more sure of ourselves, we attempted again to approach New York.

Fineberg: So why do you think it seemed so impossible to do a New York project before *Running Fence*?

Jeanne-Claude: At the time of *Valley Curtain,* then *Running Fence,* then *Wrapped Walk Ways,* our enthusiasm toward wrapping a building faded.

Christo: No, no, no . . . I'm not talking about wrapping a building—doing a project in New York. . . . The question is still, probably, we would feel it very difficult to approach the people here. . . . I was starting to feel we would find it more workable in the West.

Jeanne-Claude: No but, it is very important that you please mention that the last time in our life we ever had a wish to use wrapping to create a work of art was in 1975. That is the last time we had a wish to do a wrapping and it was the Pont-Neuf. We never, after '75, ever had an idea involving wrapping, and the media keep calling us the wrapping artists. The *Reichstag* was started in '71 and in '72 we had already done *Valley Curtain,* '76 *Running Fence,* nothing to do with wrapping. After '75 we were no longer ever interested in wrapping.

Fineberg: Is there something different for you in the feeling, in the idea of actually wrapping an object, was there some kind of change in your thinking at that moment in 1975?

Jeanne-Claude: I didn't say "object," to do a project . . . because wrapped flowers, he did even three years ago, big bouquets. . . . We feel that wrapping belongs to our youth.

Fineberg: But you have still done wrapped monument projects as recently as 1995 in Berlin?

Christo: But we started it in 1971. Aesthetically, visually, the projects that we failed, our rejected proposals, we take it very painfully. We spend a lot of time, energy, money, enthusiasm, and excitement, and for it to not happen is a very sad story. I remember that our first proposal to wrap a bridge was Ponte Sant'Angelo in Rome in 1967. I was so excited, even Grace Glueck [art critic for the *New York Times*] wrote that because we were so excited, she was thinking that the Italians would give us permission. But, no way, they wouldn't even budge. Of course, when it fails it's very sad. And 1972, again we started to work on the Pont Alexandre III for Paris, and no way.

Jeanne-Claude: But for a very short time.

Christo: And finally in 1975 the Pont-Neuf idea came. We felt that wrapping a bridge would be very exciting, and that's why we did not lose interest. It took us a long time. The same things with the buildings. Probably the buildings, the first proposal in 1961 to wrap a public building was really for a parliament. Naturally, the first public buildings we wrapped were art institutions, and it's very understandable that with art institutions we have more chance . . .

Fineberg: But the first idea was for a parliament? Not any specific parliament but just "a parliament"?

Christo: Yes, "a" parliament, a parliament or prison, two public

buildings. This is why we are very eager, each time, to reproduce the text of 1961 where it is written on the collage that it is a parliament, this is the seminal word. . . . Because the true public building is owned by everybody. Okay, now, of course, we wrapped the museum in Bern, the museum in Chicago, but we were still eager to wrap a public building. This is how in 1971 the Reichstag came into the picture. It was not a real parliament, but a former parliament.

Jeanne-Claude: A true public building, because museums are not true public buildings.

Christo: The ultimate objective was to wrap a parliament . . .

Jeanne-Claude: The *Wrapped Pont Neuf* in Paris was much more based on an aesthetic motive because of the marvelous shape of the twelve arches.

Christo: Actually, we even did not go to a permitting process for the Pont Alexandre III. Very shortly after a few sketches and drawings we found that this huge one shape is not the thing we are after . . . It's only one arch. That having twelve arches on the water would be completely . . .

Jeanne-Claude: The Pont Neuf has those twelve fingers in the water.

Fineberg: Was the historic character of the Pont Neuf important for you?

Christo: No, no, actually aesthetic.

Jeanne-Claude: I think we were not fully aware of the historic dimension . . . not then.

Christo: The aesthetic was the most important. It was not simply a bridge from one part of the city to another. The bridge goes from the Left Bank to the Right Bank, crossing the island of the city and getting this very rich, complex relation that no other bridge has. It has that square and it has a smaller branch and a longer branch unlike any other bridge.

Jeanne-Claude: Yes, the first consideration was aesthetic. All the rest we learned as we went.

Christo: Yes. Actually, it was much more difficult to get permission because this was an old bridge, but that is another part of the story. Probably through the seventies, we realized that we should not do a building. The people walking on the sidewalks, walking in the streets, living in Manhattan, are so much intimidated by structures that any art or any architectural building would compete with these elements, which are part of the long panorama of Manhattan. Even the great architecture has no striking presence here because it's part of the ensemble. This is probably one of the main reasons we start to focus . . .

Jeanne-Claude: As we lived in New York, more and more years, and started to know New York better, and traveling all over the world, we realized that New York is the most walking city in the world. And where do people walk leisurely? In the park, and which park? Central Park.

Christo: Also the greatness of the site. All our projects work in that, really, the importance of the site, the site is really the meaning of the project, the forces and the logistics, and the site is incredible . . .

Jeanne-Claude: The name of *The Gates,* we did not invent. It comes from Central Park. Mr. Vaux and Mr. Olmsted surrounded Central Park with a stone wall. The wall interrupts from time to time so that you can enter the park. It's only an interruption, but they called them "gates," and they gave names to those gates—the gates of the boys, of the girls, of the soldiers, of the mariners—they called them "gates." So the word comes from them, from Central Park.

Christo: I remember I had a discussion with Gordon Davis [then commissioner of parks and recreation for the City of New York]. He said, "Why don't you pick another park?" This is the only park that's extremely cut out of any natural forms. Riverside Park you have the Hudson River, Battery Park you have Hudson Bay, Prospect Park has big houses and gardens, with vegetation of the trees, it is diluted with private gardens, very rich properties around Prospect Park in Brooklyn. All the pink on the map around Central Park is buildings. It is absolutely cut out, and this great contrast between artificial, man-made, grid system against a more organic vegetation, and a serpentine-type walkways system.

The first drawing to be shown in the Metropolitan Museum exhibition is the drawing from 1979 called *The Thousand Gates;* I don't have a reproduction of that. We never reproduced it, but of course it will be reproduced in the Metropolitan Museum catalogue. The gates were only twelve feet tall and very curiously enough, again, it shows how much of our work often comes from previous projects. The gates were coming from *Running Fence.* You will see the drawings like that—two poles, third pole, . . . cable here, and the fabric is hanging like *Running Fence* on cables. That is the first drawing of the gates.

Now, the rectangular shape of the poles reflects the rectangular shape of the city blocks; you can see this very well, all this black shadow of the city blocks, hundreds of city blocks all around Central Park. With the fabric attached only at the upper part of the gates, moving in all directions, the wind moves it sensually to reflect the serpentine character of the walkway system, and the naked branches of the tree, all these contrasts between the geometry of the city, the regularity, very strict regularity of the city . . .

Jeanne-Claude: The gates, our work of art, is absolutely for Central Park. It is site-specific, it couldn't be any more specific, even its name.

Christo: Now the interesting thing about the process, how that developed, in the beginning the poles were very skinny, and the pole was only supporting the fabric, and more and more through the years, we discovered that the poles need to have this commanding dimension, that there should be thicker poles, because they're a very important part of that space.

Jeanne-Claude: It's a sculpture, not just a support for fabric.

Christo: Basically, creating that inner space because you walk through that inner space and, of course, the thickness, the wall, should be much more visible. This is why from the two-inch poles they came to be five-by-five-inch square poles.

Fineberg: So, the geometry of the frame itself is almost like the city blocks.

Jeanne-Claude: Yes.

Christo: Exactly.

Fineberg: . . . And the fabric is like the organic quality of the park caught in the middle. If you look at that map, the map has the geometric outline of Central Park like the shape of the individual gates.

Christo: Yes, absolutely.

Jeanne-Claude: Yes, absolutely at right angles.

Christo: And of course it would be incredibly beautiful to see that, because in the winter days when you have the naked branches of the trees, they are so rich in their movement. You don't see the branches covered with leaves in summer, it's like a jungle, but in the winter . . . that contrast will be much greater. That contrast between the branches of the trees, the walkway system, and of course, extremely commanding gates. And naturally it was important that the gates would grow in thickness, little by little through the years . . .

Jeanne-Claude: And in height. Because until five years ago, the gates were fifteen feet tall, now they are sixteen feet tall. And those poor things started at twelve feet tall. And some newspapers are still writing, still in the *Wall Street Journal,* two days ago, that we have reduced the project.

Christo: You can see that we were very young in 1979. After the attention we had on *Running Fence,* we were feeling more secure.

Fineberg: But in 1980 you had a very negative review in the *New York Times* on the proposal for *The Gates.* That must have been quite a blow.

Jeanne-Claude: We were feeling devastated, but we couldn't stop ourselves telling everybody, oh this is not the first editorial against us, there's been one before, which was true, in *Pravda.*

Christo: In 1977, it was in *Pravda.* In 1980, it was in the *New York Times.* The refusal came up in February of '81, but, of course, already the thing was going very wrong already in autumn of '80. We were feeling so much against us, so much screaming from different groups of people.

Jeanne-Claude: We knew Gordon Davis was going to say no.

Christo: But we tried to push it back [to postpone the decision]. This is why when the situation of Miami became possible, . . .

Jeanne-Claude: "The Festival of the Two Worlds" . . .

Christo: We were eager. Meanwhile, the sad story is that the *Pont Neuf* was also going very badly. [Jacques] Chirac did not want to see us because there would be an election coming up. This was another big problem in 1980.

Jeanne-Claude: We were making multiple trips to Paris, to Abu Dhabi.

Christo: And to Berlin, where the second refusal was in '81, and also to Barcelona . . . it was a nightmare.

Jeanne-Claude: And then we said the hell with it, . . . 'let's do Florida.'

Christo: And I vividly remember being, not saddened, but infuriated. But Gordon was being very gentle, because we promised many color-slide presentations before the book was published, we could not cancel them. There was one presentation of our works, including *The Gates,* in the New York Public Library. I remember, Gordon was there, and I was so eager to put color slides of the *Surrounded Islands,* to say forget it, we don't care about you, we are doing something very exciting now in Biscayne Bay. But basically I was very upset at that, I was very pissed off.

Jeanne-Claude: We were furious and sad.

Christo: And we put all the energy in *Surrounded Islands,* but at the same time we have all these commitments: Abu Dhabi, Barcelona, Paris, and Berlin. I think the *Surrounded Islands* project was extremely helpful to give us energy in the early eighties when we had the refusal of *The Gates. [Surrounded Islands]* was Jeanne-Claude's idea.

Jeanne-Claude: You know that people never really look at the work and they never noticed that the *Surrounded Islands* is definitely the most feminine of all our projects. I don't know if it's obvious to you.

Fineberg: It's painterly . . .

Jeanne-Claude: Painterly, flat, pink, and corny . . .

Fineberg: It was Jeanne-Claude's idea?

Christo: Yes, absolutely. We were only in Miami once before. We were in Miami with the architectural writer of the *Miami*

Herald, Beth Dunlap, and she had the duty to show us all of Miami and the Dade County area.

Jeanne-Claude: Because Jan van der Marck was hoping that we would want to do a wrapping somewhere in Miami.

Christo: And we were working at the Pont-Neuf, and she thought that we want to wrap . . .

Jeanne-Claude: No, no, no, wait, don't ruin the story. In her old Mercedes, she was in charge of driving us everywhere, and showing us every possible building there, et cetera. I kept asking, can we please go back again on that causeway? And when we would arrive, I would say, can we take the other causeway over there, please? And she thought we wanted to wrap a bridge.

Christo: Because we were working at the Pont-Neuf, they thought we will wrap a bridge. Actually, they even wrote an article, "they will wrap a bridge."

Jeanne-Claude: Then, on a causeway I asked her to please stop and Christo and I came out of the car and I don't know if she came out of the car, maybe. I was looking at all the small islands, and that's when I said, wouldn't it be beautiful to surround *some* islands, and I was thinking three or four.

Christo: Two or three.

Jeanne-Claude: Two or three, and I said it would be pink floating fabric, and Christo said, that's beautiful, but why pink? And I remember, I looked at him and I said, darling, we're in Miami!

Fineberg: I didn't realize that, I never heard that story before.

Jeanne-Claude: Well, in those days, we kept our mouth shut, because, if we had said it's a Jeanne-Claude idea, forget the permits, it would never have happened.

Christo: I remember, you came to our meetings there . . .

Jeanne-Claude: We had enough problems as "he," if we had said this is a Jeanne-Claude idea, forget it.

Christo: I was thinking also it would be easy to get permission, but it was not so easy to get. In the beginning, Jan van der Marck was saying that the project would be very fast. But it would take us another two and a half to three years.

Jeanne-Claude: But that *was* very fast.

Christo: Relatively fast, but not so fast. Now, the story is that the refusal of Gordon Davis, and all the writing against *The Gates,* makes me so obstinate. So I tell them, we will not do anything in New York except *The Gates.* And I vividly remember how other people tried to ask us to do all kind of things.

Jeanne-Claude: And exhibitions. There haven't been any exhibitions in New York, because we always answered, no, the only thing we want to do in New York is *The Gates* in Central Park.

Fineberg: So the 2004 Metropolitan Museum exhibition is the first museum exhibition in New York since the 1968 MoMA exhibition *Projects for a Non-Event*?

Christo: Yes.

Jeanne-Claude: We really, really insisted . . . it's *The Gates* or nothing.

Christo: I remember, early eighties, all around *The Gates,* Thomas Messer [director of the Guggenheim Museum] wanted to have the *Running Fence* documentation exhibition at the Guggenheim. And we were hoping that the *Running Fence* exhibition would help us for *The Gates.* And Thomas Messer came to the Louisiana Museum in Copenhagen to see

the *Running Fence* exhibition, and he was appalled because it was not only drawings.

Jeanne-Claude: He said, that's not an art exhibition.

Christo: There were steel poles, steel cables, steel anchors, and the fabric. . . .

Jeanne-Claude: But if he had wanted it, we would have lent it.

Christo: But I remember the exhibition was started in European museums. The last stop was at Kestner Gesellschaft in Hanover, just when we were working on *The Gates,* and we were very eager to bring it to New York.

Fineberg: Now, there were some projects that had ideas that seem to me to be forerunners for *The Gates.* I'm thinking of things like the project for St. Stephen's Green Park in Dublin and Ueno Park in Tokyo, *Wrapped Walk Ways* in Kansas City in 1978 . . .

Christo: *Wrapped Walk Ways,* of course, was in a park. But it was covering the rough floor, it had more links to the wrapped floors that were in the Museum of Contemporary Art in Chicago. At the Haus Lange Museum in Krefeld I also did wrapped floors and covered windows. And that is closer to the floor situation. The first proposal to do a project involving two sites was a two-part project for Japan and Holland; it was wrapped walkways. It was for Ueno Park in Tokyo, in 1971, and in Sonsbeek Park in Holland. That never went through. In 1976 there was a project for St. Stephen's Green in Dublin, and finally we did it in 1978 in Kansas City.

Jeanne-Claude: So, as you see, *Wrapped Walk Ways, Kansas City, Missouri* started as a two-part project.

Christo: That is not so much about a park, because that project technically came very closely after Chicago in '69. The first proposal was in '71, and there are many elements of that in the Chicago wrapped floor. Probably the pattern of the walkway system. But in the Ueno Park they have a huge open area, not so narrow, . . . even here we have a floor; actually here we have a spectacular floor. In fact, that inner space, the pavilion in Kansas City, is very much like the floor in Chicago. . . . Of course you can find a natural development from Chicago to the large kind of spaces . . .

Jeanne-Claude: But remember that there, in Kansas City, we were enchanted by the fact that there were so many people walking, and the idea: New York is the most walking city.

Christo: In the Ueno Park, I was planning to have the fabric go over the stairway in the museum, and Ueno Park has a lot of large open areas.

Fineberg: Looking ahead, the experience of walking on different kinds of surfaces under the fabric—which was an issue in *Wrapped Walk Ways*—it carries forward into the *Over the River* project, because it's a walking experience, to walk along the road above and to raft under this fabric along the river.

Christo: *The Gates, The Umbrellas,* and *Over The River,* they are very strongly linked with that inner and outer space. You can go *under* the umbrellas, you can go out of the umbrellas. You can go *under* the gates, you can go out of the gates. . . . Of course, the precursor of *The Umbrellas* was *The Gates* because *The Gates* was several years earlier than the idea of *The Umbrellas.* And also it created that freedom. *The Umbrellas* and *The Gates* have the similarity of that spreading quality. I want to show you the new maps of Central Park.

Jeanne-Claude: The people who say we do the same things all the time, maybe they have something right. You see this storefront? You see *Running Fence*?

Fineberg: And the *Valley Curtain*!

Jeanne-Claude: And the *Valley Curtain,* yes. Here you already have the inner and outer space.

Christo: Jonathan, here [pointing to the latest engineering plans of the Central Park project] is the unbelievable, that type of spreading, you know, things like that, if you remember the maps of *The Umbrellas.* The umbrellas also were going in branches like that.

Jeanne-Claude: In every direction.

Christo: For *The Umbrellas* we designed the pattern, while here, we take the pattern of the existing walkway system.

Fineberg: It's open-ended.

Christo: Open-ended, exactly.

Fineberg: *Surrounded Islands* also had that sense of spreading out into space.

Christo: We always say that the dynamic of all the projects is in the fabric. That fabric will move with the wind, the water, with the natural elements. They are not still images. Often when we show color slides, we try to say to the public: you know the fabric is moving, like breathing. The *Reichstag* fabric moves, the fabric of *Running Fence* moves. Of course, that energy of the wind is so much translated with *The Gates.* It's so incredibly present.

Jeanne-Claude: Yes, but we should not compare the early objects with these projects because they truly are two different things.

Christo: The most important part of the project is the human scale. All the objects of a room-size structure don't work in this endless quality that the outdoor projects have. It's not like a home, it's not like a room, it's not like the inner space of a house, it is outside space used by millions of people.

Jeanne-Claude: But that's since 1961, *Dockside Packages,* because, they too were moving in the wind . . . already, it's no longer an object.

Christo: I am talking about outside space. Outside space is so important. You have said that our projects work well for television, how our work is argued, discussed, because we choose places with so much meaning. The greatest example is Central Park. How the project now grows in the minds of thousands of people, millions of people, because the place is so incredible. The same thing with the *Reichstag* . . .

Jeanne-Claude: And the *Pont Neuf.*

Christo: This is our privilege, we borrow spaces, that is why we are definitely stuck in borrowing those places, *the* Central Park, *the* Reichstag, *the* Pont-Neuf.

Jeanne-Claude: And we always, in our lectures, like to explain that we inherit everything which is inherent to that site. It is part of the work of art.

Christo: But we don't invent that, it's there, all the texts, all the articles, the article of Gordon Davis two days ago [*Wall Street Journal,* July 22, 2003], is an absolute demonstration of how the work is in the minds, for all kinds of reason, the minds of people, before the work exists, it's not physically there. It doesn't exist at all. And of course that makes the work so dynamic, . . . it gives this life-blood—absolutely incredible power and energy. And this is why we want to do these projects. Because we want to build up that tremendous energy . . . like we have with *Over the River.* Imagine, we are in Washington, at the Department of Interior. The secretary of interior, Bruce Babbitt, summons the seven hundred employees of the Department of the Interior to listen to a lecture by us about the *Over the River* project, because the Department of the Interior

owns 20 percent of all the land in the United States and they need to think about our project. Now it is not that he did that to make it exciting for us, because this is what the project is. Of course, this is something so invigorating, so unbelievably extraordinary for the work. Of course, it's a big problem for us, a lot of pain and frustration and difficulty, but in the same way if we can overcome, get the permission and work on the project, the project will carry all these multi-levels of people that in no way can be invented, nobody can invent the meanings that the site has for 200 years, 150 years. Now we are, in these last seventeen months' completion of *The Gates,* we have been visiting the manufacturing plants, so many things we need to put together in only seventeen months. How many thousands of pieces, the logistic is absolutely unbelievable. Fortunately, we have Vince and Jonita Davenport to take care of all this. But this is unbelievable, my head is like a balloon. The logistic is horrendous. Because the space is so concentrated. You know, in *The Umbrellas* and *Running Fence,* even in the *Islands* projects, we had so much room around them, but here, we don't have room here; the park is physically so enclosed by the surrounding buildings.

Fineberg: You don't have the space to work in.

Christo: We need to do everything step by step and at very precise moments, moving things, everything must be absolutely planned to move in the right place.

Fineberg: So, you can't construct the thing in one corner of the park and bring it to someplace else.

Jeanne-Claude: A truck cannot back up on the grass.

Christo: No, not just that. But the question is, you need to plan that step by step that everything will click together . . . we cannot allow any improvisation at the site.

Fineberg: What about the Central Park project stands out

most for you as unique and new in comparison with the other projects?

Jeanne-Claude: Definitely, aesthetically, the form; the shape is something we have never done.

Christo: The most interesting thing is that, really, we've never done a project in New York. Even though we have lived forty years in New York . . .

Jeanne-Claude: Yes, but we've done a project in Berlin, Berlin is a big city . . .

Christo: No! No! No! That's not the same, that's not the same ballgame. Not at all, I'm sorry to tell you. They are different groups of people. Ask how many of your friends have ever been in the northern part of the project, in Harlem. It is safe, but the incredible story is that very few of our friends go there, venture in there, and one of the most beautiful parts of the project is there, in that topography. The project also deals with this idea—I think it will be unbelievably beautiful.

Jeanne-Claude: But he asked you a very precise question, darling, and I don't have the answer.

Fineberg: Let me ask it another way. It seems to me that each of the projects has had a very specific relation to, not only the geological situation of the project, but also the political and social patterns. And in each venue, it seems to me that the project has made extraordinarily visible the normal processes of government and society in that place. In Paris, for example, the process for the permitting had to do with a social structure that necessitated going quietly to the mayor and working behind the scenes through a certain set of connections, and ultimately the way the decision was taken in Paris foregrounded the nature of how decision making happens at the highest levels in Paris generally. And it seems to me that it was very different in Miami, and I think that it's very differ-

ent again in New York and in Japan. So I want to talk about where you see the real differences between the New York project and . . .

Christo: Okay, it's a very good question. In 1979, first, when the project failed to get permission I always blamed myself and Jeanne-Claude. We were not intelligent enough to find a way to get the permission. We were naive, we were too sure of ourselves, we were not aware how things are made in Manhattan or New York City. We were thinking that we would propose a gentle idea, it was not complicated, and we can work out the simple negotiations with government officials. We understand that in New York City, every square meter, every square inch is highly used, politicized, and with interests of millions of people, especially Central Park. Suddenly, to succeed to do something in New York, you need to do it a completely different way.

Jeanne-Claude: We did not know the political structure . . . and who rules the city.

Christo: How things are done in New York City. How La Guardia or how some other mayor, or how Mr. Moses built those highways? Is not so transparent like it was in *Running Fence*. Not so transparent like it was probably in some of the more rural areas. There are huge, private, political interest groups with tremendous power of decision making.

Fineberg: Now you could say that was true of Paris, too.

Christo: Paris was very complicated because there was the mayor against the president, it was two people who don't like each other.

Jeanne-Claude: We needed the permission from two men who never agree on anything together.

Christo: They hated each other.

Fineberg: They needed to agree?

Christo: Yes. But they were seeing that agreeing would give signals that they have a consensus. And they didn't want to have a consensus between themselves.

Jeanne-Claude: Jacques Chirac says it in the Maysles film, *Christo in Paris*. "Don't see it as a consensus." He said that!

Christo: It was amazing to the journalists, they were asking, if this is a demonstration of consensus.

Jeanne-Claude: In the film, we are at the bridge drinking champagne with Chirac.

Christo: The story is that the New York people, the real movers and shakers, they are business people, very wealthy people who build the city with their wealth and generosity, with their donations, everything in Manhattan—the museums, the libraries, they give money—and of course they have an unavoidably huge influence in New York City.

Jeanne-Claude: And in the case of Central Park, of course it is the Central Park Conservancy.

Christo: The Central Park Conservancy was just born in '79 or '80—Gordon Davis was the founder, wasn't he?

Jeanne-Claude: Yes. We did not know who the real power is in New York.

Christo: And naively enough, we arrived to Gordon Davis's office, thinking that knowing Mrs. Bartos and knowing John Powers would be enough. Mrs. Bartos is a big donor of art and the Public Library, and a big philanthropist in New York City, and she helped us tremendously, she organized a meeting with very furious people against us in the eighties. We understood that we had an uphill road.

Jeanne-Claude: But we are always very naive, when we start a project. Always. I believe that naive is not the pejorative word that most people think. Christo and I believe that it can also be a quality, it is very naive to think you can hang a curtain between two mountains, but only if you are, if you have that naïveté, you can do what we do.

Christo: No, the problem is not naïveté . . .

Jeanne-Claude: No, we *are* naive.

Christo: No, it's not naive, childlike . . .

Jeanne-Claude: And in the case of *The Gates* we were very naive, we didn't know anything.

Christo: I remember that we were so enthusiastic to go to that meeting, to make our case, and try to prove this to people. But understand, they were voting against us . . .

Jeanne-Claude: But all these public hearings we went to, that was for nothing, because these people have no power whatsoever . . . they are powerless. We didn't know that.

Christo: They give their opinions, . . . but the power is up there with the people who make decisions, who give money. I remember vividly, they said, if you don't have the *New York Times*, forget it, you cannot do anything in that city. . . . But it's true, that is the power structure, the . . .

Fineberg: The *New York Times*?

Christo: Not the art critics, *"The" New York Times*. We were told that.

Jeanne-Claude: When Steven Weisman wrote about the *Wrapped Reichstag* in 1995 [in an article in the *New York Times*], he ended it saying, "Well, New York, maybe now it's time for *The Gates*?" And we rejoiced, like two idiot naives. The *New York Times* was flooded with letters against, because of that little sentence he put in.

Christo: Not little sentence, it was a paragraph.

Jeanne-Claude: A paragraph. Because he praised the *Reichstag*, and so on and maybe now it's time for *The Gates*?

Christo: No, no, no . . . it was much more positive and there were allegations, they thought the *New York Times* was endorsing *The Gates*.

Jeanne-Claude: And they received only letters against.

Christo: . . . that was the editorial page. Now, the story is that in 1979–81, we saw how things happen in New York. I remember that Ted Kheel [Christo and Jeanne-Claude's attorney Theodore W. Kheel] had, and still has, a house in East Hampton, and we spent a lot of time in East Hampton—Ted Kheel organized meetings with all these powerful wealthy people who do things. I remember meeting Mr. Arthur Ross [a prominent philanthropist and businessman], meeting Lou Rudin [a prominent New York City realtor] and all these people. We did not want financial support, but understanding or tolerance from the establishment of Manhattan. Now what is the New York establishment? It is the people who make things happen in New York. It is not so simple . . .

Jeanne-Claude: The people who have spent $200 million of their own money for Central Park.

Christo: $300 million.

Fineberg: Is that different than Miami?

Christo: It's different from Miami.

Jeanne-Claude: Completely.

Christo: Miami is different because in Miami we are dealing with a complex issue. Miami was basically different, we have people against the project, but the Miami newspapers do not have the same power as the *New York Times*. And there was not some Miami establishment who was against the project. And in principle we had an opposition but it was the same type of opposition, it was like the Committee to Stop the Running Fence, basically built locally, they took us to court. We were told that, even here, in New York, anybody can take us to court. We are not immune. That can happen. All you need is to have some lawyer who wants to be on television. . . . Of course, if the judge accepts to consider the case, that is another matter.

Jeanne-Claude: The judge could consider it frivolous, and not hear it.

Christo: Dismiss it. But *Running Fence,* the Sonoma County judge considered the case of the Committee to Stop the Running Fence very legitimate, and he removed our permission. We needed to go to appeal.

Fineberg: So, here, you don't think that could happen?

Christo: It could happen!

Jeanne-Claude: Yes, it can. Any citizen of New York City is allowed to sue us.

Christo: Michael Bloomberg told us that. That is one of the reasons they were a little nervous that the project could not happen right away. They were eager, Mr. Bloomberg, the mayor, and Patti Harris, deputy mayor.

Jeanne-Claude: You know he [Bloomberg] came here? He bought two drawings, a big one and a medium for his home.

Christo: Patti Harris was saying we would like to have it as soon as possible because everything can happen, even when [Bloomberg] was here, he said he could be killed. He said that.

Jeanne-Claude: Yes, he said that.

Christo: Anything can happen.

Fineberg: So the more time lag you have, the more vulnerability.

Jeanne-Claude: Because they wanted it in 2004, and we said, physically and financially it cannot be done. Even 2005 is too early for us.

Christo: We will still be fabricating nonstop until November 2004, the steel, the aluminum, the vinyl poles, and the fabric.

Jeanne-Claude: Do you know what the rent is in Maspeth, our assembly plant? $21,000 a month. A month! And there is five tons of steel that they are delivering little by little. . . .

Fineberg: Okay, what else distinguishes this project from the others?

Christo: In a way, each project has its own chemistry. There is no way to apply the method of *Surrounded Islands* here or the one from *The Umbrellas* here or of the *Reichstag* here. We need to go ahead and to listen to the advice of people and sometimes they give the wrong advice, sometimes the right advice. There are not any recipes we can go by. And we're sixty-eight and even at our age we're still always juggling. Our forty-seven-page contract with the city says that the city can remove the permit any time. They kept that right.

Fineberg: Okay, what haven't we talked about with regard to *The Gates* that we want to be sure is in the Metropolitan catalogue?

Jeanne-Claude: We have forgotten the most important, which is indeed, the same for all our projects. We always do the same thing. That is, what is it we do? We wish to create works of art of joy and beauty. That is indeed the common denominator and most of the time we use fabric, not always, because we have used oil barrels.

Christo: But the question is, many people think that when Jeanne-Claude says that, we should not say that because beauty is not the fashion today.

Jeanne-Claude: No, beauty is back.

Christo: I think it's very important, after working so many years, with so much effort, and making drawings, when the work is there, it has visual impact. If we don't use the word "beauty," some visual exhilaration, or impact. I was so happy, when we did these life-size tests. I enjoyed tremendously these tests because, even myself, I am in doubt how it will look. I cannot simulate everything with drawings. To have it *real* in the test is so . . . it boosts the expectations. It gives us some energy to our expectations, that the work will be incredible.

Jeanne-Claude: You know, I demanded a *Running Fence* life-sized test. I demanded it. He didn't want it. We were very poor, and I demanded it, because I said, I don't want it to look like bed sheets drying in the sun.

Christo: Now, *The Gates* will be, . . . one of the most exciting projects. We did the survey last autumn and this winter, we went back when the leaves were gone to survey some additional areas where we couldn't see well with the leaves. The visibility of that project will be absolutely unbelievable. With these bare, naked, leafless trees, with this fire-quality color of the poles, will be unbelievable. When you go to the park you don't see where the faraway walkways are, you can only see them if people are walking on them. But if there are no people walking, you do not see the walkways. Imagine how it will be

with our *Gates,* there will be views from far away because there will be no leaves. One extraordinary thing about this project, unlike *Running Fence,* where there are only few occasions where one section of fence is reflecting another, and another . . .

Jeanne-Claude: . . . but almost never superimposed. In addition, Central Park has many, many hills. It's not flat at all. You will see those hills even more when there is something accentuating the topography.

Christo: I can show you the sketch.

Jeanne-Claude: Did you show him the engineering? It is still there on the floor. Jonathan, did he show you the double row? Sometimes, and for no reason at all, it's just a capricious thing, there is a double row of gates running parallel.

Fineberg: How did you choose the color?

Jeanne-Claude: If you walk in the forest in the United States in the fall, all the leaves that have fallen all have different colors, some are red, some are yellow, some are orange and brown. But if you squint your eyes, the whole thing is saffron. It's that color. The mixture of all the fall foliage. In addition, it's very gay, luminous. We love it, it's beautiful. It's not because my hair is red.

Fineberg: Did you always think this would be a fall or winter project?

Jeanne-Claude: At first, we thought it would be a late-fall project. We wanted it late fall when the trees have no more leaves. But by observing Central Park, year after year, we discovered that you never know when the leaves will fall. One year, it's two months ahead, another year, it's two months later, depending on how many rains you had, how much winds you have. And you can never count on a specific time. You can never know when it will really be leafless. While in February, we are sure, the leaves will have fallen and the new leaves will

not have come yet. . . . Many people say, well, did you choose it because it's a Buddhist color? We didn't, but we love Buddhist colors, it's a lovely idea. I suppose that the Buddhists chose that color because it's beautiful.

Fineberg: And probably because it relates to nature.

Jeanne-Claude: Yes.

Christo: It also has some kind of gentleness, . . .

Fineberg: Calming?

Christo: Yes, calming.

Jeanne-Claude: Not truly calming. Pink is calming.

Christo: No, no, no.

Jeanne-Claude: But this is a color that is almost not an art color. As you said, it's closer to nature. We haven't answered your question at all about the differences.

Christo: What differences?

Jeanne-Claude: Between each project . . .

Christo: I always say, each of our projects is a slice of our life. It is a very important thing to say that. Each project happens at the time it should happen. Probably we were not mature enough to do the *Reichstag* project in '71, when we started it. Probably it was not the right time to do *The Gates* project in '80–'81.

Jeanne-Claude: Especially at twelve feet tall as the first drawing of 1979 shows.

Christo: Understand, these are very strange things and, proba-

bly, the passing of time is always in some way good for the project. Also, another thing, probably the project through time becomes more important, it builds more personality.

Fineberg: I want to talk about your presentation of your role in the projects, Jeanne-Claude; this has changed. In 1976, you were doing all the things you're doing now and you weren't talking about it.

Christo: Yes.

Fineberg: Is that right?

Christo: Yes, exactly correct. In *Valley Curtain* also.

Jeanne-Claude: . . . until '94.

Christo: *Wrapped Coast*, everything.

Fineberg: Why did that change?

Christo: She herself was not willing to use her name.

Jeanne-Claude: Okay, I'll tell you how it changed and why. In early 1994 or maybe late '93, Cooper Union asked us to lecture. And they said we want Christo to lecture, and I said, no, these days we both lecture. They said no, we want only Christo. I said, well then he won't come. So they said, okay, okay, we will say Christo and Jeanne-Claude will lecture. Fine. And it had started badly. Then, the lecture goes very well, lots of questions, he answers, I answer, it goes very well. And then, afterward as we were leaving, some people wanted us to sign books, whatever. And a very charming, elderly—elderly means much older than us—gentleman comes and he says, "How is Cyril?" I was surprised, and I didn't say anything, and he said, "Cyril, the young poet, Christo's son, how is he?" And Christo said, "Christo's son? She pushed three days and three nights to give him birth. He is not Christo's son, he is our son." And then in

the taxi, coming home, he said, "Enough is enough, it will be always and forever, Christo and Jeanne-Claude." Because even my maternity I wasn't granted, and that is a little bit too much.

Christo: I remember, that was autumn of '93; we did not have the permission yet for the *Reichstag*. The permission came in February '94, it was cold days. Jeanne-Claude was all the time, all the time, in all the movies of the Maysles brothers you see her all the time, everything—in the meetings, and with the fabric . . .

Jeanne-Claude: And it's silly that it came not because of art, but because of maternity.

Christo: But Jeanne-Claude, until '93, Jeanne-Claude was making the point that she don't like to be in front.

Jeanne-Claude: Yes, I always said, I'm not an artist.

Christo: She was making it a point.

Jeanne-Claude: Because it was more helpful to our work that the people believed that there was good cop and bad cop. But the people who came to buy, they will tell you, Christo is much tougher than Jeanne-Claude when they buy. He's a much better dealer. And we do really everything together. Now, the legends say, Jeanne-Claude is a fantastic art dealer. Even that wasn't true, because we always sold together.

Christo: Yes, we tried to sell together. Absolutely. And, anyway, I have a greater memory than Jeanne-Claude. I remember to whom we should sell.

Jeanne-Claude: He has an elephant memory and I don't.

Christo: But now let's start talking about the serious things.

Fineberg: But there really was a change that took place . . .

Christo: No change. We worked together forty-five years.

Jeanne-Claude: The change in the work? None. For the public? Total.

Fineberg: But when they called you and said we want Christo to lecture, and you said, only if you both lecture—a year or two before that you would not have said that.

Christo: But she's always sitting in the front row, you remember . . .

Fineberg: Oh, I know.

Christo: And she would ask questions . . .

Jeanne-Claude: I was writing cue cards with big letters with magic markers and show it to him, so he wouldn't forget to say something, or a precise detail, or whatever. . . .

Christo: But that was only the visual lecture, but in the public hearings, often Jeanne-Claude was talking. She comes down talking, answers questions and things. You know, but only in the lecture like the university. But actually, even at the university she lectured . . .

Jeanne-Claude: I even lectured without him, twice.

Christo: Because I refused to go.

Jeanne-Claude: At the Museum of Modern Art, and in Huntsville, Alabama, probably it was 1980. One day, I told Christo, you know, darling, tomorrow you are flying to Huntsville, Alabama, to lecture without me. And he said, "What? I have to fly tomorrow?" I said, yes, it's on the agenda, you knew about it. He said, I don't want to go. And I, I said, but darling it might be fun. Oh, that was the wrong word! Fun? You go!

Christo: And Jeanne-Claude went there.

Jeanne-Claude: I called them and I said, I'm so sorry, Christo has the flu, and if you want I can come or you can cancel it, whatever you prefer. And they say, oh no, please, please come. But we pay only half the lecture fee. And I said, that's fine, no problem. But when I came back, I came back with a headline of the morning newspaper when I was flying back. It's a small place, and it said, "Isn't it lucky that Christo had the flu, Mrs. Christo is a lot of fun." Big headline. And once, MoMA was showing one of the Maysles films . . .

Christo: Yes, and I was not here.

Jeanne-Claude: You were in Europe. What they often do, they show a film, and afterward the audience is allowed to ask questions. You know what Philippe de Montebello asked us when we were in his office? If the Museum of Modern Art had wanted that exhibition . . .

Christo: and was not under construction . . .

Jeanne-Claude: and was not under construction, would you have given them preference, and Christo was so smart and political, Christo said, but you are in the park!

Christo: The only museum physically in the park.

Jeanne-Claude: You do know that it's not the first time that Philippe de Montebello does that, a pre-project exhibition? . . .

Christo: In 1971, we failed the first *Valley Curtain,* you remember. It was finally done in '72. We put up the first curtain in 1971, when Philippe was director of the Houston Fine Arts Museum, and he had a *Valley Curtain,* a pre–*Valley Curtain* exhibition.

Jeanne-Claude: Now, Philippe de Montebello, everybody knows, it's not a secret, has absolutely no interest, whatsoever, for contemporary art, except *Valley Curtain,* pre–*Valley Curtain,* pre-*Gates,* nobody understands why he wants it.

Christo: It will help us tremendously, like the pre–*Valley Curtain* documentation. For the pre-*Gates* documentation exhibition, basically, all the pieces, we don't want to sell anyway.

Jeanne-Claude: Not one work will be for sale at the Met. People who like the works at the Met and want to buy works will have to come here to our home.

Fineberg: You always make a large exhibition for each project, which permanently stays together afterward, so . . .

Jeanne-Claude: And that way, a big part of our large *Gates* documentation exhibition would be ready.

Fineberg: I want to come back again to my question about the uniqueness of each project. Can you give me, in a couple of sentences, for each of the big temporary projects, the thing that stands out to you most about that project?

Christo: I will tell you some of the differences. As I said before, I will try to encapsulate it or put it in the frame of our life span. In some ways, all our projects are our life, the life span of ourselves. A period of our life is encased in the period of each project.

Jeanne-Claude: And we were different at each period.

Christo: You ask this question, it's like going back forty or forty-five years ago to think how that project was, what is most memorable. I remember now, starting with the rue Visconti, I needed to rent these barrels, and I needed the French workers, starting very early in the morning. And I remember vividly the street . . .

Jeanne-Claude: . . . loading the truck.

Christo: And the workers went to drink wine, I had to drink wine with them, in the morning! Then driving the truck. And of course at that moment, I was aware it was illegal. I was stacking these barrels and ready to go to the police. I was how old? Twenty-six, twenty-seven. I always refer to the Kassel project like it was a war. There was this incredible pouring rain, rainy days, cold days, and you could hear sounds from inside this huge balloon lying on the ground, like a huge belly of a whale. We had all the workers there, paid by the hour, but they couldn't do anything. We had broken the second skin, and the only way to repair it was to send for a special rope rigger. You know the package had many kilometers of rope.

Jeanne-Claude: The riggers came from Hamburg.

Christo: One of them was very fat, but a very good rope rigger. Fat, very big man. We put him up with a crane. The package, lying on the ground, was thirty-three feet high, the diameter was thirty-three feet, it's not a little thing. And he's on the top and the air pressure was so big that he cannot repair that splicing of the rope. So he asked Mitko to deflate it a little bit, but when he deflated it, Mr. Steinbach [one of the riggers] disappeared! Inside. It was so beautiful. I never forgot that. And, finally it was ready, and now Mitko told us that the only time we don't have wind is very early in the morning, and the elevation should happen before the wind comes, basically, just before dawn, before the wind comes up. In the evening they arrived with the cranes. They all are burly men, and they said, we will lift it, but I told them, no, you have so many sharp points sticking out on the cranes, it would be terrible. . . . The thing was very big, and we needed to do an enormous amount of work in the evening, cover all the sticking points with rubber tires. Now the scenario: We did the elevating job early in the morning, the things started to go up, the crane lifting, you know there were two cranes. They lifted the thing up, but up there the top of the cranes were very close to the air package. And the air package is sitting in a steel cradle, sitting there. And when they almost arrived at a vertical position the wind came, and the thing's not yet secure with the guy wires.

Jeanne-Claude: . . . they were steel cables . . . to keep it straight, but not yet installed.

Christo: Guy wires, anchors set in a circle six hundred feet all around . . . and then the balloon starts to sway . . . bang . . .

Jeanne-Claude: . . . and banging on the crane to the right, bouncing back and banging on the left crane . . .

Christo: . . . and the crane started to move. Then one crane operator left the crane, he ran away. And I will never forget that. The crane could have collapsed.

Jeanne-Claude: And the other crane operator, I didn't want him to get killed. So I ran to him . . . the balloon was banging back and forth . . . and I screamed, "Jump out!" And he said something in German that I did not understand and I asked someone, what did he say? And he said, "You bitch, let me do my work!" I wanted to protect his life.

Christo: And of course, like today, I see the sky, the things, the enormous 285 feet tall . . .

Jeanne-Claude: And if we had not put those tires, that they didn't want to put, it would have exploded.

Christo: It would have exploded. . . . Mitko said, now look, we work like slaves so much we should be sure that things will stay. And the only thing that would make it stay was air blown constantly. That blowing air was coming in by electricity, by an electric pump . . .

Jeanne-Claude: The steel cables kept it straight, but what kept it erect . . .

Christo: . . . was the air, under a precisely calculated pressure.

Jeanne-Claude: . . . but by that time, we had no more money.

Christo: And Mitko said, "You know, there could be a black-out in town."

Jeanne-Claude: . . . and then the whole thing goes down! . . .

Christo: And we had to buy, for thirty thousand marks or dollars, a stand-by generator and probably will not use it, but, and now, finally we installed the generator. After spending so many weeks in miserable Kassel, Mitko was driving us away, back to Cologne. We had just left Kassel when a huge storm arrived. The entire city of Kassel was in a blackout.

Jeanne-Claude: But our generator took over.

Christo: We run back to see and our project was still standing there. Still now, I see these images, I see them. Each project is an adventure . . .

Jeanne-Claude: But a different kind of adventure. At the *Wrapped Coast,* there were those cliffs, the boulders . . . you had the South Pacific Ocean, giant waves coming, if you're not careful, it would just throw you in the ocean. And in the ocean you could see hundreds of sharks. Of course, we didn't have that at *Surrounded Islands* or in Kassel. It's a different experience.

Christo: But the most beautiful thing in the *Wrapped Coast,* I never really anticipated that, basically we were covering the rocks. But by covering the rocks we created huge empty space between one rock to another rock.

Jeanne-Claude: Imagine there is a boulder here, a boulder here, and here there is fabric, but if you put your foot here, you go down, you twist your ankle, or you dislocate your shoulder, which he did . . .

Christo: Also in the space under the fabric air can go inside.

And of course, we were not aware of this. This is why, the *Wrapped Coast* with the wind was one of the most spectacular moving things. You can see in the film [*Wrapped Coast,* by Blackwood Productions]. It was like unbelievable, you see these thousand feet . . .

Jeanne-Claude: You see those photos? It wasn't like that at all! The whole fabric was moving the whole time . . .

Christo: It was an enormous beauty . . . unbelievable beauty. The wind was going underneath and the fabric was moving, but, of course, the areas where the fabric was tied around a rock the fabric was not moving. It was a beautiful contrast. We never expected that. Those images, I still see them today . . .

Jeanne-Claude: But many, many years later, we were back in Australia to lecture, and we, of course, sentimentally went to see the site. . . . Now the site has changed, because what we wrapped was a garbage dump, now it's a golf course. We put the shame on them. It was a garbage dump at the big gully. And we were there and we looked at the site, Christo and I, and we felt we must have been crazy. We wouldn't dare do that project today.

Christo: I remember we asked John Kaldor to sew these huge sections of fabric, six to seven hundred feet each, and in the first morning, in a very simple way, we all said, "Okay, here is the fabric, where do we start?" We started from the top and rolled the fabric down to the gully. The other panels were there, and the climbers stitched them together and placed the ropes. I remember it was so simple.

Jeanne-Claude: But when you have a piece of fabric with the wind of the Pacific, when the wind takes that . . .

Christo: *Valley Curtain* is totally different. . . . *Valley Curtain* was the first time we really were confronted, not confronted, but involved, with American construction workers, people

who build things. Before, for the Chicago museum there were workers, but not really these professional workers who build skyscrapers and bridges and things. Since *Valley Curtain* we always have people who build things, steelworkers, carpenters, and machinists. The Chicago museum was a little bit, still more amateurish in some way, we have some of the movers help us to put the fabric, it was not too high a building, only a two-story building, not a big thing. In Germany we had professional workers but not American professional union workers. All the construction of putting the anchors, fabrication of the steel, bringing the steel, the pulley system, the operators, all this was union. All these things were revealed through the *Valley Curtain* project. Really, the ironworkers were almost like movie stars, you know.

Jeanne-Claude: And we were learning the English technical words from them, which we didn't know. I learned a lot of words, like I learned that there was a monkey wrench, I didn't know. I learned about the fucking hammer. Because he said, "Hey you, son of a bitch, hand me the fucking hammer..."

Christo: Ironworkers in the West were paid like movie actors, like a star, they have an agent. Like movie actors, they have an agent. I remember vividly... and he would call some of his people, he would propose to me if they accept. If you accept, they come to see it, and they were very handsome, coming with their cars and they buy houses. For me, it was unbelievable. They buy a house to have a job only for one year.

Jeanne-Claude: The ironworkers, they're the ones who build the skyscrapers... and the suspension bridges.

Christo: They are paid so much, they only want to work overtime.

Jeanne-Claude: They work when they want and at what they want.

Christo: They don't accept to work only eight hours a day. They always work overtime, they cannot be up at the cables and come down because eight hours is over. They stay probably ten or twelve hours. We liked them very much. They were fabulous people. We loved them, unbelievable. This is something... and of course these people were so professional. But also we were speaking bad English, in the beginning they were probably making fun of us. But we became like brothers.

Jeanne-Claude: In the beginning, really, they had not the slightest interest, but when they understood what they were working at, they became so involved.

Christo: Yes, it's unbelievable.

Jeanne-Claude: You see them in the film.

Fineberg: And what happened with the unions? That was a big problem.

Jeanne-Claude: No, no problem.

Christo: No, there was a problem with the builder-contractor, Morrison-Knudsen.

Jeanne-Claude: We fired the first builder-contractor, before Ted Dougherty took their place. And we fired the New York engineers.

Christo: We had done the *Wrapped Coast*, and the only people we knew were Armand Bartos, and John Powers, important collectors. Armand Bartos is an architect, he built the Jerusalem Museum...

Jeanne-Claude: With Frederick Kiesler.

Christo: Now Armand Bartos told us, you know, *Valley Cur-*

tain is a large engineering job, you should talk to Lev Zetlin, who is a big specialist, structural engineer. Armand Bartos introduced us to Lev Zetlin.

Jeanne-Claude: Zetlin was a very famous engineering company in New York. Not in Colorado. The terrain of New York is not the same as the mountains of Colorado.

Christo: And now, the funny thing is that Lev Zetlin, . . . one of the engineers of Lev Zetlin was one of the most important hired persons about the 9/11 tragedy. He was hired by the United States government to review how the building was built.

Jeanne-Claude: They designed the anchors in the mountains for Colorado in their New York office, they never came once to the site. The first thing that Zetlin said was to blast the mountain.

Christo: And of course they also don't know how to hang fabric. It was a disaster. But, Dr. Ernie Harris, I don't know if you remember Dr. Ernie Harris, the little professor, you probably met him? The State of Colorado sent Dr. Harris to be the inspector of the job. And when the first *Valley Curtain* collapsed, in 1971, and we had already spent hundreds of thousands of dollars . . .

Jeanne-Claude: It didn't collapse, it never went up.

Christo: We understood that we have the lousiest company because Morrison-Knudsen is the biggest builder-contractor and send us their lousiest workers.

Jeanne-Claude: Of course, for an art project.

Christo: Of course. This is why, in desperation, we ask, but who we should hire? We should hire the inspector, we asked the inspector . . .

Jeanne-Claude: the inspector, engineer-inspector . . .

Christo: . . . appointed by the State of Colorado.

Jeanne-Claude: . . . appointed by the State of Colorado highway department. Who, for us, he was the big bad wolf. Whenever there was something not well done, we would put tarps on it so he wouldn't see it. Because he was inspecting us. And so when we fired those New York engineers and that builder-contractor we thought who will be the engineer and the builder-contractor?

Christo: We should hire the inspector because he's the only one who knows everything.

Jeanne-Claude: We asked the highway department, would it be all right, if there is no conflict of interest, that your inspector-engineer would become our chief engineer? And they said that's fine, because he knew everything about the project. And then we asked Dr. Ernest C. Harris, what contractor should we hire? And he said, well we don't have people in Colorado of the prestige of Morrison-Knudsen, who have built all the highways in Vietnam and the Hoover Dam. And we said, we don't want a big, big builder-contractor, we want a small, good builder-contractor, and that was Theodore Dougherty, A & H Builders.

Christo: And of course Ted brought his people, and this is how it worked. And of course, having Ernie and Ted became like a family. And Ted, of course, did not give us his lousiest people, he gave us his very best people. When we did *Running Fence,* even though it was in California, and Ted and Ernie were from Colorado, they moved to California to work with us. There are no better people than Ted and Ernie. And I remember after the *Valley Curtain,* Ernie Harris suggested that since we were going to California, we should go mostly to the northern part to look for a site. He gave us the name of somebody around the San Francisco area, surveyors. And of course, now the *Run-*

ning Fence project is a totally different story. The *Running Fence* project is probably a hundred little pieces. . . .

Jeanne-Claude: But, for *Running Fence,* it was the first time we were sued. We were never sued before. Now, the governor of Colorado did not want to give the permit for *Valley Curtain.* But, in the little town of Rifle, the radio station man made a poll of all the citizens, and then, they went, the delegation from little Rifle, Colorado, they went to the capital in Denver and told the governor, if you don't give the permit, you have the entire town of Rifle voting against you next coming election. We got the permit, but the governor wanted to protect himself, so to the media he said, but it's the last time I give a permit for a *Valley Curtain.* Like there were fifty other artists waiting, right?

Christo: But, you're laughing, but this phrase came up very recently, not the same way, by Adrian Benepe, at some public meetings, somewhere recently, he is the park commissioner, who says that our forty-seven pages of contract with the City of New York created such a precedent, that probably this is the last time that something like that would happen in Central Park.

Jeanne-Claude: I will explain. Gordon Davis in his thick book [refusing to grant a permit for the project in the early 1980s] said it would create a precedent.

Christo: And there would be a line of strange people . . .

Jeanne-Claude: Now, he even compared it, he said, if someone wants a motorcycle race, I will have to say yes because we said yes for *The Gates.* All right, the years move on. Now, we have commissioner of parks and recreation, Benepe, who likes us. And we have the park's administrator, Douglas Blonsky, who likes us. But they have to protect themselves. So now they went exactly reverse, now, indeed, our contract with the city has created a precedent, a precedent they can use. Which is, any artist who is going to pay for himself, remove everything, . . .

Christo: And give money to the park . . .

Jeanne-Claude: . . . restore the park, recycle the material, give $3 million to the park, which we are doing, then, under all those precedents, then we would say yes. Now, they have a good precedent to protect the park.

Christo: And, the precedent is draconian.

Jeanne-Claude: So now they are happy to have a precedent behind which they can retrench and say, oh wait, you don't fulfill all these conditions.

Christo: Now the park has a precedent. Usually when an architect goes to build a bridge, or highway, or skyscraper, there is a book, and the book says the skyscraper should be built like that, and they should fulfill these things. They need to fit the book, the physical things in some kind of reference, the logic of permission. But with our project—this is always the problem, that was the problem also with *Running Fence*—I remember our opposition was claiming that was hiding the landscape like advertising panels. . . . Imagine comparing *Running Fence* with advertising panels . . .

Fineberg: So they have to find something that's already been done with which to compare it?

Christo: Yes, and they did not find it, and this is why, in the case of *The Gates,* they create that very exhausting forty-seven pages of contract, very, very complex contract.

When we designed *Running Fence,* Jeanne-Claude and myself, we were walking putting these stakes . . . and there was no way to see where the *Fence* will go. I tried to visualize, but there were only some stakes, far away. One of the most exhilarating things with *Running Fence* was that the *Fence* was so rich in the layers, far away, sometimes superimposed. We are expecting to have a little bit of that here with *The Gates.*

Fineberg: Visually.

Christo: Yes. It was surprising, so surprising even though I tried to predict what it would look like, it was impossible to predict. I remember, during *Running Fence,* I had time to spend up on the hills with the wind. Something that I was never aware of, that richness of the folds of the fabric. I drew it in my drawings, but I never foresaw that the shifting winds would create a belly in one direction in one panel and in the opposite direction in the next panel. In my drawings, *Running Fence* had been a line, but it did not show the complex directions of the wind, creating a continuous shifting of the fabric, something that I was not capable to visualize before. There are beautiful pictures of that fabric moving.

Fineberg: What about the *Walk Ways*?

Christo: The *Walk Ways* was turned down in Japan and Holland. In 1976, there was some exhibition and Dorothy Walker, she was involved with the Arts Council of Ireland and she remembered the *Wrapped Walk Ways* proposal, and she told us, we have this great park, where all the great writers, poets go there. It's a small park, it's perfect, it's not complicated. I remember, we went to Dublin. We talked about the drawings again. The city refused. It was something with the security, they were worried that the people would fall. That was the same reason the permit was refused for Sonsbeek Park and in Ueno Park. I remember when we came to Kansas City, there was the same objection. How did we overcome that? We had a very good park commissioner, an older gentleman who said, "The only way I can give the permission is if I can see that I can walk and the runners can run." And, of course, we did that. We fabricated a small fabric section, I think about seventy feet of fabric. I remember, we installed the fabric, and he asked for some runners to run on the fabric.

Jeanne-Claude: Real runners, every day, and they ran on it, none of them broke a leg . . .

Christo: No problems. And we get initially very fast the permits.

Jeanne-Claude: And that is why nobody knows about that project. There was no controversy on television, no battle in the newspaper, we were not sued in court, nobody knows about one of our most exquisite projects. It's amazing.

Christo: Oh, I love that project. But it happened like that.

Fineberg: So for you what was the most memorable part of it?

Christo: The most memorable part of the *Wrapped Walk Ways* was the blind people. Jeanne-Claude cried. Jeanne-Claude will tell you the story, it was in 1978.

Jeanne-Claude: We saw a group of people walking on the covered walkway from far away and there was about twenty, thirty, twenty-five people, and they had their shoes in their hands. And in front of them there was a man talking to them, but he had his shoes on his feet. And then as they came nearer, the man who was wearing his shoes introduced himself and he said, I am leading a group of blind people. And he pointed at one of them, and he said, Christo and Jeanne-Claude are here, the artists, and he wants to say something to you, and we said, hello, thank you for coming. And he said, we have seen your work, it's beautiful. That's why they were holding their shoes in their hands . . . and that's when I started crying.

Christo: Now the funny story, . . . that same group of people came in 1991 to see *The Umbrellas*. They called Tom Golden [project director for *The Umbrellas*].

Jeanne-Claude: We did not meet them, we were god knows where then, maybe in Japan. Tom Golden told us when we came back, . . . one of them said we didn't realize the umbrellas were so wide and so big, and Tom Golden said, but how do you know? They said, oh, it's very simple, we stepped on the base, we held the pole, and then we came down from the base

and the shade stopped and the sun hit us and we know exactly the dimension. But we could never, never have thought of that. . . . We designed the base so that people could sit on it, and they did, in both countries, they had picnics there. In Japan they removed their shoes before stepping under the um-brellas. But we didn't ever think about that. In Japan you re-move your shoes before you enter a house. After all those years in Japan, after so many times removing our shoes, we had never thought of that.

Chronology

1935 Christo Javacheff born June 13 in Gabrovo, Bulgaria, to an industrialist family.

Jeanne-Claude de Guillebon born June 13 in Casablanca, Morocco, of a French military family; later educated in France and Switzerland.

1952 Jeanne-Claude earns baccalaureat in Latin and philosophy, University of Tunis.

1953–56 Christo studies at Fine Arts Academy, Sofia; arrives in Prague 1956.

1957 Christo studies one semester at the Vienna Fine Arts Academy.

1958 Christo arrives in Paris, where he meets Jeanne-Claude. Packages and *Wrapped Objects*.

1960 Birth of their son, Cyril, May 11.

1961 *Project for the Wrapping of a Public Building*, Paris. *Stacked Oil Barrels* and *Dockside Packages* at Cologne harbor; CHRISTO AND JEANNE-CLAUDE'S FIRST COLLABORATION.

1962 *Iron Curtain, Wall of Oil Barrels, Rue Visconti, Paris, 1961–62*. *Stacked Oil Barrels*, Gentilly, near Paris; *Wrapping a Woman*, London.

1963 *Showcases*.

1964 Establishment of permanent residence in New York City; *Store Fronts* and *Show Windows*.

1966 *Air Package* and *Wrapped Tree*, Stedelijk van Abbemuseum, Eindhoven, Holland.

42,390 Cubic Feet Package, Walker Art Center and the Minneapolis School of Art.

1968 *Wrapped Fountain* and *Wrapped Medieval Tower*, Spoleto.

Wrapping of a public building, *Wrapped Kunsthalle, Bern, Switzerland*.

5,600 Cubic Meter Package, Documenta 4, Kassel, Germany, an air package 280 feet high, foundations arranged in a 900-foot-diameter circle; *Corridor Store Front*, total area 1,500 square feet.

1,240 Oil Barrels Mastaba, and *Two Tons of Stacked Hay*, Institute of Contemporary Art, Philadelphia.

1969 *Wrapped Museum of Contemporary Art, Chicago*, 10,000 square feet of tarpaulin.

Wrapped Floor and Stairway, 2,800 square feet of drop cloths, Museum of Contemporary Art, Chicago.

Wrapped Coast, One Million Square Feet, Little Bay, Sydney, Australia, 1,000,000 square feet of erosion control fabric and 35 miles of rope.

Project for stacked oil barrels, *Houston Mastaba, Texas*, 1,249,000 barrels.

Project for *Closed Highway*.

1970 Wrapped Monuments, Milan, *Monument to Vittorio Emanuele, Piazza del Duomo; Monument to Leonardo da Vinci, Piazza della Scala*.

1971 *Wrapped Floors, Covered Windows and Wrapped Walk Ways*, Haus Lange, Krefeld, Germany.

1972 *Valley Curtain, Grand Hogback, Rifle, Colorado, 1970–72*, width, 1,250–1,368 feet, height, 185–365 feet, 142,000 square feet of nylon polyamide, 110,000 pounds of steel cables, 800 tons of concrete.

1974 *The Wall, Wrapped Roman Wall, Via V. Veneto and Villa Borghese, Rome*.

Ocean Front, Newport, Rhode Island, 150,000 square feet of floating polypropylene fabric over the ocean.

1976 *Running Fence, Sonoma and Marin Counties, California, 1972–76*, 18 feet high, 24 1/2 miles long, 2.3 million square feet of woven nylon fabric, 90 miles of steel cables, 2,050 steel poles (each 3 1/2 inch diameter, 21 feet long).

1977 *The Mastaba of Abu Dhabi, Project for the United Arab Emirates;* IN PROGRESS.

1978 *Wrapped Walk Ways, Loose Park, Kansas City, Missouri, 1977–78*, 15,000 square yards of woven nylon fabric over 2.8 miles of walkways.

1979 *The Gates, Project for Central Park, New York City;* IN PROGRESS.

1983 *Surrounded Islands, Biscayne Bay, Greater Miami, Florida, 1980–83*, 6.5-million-square-foot pink woven polypropylene floating fabric.

1984 *Wrapped Floors and Stairways and Covered Windows*, Architecture Museum, Basel, Switzerland.

1985 *The Pont Neuf Wrapped, Paris, 1975–85*, 440,000 square feet of woven polyamide fabric, 42,900 feet of rope.

198

1991 *The Umbrellas, Japan-USA, 1984–91*, 1,340 blue umbrellas in Ibaraki, Japan, 1,760 yellow umbrellas in California, United States; each umbrella is 19 feet 8 inches high, diameter 28 feet 6 inches.

1992 *Over The River, Project for The Arkansas River, State of Colorado;* IN PROGRESS.

1995 *Wrapped Floors and Stairways and Covered Windows,* Museum Würth, Künzelsau, Germany.

Wrapped Reichstag, Berlin, 1971–95, 1,076,000 square feet of polypropylene fabric, 51,181 feet of rope, and 200 metric tons of steel.

1998 *Wrapped Trees, Fondation Beyeler and Berower Park, Riehen-Basel, Switzerland, 1997–98*, 178 trees wrapped with 592,034 square feet of woven polyester fabric and 14.3 miles of rope.

1999 *The Wall, 13,000 Oil Barrels, Gasometer, Oberhausen, Germany,* an indoor installation.

Bibliography

Books

1965

Christo. Texts by David Bourdon, Otto Hahn, and Pierre Restany; designed by Christo. Milan: Edizioni Apollinaire.

1968

Christo: 5,600 Cubic Meter Package. Photographs by Klaus Baum; designed by Christo. Baierbrunn, Germany: Verlag Wort und Bild.

1969

Christo. Text by Lawrence Alloway; designed by Christo. New York: Harry N. Abrams; Stuttgart: Verlag Gerd Hatje; London: Thames and Hudson.

Christo: Wrapped Coast, One Million Square Feet. Photographs by Shunk-Kender; designed by Christo. Minneapolis: Contemporary Art Lithographers.

1970

Christo. Text by David Bourdon; designed by Christo. New York: Harry N. Abrams.

1971

Christo: Projeckt Monschau. By Willi Bongard. Cologne: Verlag Art Actuell.

1973

Christo: Valley Curtain. Photographs by Harry Shunk; designed by Christo. Stuttgart: Verlag Gert Hatje; New York: Harry N. Abrams; Paris: Pierre Horay; Milan: Gianpaolo Prearo.

1975

Christo: Ocean Front. Text by Sally Yard and Sam Hunter; photographs by Gianfranco Gorgoni; edited by Christo. Princeton: Princeton University Press.

Environmental Impact Report: Running Fence. Prepared by Paul E. Zigman and Richard Cole. Foster City, California: Environmental Science Associates.

1977

Christo: The Running Fence. Text by Werner Spies; photographs and editing by Wolfgang Volz. New York: Harry N. Abrams; Paris: Édition du Chêne; Stuttgart: Editions Gerd Hatje.

1978

Christo: Running Fence. Chronicle by Calvin Tomkins; narrative text by David Bourdon; photographs by Gianfranco Gorgoni; designed by Christo. New York: Harry N. Abrams.

Christo: Wrapped Walk Ways. Essay by Ellen Goheen; photographs by Wolfgang Volz; designed by Christo. New York: Harry N. Abrams.

1980

Catalogue Raisonné of Original Works. Prepared by Daniel Varenne, with the collaboration of Ariane Coppier, Marie-Claude Blancpain, and Raphaëlle de Pourtales, in progress.

1982

Christo: Complete Editions, 1964–82. Catalogue raisonné, introduction by Per Hovdenakk. Munich: Verlag Schellmann and Kluser; New York: New York University Press.

1984

Christo: Works, 1958–83. Text by Yusuke Nakahara. Tokyo: Publication Sogetsu Shuppan.

Christo: Surrounded Islands, Biscayne Bay, Greater Miami, Florida, 1980–83. Text by Werner Spies; photographs and editing by Wolfgang Volz. Cologne: Dumont Buchverlag; New York: Harry N. Abrams (1985); Saint-Paul de Vence, France: Fondation Maeght (1985); Barcelona: Ediciones Poligrafa (1986).

Christo: Der Reichstag. Compiled by Michael Cullen and Wolfgang Volz; photographs by Wolfgang Volz. Frankfurt: Suhrkamp Verlag.

1985

Christo. Text by Dominique Laporte. Paris: Art Press/Flammarion; New York: Pantheon (1986).

1986

Christo: Surrounded Islands, Biscayne Bay, Greater Miami, Florida, 1980–83. Photographs by Wolfgang Volz; introduction and picture commentary by David Bourdon; essay by Jonathan Fineberg; report by Janet Mulholland; designed by Christo. New York: Harry N. Abrams.

1987

Le Pont-Neuf de Christo, Ouvrage d'Art, Oeuvre d'Art, ou Comment Se Faire une Opinion. By Nathalie Heinich; photographs by Wolfgang Volz, Harry Shunk, and Jeanne-Claude. Paris: ADRESSE.

Helt Fel I Paris. By Pelle Hunger and Joakim Stromholm; photographs by J. Stromholm. Fromme, England: Butler and Tanner, The Selwood Printing Works.

1988

Christo: Prints and Objects, 1963–87. Catalogue raisonné edited by Jörg Schellmann and Josephine Benecke; introduction by Werner Spies. Munich: Editions Schellmann; New York: Abbeville.

1990

Christo: The Pont Neuf Wrapped, Paris, 1975–85. Photographs by Wolfgang Volz; texts by David Bourdon and Bernard de Montgolfier; designed by Christo. New York: Harry N. Abrams; Paris: Adam Biro; Cologne: Dumont Buchverlag.

Christo. By Yusuke Nakahara. Tokyo: Shinchosha.

Christo. By Marina Vaizey. Barcelona: Poligrafa; New York: Rizzoli; Paris: Albin Michel; Amsterdam: Meulenhoff/Landshoff; Recklinghausen, Germany: Verlag Aurel Bongers; Tokyo: Bijutsu Shupan-Sha.

1991

Christo: The Accordion-Fold Book for The Umbrellas, Joint Project for Japan and USA. Photographs by Wolfgang Volz; foreword and interview by Masahiko Yanagi; designed by Christo. San Francisco: Chronicle.

1993

Christo: The Reichstag and Urban Projects. Edited by Jacob Baal-Teshuva; photographs by Wolfgang Volz; contributions by Tilmann Buddensieg, Michael S. Cullen, Rita Süssmuth, and Masahiko Yanagi. In German for the exhibitions at the Kunsthaus Wien, Austria, the Villa Stuck, Munich, and the Ludwig Museum, Aachen. Munich: Prestel Verlag; New York: Prestel Publications (in English).

1994

Christo and Jeanne-Claude: Der Reichstag und Urbane Projekte. Edited by Jacob Baal-Teshuva; contributions by Tilmann Buddensieg and Wieland Schmied; interview by Masahiko Yanagi; chronology by Michael S. Cullen; photographs by Wolfgang Volz. Munich: Prestel Verlag.

1995

Christo & Jeanne-Claude. By Jacob Baal-Teshuva; photographs by Wolfgang Volz; designed by Christo; edited by Simone Philippi and Charles Brace. Cologne: Benedikt Taschen Verlag.

Christo, Jeanne-Claude, Der Reichstag dem Deutschen Volke. By Michael S. Cullen and Wolfgang Volz; photographs by Wolfgang Volz. Bergisch-Gladbach, Germany: Bastei-Lübbe, Gustav Lübbe Verlag.

Christo and Jeanne-Claude, Prints and Objects, 1963–95. Catalogue raisonné, edited by Jörg Schellmann and Joséphine Benecke. Munich: Editions Schellmann; Munich: Schirmer Mosel Verlag.

Christo & Jeanne-Claude Postcard Book. Cologne: Benedikt Taschen Verlag.

Christo & Jeanne-Claude, Poster Book. Photographs by Wolfgang Volz; text by Thomas Berg. Cologne: Benedikt Taschen Verlag.

Christo and Jeanne-Claude: Wrapped Reichstag, Berlin, 1971–95. The Project Book. Photographs by Wolfgang Volz. Cologne: Benedikt Taschen Verlag.

1996

Christo and Jeanne-Claude, Wrapped/Verhüllter Reichstag, Berlin 1971–95. Photographs by Wolfgang Volz; picture notes by David Bourdon; edited by Simone Philippi; designed by Christo. Cologne: Benedikt Taschen Verlag.

Christo and Jeanne-Claude Projects Selected from the Lilja Collection. Second edition. Photographs by Wolfgang Volz; preface by Torsten Lilja; text by Per Hovdenakk. London: Azimuth Editions.

1998

Christo and Jeanne-Claude, The Umbrellas, Japan-USA, 1984–91. Photographs by Wolfgang Volz; picture notes by Jeanne-Claude and Masa Yanagi; designed by Christo; edited by Simone Philippi. Two volumes in one box. Cologne: Benedikt Taschen Verlag.

Christo and Jeanne-Claude, Wrapped Trees, 1997–98. Photographs and picture notes by Wolfgang and Sylvia Volz; introduction by Ernst Beyeler; edited by Simone Philippi. Cologne: Benedikt Taschen Verlag.

1999

Erreurs les plus Fréquentes. Text by Jeanne-Claude. *Christo and Jeanne-Claude, Most Common Errors.* Edited by Jeanne-Claude, English and French. Paris: Editions Jannink (2000).

Christo und Jeanne-Claude, Eine Biografie. By Burt Chernow; epilogue by Wolfgang Volz; 55 illustrations, plus 28 in color. Cologne: Verlag Kiepenheuer & Witsch.

2001

Christo e Jeanne-Claude, Una Biografia. By Burt Chernow; epilogue by Wolfgang Volz; 99 illustrations, plus 28 in color. Skira, Italy: Fondazione Ambrosetti Arte Contemporanea.

Christo & Jeanne-Claude. By Jacob Baal-Teshuva; photographs by Wolfgang Volz; designed by Christo; edited by Simone Philippi; 120 illustrations. Cologne: Taschen.

Christo and Jeanne-Claude: Early Works, 1958–69. Texts by Lawrence Alloway, David Bourdon, Jan van der Marck; edited and updated by Susan Astwood; photographs by Ferdinand Boesch, Thomas Cugini, André Grossmann, Eeva-Inkeri, Jean-Dominique Lajoux, Harry Shunk, Wolfgang Volz, Stefan Wewerka, and many others. Cologne: Taschen.

2002

Christo and Jeanne-Claude: A Biography. By Burt Chernow; epilogue by Wolfgang Volz; 65 black-and-white illustrations, 28 in color. New York: St. Martin's.

Christo and Jeanne-Claude in the Vogel Collection. National Gallery of Art, Washington, D.C. Introduction by Earl A. Powell, III; text and interview by Molly Donovan; photographs by Wolfgang Volz. New York: Harry N. Abrams.

2003

Christo and Jeanne-Claude, The Gates, Project for Central Park, New York City. Photographs by Wolfgang Volz; picture commentary by Jeanne-Claude and Jonathan Henery. Westport, Connecticut: Hugh Lauter Levin Associates.

Catalogues for Personal Exhibitions

1961

Christo. Galerie Haro Lauhus, Cologne, Germany. Text by Pierre Restany; poem by Stephan Wewerka.

1962

Le Docker et le Décor. Rue Visconti, Paris. Text by Pierre Restany.

1966

Christo. Stedelijk van Abbemuseum, Eindhoven, Netherlands. Text by Lawrence Alloway.

1968

Christo Wraps the Museum. Museum of Modern Art, New York. Text by William Rubin.

Christo. Institute of Contemporary Art, University of Pennsylvania, Philadelphia. Text by Stephen Prokopoff.

1969

Woolworks. National Gallery of Victoria, Melbourne, Australia. Text by Jan van der Marck.

1971

Wrapped Floors, Covered Windows, and Wrapped Walk Ways. Haus Lange Museum, Krefeld, Germany. Text by Paul Wember.

Valley Curtain, Project for Rifle, Colorado, Documentation in Progress. Museum of Fine Arts, Houston, Texas. Text by Jan van der Marck.

1973

Valley Curtain, 1970–72, Documentation Exhibition. Kunsthalle, Düsseldorf, Germany. Text by John Matheson; photographs by Harry Shunk.

1974

Valley Curtain, 1970–72, Documentation Exhibition. Musée de Peinture et de Sculpture, Grenoble, France. Text by Maurice Besset.

1975

Christo. Galerie Ciento, Barcelona, Spain. Text by Alexandre Cirici.

Exposición Documental Sobre El Valley Curtain 1972–76. Museo de Bellas Artes, Caracas, Venezuela. Photographs by Harry Shunk. Caracas: Impresion Editorial Arte.

1977

Christo. Minami Gallery, Tokyo, Japan. Text by Yusuke Nakahara.

Wrapped Reichstag, Project for Berlin. Landische Museum, Bonn, Germany. Texts by Wieland Schmied and Tilmann Buddensieg.

Wrapped Reichstag, Project for Berlin. Annely Juda Fine Art, London, England. Photographs by Wolfgang Volz; texts by Wieland Schmied and Tilmann Buddensieg.

1978

Galerien Maximilianstrasse. Galerie Art in Progress, Munich, Germany. Text by Albrecht Haenlein.

The Mastaba. Rijksmuseum Kröller-Müller, Otterlo, Netherlands. Introduction by R. W. D. Oxenaar; text by Ellen Joosten.

1979

Running Fence, Documentation Exhibition, 1972–76. Wiener Secession, Vienna, Austria. Photographs by Wolfgang Volz; text by Werner Spies; introduction by Herman J. Painitz.

Urban Projects. Institute of Contemporary Art, Boston; Laguna Gloria Art Museum, Austin, Texas; Corcoran Gallery of Art, Washington, D.C. Introduction by Stephen Prokopoff; text by Pamela Allara and Stephen Prokopoff.

1981

Urban Projects. Museum Ludwig, Cologne, Germany; Staedel Museum, Frankfurt, Germany. Introduction by Karl Ruhrberg and Klaus Gallwitz; text by Evelyn Weiss and Gerhard Kolberg.

Surrounded Islands, Project for Florida. Juda-Rowan Gallery, London, England. Photographs by Wolfgang Volz; text by Anitra Thorhaug.

Collection on Loan from the Rothschild Bank AG, Zürich. La Jolla Museum of Contemporary Art, La Jolla, California. Introduction by Robert McDonald; text by Jan van der Marck.

1982

Wrapped Walk Ways, 1977–78, Documentation Exhibition. Hara Museum of Contemporary Art, Tokyo, Japan. Photographs by Wolfgang Volz; texts by Toshio Hara, Ellen R. Goheen, and Toshio Minemura. Tokyo: Fondation Arc-en-Ciel.

Environmental Art Works. United Arab Emirates University, Al-Ain, United Arab Emirates. Photographs by Harry Shunk and Wolfgang Volz; foreword by Ezzidin Ibrahim.

1984

The Pont Neuf Wrapped, Project for Paris. Satani Gallery, Tokyo, Japan. Photographs by Wolfgang Volz; text by Yusuke Nakahara; interview by Masahiko Yanagi.

Objects, Collages, and Drawings, 1958–84. Juda-Rowan Gallery, London, England.

Wrapped Floors, im Architekturmuseum, Basel. Architekturmuseum, Basel, Switzerland. Photographs by Wolfgang Volz; text by Ulrike and Werner Jehle-Schulte.

1986

Wrapped Reichstag, Project for Berlin. Satani Gallery, Tokyo, Japan. Photographs by Wolfgang Volz; interview by Masahiko Yanagi.

Dibuixos i Collages. Galeria Joan Prats, Barcelona, Spain.

1987

Surrounded Islands, 1980–83, Documentation Exhibition. Museum of Contemporary Art, Gent, Belgium. Photographs by Wolfgang Volz; text by Werner Spies.

A Collection on Loan from the Rothschild Bank, Zürich. Seibu Museum of Art, Tokyo, Japan. Texts by Torsten Lilja, Yusuke Nakahara, Tokuhiro Nakajima, and Akira Moriguchi; interview by Masahiko Yanagi; photographs by Wolfgang Volz.

Dessins, Collages, Photographs. Centre d'Art Nicolas de Staël, Braine-L'Alleud, Belgium. Photographs by Wolfgang Volz; text by A. M. Hammacher; interviews by Marcel Daloze and Dominique Verhaegen.

Laudation zur Verleihung des Kaiserrings, Goslar, September 26, 1987, Germany. Edition Mönchehaus-Museum Verein zur Förderung Moderne Kunst, Goslar, Germany. Text by Werner Spies; photographs by Wolfgang Volz.

1988

The Umbrellas, Joint Project for Japan and USA. Satani Gallery, Tokyo, Japan. Photographs by Wolfgang Volz; introduction by Ben Yama; text by Masahiko Yanagi.

The Umbrellas, Joint Project for Japan and USA. Annely Juda Fine Art, London, England. Photographs by Wolfgang Volz; interview and text by Masahiko Yanagi.

Collection on Loan From the Rothschild Bank AG, Zürich. Taipei Fine Arts Museum, Taipei, Taiwan. Preface by Kuang-Nan Huang; texts by Werner Spies and Joseph Wang; photographs by Wolfgang Volz.

1989

The Umbrellas, Joint Project for Japan and USA. Guy Pieters Gallery, Knokke-Zoute, Belgium. Photographs by Wolfgang Volz; text by Masahiko Yanagi; picture commentary by Susan Astwood.

Selection from the Lilja Collection. Musée d'Art Moderne et d'Art Contemporain, Nice, France. Texts by Torsten Lilja, Claude Fournet, Pierre Restany, Werner Spies, and Masahiko Yanagi; photographs by Wolfgang Volz.

Works: 1965–88. Galerie Catherine Issert, Saint-Paul de Vence, France. Text by Raphael Sorin.

1990

Works, 1958–89, from the Lilja Collection. The Henie-Onstad Art Centre, Høvikodden, Norway. Introduction by Torsten Lilja; text by Per Hovdenakk; interview by Jan Åman; photographs by Wolfgang Volz.

Surrounded Islands, 1980–83, Documentation Exhibition. Hiroshima City Museum of Contemporary Art, Japan; Hara Museum, ARC, Gunma, Japan; Fukuoka Art Museum, Japan. Photographs by Wolfgang Volz; text by Jonathan Fineberg.

Works from 1958–90. The Art Gallery of New South Wales, Sydney, Australia. Foreword by John Kaldor; texts by Albert Elsen, Toni Bond, Daniel Thomas, and Nicholas Baume; photographs by Wolfgang Volz.

Drawings-Multiples. Bogerd Fine Art, Amsterdam, Holland.

Prints and Lithographs. Gallery Seomi, Seoul, Korea.

The Umbrellas, Joint Project for Japan and USA. Satani Gallery, Tokyo, Japan. Photographs by Wolfgang Volz; text by Masahiko Yanagi.

1991

Projects Not Realized and Works in Progress. Annely Juda Fine Art, London, England. Foreword by Annely Juda and David Juda.

Obra 1958–91. Galeria Joan Prats, Barcelona, Spain. Text by Marina Vaizey.

Valley Curtain, 1970–72, Documentation Exhibition and *The Umbrellas, Joint Project for Japan and USA, Work in Progress*. Art Tower Mito, Ibaraki, Japan. Photographs by Harry Shunk and Wolfgang Volz; text by Jan van der Marck; interview by Masahiko Yanagi.

Early Works, 1958–64. Satani Gallery, Tokyo, Japan. Text by Masahiko Yanagi and Harriet Irgang.

1992

Works from '80s and '90s. Gallery Seomi and Gallery Hyundai, Seoul, Korea. Exhibitions curated by Carl Flach; photographs by Wolfgang Volz.

Valley Curtain, 1970–72, Documentation Exhibition and *The Umbrellas, Japan-USA*. Marugame Genichiro Inokuma Museum of Contemporary Art, Japan. Photographs by Harry Shunk and Wolfgang Volz; text by Jan van der Marck; interview by Masahiko Yanagi.

1993

Works from the '80s and '90s. Art Front Gallery, Hillside Terrace, Tokyo, Japan. Photographs by Wolfgang Volz; curated by Carl Flach; text compiled by Masahiko Yanagi.

The Reichstag and Urban Projects. Prestel Verlag, Munich, Germany. Edited by Jacob Baal-Teshuva; photographs by Wolfgang Volz; contributions by Tilmann Buddensieg and Wieland Schmied; interview by Masahiko Yanagi; chronology by Michael S. Cullen.

1994

The Pont Neuf Wrapped, Paris, 1975–85, Documentation Exhibition. Kunstmuseum, Bonn, Germany. Photographs by Wolfgang Volz; excerpts from Jeanne-Claude's agenda; texts by Volker Adolphs, Bernard de Montgolfier, Dieter Ronte, and Constance Sherak.

1995

Christo and Jeanne-Claude Projects Selected from the Lilja Collection. First edition. Azimuth Editions, London, England. Photographs by Wolfgang Volz; preface by Torsten Lilja; text by Per Hovdenakk.

The Works in the Collection Würth. Museum Würth, Künzelsau, Germany. Texts by Lothar Romain and C. Sylvia Weber; photographs by Wolfgang Volz. Sigmaringen, Germany: Thorbecke Verlag.

Christo and Jeanne-Claude, Wrapped Floors and Stairways and Covered Windows. Museum Würth, Künzelsau, Germany. Photographs by Wolfgang Volz; edited by C. Sylvia Weber; texts by Wulf Herzogenrath, Hans Georg Frank, Sibylle Peine, Andreas Sommer, Wolfgang Reiner, and Christian Marquart. Sigmaringen, Germany: Thorbecke Verlag.

Christo and Jeanne-Claude, Three Works in Progress. Annely Juda Fine Art, London, England. Foreword by Annely Juda and David Juda; photographs by Wolfgang Volz.

Wrapped Reichstag, Berlin, and Works in Progress. Art Front Gallery, Tokyo, Japan. Photographs by Wolfgang Volz, Sylvia Volz, André Grossmann, Michael Cullen, and Yoshitaka Uchida.

1997

Christo & Jeanne-Claude, Sculpture and Projects, 1961–96. Yorkshire Sculpture Park, U.K. Preface by Peter Murray; designed and produced by Claire Glossop.

Christo and Jeanne-Claude Projects, Works from the Lilja Collection. The Museum of Sketches, Lund, Sweden. Photographs by Wolfgang Volz; introduction by Jan Torsten Ahlstrand.

1998

Christo and Jeanne-Claude, The Gates, Project for Central Park, New York; and Over the River, Project for the Arkansas River, Colorado. Galerie Guy Pieters, Belgium. Photographs by Wolfgang Volz; designed by Christo; picture notes by Jeanne-Claude and Jonathan Henery.

Christo and Jeanne-Claude. Galerie Beyeler, Basel, Switzerland. Excerpts from a text by David Bourdon; text by Werner Spies.

1999

Christo and Jeanne-Claude: The Umbrellas, Japan-USA, 1984–91, A Documentation Exhibition; *Wrapped Reichstag, Berlin, 1971–95, A Documentation Exhibition. The Wall, 13,000 Oil Barrels*. IBA, Gasometer, Oberhausen, Germany. Photographs by Wolfgang Volz; preface by Karl Ganser; texts by Marion Taube, David Bourdon, and Wolfgang Volz; edited by Simone Philippi. Cologne: Benedikt Taschen Verlag.

2000

Christo and Jeanne-Claude, Black and White. Annely Juda Fine Art, London, England.

2001

Christo e Jeanne-Claude, Progetti Recenti, Progetti Futuri. Projects and Realisations for Wrapped Trees, 1966–98; Projects and Realisations with Oil Barrels, 1958–82, and 13,000 Oil Barrels, Oberhausen, 1999; Two Works in Progress: Over the River and The Gates. Palazzo Bonoris, Brescia, Italy. Organized by Fondazione Ambrosetti Arte Contemporanea. Texts by Loredana Parmesani, Ettore Camuffo, Marion Taube, Christo, and Jeanne-Claude; photographs by Wolfgang Volz, Eeva-Inkeri, Jean-Dominique Lajoux, Harry Shunk, Ferdinand Boesch, and André Grossmann.

Christo and Jeanne-Claude: The Art of Gentle Disturbance. Macy Gallery, Teachers College, Columbia University, New York. Photographs by Wolfgang Volz, Jean-Dominique Lajoux, and Harry Shunk.

Christo and Jeanne-Claude. Two Works in Progress: Over the River, Project for the Arkansas River, Colorado, and The Gates, Project for Central Park, New York. State University Art Gallery, Kennesaw, Georgia. Photographs by Wolfgang Volz.

Christo and Jeanne-Claude, The Gates, Project for Central Park New York City, and Over the River, Project for the Arkansas River, Colorado, Two Works in Progress. Guy Pieters Gallery, Saint-Paul de Vence, France. Two cata-logues in a box: "Over the River," picture commentary by Jeanne-Claude and Jonathan Henery, photographs by Wolfgang Volz, Sylvia Volz, and Simon Chaput; "The Gates," picture commentary by Jeanne-Claude and Jonathan Henery, photographs by André Grossmann and Wolfgang Volz. (In English; also published in German.)

Christo and Jeanne-Claude: Early Works, 1958–69. Martin Gropius Bau, Berlin. Texts by Lawrence Alloway, David Bourdon, Jan van der Marck; edited and updated by Susan Astwood; photographs by Wolfgang Volz, Ferdinand Boesch, Thomas Cugini, André Grossmann, Eeva-Inkeri, Jean-Dominique Lajoux, Harry Shunk, Stefan Wewerka, and many others. Cologne: Taschen.

Christo and Jeanne-Claude, Wrapped Reichstag, 1971–95, A Documentation Exhibition. Martin Gropius Bau, Berlin. Photographs by Wolfgang Volz; picture commentary by David Bourdon, Michael S. Cullen, Christo, and Jeanne-Claude. Cologne: Taschen.

Christo and Jeanne-Claude, The Tom Golden Collection. Sonoma County Museum, Santa Rosa, California. Texts by Kevin Konicek, Gay Shelton, Thomas M. Golden, and Peter Selz; photographs by Wolfgang Volz, Harry Shunk, Jean-Dominique Lajoux, Klaus Baum, Jeanne-Claude, and Eeva-Inkeri.

Christo and Jeanne-Claude, The Gates, Project for Central Park, New York City, and Over the River, Project for the Arkansas River, Colorado, Two Works in Progress. Park Ryu Sook Gallery, Seoul, Korea. One volume in Korean and English. Picture commentary by Jeanne-Claude and Jonathan Henery; photographs by Wolfgang Volz, Sylvia Volz, and Simon Chaput. "The Gates," picture commentary by Jeanne-Claude and Jonathan Henery; photographs by André Grossmann and Wolfgang Volz.

2002

Christo and Jeanne-Claude in the Vogel Collection. National Gallery of Art, Washington, D.C. Introduction by Earl A. Powell, III; text and interview by Molly Donovan; photographs by Wolfgang Volz.

Christo and Jeanne-Claude: The Weston Collection, Toronto, Canada. The Gallery at Windsor and Vero Beach Museum of Art, Florida. Foreword by W. Galen Weston; essay by Molly Donovan; photographs by Wolfgang Volz, and additional photographs by Simon Chaput, Jean Desjardins, André Grossmann, Eeva-Inkeri, Thomas Moore, and Harry Shunk. Published by George Weston Limited.

2003

Christo and Jeanne-Claude, The Gates, Project for Central Park, New York City, and Over the River, Project for the Arkansas River, Colorado, Two Works in Progress. Galleria Morone, Milan, Italy. Photographs by Wolfgang Volz.

Films and Videos

1969

Wrapped Coast. Blackwood Productions. 30 minutes.

1970

Works in Progress. Blackwood Productions. 30 minutes.

1972

Valley Curtain. Maysles Brothers and Ellen Giffard. 28 minutes. The film was nominated for the Academy Award in 1973.

1977

Running Fence. Maysles Brothers/Charlotte Zwerin. 58 minutes.

1978

Wrapped Walk Ways. Blackwood Productions. 25 minutes.

1985

Islands. Maysles Brothers/Charlotte Zwerin. 57 minutes.

1990

Christo in Paris. (The Pont Neuf Wrapped, 1975–85.) David and Albert Maysles, Deborah Dickson, Susan Froemke. 58 minutes.

1995

Christo and Jeanne-Claude, an Overview of the Oeuvre, 1959–95. Blackwood Productions. 58 minutes.

1996

Umbrellas. Albert Maysles, Henry Corra, and Graham Weinbren. 81 minutes. The film won the Grand Prize and the People's Choice Award at the 1996 Montréal Film Festival.

Christo und Jeanne-Claude, "Dem Deutsche Volke," Verhüllter Reichstag, 1971–95. (Wrapped Reichstag.) Wolfram and Jörg Daniel Hissen, EstWest. 98 minutes.

1998

Christo and Jeanne-Claude, Wrapped Trees. Gebrüder Hissen, Wolfram and Jörg Daniel Hissen, EstWest. 26 minutes.

Museum Collections

Akron Art Museum, Ohio
Albright-Knox Art Gallery, Buffalo, New York
Albuquerque Museum of Art, New Mexico
Allen Memorial Art Museum, Oberlin, Ohio
Art Gallery of New South Wales, Sydney, Australia
Art Gallery of Ontario/Musée des Beaux Arts de
l'Ontario, Toronto, Canada
The Art Institute of Chicago, Illinois
The Art Museum of Santa Cruz County, Soquel,
California
Art Tower Mito, Ibaraki, Japan
Australian Museum, Sydney, Australia

Ball State University Art Gallery, Muncie, Indiana
Basil and Elise Goulandris Museum of Modern Art,
Andros, Greece
Bayerische Staatsgemäldesammlungen, Neue
Pinakothek, Munich, Germany
Berlinische Galerie, Berlin, Germany
Boise Art Museum, Idaho
Bowdoin College Museum of Art, Brunswick, Maine

Caixa Forum, Barcelona, Spain
Campbelltown City Bicentennial Art Gallery,
Campbelltown, New South Wales, Australia
Centre Canadien d'Architecture, Montréal, Canada
Centre National d'Art et de Culture Georges Pompidou,
Paris, France
The Chrysler Museum, Norfolk, Virginia
CIGNA Museum and Art Collection, Philadelphia,
Pennsylvania
The Cleveland Museum of Art, Ohio
Corcoran Gallery of Art, Washington, D.C.

Dallas Museum of Art, Texas
David Winton Bell Gallery, Brown University,
Providence, Rhode Island
Des Moines Art Center, Iowa

The Detroit Institute of Arts, Michigan
Deutsches Architektur Museum, Frankfurt Am Mein,
Germany

Fogg Art Museum, Cambridge, Massachusetts
Frederick R. Weisman Art Museum, University of
Minnesota, Minneapolis
Fukuoka Art Museum, Fukuoka City, Japan

Galerie d'Art Moderne, Geneva, Switzerland
Galleria degli Uffizi, Florence, Italy
Greenville Museum of Art, North Carolina

Hamburger Kunsthalle, Hamburg, Germany
The Hara Museum of Contemporary Art, Tokyo, Japan
Henie-Onstad Kunstsenter, Høvikodden, Norway
High Museum of Art, Atlanta, Georgia
Hiroshima City Museum of Contemporary Art, Japan
Ho-Am Museum, Yongin-Gun, Kyunggi-Do, Korea
Hood Museum of Art, Dartmouth College, Hanover,
New Hampshire
Housatonic Museum of Art, Bridgeport, Connecticut
Hugh Lane Municipal Gallery of Modern Art, Dublin,
Ireland
Hunter Museum of Art, Chattanooga, Tennessee

The Israel Museum, Jerusalem, Israel
Iwaki City Art Museum, Fukushima, Japan

John and Mable Ringling Museum of Art, Sarasota,
Florida

Kemper Museum of Contemporary Art & Design,
Kansas City Art Institute, Missouri
Kestner Gesellschaft, Hanover, Germany
Kitakyushu-City Municipal Museum of Art,
Kitakyushu-City, Japan

Krefelder Kunstmuseen (Kaiser Wilhelm Museum),
Krefeld, Germany
Kunstgewerbemuseum Der Stadt, Zurich, Switzerland
Kunsthaus, Zurich, Switzerland
Kunstmuseum, Basel, Switzerland
Kunstmuseum, Bern, Switzerland
Kunst Museum, Hannover, Germany
Kunstmuseum der Stadt Bonn, Bonn, Germany
Kupferstichkabinett Basel, Basel, Switzerland

Los Angeles County Museum of Art, California
Los Angeles Museum of Contemporary Art, California
Louisiana Museum of Modern Art, Humlebaek,
Denmark
Lowe Art Museum, University of Miami, Florida

Madison Art Center, Wisconsin
The Menil Collection, Houston, Texas
The Metropolitan Museum of Art, New York
Miami Dade Community College, Miami, Florida
Milwaukee Art Museum, Wisconsin
Minnesota Museum of American Art, Saint Paul,
Minnesota
Mint Museum of Art, Charlotte, North Carolina
Mississippi Museum of Art, Jackson
Moderna Museet, Stockholm, Sweden
Mönchehaus Museum für Moderne Kunst, Goslar,
Germany
Musée d'Art Contemporain, Carré d'Art, Nimes, France
Musée d'Art Contemporain de Montréal, Canada
Musée d'Art et d'Histoire, Geneva, Switzerland
Musée d'Art Moderne et d'Art Contemporain, Nice,
France
Musée d'Art Moderne de la Ville de Paris, France
Musée Cantini, Marseille, France
Musée de Grenoble, France
Musée de Toulon, France

Musées Royaux des Beaux-Arts de Belgique, Brussels, Belgium

Museum Boijmans Van Beuningen, Rotterdam, The Netherlands

Museum of Contemporary Art, Chicago, Illinois

Museum of Contemporary Art, San Diego, La Jolla, California

Museum of Contemporary Art San Diego, San Diego, California

Museum of Contemporary Art, Skopje, Macedonia

Museum of Contemporary Art, Sydney, Australia

Museum of Contemporary Art, Teheran, Iran

Museum of Contemporary Art, Tokyo, Japan

The Museum of Fine Arts, Houston, Texas

Museum van Hedendaagse Kunst (SMAK), Gent, Belgium

Museum für Kunst und Gewerbe, Hamburg, Germany

Museum Ludwig, Cologne, Germany

The Museum of Modern Art, New York

Museum of Modern Art, San Francisco, California

The Museum of Modern Art, Shiga, Japan

The Museum of Modern Art, Toyama, Japan

The Museum of Modern Art, Wakayama, Japan

Museum Würth, Künzelsau, Germany

Museum des 20 Jahrhunderts, Vienna, Austria

Naoshima Contemporary Art Museum, Kagawa, Japan

Nationalgalerie, Berlin, Germany

National Gallery of Art, Washington, D.C.

National Gallery of Australia, Canberra, Australia

National Gallery of Victoria, Melbourne, Australia

National Museum of Art, Osaka, Japan

National Museum of Wales, Cardiff, Wales, United Kingdom

Nelson-Atkins Museum of Art, Kansas City, Missouri

Neuberger Museum, State University of New York, Purchase, New York

Neue Galerie Der Stadt, Aachen, Germany

Neue Galerie Der Stadt Linz, Wolfgang Gurlitt Museum, Linz, Austria

New Britain Museum of American Art, New Britain, Connecticut

New England Regional Art Museum, Armidale, Australia

New Tokyo Metropolitan Art Museum, Japan

Obala Gallery, Sarajevo, Bosnia

The Ohara Museum of Art, Kurashiki City, Okayama Prefecture, Japan

The Pennsylvania Museum of Fine Arts, Philadelphia

Philadelphia Museum of Art, Philadelphia, Pennsylvania

Portland Museum of Art, Portland, Maine

The Power Institute of Fine Arts, Sydney, Australia

Rainbow Museum of Modern Art, Shimizu-shi, Shizuoka-ken, Japan

Rheinisches Landesmuseum, Bonn, Germany

Rijksmuseum Kröller-Müller, Otterlo, The Netherlands

Saint Louis Art Museum, Missouri

Santa Barbara Museum, California

Sara Hildenin Taidemuseo, Tampere, Finland

Skissernas Museum, Lund, Sweden

Smith College Museum of Art, Northampton, Massachusetts

Smithsonian American Art Museum, Washington, D.C.

Smithsonian Institution, Hirshhorn Museum and Sculpture Garden, Washington, D.C.

The Sogetsu Foundation, Tokyo, Japan

Sprengel-Museum, Hannover, Germany

StaatsGalerie, Stuttgart, Germany

Städtisches Museum Abteiberg, Mönchengladbach, Germany

Stedelijk Van Abbemuseum, Eindhoven, The Netherlands

Stedelijk Museum, Amsterdam, The Netherlands

Stiftung Haus der Geschichte der Bundesrepublik Deutschland, Bonn, Germany

Takamatsu Municipal Museum of Art, Marugame-City, Takamatsu, Japan

The Takanawa (Seibu) Museum of Art, Karuizawa, Japan

The Tate, London, England

Tokushima Prefecture Modern Art Museum, Tokushima, Japan

Ulmer Museum, Ulm, Germany

University of Iowa Museum of Art, Collection Dorothy Schramm, Iowa City, Iowa

University of Michigan Museum of Art, Ann Arbor

Vancouver Art Gallery, British Columbia, Canada

Victoria and Albert Museum, London, England

Virginia Museum of Fine Arts, Richmond, Virginia

Walker Art Center, Minneapolis, Minnesota

Weatherspoon Art Gallery, University of North Carolina, Greensboro, North Carolina

Whitney Museum of American Art, New York

Wilhem-Lehmbruck-Museum, Duisburg, Germany

Worcester Art Museum, Massachusetts

Yale University Art Gallery, New Haven, Connecticut

Yamanashi Prefectural Museum of Art, Kofu, Japan

Acknowledgments

This book represents a culmination in a thirty-year friendship with two artists whom I deeply admire. In an era when the impact of the traditional fine arts has receded in favor of film and television, these two artists have succeeded in widening the influence of art, reaching out to a broader public and fostering a profound discourse on our cultural and political values. I want to thank them both, and particularly Jeanne-Claude for patiently wading through these interviews and texts with meticulous care despite the extraordinary demands on her time.

I also want to thank United Technologies Corporation, especially its chairman, George David, but also Gabriella de Ferrari and Krista Pilot, for their steady support for the social value of the kind of research and writing that I do. In addition, I want to thank Patricia Fidler of Yale University Press, who I hope will always be my publisher. She and her staff have been fantastic to work with in more ways than I can list here. I owe significant peace of mind to my friend Richard Herman, the provost of the University of Illinois, whose support has made space for this kind of undertaking. I also want to acknowledge the contribution of my wife, Marianne, who does so much to smooth the writing process for me and is, at the same time, also my first reader and often the source of my best ideas.

Jonathan Fineberg

Index

Designed by Sam Potts Inc.
Set in Adobe Caslon by Tina Thompson
Book production by Ken Wong
Printed by Kwong Fat Offset Printing in Hong Kong